THE ARTIST REVEALED

THE ARTIST REVEALED

ARTISTS AND THEIR SELF-PORTRAITS

Ian Chilvers
Editor: Rachel Bean

THUNDER BAY
P·R·E·S·S
San Diego, California

Thunder Bay Press
An imprint of the Advantage Publishers Group
5880 Oberlin Drive, San Diego, CA 92121-4794
www.thunderbaybooks.com

All notations of errors or omissions should be addressed to Thunder Bay
Press, editorial department, at the above address. All other correspondence
(author inquiries, permissions) should be addressed to:
The Brown Reference Group plc
8 Chapel Place, Rivington Street, London, EC2A 3DQ, UK.
www.brownreference.com

ISBN 1-57145-948-0
Library of Congress Cataloging-in-Publication Data available upon request.

Printed in China

1 2 3 4 5 07 06 05 04 03

For The Brown Reference Group plc:
Editor and additional text: **Rachel Bean**
Editorial Assistant: **Tom Webber**
Art Director: **Dave Goodman**
Designers: **Joanna Walker, Iain Stuart**
Picture Researcher: **Susannah Jayes**
Picture Research Assistant: **Susy Forbes**
Production Director: **Alastair Gourlay**
Indexer: **Kay Ollerenshaw**
Editorial Director: **Lindsey Lowe**
Managing Editor: **Tim Cooke**

CONTENTS

INTRODUCTION

Self-portraiture can be traced back at least as far as the ancient Greeks, but the early history of the subject is extremely fragmentary and it is not until the Renaissance that it begins to emerge as a significant strand in art. The most famous of Greek sculptors, Phidias (who lived in the fifth century B.C.), and the most famous of Greek painters, Apelles (who lived in the fourth century B.C.), are said to have made self-portraits, for example, but these works have not survived. Later, during the Middle Ages, the artists who decorated manuscripts sometimes included small images of themselves in their illuminations, but these may well have been intended more as symbolic figures than as realistic portraits of particular individuals.

The earliest independent painted self-portraits date from the fifteenth century, the example by Jan van Eyck (see pages 10–13) being one of the first known. There are several reasons why such works began to develop around this time. Most obviously, portraiture in general was becoming more common after a long period in which religious subjects had virtually monopolized European art. At the same time the status of the artist was beginning to rise, and a self-portrait was a way of expressing pride in the painter's profession. On a technical level, mirrors were becoming more readily available and of better quality, making self-examination easier.

Below: Jan van Eyck, The Arnolfini Wedding, *1432 (detail, see page 13). A convex mirror is featured amid the costly possessions of the wealthy couple portrayed in the painting.*

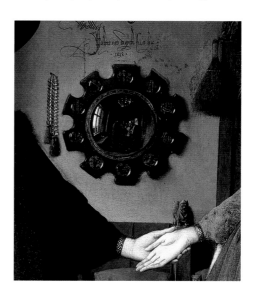

In the ancient and medieval world mirrors were usually made of small disks of highly polished metal. By the thirteenth century they were being manufactured from glass backed with a reflective surface of metal, but they were expensive luxury items—so much so that heads of state sometimes presented mirrors to other rulers as diplomatic gifts. It was not until the fifteenth century that advances in technology enabled

good-quality glass mirrors to be produced in substantial numbers, although they still remained very costly. Venice, which was famous for glassware in general, was the main center of manufacture during the Renaissance.

When an artist looks at himself or herself in a mirror, the image is seen reversed from left to right. Usually artists accept the distortion of the truth that this involves, so that when, for example, Vincent van Gogh portrayed himself after mutilating his left ear, in the picture it appears to be his right ear that is bandaged (see pages 182–85). When they represent themselves with the tools of their trade, however, most artists partly "correct" the image by showing themselves holding a brush in their right hand (assuming they are right-handed, as most people are) and a palette in their left. Joshua Reynolds (see pages 82–85) and Édouard Manet (see pages 138–41) are among the exceptions, showing the palette in the right hand.

Van Gogh, as we know from his letters, sometimes painted himself simply because he was a convenient free model. Countless other artists must have painted themselves for the same reason, but there have been many other motives for self-portraiture. One of these, of course, is vanity. Anthony van Dyck's youthful self-portrait (see pages 62–65), for example, clearly suggests he was proud of his looks, an interpretation backed up by everything we know about his personality from contemporary accounts. Benjamin West (see pages 94–97), Elisabeth Vigée-Lebrun (see pages 110–13), and Dante Gabriel Rossetti (see pages 134–37) are among the other artists who rejoiced in their own physical charms. On the other hand, Edvard Munch was a superb physical specimen, yet he was concerned with exploring his inner feelings rather than with showing off his tall, strong frame and handsome features (see pages 190–93).

Some artists have painted self-portraits to celebrate events of particular significance in their lives, as Peter Paul Rubens did

Below: Sofonisba Anguissola, Self-Portrait Painting the Virgin, *c.1555–60 (detail, see page 39). The artist has corrected the mirror image to show herself working right-handed.*

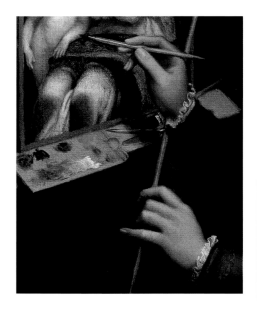

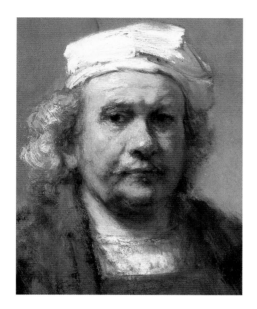

Above: Rembrandt, Self-Portrait, c.1665 *(detail, see page 67). Rembrandt's numerous self-portraits show his changing features and fortunes throughout his eventful life.*

when he marked his first marriage in a picture that radiates happiness (see pages 50–53). Other painters have used them as manifestos of their beliefs, as William Hogarth did when he presented himself as a kind of British bulldog, confidently taking on the foreigners who had hitherto dominated his country's art (see pages 74–77). With many self-portraits, however, we can only speculate on the motivation behind their creation, not least in the case of Rembrandt van Rijn, the artist who above all others is famous for his portrayals of himself (see pages 66–69).

Occasionally self-portraits have been specially commissioned, notably for the unrivaled collection of such works in the Uffizi gallery in Florence. This collection was founded in the seventeenth century by Cardinal Leopoldo de' Medici, and as its fame grew, artists sent, or were invited to send, pictures of themselves to add to it. These portraits—for example the paintings by William Holman Hunt (see pages 130–33) and John Singer Sargent (see pages 186–89)—tend to present a very public image of their authors, showing them as they would like to be seen among their peers and remembered by posterity.

At the other extreme are self-portraits that are almost painfully intimate, such as those by Egon Schiele (218–21) and Frida Kahlo (234–37). These two painters show how free artists can be when they are creating self-portraits for their own satisfaction. They are not bound by contracts or the demands of patrons, and they do not have to flatter or impress. With no one else to answer to, they often express themselves with particular freshness and immediacy. This helps to explain the endless fascination of self-portraits. Even on the most superficial plane, they are intriguing because they satisfy our curiosity to know what great men and women looked like. And on a deeper level, they offer glimpses into the hearts and minds of some the most colorful and creative figures of the past six centuries.

JAN VAN EYCK

c . 1 3 9 0 – 1 4 4 1

Impassive and watchful beneath his extraordinary headgear, the middle-aged man gazes skeptically out of the picture, as if weighing up the spectator. It is one of the first portraits in European art in which the subject makes such eye contact with the viewer, and the idea could well have occurred to Jan van Eyck as he studied his own reflection in a mirror. The picture was certainly painted by van Eyck—the frame has a contemporary inscription saying so—and there is no reason to doubt the long-standing tradition that it is a self-portrait.

When he produced the portrait, van Eyck was probably in his forties, although there is no record of his date of birth and his early years are obscure. By the time of the first known reference to him in 1422 he was already an established and respected artist, and in the remaining two decades of his life he became the most renowned painter of the age outside Italy. He spent most of his career, from 1425, working for Philip the Good, duke of Burgundy, who ruled large areas of what are now France and Belgium and was one of the most cultured and extravagant patrons of the time. Philip valued van Eyck not only for his artistic skills, but also for his personal qualities. The painter must have been intelligent and tactful, because he was sent on several sensitive missions, including one to Portugal in 1428–29 to negotiate a marriage between Philip and Princess Isabella, daughter of the king of Portugal. Philip showed his personal regard for van Eyck by becoming godfather to one of his children, and when his court accountants once queried the high payments made to the artist, he replied that they must be made "without further delay, alteration, variation, or difficulty whatever," for he "would never find a man so outstanding in his art and science."

During his service to the duke, van Eyck lived mainly in Bruges, but his most famous work is a huge multipaneled altarpiece painted for Ghent Cathedral. The altarpiece was begun by van Eyck's brother, Hubert, who died in 1426, and was finished in 1432. It is uncertain how much either brother contributed to the work, but there is no doubt about its status as one of the supreme masterpieces of European art.

Portrait of a Man ("Man in a Red Turban"), 1433, oil on panel, National Gallery, London

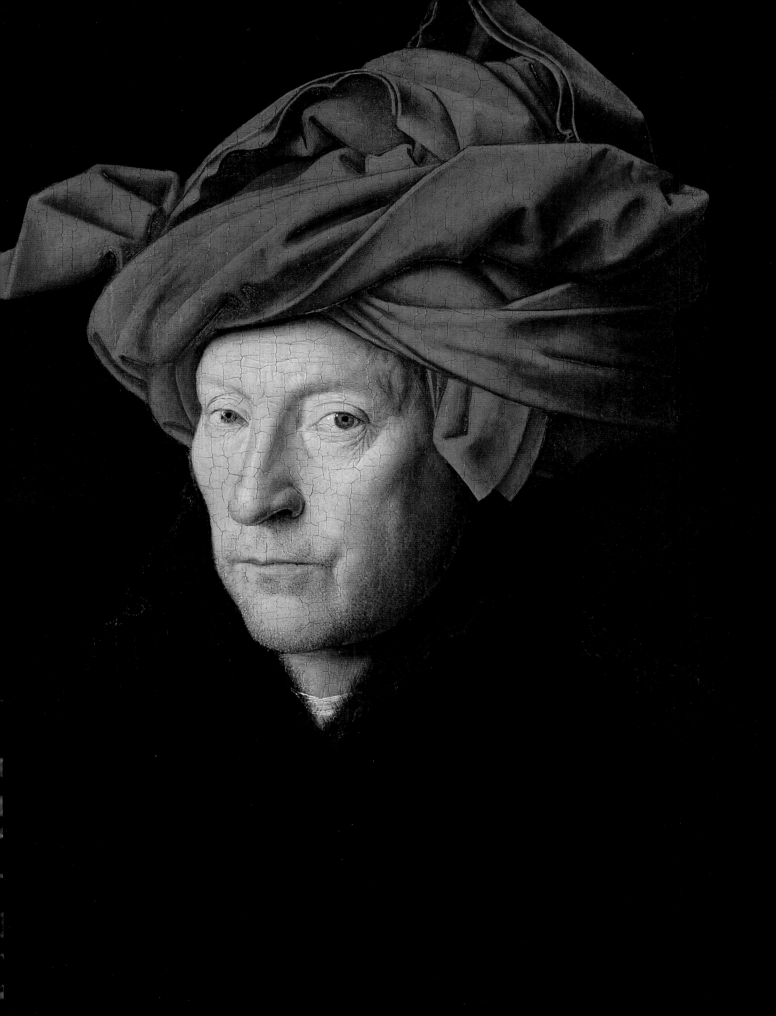

Style and technique

Van Eyck was once thought to have invented oil paint. It is now known that oils were in use long before his time, but he certainly did play a key role in popularizing such paints and showing their potential for creating glowing colors and precise details. His sharpness of observation and delicacy of technique have rarely been matched. From the stubble on his own chin to a distant landscape, he depicted the colors and textures of the natural world with amazing richness and fidelity, and this sheer illusionistic skill has always been the basis of his fame.

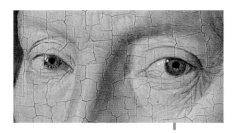

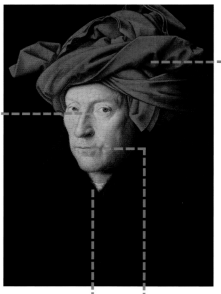

Four tiny touches of white suggest light catching van Eyck's left eye and help to create a glistening effect. The sitter appears to look directly out at the spectator—a novelty in portraiture at this time and one possibly inspired by van Eyck's use of a mirror.

The magnificent head-covering—after which the painting takes its popular name, "Man in a Red Turban"—is in fact an elaborate hood called a chaperon that was fashionable in Europe in the fourteenth and fifteenth centuries. Van Eyck used many thin layers of oil paint to build up the glowing tones of the sumptuously draped red fabric.

At the neckline there is a contrast of textures and colors, where the skin and white undergarment are set against the soft fur-trimmed robe. The dark robe and background focus the viewer's attention on the sitter's face and elaborate headgear.

The mouth is thin and slightly compressed at the corners, helping to create what the art historian Erwin Panofsky called "an air of skepticism … We feel observed and scrutinized by a wakeful intelligence."

Netherlandish portraits

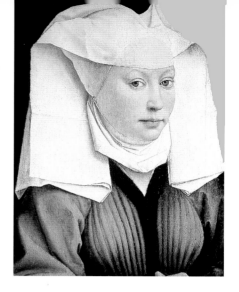

In van Eyck's time the great majority of paintings depicted religious subjects, but portraiture was beginning to develop as an important secondary strand in art.

In earlier times only the highest-ranking people, such as kings or popes, had portraits made of them, but in the fifteenth century art became more democratic. There are about ten single portraits by van Eyck and they depict people from various walks of life, including a cardinal, a goldsmith, and a merchant, as well as the painter's wife, Margaret. All these portraits are fairly similar in type, showing the sitter bust-length (the head and upper body) and turned slightly to one side against a plain background. However, van Eyck also painted a full-length double portrait of the Italian merchant Giovanni Arnolfini and his wife, and this is highly original in conception. It shows the couple in an exquisitely depicted interior setting, full of details that probably refer symbolically to their married state. The dog that stands at their feet, for example, is a traditional symbol of fidelity.

No other early Netherlandish painter matched van Eyck in so closely scrutinizing the details of the human face, but there were several outstanding portraitists among his successors. The greatest was Rogier van der Weyden (c.1399–1464), whose portraits are less penetrating in observation but more aristocratic in bearing and more pious or spiritual in feeling than van Eyck's. He worked mainly in Brussels. In Bruges, van Eyck's chief successor was Petrus

Christus (c.1410–75), who was one of the first painters to abandon the usual dark background in single portraits to depict the subject in a room. In Louvain, Dirk Bouts (c.1420–75) took this process further and was perhaps the first Netherlandish painter to show a view through a window behind the sitter in a portrait. This feature soon became popular in portraiture.

Above: Rogier van der Weyden, Portrait of a Lady, *c.1435. Its serene air and refined style are typical of Rogier's work.*

Below: Van Eyck, The Arnolfini Wedding, *1434. This elaborate portrait shows the two figures in an expensively furnished room.*

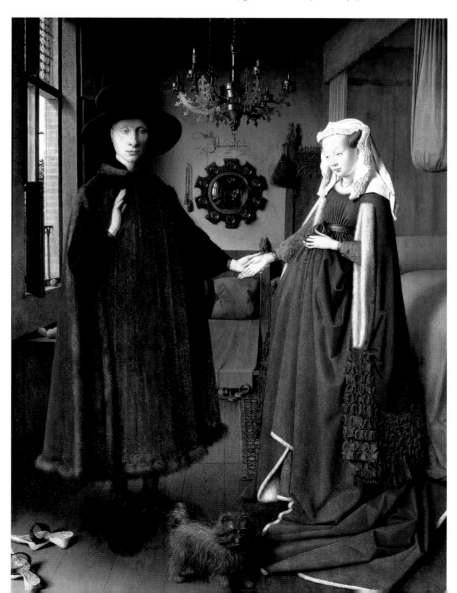

LEONARDO DA VINCI

1452–1519

This "great furrowed mountain of a face," as the art historian Kenneth Clark memorably described it, is one of the most familiar images of genius in Western art. It has traditionally been regarded as a self-portrait of Leonardo (an old inscription on the drawing describes it as such), but some scholars think that it is an idealized picture of an aged philosopher rather than a record of the artist's own features. There is no unquestionably authentic likeness of Leonardo against which to compare it, but contemporary accounts indicate that he was strikingly imposing in appearance. There is also evidence that he looked older than his years, so even if this portrait is not literally true, it is poetically true—it shows Leonardo as posterity would like him to have looked.

It is the image of a man of thought, rather than of action, and Leonardo was indeed more concerned with the intellectual aspects of his calling than any other artist of his time. His attitude helped to bring about a major shift in the way the visual arts were perceived. Before Leonardo, even the best painter or sculptor was regarded as merely a master craftsman; after Leonardo, painters and sculptors could expect the same respect as poets or composers. In a nutshell, Leonardo created the modern idea of the artist as genius. Unfortunately, his intellectual curiosity and versatility had a negative side, for he was constantly finding new things—in science as well as art—to engage his mind and often left projects unfinished, to the dismay of his patrons. He completed only a handful of major paintings, but these were enormously influential. He also left a huge number of drawings—more than any other Renaissance artist—and many authorities regard him as the greatest draftsman of all time.

Leonardo was born in the small town of Vinci (or the nearby hamlet of Anchiano), near Florence, where he trained as a painter. He worked in Florence until he was about thirty, then lived in Milan until 1499. Subsequently he moved about a good deal, but divided his time mainly between Florence and Milan. In 1516 or 1517 he accepted an invitation from King Francis I of France to settle in his country and he died at the royal chateau of Cloux in the Loire Valley, already a legendary figure.

Self-Portrait?, c.1512, red chalk on paper, Biblioteca Reale, Turin

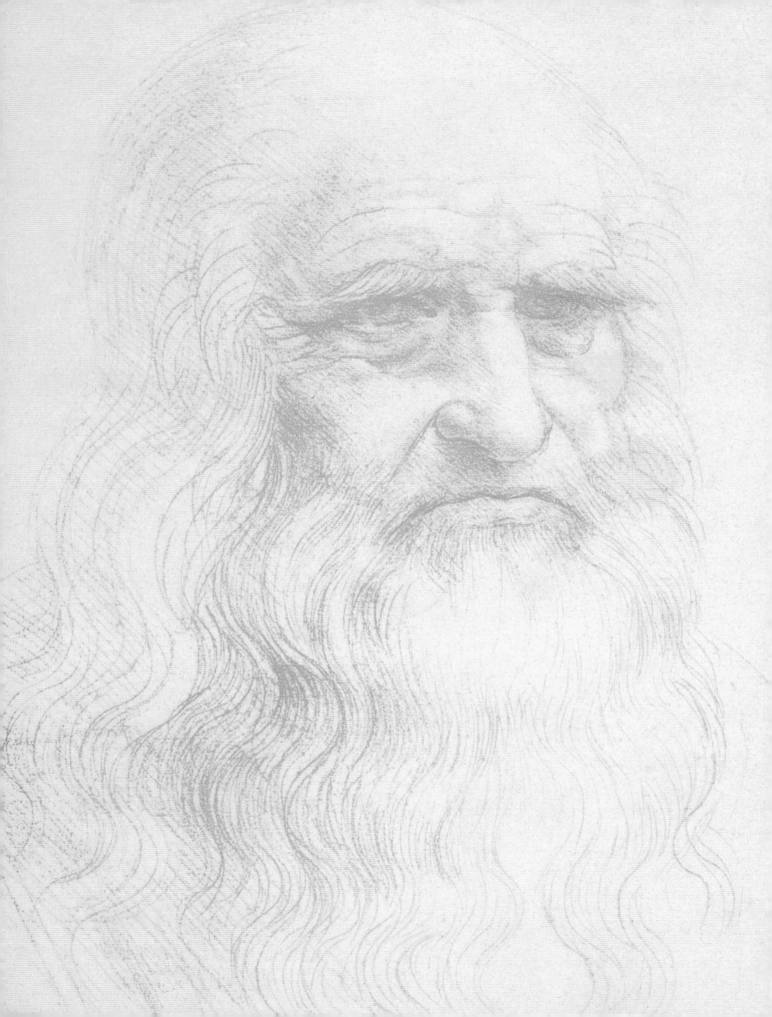

Style and technique

With his scientifically observed detail, his mastery of light and shade, and his unprecedentedly subtle handling of gesture and expression, Leonardo made painting more naturalistic than it had ever been before. However, there is far more to his work than naturalism; it often has a wonderful sense of mystery or fantasy. In drawing, he worked with equal brilliance in all the main media of the time: ink, chalk, and metalpoint, in which a pencil-like tool tipped with metal (usually silver) is used on specially prepared paper, producing a line of extraordinary delicacy.

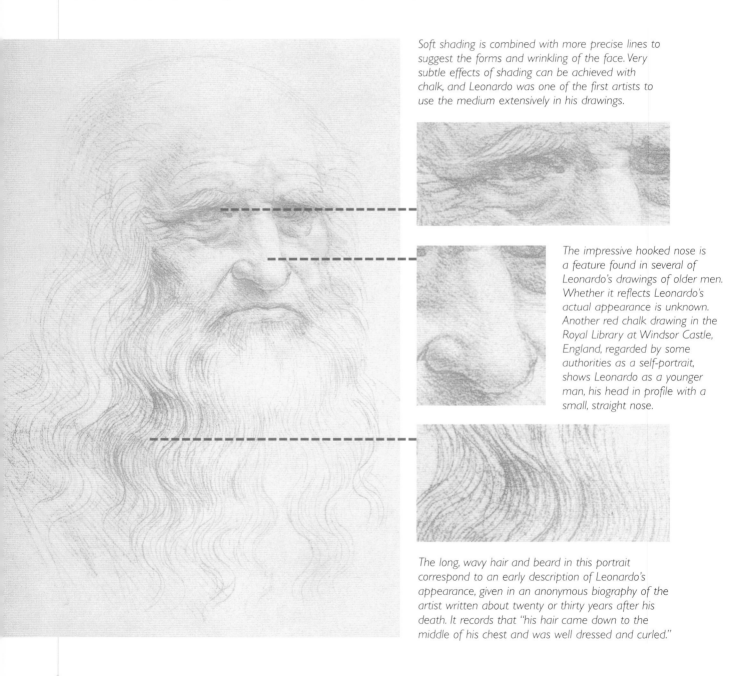

Soft shading is combined with more precise lines to suggest the forms and wrinkling of the face. Very subtle effects of shading can be achieved with chalk, and Leonardo was one of the first artists to use the medium extensively in his drawings.

The impressive hooked nose is a feature found in several of Leonardo's drawings of older men. Whether it reflects Leonardo's actual appearance is unknown. Another red chalk drawing in the Royal Library at Windsor Castle, England, regarded by some authorities as a self-portrait, shows Leonardo as a younger man, his head in profile with a small, straight nose.

The long, wavy hair and beard in this portrait correspond to an early description of Leonardo's appearance, given in an anonymous biography of the artist written about twenty or thirty years after his death. It records that "his hair came down to the middle of his chest and was well dressed and curled."

Portrait drawings

Portrait drawings have been part of the repertoire of many artists; for some they have been occasional or experimental pieces, but for others they have been a means of earning a living.

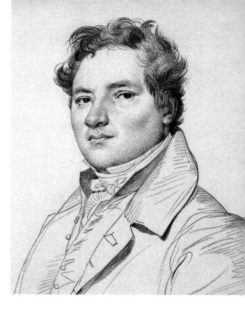

Above: Portrait of a Man *made in 1834 by the French artist Ingres. Its delicate tones, precise control of line, and assurance of handling are typical of Ingres's portrait drawings.*

A significant advantage that drawing has over painting is that a drawing can usually be made much more quickly and therefore economically than a comparable painting. In 1500 Leonardo briefly visited Mantua, where he made a profile portrait drawing of Isabella d'Este, who was wife of the ruler of the city and one of the outstanding female patrons of the Renaissance. For several years she tried to persuade Leonardo to turn the drawing into a painting or produce some other painting for her, but her efforts were in vain.

Among Leonardo's contemporaries, the supreme exponent of the portrait drawing was Hans Holbein (see pages 30–33). In 1538 Holbein's royal master, King Henry VIII of England, sent him to Brussels to make a portrait of a potential bride, Christina of Denmark. Holbein was given a sitting of three hours, during which he made a drawing of the sixteen-year-old princess that pleased Henry greatly when he saw it, but the marriage negotiations fell through. There are about eighty portrait drawings by Holbein in the Royal Library at Windsor Castle; his drawing of Christina no longer survives, but the full-length painting he made of her, which is now in the National Gallery, London, is presumably based on it.

The most prolific of all great portrait draftsmen was the French artist Jean-Auguste-Dominique

Ingres (1780-1867). He was successful for most of his career, but at times he had to earn his living mainly by making pencil drawings of tourists to Italy. He regarded this work as drudgery, once complaining: "I am stricken with a kind of horror at anything to do with drawing." However, the portraits he produced are small masterpieces of delicate draftsmanship, and it is difficult to imagine pencil being used with more finesse.

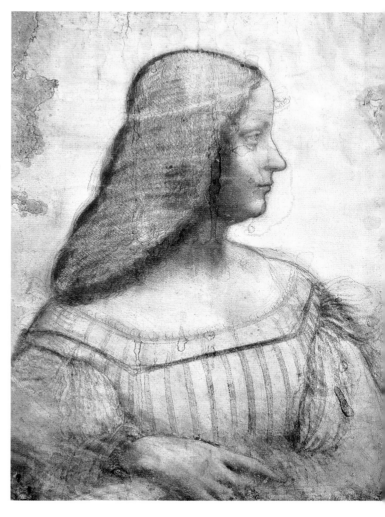

Right: Leonardo's Portrait of Isabella d'Este, *a chalk and pastel drawing made on his visit to Mantua in 1500. He shows Isabella's face in profile, a convention made popular in portraiture in the fifteenth century by the fashion for portrait medals, inspired by ancient Greek and Roman examples on coins and carved gems.*

ALBRECHT DÜRER

1471–1528

The starkly frontal pose, the shoulder-length hair, and the grave, commanding features in this self-portrait instantly bring to mind the traditional image of Christ. The association was quite deliberate, for when Dürer painted the image in 1500 it was not considered sacrilegious to identify oneself with holy figures in such a way, and he perhaps intended to convey the idea that his artistic talent was God-given. As the picture suggests, Dürer was proud of his appearance and status, but he was also a devout and deeply thoughtful man, who pondered the mysteries of life and religion.

Dürer was twenty-eight at the time he painted the portrait and already well on the way to establishing himself as the foremost artist in Germany. Although he was highly esteemed as a painter, his fame and success depended mainly on his prints, which—because they existed in multiple copies and were easily transportable—made his name known throughout Europe. Some of his prints were produced as book illustrations, but most of them were independent works. The majority are woodcuts, but Dürer was also a master of copperplate engraving. In addition to his paintings and prints, he made hundreds of drawings that show his insatiable curiosity about the world. Like his great Italian contemporary Leonardo da Vinci (see pages 14–17), with whom he is often compared, Dürer seemed to be interested in anything and everything, and his drawings depict many subjects—even a lowly piece of turf—that few other artists of the time would have considered worthy of attention.

Dürer spent almost all his career in his native city of Nuremberg, which was one of Europe's major centers of commerce and culture. However, he also made two visits to northern Italy, mainly Venice, in 1494–95 and 1505–07, which were of great importance in shaping his artistic outlook. This self-portrait was painted midway between the two visits. Dürer was the leading figure in bringing the ideals of Italian Renaissance art to northern Europe and he influenced countless artists, including many who trained in his workshop. His patrons included some of the most eminent men of the day, notably the Holy Roman emperors Maximilian I and Charles V, and by the time of his death he was probably second only to Michelangelo as the most famous and revered artist in the world.

Self-Portrait at Twenty-Eight, 1500, oil on panel, Alte Pinakothek, Munich

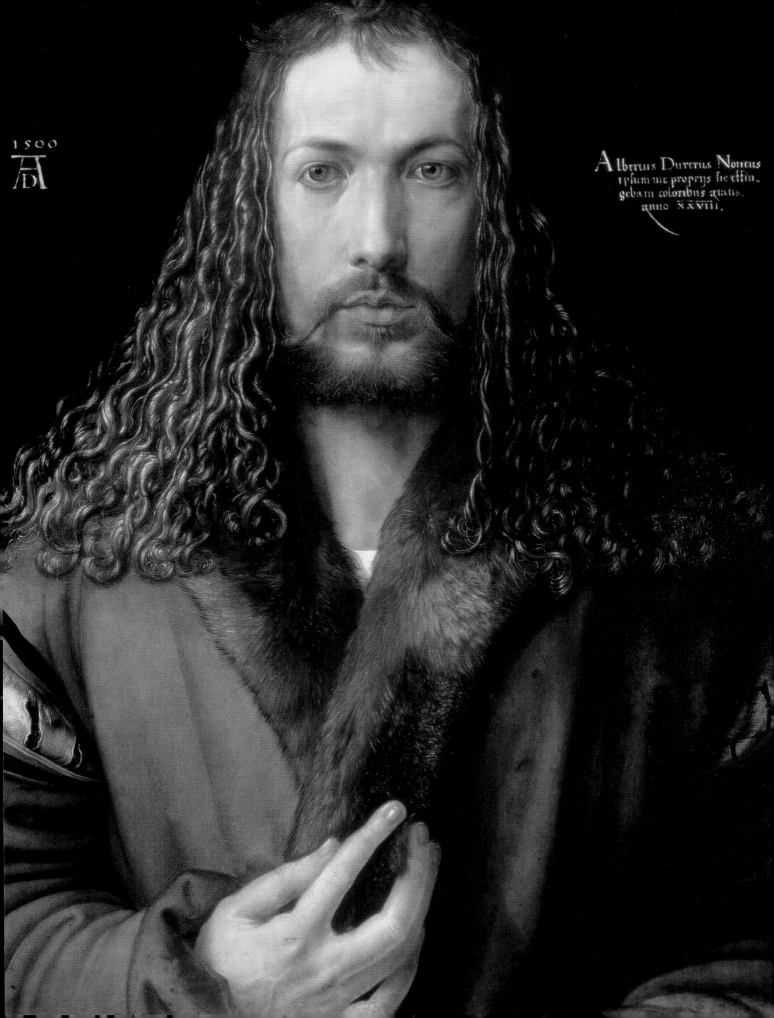

Style and technique

Dürer was brought up in a tradition of exquisitely refined craftsmanship, but he came to love the classical dignity of Italian Renaissance art. His stylistic development is largely the story of his efforts to reconcile his native love of precise detail with the grandeur and breadth of Italian art. His early works tend to have crowded compositions and emphatically emotional expressions, but he became much more sober and restrained. He was a master of virtually every technique of painting, drawing, and printmaking known in his day, including watercolor, of which he was one of the first great exponents.

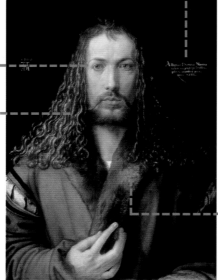

Dürer's expression is one of great dignity. Viewed frontally, his face is symmetrical and with its closed lips, long nose, and steady gaze exudes an air of calm and reflection.

Dürer has painted an inscription: "Thus I, Albrecht Dürer from Nuremburg, painted myself with indelible colors at the age of twenty-eight years." Inscriptions were often included in Renaissance portraits to identify the sitters and record them for posterity, and they appear in the two self-portraits Dürer painted in the 1490s.

Dürer portrays himself with long ringlets of brown hair. In his earlier self-portraits he showed himself with lighter hair and it is likely that he made it browner here to coincide with traditional images of Christ, in which he was portrayed with long, brown, centrally parted hair.

The soft texture of the fur edging on Dürer's jacket is masterfully conveyed with many fine brush strokes. Dürer's contemporaries, notably the Venetian painter Giovanni Bellini, marveled at the skill with which he painted details such as hair.

The status of the artist

Dürer was the first artist to produce a series of self-portraits, rather than one or two isolated examples; in these works he shows his intellectual and social ambitions as well as his artistic concerns.

Dürer's first surviving work is a self-portrait, a beautifully delicate drawing made in 1484 when he was only thirteen years old. Subsequently he produced several others. There are three highly finished oil paintings made in 1494, 1498, and 1500, as well as a number of drawings; in addition, Dürer introduced his own features into several of his religious pictures. In the drawings he shows himself in a variety of ways, sometimes very intimately—sick or nude, for example—as if he were exploring his own inner life. The three self-portrait paintings are different in spirit, presenting his public face. Whereas many artists depicted themselves with the tools of their trade, Dürer shows himself as an expensively dressed and immaculately groomed gentleman—someone who cared deeply about his place in society.

Dürer had good craftsmanship in his blood: his father and both his grandfathers were goldsmiths and up to the age of fifteen, when he turned to painting, he trained as a goldsmith himself. At this time such craftsmen had a fairly lowly status in society; they were regarded as skillful with their hands, like shoemakers, but no more. From an early age, however, Dürer was interested in the world of ideas and wanted to be accepted as someone who worked with his brain as much as his hands. In Italy the artist had a higher status, and during his second visit there Dürer wrote to a friend, "Here I am a gentleman, at home a parasite." This statement was an exaggeration, for he was successful and respected in Germany, but it helps explain why he portrayed himself as he did, rather than as a craftsman in his workshop.

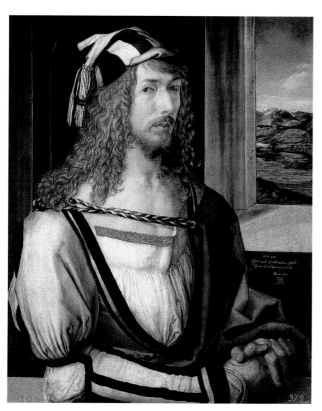

Left: In Self-Portrait at Twenty-Six (1498) *Dürer shows himself in costly and flamboyant dress: a white jacket with black detailing and matching hat, a finely pleated, embroidered shirt, and kid gloves. The mountainous landscape glimpsed through the window probably refers to his earlier journey across the Alps to Italy.*

Right: Dürer, Self-Portrait, c.1505. This vigorous pen-and-ink drawing with white heightening is a much more frank and private study than the artists' painted self-portraits.

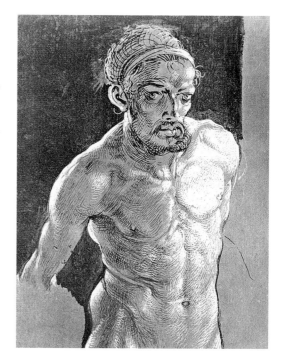

RAPHAEL

1483–1520

Ferom comparisons with other portraits, we can be fairly sure that the man on the left of this painting is Raffaello Sanzio, known in English as Raphael, but the identity of his companion is unknown. The traditional idea that he is the painter's fencing master must have come about because he has his hand on a sword, but it is obviously not a fencing lesson that is depicted. Indeed, it is difficult to gauge what is supposed to be going on in the painting: Why does the "fencing master" gesture so vigorously out of the picture while Raphael, his hand on the man's shoulder, looks on reservedly? The reasons for this intimate drama are now lost, but it has been suggested that the "fencing master" was a friend of Raphael who was about to leave Rome; this would explain his pointing gesture and also Raphael's expression, which could be interpreted as showing resigned acceptance of his departure.

Raphael at this time was in his mid-thirties, but he had been the dominant artist in Rome for several years and had already achieved a degree of wealth and status that no earlier artist had enjoyed. His career was a story of continual success, based not only on his genius, but also on his capacity for hard work and his winning personality. Unlike his two older contemporaries Leonardo and Michelangelo, who had difficult temperaments, Raphael seems to have gotten along with everyone, and this helped him in organizing the large studio that helped him to carry out his vast workload.

Raphael was born in the Italian city of Urbino, the son of a minor painter. He was highly precocious and was established as an independent master by the time he was seventeen, an age when most painters were still serving their apprenticeships. Early in his career he worked in various parts of central Italy, and from 1504 to 1508 he spent much of his time in Florence, where he learned from the work of Leonardo and Michelangelo. In 1508 he moved to Rome, where he spent the rest of his career, mainly in the service of Pope Julius II and his successor Leo X. Raphael worked as an architect as well as a painter and directed a survey of the monuments of ancient Rome. His early death on his thirty-seventh birthday is said to have plunged the whole papal court into grief.

Raphael with His Fencing Master, c.1518, oil on canvas, Louvre, Paris

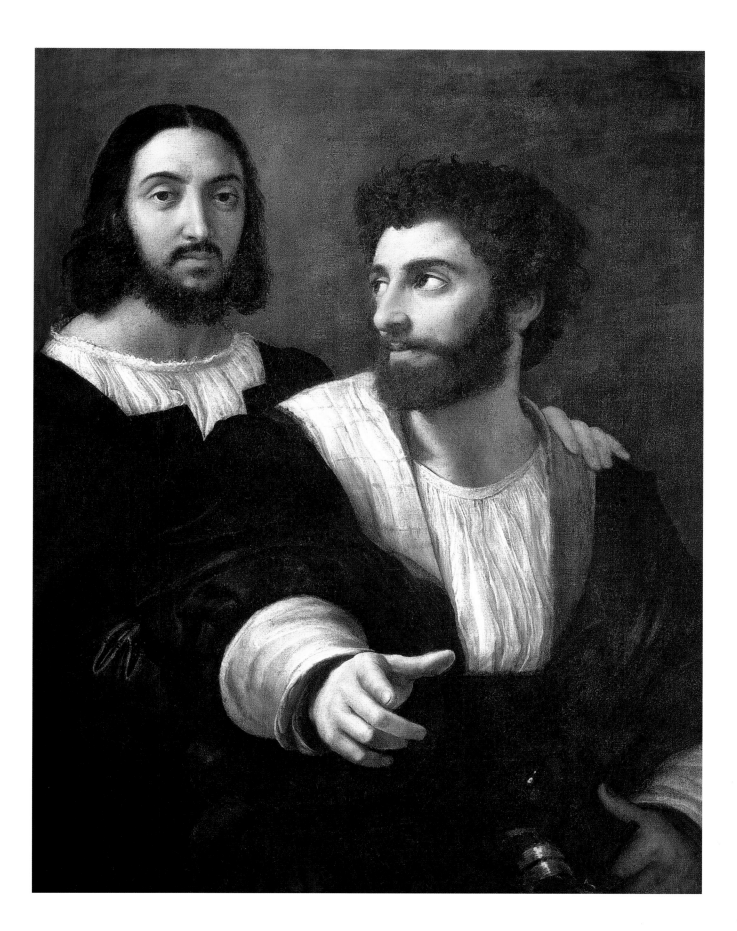

Style and technique
Raphael is regarded as one of the great "synthesizers" in the history of art—someone who built on the ideas of others, blending and refining them into a supremely graceful and balanced unity. His work does not have the disturbing intellectual complexity of Leonardo's or the overwhelming power of Michelangelo's, but instead has a healthy, humane dignity. Many of his most ambitious works were wall paintings in the fresco technique, but in his smaller paintings, such as his portraits, he was one of the first Italian artists to reveal the richness and subtlety of oil paint.

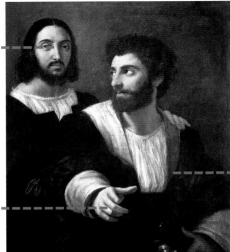

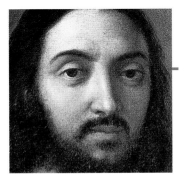

The figure usually thought to be Raphael looks out of the painting at the viewer with an expression of calm reserve, balancing the more active pose and expression of his companion.

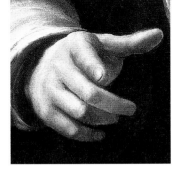

The pointing hand thrust out toward the viewer shows Raphael's skill at perspective. Such daring displays of fore-shortening were often included in Renaissance paintings but were unusual in portraits.

Delicate brushwork conveys the fine folds of the soft white shirts worn by both men beneath their black silk gowns.

The highlights of the glistening sword hilt are suggested with fluid squiggles of paint. The man's sword has led some scholars to identify him as Raphael's fencing master. However, for centuries a sword was a sign of status and here probably alludes to the man's high social standing.

Famous contemporaries

Raphael was one of the foremost portraitists of the Renaissance; his subjects included some of the most famous and powerful men and women of the day, whom he depicted in images of great beauty and subtlety.

Although he is primarily famous as a religious painter, particularly for his many pictures of the Virgin and Child, Raphael was also one of the outstanding portraitists of his age, rivaling Leonardo in subtlety of characterization and Titian in splendor of coloring. He was so much in demand for other types of work that portraiture was something of a sideline. However, because it was a sideline it tended to be reserved for special occasions. Raphael's sitters—especially in his later years—are usually either people of great importance, who could command his services, or friends, whom he portrayed out of affection rather than necessity. For these reasons there is rarely any trace of routine about his portraits, and they are usually painted entirely in his own hand, whereas his other works were often executed with the aid of assistants.

Raphael's most prestigious sitters were the two popes for whom he worked, Julius II and Leo X. In his portrayal of Julius he established a model for papal portraits that was imitated for more than two centuries, and his picture of Leo is one of the most splendid group portraits of the Renaissance, showing the pope with two of his nephews, both of whom were cardinals. Among the friends whom Raphael painted, the best known is Baldassare Castiglione (1478–1529), the author of a famous

book called *The Courtier* (published in 1528), which discusses the physical and intellectual qualities necessary in the ideal courtier. In his portraits Raphael usually worked on canvas, rather than wooden panel, and he used it to exploit the textural possibilities of oil paint, notably in the soft and subtle way he depicted fur and hair.

Right: Raphael, Portrait of Castiglione, *c.1514–15. In this sensitive picture of his friend, Raphael uses muted colors to complement Castiglione's reflective gaze.*

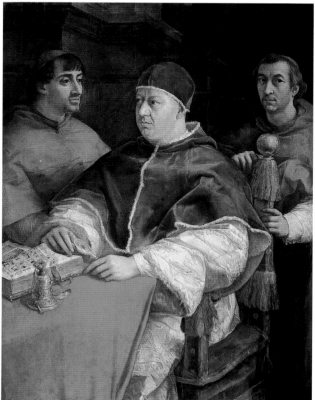

Left: Raphael, Portrait of Pope Leo X with Two Cardinals, *1517. This image, dominated by stunning reds, celebrates both the pope's spiritual authority—showing Leo looking up from studying the Bible— and his worldly wealth and power, conveyed through his sumptuous ermine-trimmed velvet and satin robes, his tassled throne, and his solid presence.*

TITIAN

c. 1 4 8 5 – 1 5 7 6

iziano Vecellio, known as Titian in English, shows himself as a man of dignity and wealth in this powerful late self-portrait. His career lasted over sixty years and he lived to a ripe old age; however, there is uncertainty about his birth date, so we do not know exactly how old he was when he died. On the basis of style, this self-portrait is generally dated to the 1550s, and Titian was probably around seventy when he painted it—still vigorous and commanding in spite of his years. He had achieved worldly fame and honors that were unprecedented for an artist. In 1533 he had been ennobled by the Holy Roman emperor Charles V, and he devoted much of his later years to working for Charles's son, King Philip II of Spain, who admired Titian so much that he gladly accepted whatever pictures the master cared to send him, rather than tying him to specific commissions.

Titian was born in the town of Pieve di Cadore, in the foothills of the Alps. When he was a boy he moved to Venice, about seventy miles to the south, where he studied with Giovanni Bellini, the most illustrious painter of the day. Venice was his home for the rest of his life, and after Bellini's death in 1516 he was recognized as the leading painter in the city. His reputation soon spread and by the 1530s his fame was international. He was supreme not only as a portraitist, but also as a painter of religious and mythological scenes. Indeed, he surpassed all of his contemporaries in the range of his subjects and his variety of treatment of them.

Titian's early work had been bright and vivacious, often with a strong sense of movement, but during the course of his long career his style became increasingly mellow and reflective, more concerned with inner feeling than with outward drama. His handling of paint became very broad and free, as in this self-portrait, and the blurred forms and rough brushwork seen in some of his later paintings may have been partly caused by failing eyesight and weakness of hand. Nevertheless, his reputation was such that a year before his death one of his patrons commented: "a blotch by Titian will be better than anything by another artist."

Self-Portrait, c.1550–60, oil on canvas, Gemäldegalerie, Berlin

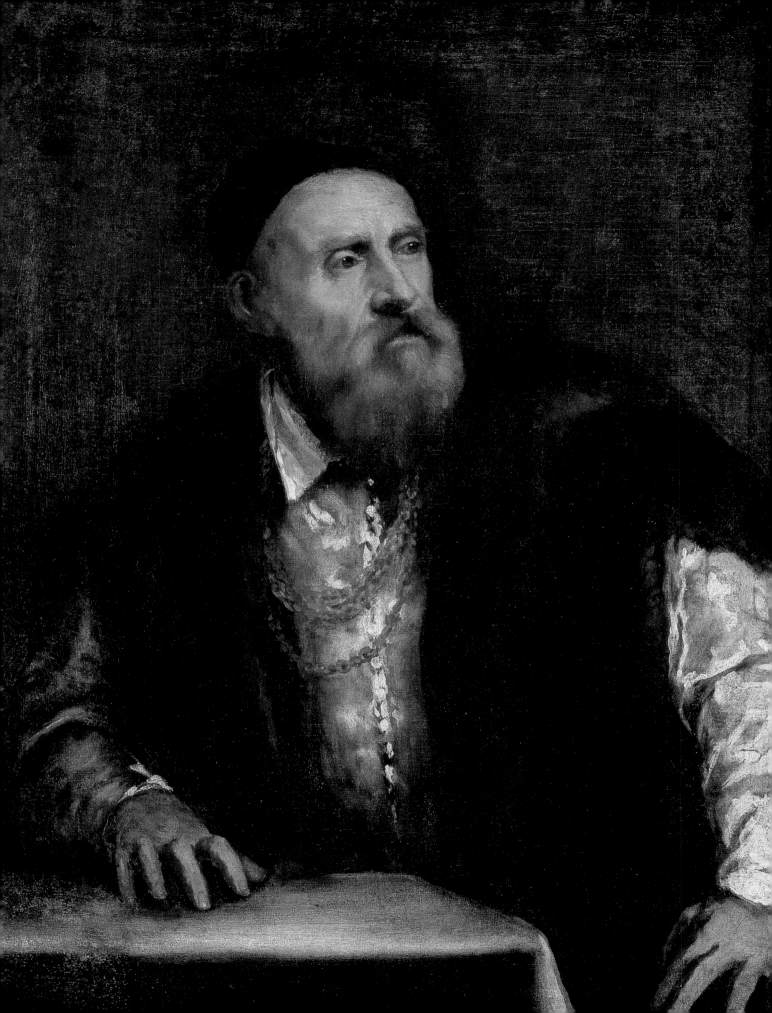

Style and technique
Titian revolutionized the technique of painting, for he was the first artist to show the full expressive potential of oil paint. Earlier artists, notably his teacher Giovanni Bellini, had used oils to create subtle effects of color and texture that were impossible in the traditional medium of tempera (a quick-drying paint mixed with egg), but Titian went much further. He used paint to create a vigorous pictorial surface, in which his personal "handwriting" is shown in every touch of the brush, and often allowed the canvas to show through to emphasize the sense of texture.

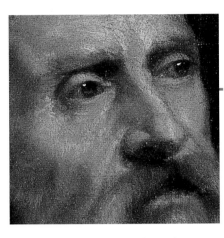

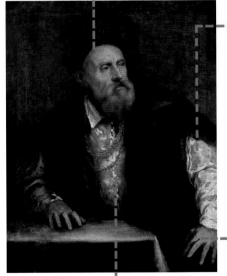

The face is the most highly finished part of the painting, with carefully modulated skin tones suggesting the aged painter's thin cheeks and prominent nose. The slightly hooded eyes further indicate Titian's age; they do not look directly out at the viewer—as in most self-portraits—but away to the side, enhancing the impression of his aloofness. When painting self-portraits, artists sometimes used more than one mirror so that they could picture themselves other than frontally.

Broad strokes of rapidly applied paint convey the sheen of white satin sleeves. Titian shows himself in expensive clothes—a satin shirt and fur-lined robe—which, with the chain and bulk of his body, convey his power and wealth.

Dabs of red and earth-colored paint indicate the links of the gold chain that hangs around Titian's neck. The chain was a mark of Titian's status and was bestowed on him by the Holy Roman emperor Charles V in 1533, when he made the painter an imperial knight.

The hands are some of the least-finished elements in the painting, being only broadly blocked in with fluid washes of color and thicker highlights.

Painter of princes

Although Titian spent almost all his career in Venice, he worked for many major patrons outside the city and also outside Italy, establishing a brilliant international reputation.

The sixteenth-century biographer Giorgio Vasari wrote that "there is hardly any nobleman of repute, nor prince, nor great lady, who has not been portrayed by Titian." This claim may have been an exaggeration, but Titian certainly had a dazzling clientele, including royalty, aristocracy, the highest officials of the church,

military leaders, and literary and artistic celebrities (his best friend was the poet Pietro Aretino). In spite of the widespread demand and acclaim for his work, Titian was always reluctant to leave Venice. He made several short visits to other cities in northern Italy in the course of work for important clients, but it was not until 1545–46 that he made a major journey, when he spent several months in Rome as the guest of Pope Paul III. In 1547–48 he undertook a more arduous journey, when he visited the court of the Holy Roman emperor Charles V at Augsburg in Germany. The crossing of the Alps in winter must have been grueling for a man who was probably in his sixties by this time. Titian returned to

Augsburg in 1550–51, but this was his last major trip; both Charles and his son Philip failed to persuade him to visit Spain.

Titian's patrons wanted all kinds of works from the master. Charles V and Philip II were deeply devout, and each commissioned major religious pictures from him. However, it was for his portraits that Titian had the greatest international renown. He was beyond a doubt the most influential portraitist who ever lived, establishing types of poses and compositions that were imitated for generations afterward. Van Dyck, Rembrandt, Rubens, and Velázquez were among the great portraitists of the seventeenth century who particularly admired him.

Left: Titian's Portrait of Charles V Seated, *which was painted during the artist's first visit to the emperor's court in 1547–48. It is a subtle image of power, complementing Titian's portrayal of Charles as a warrior (see page 93). The emperor is shown in thoughtful mood, seated on a throne with a red carpet at his feet, a sumptuous silk brocade and column behind him, and an idealized landscape beyond.*

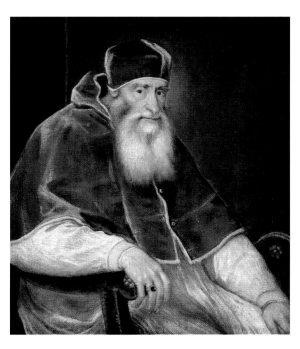

Right: Portrait of Pope Paul III, *one of several portraits Titian made of the pope and his family during his visit to Rome in 1545–46.*

HANS HOLBEIN
THE YOUNGER
c.1497–1543

he Latin inscription at the top of the drawing informs us that this is an image of Hans Holbein of Basle, done by himself at the age of forty-five. It must have been produced near the end of his life, because he was almost certainly born in 1497, meaning that he could have been no more than forty-six at the time of his death in 1543. Although he was still fairly young when he died (perhaps of plague), he had already established himself as one of the great artists of his age and as one of the sharpest observers of his fellow men and women who ever lived. The keen, steady gaze that meets us from this drawing suggests that little escaped his scrutiny; his expression has even been described as that of an assassin lying in wait for his victim.

Holbein was born in Augsburg, in southern Germany, the son of a painter, Hans Holbein the Elder. While still in his teens he settled in Basle, Switzerland, where he quickly became the leading artist of the day. In addition to portraits, he produced a wide range of other work, including altarpieces, wall paintings, and designs for stained glass and book illustrations. Sadly, much of this work has been destroyed. Holbein was mainly based in Basle until 1526, when he moved to England. It might seem strange that he should leave a place where he was such a success, but Basle was beginning to be disrupted by conflict between Catholics and Protestants, and England—with its strong king and prosperous economy—must have seemed an attractive place to try his fortune. Holbein went there armed with an introduction from the great scholar Erasmus to his friend Sir Thomas More, one of the leading statesmen in the country.

Holbein remained in England until 1528, when he went back to Basle. In 1532, however, he settled permanently in England. He left his wife and children behind and saw them only once more, on a brief visit to Switzerland in 1538. During his second stay in England, Holbein worked mainly for King Henry VIII and his court, and his portraits of the leading personalities of the time are so vivid that it is virtually impossible to see this era of English history other than through his eyes.

Self-Portrait, c.1542, colored chalks on paper, Uffizi, Florence

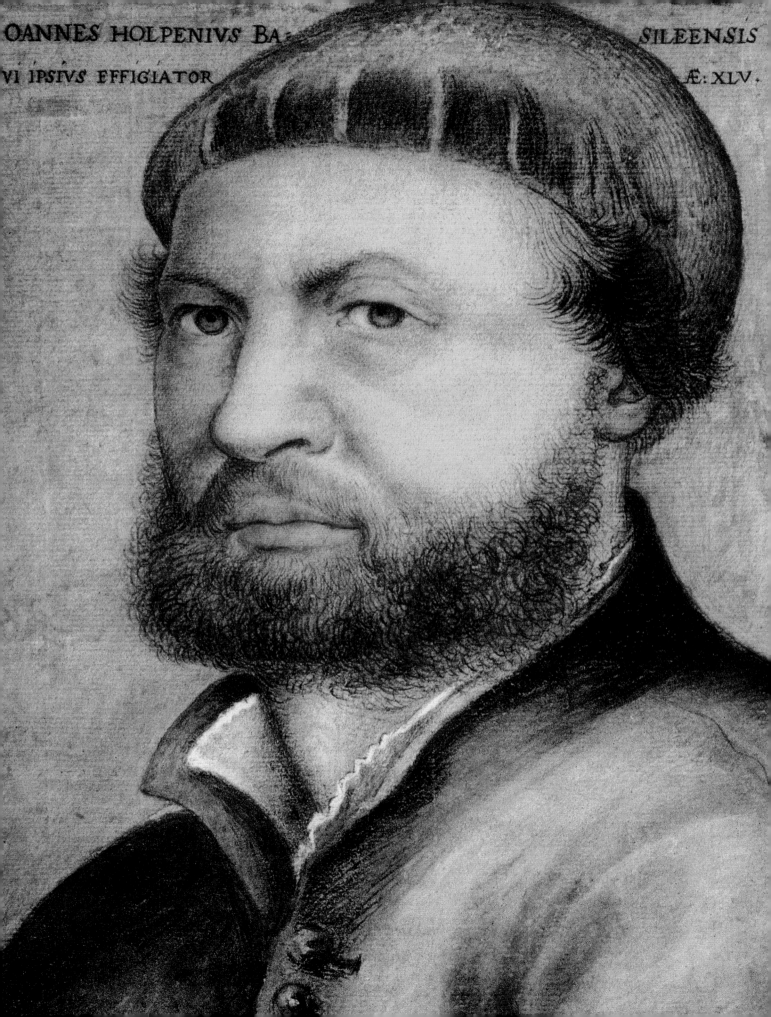

OANNES HOLPENIVS BA· SILEENSIS
VI IPSIVS EFFIGIATOR Æ: XLV·

Style and technique

Holbein is renowned for the amazing precision and clarity of his technique in both drawing and painting. He usually made elaborate preparatory drawings for his portraits, often annotating them with notes about details of costume—"white satin," "purple velvet," and so on. Some of his drawings, such as this self-portrait, are so highly finished that they must have been intended as complete works in themselves. Holbein often used colored chalks in his drawings, as here, but he was also a master of pen and ink.

The eyes, with their irises and pupils clearly delineated in black chalk, look directly out of the portrait, giving Holbein a stern, almost menacing expression.

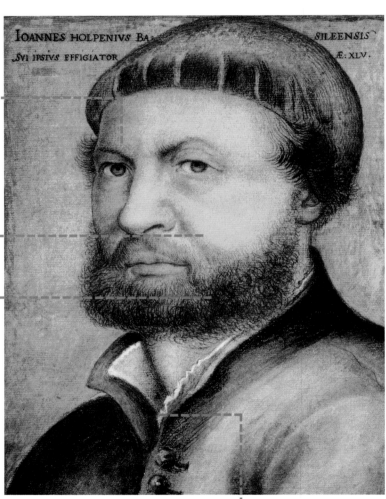

IOANNES HOLPENIVS BA SILEENSIS
SVI IPSIVS EFFIGIATOR
Æ: XLV.

White, pink, and black chalks have been carefully blended to create the delicate modeling of the face.

Sharply delineated strokes pick out the black curls of Holbein's beard, creating a foil to the soft skin tones.

Holbein depicts his clothes in less detail than his face. Strokes of white, black, and pale blue chalk have been rapidly applied to suggest his jacket and shirt. The use of blue chalk is unusual in Holbein's drawings, most of which are executed in black and white chalks, and a range of reddy browns and yellows.

A new market

Holbein's sitters included some of his most eminent contemporaries, from King Henry VIII of England to the humanist scholar Erasmus, but he also depicted ordinary citizens, most notably German merchants living in London.

Holbein's name is now so closely linked with Henry VIII and his court that it is easy to forget the many portraits he painted of people outside this circle. He was one of the first artists to show how portraits of "ordinary" people could be just as absorbing and pictorially rich as those of their contemporaries from the more glamorous reaches of society. In his early years in Switzerland, Holbein painted several portraits of Desiderius Erasmus, the most renowned scholar of the time, and these helped to establish a new type of picture showing a learned man in his study with his books. During his first visit to England Holbein also broke new ground with a picture of Sir Thomas More and his family in their home, which was the first domestic group portrait in European art. The portrait itself has been destroyed, but copies of it survive.

When Holbein returned to settle in England in 1532, More had gone into retirement and other members of the former statesman's circle had fallen out of royal favor, so Holbein had to look elsewhere for patronage. Eventually he came to Henry VIII's notice and began working mainly for him, but for a few years his chief patrons were members of the German merchant community in London. His first known portrait of one of these merchants was painted in 1532 and shows Georg Gisze. It is a large picture and with its extraordinary wealth of detail must have been intended to show off Holbein's skill and thereby attract clients. The wonderful precision and finesse of brushwork make it easy to appreciate a contemporary's comment that compared with Holbein's portraits the work of a rival painter seemed merely "slobbered."

Below: In his Portrait of Erasmus Writing, *painted in 1523, Holbein shows the scholar engaged in his studies, his gaze lowered and focused on the text that he is writing.*

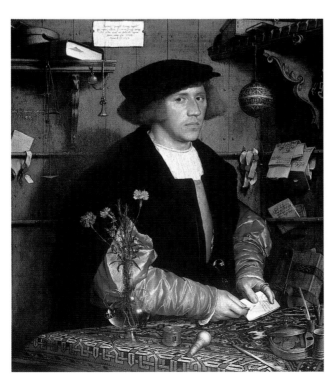

Right: Holbein's Portrait of Georg Gisze *(1532) is a masterful display of the sitter's wealth and the artist's skill. It shows the merchant in his office and is packed full of superbly painted details relating to Gisze's profession (the scales, boxes, books, letters, and seals) and his wealth (the Turkish rug, Venetian glass vase, and his fine clothes).*

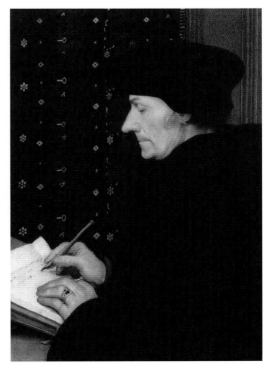

JACOPO TINTORETTO

1518–94

This stark self-portrait appears to show the face of a weary old man. After a lifetime of ceaseless work, Tintoretto would have had good reason to feel exhausted, but in fact few aged artists have retained such creative fire as he did in his final years. In his seventies he worked with undiminished skill and scarcely diminished vigor, and he ended his career in a blaze of glory. His last major painting is one of his greatest—a spectacular depiction of the Last Supper in the church of San Giorgio Maggiore, Venice, completed in the year of his death.

Tintoretto's real name was Jacopo Robusti. The nickname by which he is known means "little dyer" and derives from his father's job as a cloth dyer (*tintore* in Italian). Apart from this knowledge of his father's trade, almost nothing is known about Tintoretto's early life. From the time he was thirty, however, his career is fairly well documented and is essentially the story of a succession of commissions in Venice, mainly for large decorative canvases in the city's churches and public buildings. He hardly ever left the city, and most of his work is still in the places for which he painted it. Although he produced some impressive mythological works and was the best portraitist in Venice apart from Titian, Tintoretto was above all a religious painter. He was a deeply devout man and evidently worked more to satisfy his inner feelings than for material reward. In spite of his success, he was extremely cost-conscious and was prepared to undercut his rivals' prices.

Tintoretto's greatest undertaking, the decoration of the Scuola di San Rocco, was spread over more than twenty years. The name "scuola" literally means "school," but the Venetian *scuole* were not educational establishments in the usual sense; they were charitable institutions that carried out duties such as caring for the sick and orphans. The Scuola di San Rocco (School of Saint Roch) was the wealthiest of the *scuole*, and between 1564 and 1587 Tintoretto decorated the interior of its imposing headquarters with a wonderful series of biblical paintings. They are works of such grandeur and depth that they have been described as a Venetian equivalent of Michelangelo's Sistine Ceiling.

Self-Portrait, c.1588, oil on canvas, Louvre, Paris

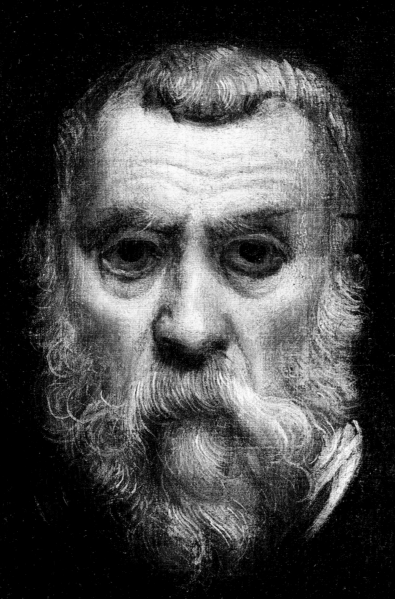

Style and technique

Tintoretto was famous for the speed at which he worked, and his quickness of hand is evident in the loose, rough vigor of his brushwork, which often conveys a sense of bristling energy. In spite of this energy, his religious paintings are typically somber and mystical in feeling, making highly individual and dramatic use of flickering lighting effects. In his portraits, too, Tintoretto was usually somber and weighty. He was particularly good at showing the dignity as well as the frailty of old age and at depicting the rich materials of Venetian costume.

The large, deeply set, and slightly drooping eyes are those of an old man, but the intensity of Tintoretto's stare suggests his inner fire. In his uncompromising expression, Tintoretto conveys the inner determination and creativity that made him one of the most successful Venetian painters of the sixteenth century.

Tintoretto's collar is suggested with a few strokes of white paint; otherwise little detracts attention from the stark frontal view of the painter's face, which stares out from the black background.

The curling gray strands of Tintoretto's hair and beard are clearly delineated with vigorous brush strokes. Such free brushwork and pronounced highlights are typical of the painter's highly individual style.

The golden age of Venice

In the sixteenth century Venice was a place of great wealth and cultural prestige, having grown rich as a center of trade between Europe and Asia. Tintoretto was only one of many illustrious artists who flourished in the city at this time.

Venice has a long and glorious tradition in the arts, which reached its peak in the sixteenth century, when the city was embellished by a host of outstanding artists, both native and imported. At this time it was one of the largest cities of Europe. It was slightly past the height of its political power, but was still immensely rich. Its wealth was based on international trade, for it was ideally placed at the crossroads between east and west, north and south.

Titian was universally recognized as the greatest Venetian painter of the age (see pages 26–29), but in his later years he worked mainly for foreign clients, enabling Tintoretto to become the leading artist in supplying pictures for the city's churches. Tintoretto's main rival in the domestic arena was Paolo Veronese (c.1528–88), but the two artists were rarely in direct competition. Although Veronese also excelled at large decorative paintings, his style was far more colorful than Tintoretto's and suited to different contexts. Other outstanding painters in Venice in this period included Jacopo Bassano, Lorenzo Lotto, and the young El Greco, whose emotional style was strongly influenced by Tintoretto.

Sculpture and architecture also flourished in the city. The two greatest architects to work there at this time were Jacopo Sansovino, also the leading sculptor of the time, and Andrea Palladio. Sansovino's most famous building is the glorious Library of Saint Mark. Palladio is most famous for his villas in the countryside near Venice, but he also designed two great churches in Venice—San Giorgio Maggiore and Il Redentore. It was for San Giorgio that Tintoretto painted his final masterpiece: the *Last Supper*.

Below: Paolo Veronese, Feast in the House of Levi, *1573. The painting's rich colors, splendid architectural settings, and sumptuous decorative appeal reflect the great wealth of Venice during its golden age.*

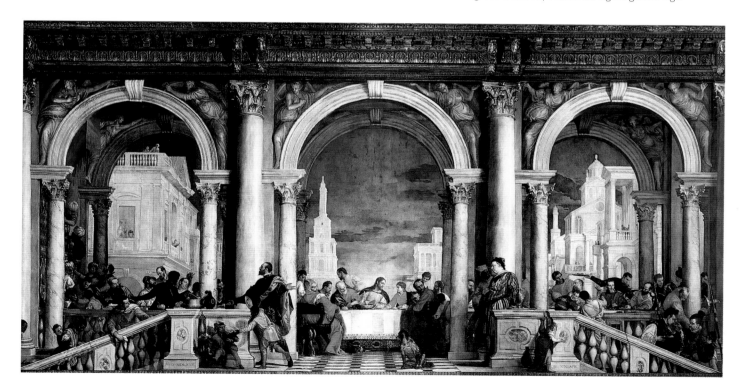

SOFONISBA ANGUISSOLA

c.1530–1625

his is one of the earliest self-portraits to provide a detailed look at the equipment and methods of the Renaissance artist. The young painter, pretty and demure, stands at an easel, which has a ledge supporting her palette and other tools. In her left hand she holds a mahlstick, or maulstick, a rod that was used to support the artist's right wrist when painting detailed passages. Mahlsticks seem to have been introduced in the sixteenth century, coinciding roughly with the adoption of oil paint on canvas as the standard method for producing easel pictures, and this is one of the first representations of the device being used. From the seventeenth century they are seen in numerous self-portraits, for example those by Rembrandt (see pages 66–69) and Vermeer (see pages 70–73).

When she produced the picture, Sofonisba Anguissola was at the start of a career that would make her the best-known woman painter of her time. Women artists in the sixteenth century were rare, and most of them entered the profession because they were the daughters of artists. Sofonisba, however, came from an aristocratic Italian family. Even more remarkably, she had five sisters all of whom also became painters, although none made much of a mark—three of them died young. Sofonisba, the eldest sister, trained with Bernardino Campi, a leading painter in her home town of Cremona in northern Italy. One of his patrons was the governor of Milan, which at the time was a Spanish possession, and it was through him that in 1559 Sofonisba was invited to the court of King Philip II in Madrid. As well as pursuing her career as a painter there, she served as a lady-in-waiting to the queen.

In about 1570 Sofonisba married a Sicilian nobleman and she later moved with him to Sicily, at the time also a Spanish possession. After her husband's death in 1584 she decided to return to Cremona, but on the ship home she met the man who became her second husband, an aristocrat from Genoa, where she settled with him. Later she moved back to Sicily, where she spent her final years. Van Dyck visited her there in 1624, when she was in her nineties, and described her as "still possessed of a good memory, clear senses, and a friendly manner."

Self-Portrait Painting the Virgin and Child, c.1555–60, oil on canvas, Muzeum Zamek, Lancut, Poland

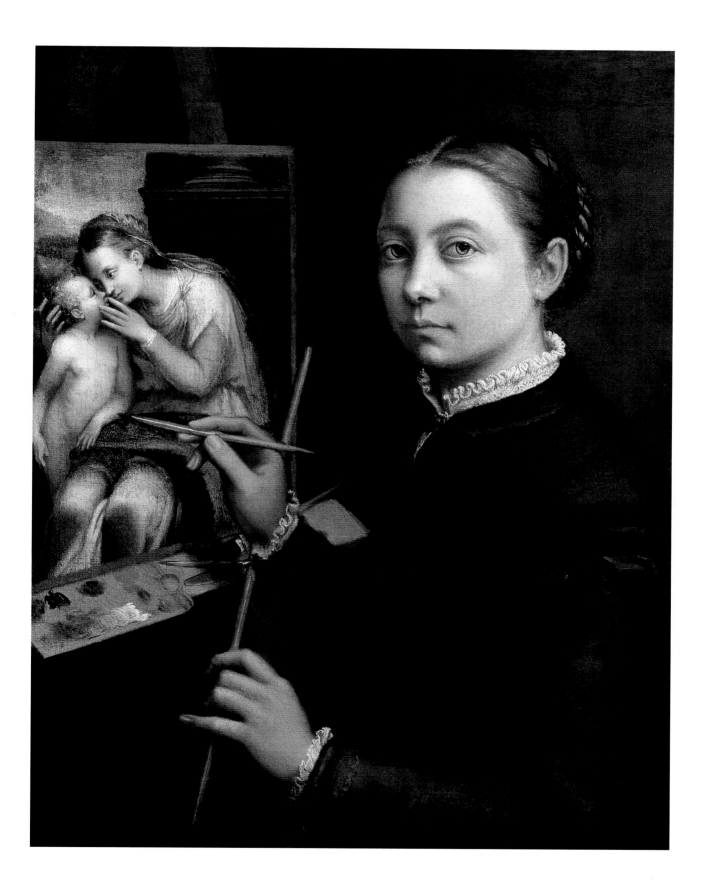

Style and technique

Sofonisba Anguissola was an accomplished painter but not outstandingly gifted, especially by the standard of her great Renaissance contemporaries. Her figures tend to be rather stiff and her grasp of perspective is uncertain, but nevertheless her work often has great charm. She painted some religious works, but she was not at her best with such imaginative subjects; instead she excelled at portraying the people and things around her. She showed particular originality in depicting groups of figures in informal family settings, for example playing chess.

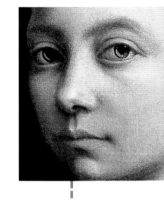

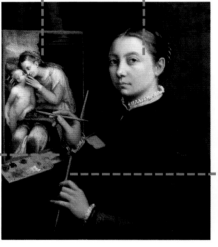

Sofonisba portrays herself with a demure, modest expression, her clear eyes gazing out the picture, her mouth straight and expressionless. This air of restraint is furthered by her lack of jewelry and the dark tones of her gown.

In showing herself painting the Madonna and Child, Sofonisba drew on Renaissance tradition. Northern European artists in particular often portrayed Saint Luke, the patron saint of artists, painting the Virgin and Child; some even gave Saint Luke their own features.

A small rectangular palette, a palette knife, and two brushes rest on the base of the easel. A limited range of oil paints has been mixed to produce the skin tones of the Christ child whose arm Sofonisba is painting.

In her left hand, with its elegantly raised little finger, Sofonisba holds a mahlstick, or maulstick, on which she rests her right wrist to steady her hand as she paints.

A woman's world

It was extremely difficult for a woman artist to make a name for herself during the Renaissance, as social conventions and expectations conspired against her.

There have been women artists since at least the days of the ancient Greeks, but it is only in fairly recent times that they have occupied a prominent place in the art world alongside men. In earlier days it was difficult for any woman who was not either exceptionally talented or exceptionally determined to break into what was essentially a man's world. During the Middle Ages and Renaissance, artists had to undergo long apprenticeships before they could become properly qualified to work in their chosen profession. Boys usually began these apprenticeships aged about twelve to fourteen years old, and the only girls who were likely to join them were daughters of artists. Lavinia Fontana (1552–1614), a successful portraitist, was the best-known woman painter of her time to enter the profession in this way; Artemisia Gentileschi (1593–1652/3) followed suit in the seventeenth century. Sofonisba Anguissola, in contrast, was highly unusual in that she had a father who was ahead of his time in hiring the best teachers he could find to encourage his six daughters—as well as his only son—to develop their talents in literature, music, and art.

Because she came from a prosperous family, Sofonisba did not have to try to earn a living with her work. She had some distinguished commissions—she made a portrait of the queen of Spain at the personal request of Pope Pius IV—but much of her work seems to have been done for her own pleasure. Most notably, there are at least a dozen surviving self-portraits by her, occupying a high proportion of her fairly small output. These portraits usually show her as a cultured lady—with a book or playing a musical instrument.

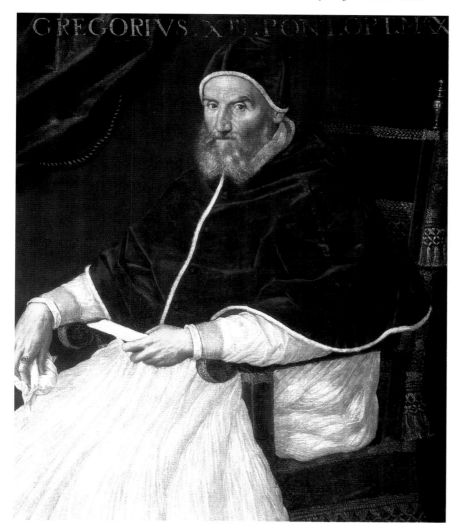

Left: Lavinia Fontana, Portrait of Pope Gregory XIII, *c.1580. The rich coloring and free brushwork show the influence of Venetian art; these qualities, combined with Fontana's gift for characterization, made her a successful portraitist.*

NICHOLAS HILLIARD

c. 1 5 4 7 – 1 6 1 9

The exquisitely curling hair and beard, the jauntily placed hat, and the slightly roguish glance help make Hilliard look as dashing as any of the Elizabethan adventurers he portrayed—Sir Francis Drake or Sir Walter Raleigh, for example. The personal charms that this self-portrait miniature so vividly convey must have stood Hilliard in good stead at the court of Queen Elizabeth I of England. He spent most of his career working for the queen and her circle, creating a superb visual record of this glamorous age in English history.

Hilliard was born in Exeter, a city in southwest England. He was the son of a goldsmith and had a thorough training as a goldsmith himself, completing his seven-year apprenticeship in 1569. It is not known if he had any formal instruction in miniature painting, but his first surviving miniatures, including a self-portrait, were made when he was only thirteen years old. He kept up his work as a goldsmith throughout his career, but it was as a miniaturist that he achieved the greatest renown. The two professions were intimately linked, for miniatures were often worn like pieces of jewelry, and Hilliard presumably designed the settings for some of his own portraits.

Hilliard painted his first portrait of Elizabeth in 1572, and the following year she praised him for his "good, true, and loyal service." However, although his work brought him great prestige, he often had financial problems. His perfectionism meant that he was a slow worker, and the queen was extremely dilatory in paying him; he also lost money in a speculative venture to find gold in Scotland. After Elizabeth's death in 1603, he continued in royal favor, working for her successor James I, but his money troubles remained and in 1617 he was briefly imprisoned for debt.

Hilliard did more than anyone else to establish the portrait miniature as a distinctive art form in England, and it continued to be a speciality in which English artists particularly excelled. He was praised by some of the leading writers of the time, and his exquisitely refined portraits form a kind of visual equivalent of the lyric poetry for which the Elizabethans are famous. His pupils included his son Laurence and also Isaac Oliver (c.1565–1617), who succeeded him as the leading miniaturist of the day.

Self-Portrait Aged Thirty, 1577, watercolor on vellum, Victoria and Albert Museum, London

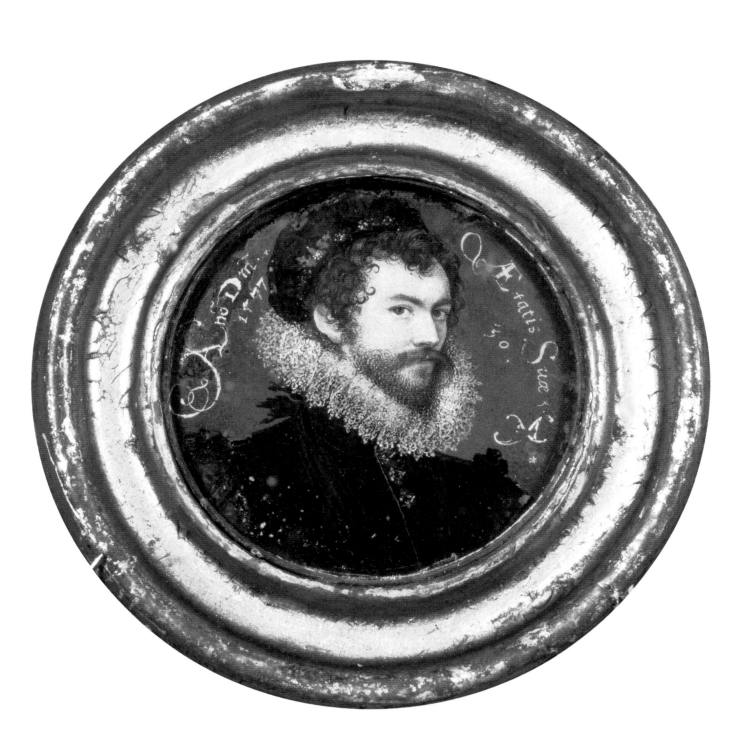

Style and technique
Hilliard wrote a treatise on miniature painting that gives fascinating information about his approach to his demanding craft. He stressed the need for a calm and absolutely clean working environment, even warning the artist to ensure that no dandruff fell on the tiny picture. Such fastidiousness comes out in the wonderfully delicate and precise brushwork of his miniatures, but in addition to sheer beauty of craftsmanship, they have a sophisticated elegance and a subtlety of characterization that place them among the finest portraits of their time, irrespective of size.

Hilliard's alert brown eyes look out of the miniature to engage the viewer. He urged artists to observe the eyes of their sitters closely, writing in his treatise, "For all the features in the face of a picture the eyes showeth most life."

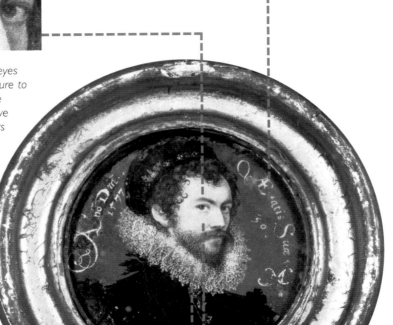

Hilliard inscribed his miniature with two elegant gold inscriptions; the one on the left gives the date the self-portrait was painted, 1577, and this one on the right reads "aetatis suae 30," Latin for "of his age 30."

The exquisitely decorative white ruff captures the elegance and grace of Elizabethan fashions. Hilliard used small brushes made of squirrel hair to paint on such a tiny scale and he never used a magnifying glass, which could lead to distortion. This miniature measures just 1⅝ in. in diameter.

To create skin tones Hilliard applied successive layers of fluid color with delicate strokes and dabs. He avoided strong shadows, as he mentioned in his treatise The Arte of Limning.

Miniatures: tokens of affection

The painted miniature portrait was invented during the Renaissance, when it grew out of a fashion for portrait medals; miniatures were often treasured tokens of love and loyalty.

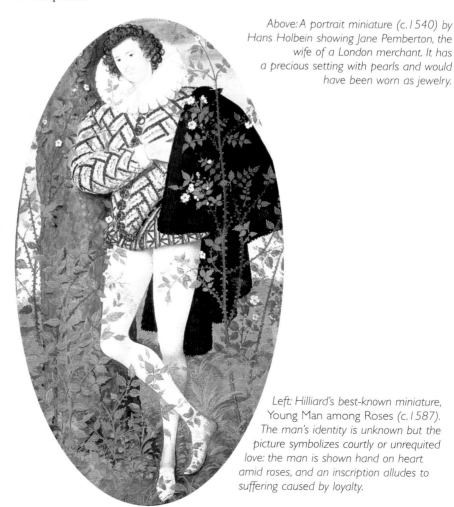

Although the type of portraits painted by Hilliard are small enough to be held in the hand or worn as jewelry, they are not called "miniatures" because of their tiny size. The word comes from the Latin *minium*, meaning "red lead." During the Middle Ages, manuscript illuminators often used paint made from this material and were consequently known as *miniators*. Hilliard's contemporaries referred to his portraits as "limnings" or "pictures in little," and they were not called miniatures until about a hundred years after his death.

Illuminated manuscripts sometimes included small portraits, but the first independent portrait miniatures seem to have been made in France in the 1520s. The first great exponent of the art form was Hans Holbein (see pages 30–33), by whom about a dozen miniatures survive. After Holbein's death in 1543 there was a considerable interval before a worthy successor appeared in Hilliard, but subsequently there was a flourishing tradition of miniature painting in England, and to a lesser extent in other countries, until photography virtually killed the art form in the mid-nineteenth century.

Early miniatures were usually painted in watercolor on vellum, a fine parchment made from the skin of a calf or other young animal; later, ivory was often used in place of vellum. Most miniatures are circular or oval in shape, although some are

oblong. Their small size made them ideal as intimate keepsakes: they were easily portable and the owner could carry the picture of a loved one just as we can carry a photograph today. Some of Hilliard's miniatures include enigmatic symbols or inscriptions that no doubt had a personal meaning for the person portrayed and for the original owner of the picture.

Above: A portrait miniature (c.1540) by Hans Holbein showing Jane Pemberton, the wife of a London merchant. It has a precious setting with pearls and would have been worn as jewelry.

Left: Hilliard's best-known miniature, Young Man among Roses (c.1587). The man's identity is unknown but the picture symbolizes courtly or unrequited love: the man is shown hand on heart amid roses, and an inscription alludes to suffering caused by loyalty.

MICHELANGELO MERISI DA
CARAVAGGIO
1571–1610

Caravaggio's early biographer Giovanni Baglione, who knew the artist personally, wrote that at the beginning of his career he made "some small pictures that were drawn from his reflection in a mirror." Among them was "a Bacchus with bunches of various kinds of grapes," a description that almost certainly refers to this picture. At the time, the young Caravaggio was struggling to make a name for himself in the highly competitive art world of Rome. He had arrived in the big city a year or so earlier, after leaving his native northern Italy— he takes his name from his home town of Caravaggio, near Milan—and for a while he lived in obscurity, doing whatever he could to scrape a living. Pictures such as this, with provocative figures brought up very close to the spectator, would certainly stand out in a crowd, and by about 1596 Caravaggio's work had impressed an important patron, Cardinal Francesco del Monte, the Florentine ambassador at the papal court.

It was probably Cardinal del Monte who gained Caravaggio his first major commission: a pair of large paintings showing the Calling of Saint Matthew and the Martyrdom of Saint Matthew for the side walls of the Contarelli Chapel in San Luigi dei Francesi, the French church in Rome. They were painted in 1599–1600 and immediately established Caravaggio as the most exciting painter in the city, for they were intensely original in the way they imagined the familiar religious stories taking place among real flesh-and-blood people. Over the next six years Caravaggio consolidated his reputation with other pictures for churches in Rome, and his style was imitated by a host of artists, making him the most influential painter of the day.

At the same time as he won this renown, Caravaggio also became notorious for his violent temperament. He was briefly imprisoned several times for assault or insulting behavior and in 1606 he fled Rome after killing a man in a quarrel about a tennis match. For the rest of his brief life he was a fugitive, but he continued producing superb paintings wherever he went—Naples, Malta, and Sicily were the main places he visited. He died of fever, aged only thirty-eight, on his way back to Rome, where he thought he was about to be pardoned.

Self-Portrait as Bacchus ("Sick Bacchus"), c.1594, oil on canvas, Galleria Borghese, Rome

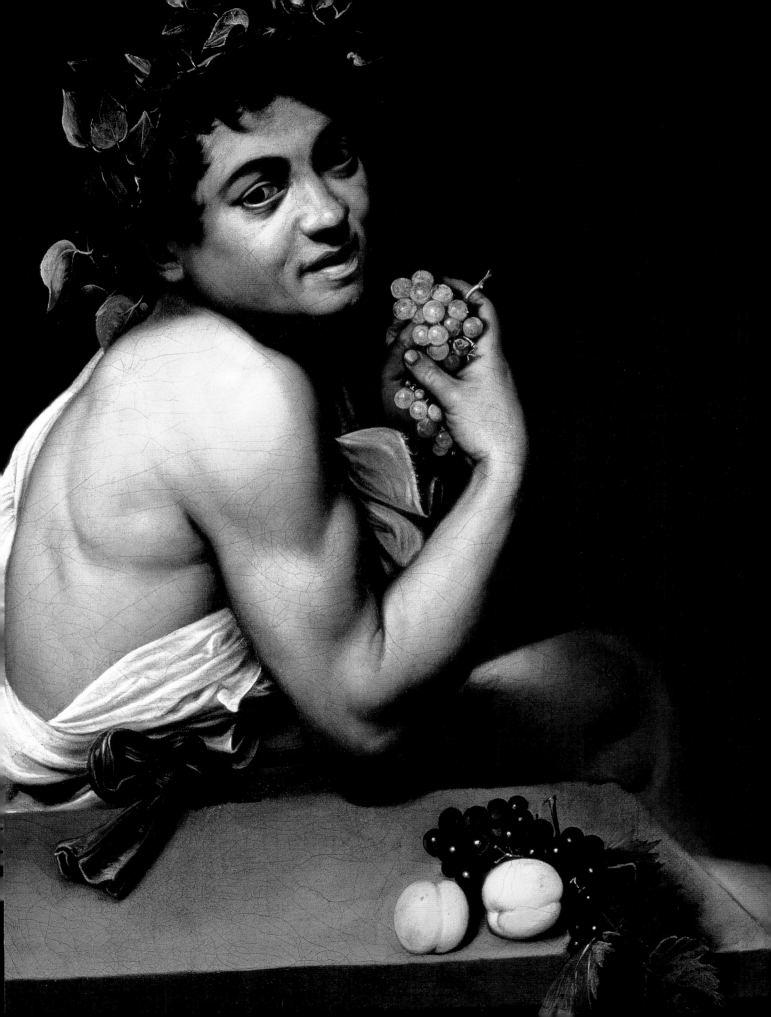

Style and technique
Caravaggio created one of the most distinctive and influential styles in the history of art. The most striking feature of his mature work is the lighting, with figures emerging dramatically from dark shadow. In his earlier paintings, however, he used clearer, lighter colors. Common to both his early and late work is the startling immediacy of the figures; no other painter had made them look so palpably real. Caravaggio had countless imitators, but most of them either sweetened or coarsened his style and could not approach the grandeur and humanity of his work.

A garland of shiny ivy leaves crowns Bacchus's head. Ivy was sacred to Bacchus in antiquity, and artists often depicted the young god and his followers adorned with the plant.

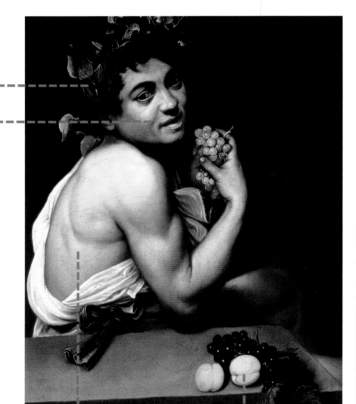

The greenish tinge of the young god's complexion led to the painting's nickname "The Sick Bacchus." Yet despite its sickly air, Caravaggio's portrayal of himself as the young Bacchus is overtly seductive: he gazes out of the picture with an inviting glance and a smile plays over his pale lips.

The drapery falls away to reveal the bare back and rounded, fleshy shoulder of Bacchus. The sensuality of the picture is continued in the loosely tied bow of his sash, the end of which rests on the stone table, as if asking to be undone.

The bloom and highlights on the black grapes are painted with sparkling clarity. With the peaches and the grapes in the young god's hands, they suggest sensual indulgence and allude to the transient nature of human beauty.

For private pleasure

Caravaggio had his greatest success with large-scale religious paintings for public settings, but early in his career he painted works of a very different type for the intimate delectation of connoisseurs.

As far as it is known, Caravaggio never painted a conventional self-portrait, but in addition to depicting himself as Bacchus he portrayed himself in one of his final works as the severed head of Goliath held by his conqueror David. According to early sources, the boy who modeled for the figure of David was the artist's lover, so in this picture Caravaggio was evidently saying something about his own sexuality. Although the evidence is far from conclusive, it is likely that he was bisexual but predominantly homosexual. Several of his early paintings feature fleshy boys or youths who look at the spectator

with blatant erotic invitation; typically they are playing music, a traditional accompaniment to love, or holding fruit, suggesting sensual indulgence. Such pictures presumably reflected Caravaggio's own taste as well as that of his clients. His first important patron, Cardinal Francesco del Monte, was notorious for his hedonistic lifestyle, giving parties at which, a contemporary noted, "as there were no ladies present, the dancing was done by boys dressed up as girls."

Caravaggio's early paintings, however, are not necessarily about erotic delectation alone, and they have been interpreted as having an

underlying moral significance. The prominence given to fruit in several of them may be intended as a reminder that human flesh, like fruit, retains its bloom for only a short time before decaying: the boys in Caravaggio's paintings are desirable now, they may be saying, but soon their youth will have withered. Such reminders of mortality and the transitory nature of all pleasures were common in seventeenth-century art.

Below: Caravaggio, Bacchus, *c.1597. In this overtly seductive painting, the young god leans forward to offer the viewer a glass of wine. Much of the fruit in the basket is rotten, possibly symbolizing moral decay.*

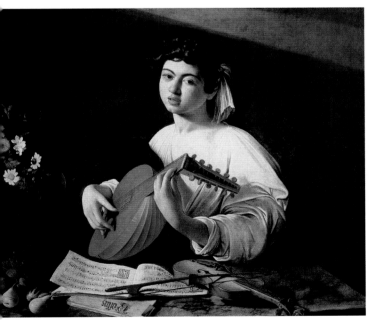

Above: One of Caravaggio's most sensual pictures, The Lute-Player *(c.1595–97), which shows an androgynous young musician singing a love song.*

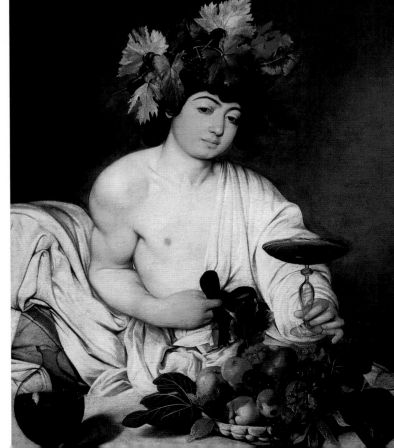

PETER PAUL RUBENS

1577–1640

Few other artists have been so richly blessed by nature as Rubens. He was handsome, intelligent, and had a robust constitution that enabled him to work prodigiously hard without ever flagging. He was also lucky in love, and in this painting he shows himself with his beautiful bride, Isabella Brant, the daughter of an eminent lawyer. They married in 1609, when Rubens was thirty-two and Isabella was seventeen. The marriage was extremely happy and they had three children, but Isabella died in 1626, aged only thirty-four. Rubens was deeply distressed by the loss of his "excellent companion," as he called her, but in 1630 he made a second marriage that was as happy as the first. His second wife, Hélène Fourment, was a niece of his first wife and was just sixteen at the time of the marriage. They had five children, the last born after Rubens's death. He often depicted his wives and children in his paintings and drawings, showing them off with heartwarming affection (see page 113).

At the time he painted his portrait with Isabella, Rubens was on the threshold of one of the most prolific and successful careers in the history of art. After training in Antwerp, he had spent most of the period from 1600 to 1608 in Italy, and it was there that he forged his style. In its dignity and power, it was strongly influenced by ancient and Renaissance art, but it had a warmth and energy that were his own. He regarded Italy as his spiritual home and returned to Antwerp in 1608 only because his mother was seriously ill—she died before he reached her. Although he intended to go back to Italy, he so quickly became a huge success in Antwerp that he settled there permanently.

Rubens dominated art in Antwerp and was widely acclaimed throughout Europe, his patrons including the kings of France, Spain, and England. He was aptly described by a contemporary as "prince of painters and painter of princes." Enormously prolific and versatile, Rubens produced a vast output of paintings of virtually every type then known—including mythological and religious scenes, portraits, and landscapes—and he also made designs of various kinds, notably for tapestries and book illustrations. Among artists of comparable stature, probably only Picasso has rivaled the sheer volume and variety of his work. He was universally admired for his character as well as his genius, and at his death was mourned as one of the greatest men of his time.

Self-Portrait with Isabella Brant, c.1609, oil on canvas, Alte Pinakothek, Munich

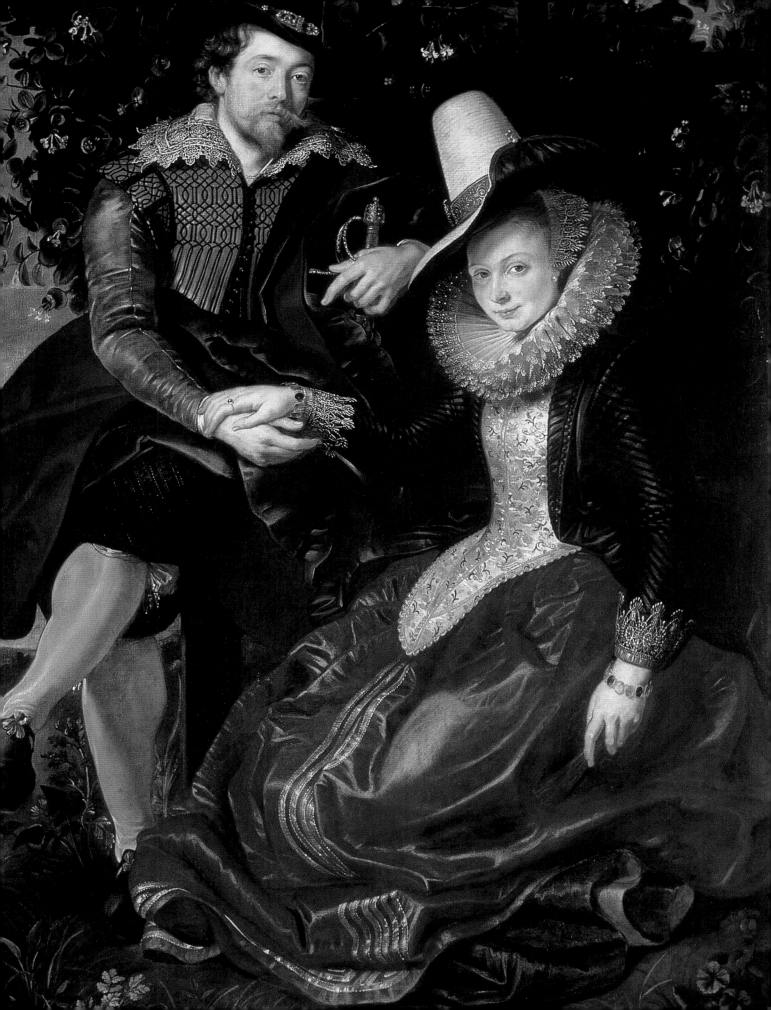

Style and technique

Rubens's amazing energy shines through his work, which is full of movement and love of life. He painted with great speed and fluency, but even he could not cope with his enormous workload single-handed, so he employed assistants and collaborators to help him, especially with large paintings. The assistants did much of the groundwork, working from Rubens's design, and the master himself supplied the finishing touches, animating and unifying the picture with his sparkling brushwork. He was honest and open about his methods, varying his charges depending on the extent of his own involvement.

A honeysuckle bower forms the backdrop to the portrait, symbolizing the young couple's love. Honeysuckle was associated with love and constancy, and the outdoor setting relates to the tradition of love gardens and pastoral landscapes, which were popular motifs in art and literature.

Rubens portrays himself as a prosperous gentleman rather than as a painter. His left hand rests on the bejeweled hilt of a sword, a sign of his social status, and, like his wife, he wears expensive silks with an elaborate lace collar.

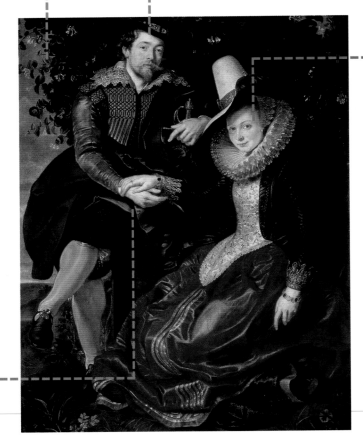

The joined hands of the couple are just to the left of the painting's center and, with their faces, form one of the focal points of the composition. They refer both to the official joining of hands in the marriage ceremony and, through the tenderness of their gesture and the delicacy of its rendering, to the couple's love for each other.

Rubens portrayed both the beauty and wealth of Isabella Brant. Her cheeks appear a soft and delicate pink, a smile plays across her lips, and her eyes sparkle with warmth and happiness. She wears an expensive gold-trimmed bodice and skirt with a splendid lace ruff, exquisitely painted.

Diplomatic duties

Not only was Rubens much sought after by royal patrons for his artistic skill—for his facility at creating powerful, celebratory images extolling their authority and achievements—he was also highly regarded for his abilities as a diplomat.

In 1609 Rubens was appointed court painter to Archduke Albert and Infanta Isabella, who governed Flanders—a region roughly equivalent to present-day Belgium—on behalf of Spain, its overlord. After Albert died in 1621, Isabella governed alone. She greatly admired Rubens and began to use him for diplomatic duties as well as for his artistic skills. He was well suited to such work: he spoke several languages and his dignified appearance, charm, and social poise inspired respect and confidence. Moreover, his career as a painter gave him good cover for his travels to other countries and for receiving foreign visitors in Antwerp—although it quickly became an open secret in the diplomatic world that he was working on sensitive business for Isabella.

The aim of Rubens's diplomatic missions was to secure peace between Flanders and its northern neighbor, the Dutch Republic, which had formerly been ruled by Spain but had rebelled and won independence. Rubens did not succeed in this, but he achieved an important preliminary step by helping to end hostilities between England, ally of the Dutch Republic, and Spain. His negotiations involved lengthy visits to Spain (1628–29) and England (1629–30), and he was knighted by the kings of both countries—Philip IV of Spain and Charles I of England. Both kings were art-lovers and Rubens painted numerous works for each of

them, including nine magnificent paintings to decorate the ceiling of Charles I's Banqueting House in London. When Rubens returned to Antwerp in 1630 he had been abroad for almost two years continuously, leaving his motherless children in the

care of relatives and now said he wanted to "remain home all my life." Isabella granted him his desire and did not send him abroad again.

Below: Three of the nine canvases Rubens painted in 1632–34 to adorn the ceiling of Charles I's Banqueting House in London.

NICOLAS POUSSIN

1594–1665

Poussin has a curious place in the history of the self-portrait: there are three impressive examples by him—a fairly early drawing and two paintings from his maturity—yet as far as we know he produced no other portraits. This painting is the best of the three and is such a masterful and commanding work that it is hard to believe that portraiture represents no more than a footnote in his output. As the austere dignity and geometrical severity of the painting suggest, Poussin was an intellectual, and he worked mainly for a small number of like-minded patrons in France and Italy. It was one of these patrons, Paul Fréart de Chantelou, who commissioned this portrait. In spite of the exclusivity of his work (he was far from prolific) and his retiring, scholarly way of life, Poussin acquired great fame and prestige, and at the time he painted the picture, at the age of fifty-six, he was one of the most revered artists in Europe.

Poussin's beginnings, however, were not auspicious. He was born into a poor farming family in northern France and decided to become an artist after an itinerant painter visited his town to carry out a commission in the local church. Aged eighteen, he left home and moved to Paris, where for the next twelve years he led an obscure life. In 1624, at the third attempt, he managed to make his way to Rome—then the artistic capital of Europe—and he lived there for the rest of his life, with the exception of a two-year interlude in 1640–42, when he reluctantly gave in to pressure to work for King Louis XIII in Paris. His style and his intellectual outlook were profoundly influenced by the culture of the ancient world. He often depicted themes from classical history or legend, and the grandeur and dignity of his figures consciously recall Roman sculptures.

Although virtually his whole creative life was spent in Italy, Poussin became a guiding light for generations of French artists. The Academy of Painting and Sculpture, founded in Paris in 1648, held him up as the embodiment of its ideals: that art should deal with serious subjects and that its creation should be a matter of rational thought. More than two centuries later he was still regarded by many as an inspiration, notably by Paul Cézanne (see pages 150–53).

Self-Portrait, 1650, oil on canvas, Louvre, Paris

EFFIGIES NICOLAI POVSSINI ANDEL
YENSIS PICTORIS. ANNO ÆTATIS 56
ROMÆ ANNO IVBILEI
1650·

Style and technique

Poussin was extremely methodical in his working procedures. He not only made many preliminary drawings for his paintings, but also used a kind of miniature stage set on which he arranged small wax figures to experiment with composition and lighting. Unlike most leading painters of the time, he did not use assistants, and he liked to work in solitude, so that nothing broke his concentration. Once, when asked how he achieved the extraordinary clarity and harmony of his paintings, he replied, "I have neglected nothing."

The stacked paintings and dark doorframe behind Poussin suggest an abstract view of his studio; they also underline the geometry and discipline on which his pictures are based.

With his fixed stare and unsmiling mouth, Poussin portrays himself as a stern and authoritative figure. His expression, combined with the smooth, meticulous style and dark tonality of the painting, conveys the intellectual rigor for which he is famous.

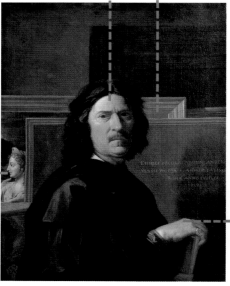

A female figure wearing a diadem decorated with an eye is shown on a painting in the background. According to Poussin's biographer Bellori she represents Painting and the hands that reach out to embrace her symbolize the painter's friendship with Chantelou, who commissioned this portrait.

Poussin's right hand rests on a portfolio of drawings. On his little finger the painter wears a ring with a diamond cut into a four-sided pyramid, which was a symbol of constancy alluding—like the hands reaching to embrace the woman in the painting glimpsed at left—to his relationship with his patron Chantelou.

The artist as intellectual

In his mid-thirties Poussin withdrew from Rome's competitive art world, abandoning public commissions to concentrate on comparatively intimate works for connoisseurs with scholarly tastes.

Poussin has been called the "painter-philosopher" and his whole approach to art was deeply thoughtful. However, he had to struggle before he reached his state of mental and artistic equilibrium. He was something of a hothead in his youth, and in his early days in Rome he tried to work in the flamboyant baroque style that was becoming fashionable. In 1628–29 he painted a large altarpiece for Saint Peter's, but it was coolly received, and in 1630 he competed unsuccessfully for a commission to paint a fresco in San Luigi dei Francesi, the French

Below: Poussin, Baptism, *c.1640–42. This picture and the painting next to it belong to one of Poussin's most highly regarded series of paintings: seven pictures of the Sacraments painted for Cassiano dal Pozzo.*

church in Rome. These two failures seem to have convinced him that his talents were not for big public works, and he found his true direction in painting relatively small, deeply pondered pictures on classical or religious themes for discerning patrons who appreciated the thought and learning that went into them.

These patrons were mainly from the middle classes rather than the aristocracy, and included bankers, merchants, administrators, and civil servants. In Rome, Poussin's most important patron was Cassiano dal Pozzo, secretary to the art-loving Cardinal Francesco Barberini. Pozzo was not particularly wealthy, but he was passionately interested in the ancient world and Poussin

learned a great deal from his vast collection of prints and drawings relating to it—his "paper museum" as Pozzo called it.

In France, Poussin's leading patron was Paul Fréart de Chantelou, a civil servant. Poussin corresponded at length with Chantelou, and he summed up his rational approach to art when he wrote to him in 1642: "My nature constrains me to seek and to love well-ordered things, and to flee confusion, which is as much my antithesis and my enemy as light is to dark."

Below: Marriage *(c.1638–40) from Poussin's series of Sacraments painted for Cassiano dal Pozzo. The picture shows the marriage of the Virgin Mary and Joseph in a starkly dignified architectural setting.*

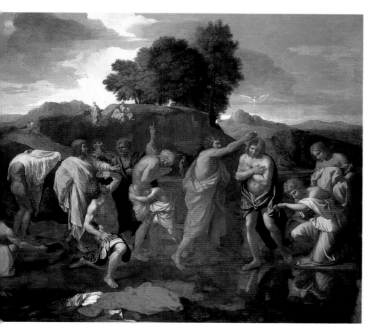

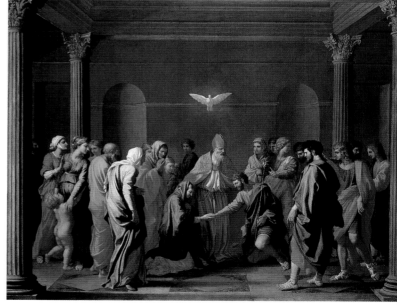

DIEGO VELÁZQUEZ

1599–1660

Velázquez stands at left in front of a huge canvas, palette and brushes in hand, in one of the most famous self-portraits in the history of art. Occupying most of the foreground are the little blonde-haired Infanta (princess) Margarita and her attendants, including two dwarfs and the two *meninas*, or "maids of honor," who give the picture its title. In the mirror on the wall at the back of the room are reflections of the king and queen of Spain: Philip IV and Mariana of Austria. The painting gives an extraordinary feeling of reality, yet it is also enigmatic in many ways, and a great deal has been written trying to explain what is going on in it. One suggestion is that Velázquez is painting a portrait of the king and queen and has been interrupted by the infanta and her retinue. Another interpretation is that he is painting the infanta—her attitude could be interpreted as reluctance to pose—and that the king and queen have arrived to see how work is progressing. On a deeper level of interpretation, many commentators feel that in producing such a complex, multilayered work that combines portrayals of the royal family and the artist, Velázquez expressed his feelings about the dignity and intellectual status of the profession of painting.

Velázquez certainly cared about status. He spent virtually his whole career, from the age of twenty-four, as the favorite painter of Philip IV, and he was given numerous other prestigious court positions by the king, who admired him greatly for his personal qualities as well as his artistic skills. From the point of view of posterity, his bureaucratic duties wasted a good deal of his time on trivial matters, but he took the work seriously and was described by a contemporary as "a courtly gentleman of such great dignity as distinguishes any person of authority."

The bulk of Velázquez's work was devoted to portraits of Philip, his family, and his courtiers. However, he also painted other types of picture, including religious and mythological works. He made two visits to Italy, in 1629–31 and 1648–51, but for generations his work was little known outside Spain. With the opening of Spain's national museum, the Prado, Madrid, in 1819, his paintings suddenly became accessible, and he became a hero to many nineteenth-century artists; Édouard Manet (see pages 138–41), for example, regarded him as the greatest of all painters.

Las Meninas (The Maids of Honor), c.1656, Prado, Madrid

Style and technique

Velázquez developed in a steady, almost serene, way, without any abrupt changes of style or direction. However, there is an enormous difference between his early and his late work. He always based his painting on acute scrutiny of nature, but as he matured his means of depicting what he saw grew increasingly subtle. His early paintings are solid and highly detailed, but he gradually sacrificed detail to overall effect and atmosphere, so that his late works—when looked at closely—seem almost like an abstract pattern of brush strokes.

In the foreground of the painting are the female dwarf Mari Bárbola and the midget Nicolás Pertusato, who teases a huge dog. Mari and Nicolás were kept for entertainment by King Philip IV. Velázquez painted portraits of many of the members of the Spanish court, and here brings together several from the highest in status to the lowest.

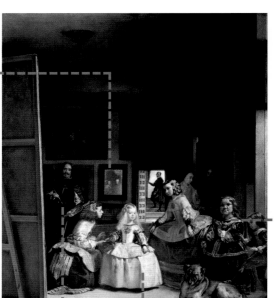

Portraits of King Philip IV and Queen Mariana are included as a reflection in the mirror. The idea of indicating someone's presence by means of a mirror may have been inspired by Jan van Eyck's famous painting The Arnolfini Wedding (see page 13), which was in the Spanish Royal Collection at this time.

Velázquez portrays himself as a dashing figure behind an enormous canvas, holding a palette in his left hand and a brush in his right. With his confident pose and expensive clothes, he shows himself as a gentleman-courtier as well as a painter. On his breast he wears the Cross of Santiago—denoting his knighthood; this detail was added after the rest of the painting was complete.

With the immediacy of an informal snapshot, Velázquez depicts the moment when the five-year-old princess glances out of the picture, possibly at her parents, who are shown reflected in the mirror behind. To either side of her stand her maids, after whom the painting is named.

The quest for knighthood

Velázquez wanted to be recognized as a gentleman as well as an artist, and the final triumph of his life came in 1659 when King Philip IV made him a knight—an unprecedented honor for a Spanish painter.

Prominently displayed on Velázquez's costume in *Las Meninas* is the red cross of the Order of Santiago, one of Spain's oldest and most prestigious orders of knighthood. *Las Meninas* was probably finished in 1656 and Velázquez did not receive his knighthood until 1659, so the cross must have been added later. According to legend, Philip IV commented "One thing is missing" and painted in the cross himself, but it has been added with professional skill, presumably by Velázquez himself.

Velázquez had nursed an ambition to be knighted since the 1630s, but even though he was a personal favorite of the king, it was no simple matter for him to be awarded such a title. The Spanish court was a place of rigid protocol, and a painter—no matter how talented—was considered fairly low down the social order.

Philip finally nominated Velázquez for knighthood in June 1658 and there then began a lengthy process to examine his eligibility. Among the many requirements, the candidate had to demonstrate that neither he, his parents, nor his grandparents had practiced any "manual or base occupations." These occupations specifically included painting, which would seem to have ruled out Velázquez from the start, but he got around this restriction by claiming that he did not accept money for his work like a common tradesman, but was employed directly by the king. After 148 witnesses had been interviewed in Seville (the artist's hometown), Madrid, and elsewhere, Velázquez's candidature was turned down by the investigating officials. Philip refused to accept the decision; he obtained special permission from the pope and knighted Velázquez on November 28, 1659.

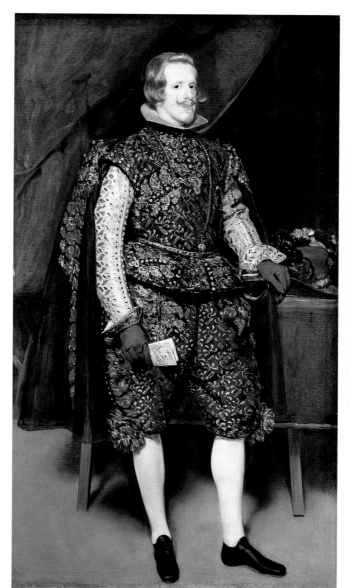

Left: Velázquez's Portrait of Philip IV of Spain in Brown and Silver (c.1631–32) presents a powerful and sophisticated image of the king. With its virtuoso rendering of Philip's splendid clothes and the nobility of his pose, the painting shows Velázquez's flair for image making that helped earn him the king's respect and ultimately a much-prized knighthood.

ANTHONY VAN DYCK

1599–1641

legant, slim, beautifully dressed, and leaning nonchalantly against the base of a classical column, the young man in this self-portrait looks eminently pleased with life. Aged about twenty-three at the time, van Dyck had every reason to feel satisfied, for he was already well launched on a glittering international career. He was a boy prodigy, and by the time he was eighteen he was working as chief assistant to the great Peter Paul Rubens, the most famous painter in Europe (see pages 50–53). By 1620 his reputation had spread from his native Antwerp to England, and in the winter of 1620–21 he spent several months in London working for King James I. Soon afterward he set out for Italy, the goal of most ambitious young artists at the time, and this portrait was probably painted in Rome in 1622 or 1623.

Van Dyck remained in Italy until 1627, and it was during this period that he began to specialize in portraits. His clients included many aristocrats and in his portrayals of them van Dyck created an enduring ideal of what a nobleman or noblewoman should look like: slender, proud, and effortlessly graceful. Van Dyck himself dressed and behaved like an aristocrat, a seventeenth-century biographer commenting that "his manners were those of a lord rather than an ordinary man." His affectations sometimes irritated his fellow artists, but his polished behavior must have been an advantage when working for people of high social standing.

After his return from Italy van Dyck was based in Antwerp for the next few years before moving to London as court painter to King Charles I in 1632. Charles was a great art-lover and van Dyck spent most of the rest of his short life—he died at forty-two—glorifying the king, his family, and his courtiers in portraits of seductive beauty and glamour. In 1640 he married one of the queen's ladies-in-waiting, but he never really settled in England and was always looking out for opportunities elsewhere; he wanted a chance to test his skill in grandiose schemes of decoration in churches or palaces—the type of painting at which Rubens excelled. Despite these unrealized ambitions, van Dyck's work had a resounding influence in England, inspiring society portraitists right up to John Singer Sargent (see pages 186–89) almost three centuries later.

Self-Portrait, c.1622–23, oil on canvas, Hermitage, Saint Petersburg

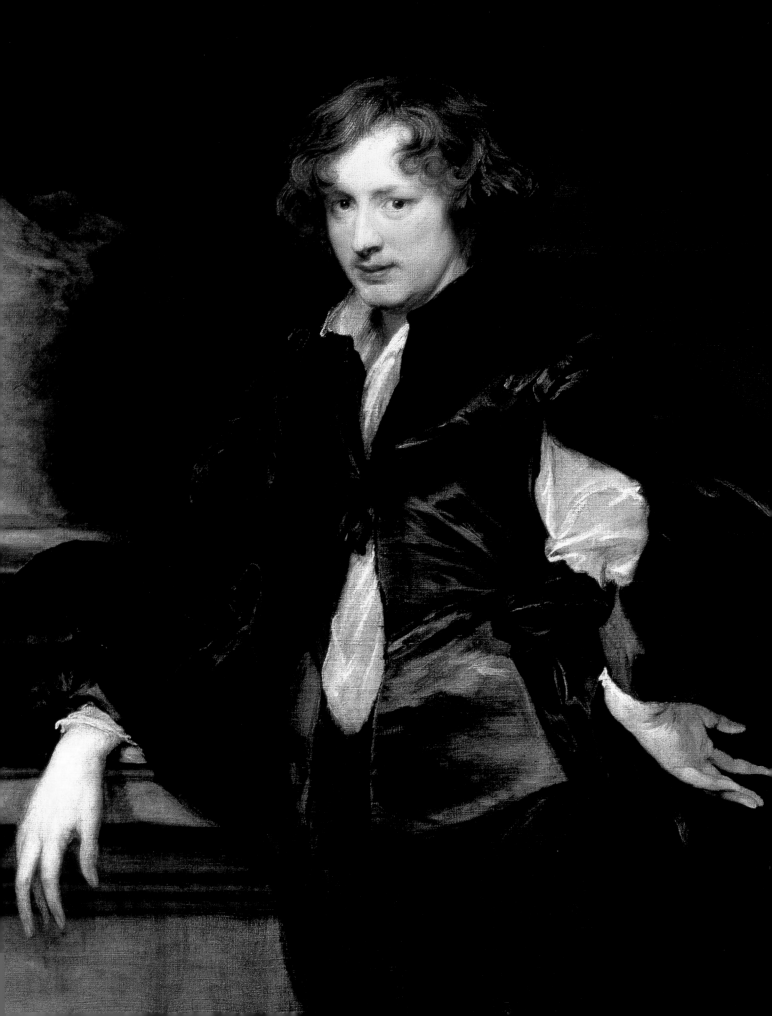

Style and technique

Van Dyck was greatly influenced by his mentor Rubens and by the Venetian artist Titian (see pages 26–29), whose work he avidly studied and collected. However, whereas both these painters were supremely robust in temperament, van Dyck's paintings have an entirely personal quality of nervous sensitivity, reflecting his highly strung personality. He painted with great fluency and deftness, his brush at times seeming to skim over the canvas. Although he was a superb draftsman, few preparatory drawings for his portraits survive, suggesting that he worked directly on the canvas, without preliminary studies.

Van Dyck portrays himself leaning against a broken column. He often included columns in his portraits—a motif borrowed from Titian—as a reference to the splendors of classical civilization, thus enhancing the image of the sitter as a cultured gentleman.

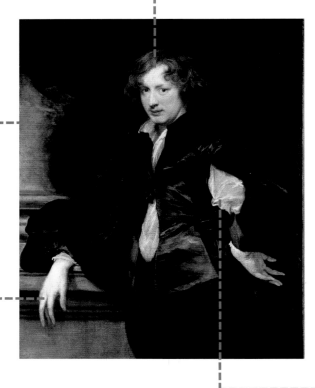

Fluidly applied and subtly blended flesh tones model van Dyck's slightly plump face. Strokes of more thickly applied paint mixed with white define the highlights— notably the bridge of the nose and the forehead.

Van Dyck's right hand rests elegantly on the base of the column. Such elongated, graceful hands with pale coloring, arranged in languid poses, are a typical feature of the artist's portraits.

Free strokes of white create a sheen on van Dyck's sumptuous black jacket and the white shirt displayed through its slashed sleeves. Van Dyck's expensive and fashionable clothes, combined with his nonchalant pose, help create the swagger of the image.

The art of flattery

Seen through van Dyck's paintings, the court of King Charles I forms the centerpiece of one of the most glamorous eras in English history—but some of its allure depends on flattery.

Charles I (1600–49), who succeeded his father James I as king of England and Scotland in 1625, was the most passionate art lover among all the monarchs of England. He formed a superb picture collection and employed some of the best artists of his own time, above all Rubens and van Dyck. It is sometimes said that the kings with the best taste tend to be the worst rulers and Charles seems to bear this out. He had many good qualities, but he was out of touch with the feelings of his subjects and his high-handed treatment of Parliament eventually led to civil war and his own execution.

Van Dyck painted numerous portraits of Charles himself and also of his wife, Queen Henrietta Maria, their children, and many of their courtiers. With their wonderful costumes and exquisite feeling for character, these portraits include some of his most glorious works. However, there is sometimes a feeling of melancholy about them, suggesting the shadow of the forthcoming civil war, which broke out in 1642, the year after van Dyck's death.

Although Charles I was a dignified man, he was rather short. Van Dyck cleverly disguised the king's lack of stature by showing him on horseback or from a low viewpoint, so that the viewer seems to be looking up at him. He evidently used more shameless flattery in depicting Queen Henrietta Maria. When a niece of Charles's first met her in 1641, she was shocked to find not the beauty she had been expecting from van Dyck's portraits, but a "small woman ... with long skinny arms and teeth like defense works projecting from her mouth."

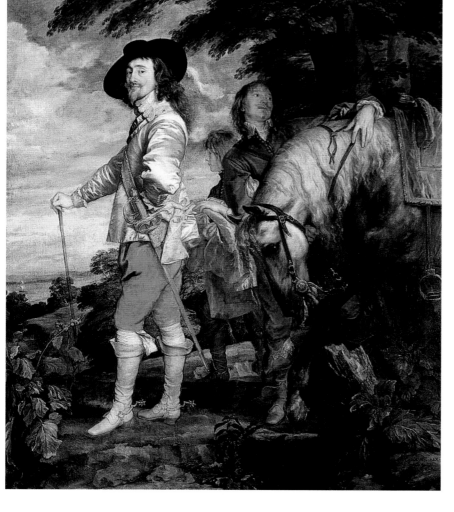

Left: In Portrait of Charles I Hunting *(c.1635) van Dyck disguised the king's short stature and emphasized his regal poise by portraying him from a low viewpoint.*

REMBRANDT VAN RIJN

1606–69

This self-portrait is one of the most majestic ever painted; from it Rembrandt looks out to confront the viewer in an image of massive authority. He does not show off in an expensive costume, as he had in several of his youthful self-portraits, but instead proudly expresses the nobility of his profession. Aged about sixty, he was near the end of an eventful life that had taken him through varied successes and reversals, both professional and private. From them he had emerged battered but dignified; his face seems to be that of a man who has no illusions about life, but no bitterness either.

Rembrandt was the son of a prosperous miller and was born in Leiden, then Holland's second biggest town. He achieved brilliant early success, and in 1631 or 1632 he moved to the capital, Amsterdam, one of the most prosperous cities in Europe, to seek his fortune. He quickly outstripped all rivals to become the city's leading portraitist, and his personal life also flourished. In 1634 he married a relative of a picture-dealer associate, and his many tender portraits of his wife, Saskia, suggest it was a blissful union. However, their happiness was marred by a series of infant deaths—three of their four children died within a few weeks of birth—and Saskia herself died in 1642, aged twenty-nine.

From about this point Rembrandt's worldly fortunes began to decline, as he turned away from fashionable portraiture to concentrate on works that appealed more to his heart, particularly biblical subjects. Although his income dropped, he continued to have extravagant tastes, and in 1656 he was declared insolvent. He had to leave his impressive house and in his remaining years he lived much more modestly. However, he continued to be a respected artist, receiving important commissions, and he was sustained by the love of Hendrickje Stoffels, who entered his household as a servant a few years after Saskia's death and became his second wife in everything but name. She died in 1663, around about the time he painted this portrait. After his own death, Rembrandt continued to be famous, but for many years he was considered a flawed genius, tainted by a vulgar streak. It was not until the nineteenth century that he became widely regarded as one of the greatest artists of all time.

Self-Portrait, c.1665, oil on canvas, Kenwood House, London

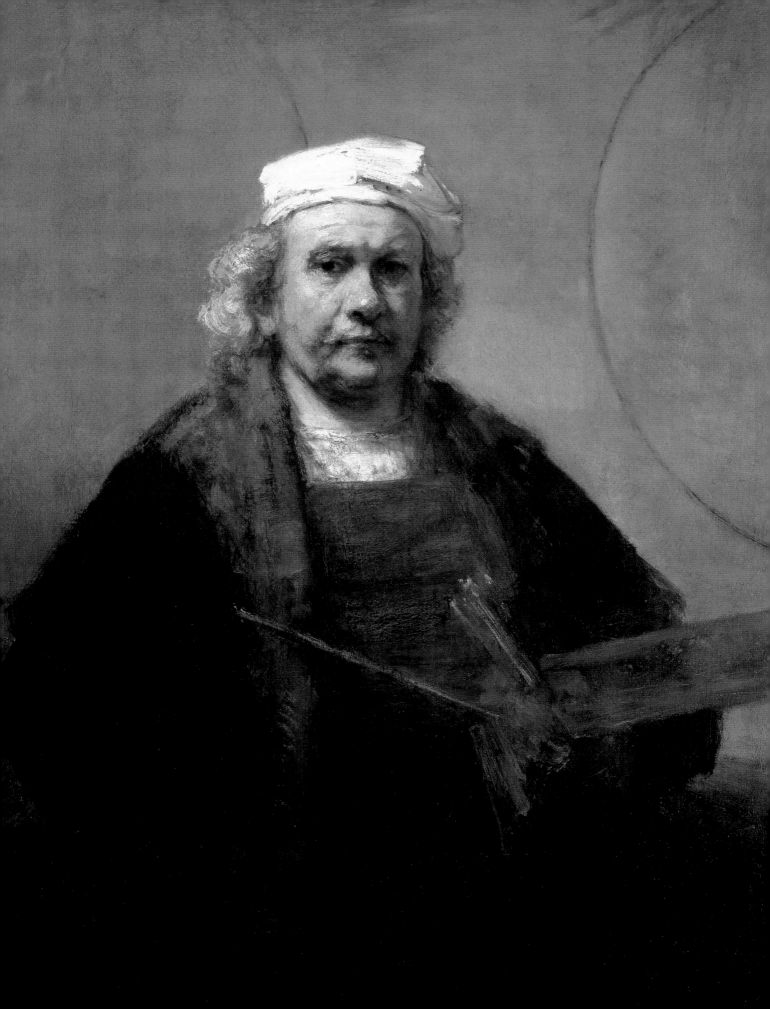

Style and technique

Rembrandt was highly prolific and enormously versatile: he was a superb draftsman and etcher as well as a painter, and his work covers a wide range of subjects and moods. In his youth his style was often attention-grabbing and his technique brilliantly polished, but he became more concerned with inner feeling than with outward show and his brushwork became increasingly broad and free. His eighteenth-century biographer Arnold Houbraken wrote, "In the last years of his life … his pictures, when examined close by, looked as if they had been daubed by a bricklayer's trowel."

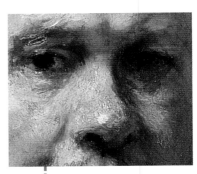

Rembrandt painted his eyes in deep shadow, with no highlights to enliven the pupils, adding to the reflective, contemplative mood of the self-portrait. The main highlight on the face falls on the end of the painter's bulbous nose, and is freely suggested with two dabs of unmixed white and crimson pigment.

Broad, gestural strokes of white paint are used to build up the turban. The restrained clothing in this portrait is quite unlike the flamboyant, exotic costumes Rembrandt painted himself wearing in several earlier self-portraits.

In his left hand Rembrandt holds the tools of his trade: a palette, brushes, and mahlstick (see page 38). They are sketched in with muted browns, like the whole lower portion of the canvas, so as not to distract attention from the face; the left hand is suggested with little more than a few smudges of paint.

The patterned neckline of Rembrandt's white undergarment is suggested by a rapid squiggle made in wet paint with the handle of a paintbrush.

A life in art

In a remarkable sequence of self-portraits, Rembrandt charted his changing appearance, his varied moods, and his unsettled fortunes over a period of four decades.

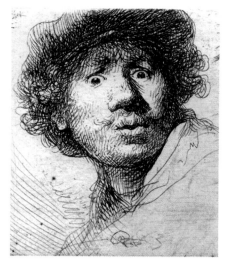

Above: Rembrandt's etched Self-Portrait Wide-Eyed (1630) is a remarkably spontaneous study in which he explores how to portray a look of surprise.

Rembrandt created easily the most famous series of self-portraits in the history of art; no other artist has approached him in producing so many unforgettable portrayals of his own features. There are about thirty surviving painted self-portraits, as well as about a dozen drawings and two dozen etchings; in addition, he occasionally included a self-portrait among the subsidiary figures in his religious pictures. Most of the drawings and etchings are early in date (there are few after the 1630s), but the paintings cover his whole career, from his early days as an independent artist in Leiden to the final year of his life, showing him developing from rebellious youth to resigned old age. Sometimes he depicts himself as a working artist, but often he wears fashionable clothing or fancy dress, and in a few portraits he paints himself as a specific character, such as Saint Paul.

Rembrandt did not leave any explanation of why he produced so many self-portraits, and neither did any of his contemporaries, but there has been no shortage of modern interpretations of these works. The temptation is to see them as a kind of spiritual autobiography and to read into them what is known about Rembrandt's life. Doing so has led some writers to an overly sentimental approach—in which they see him as a saintly model of personal integrity who triumphed in his art in spite of disasters in his personal life. However, the best of these portraits do speak to many people in an exceptionally direct and moving way. As the art historian Kenneth Clark put it, "He digs down to the roots of life; and he seems to open his heart to us."

Below: In Self-Portrait with Saskia (c.1635) Rembrandt portrays himself in ebullient mood as a prosperous dandy—the picture's subject is thought to be the Prodigal Son.

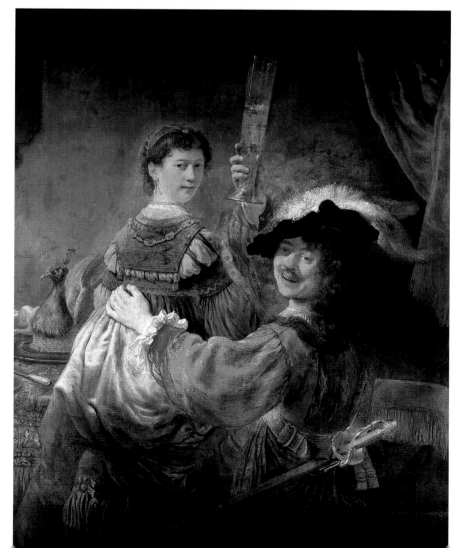

JAN VERMEER

1 6 3 2 – 7 5

This must be the most famous back view in art. We cannot be sure that the artist seated at his easel is a portrait of Vermeer himself, but it certainly makes an appropriate image by which to represent one of the most enigmatic of all great painters. It is typical of Vermeer that the picture seems startlingly real yet at the same time unfathomable. The illusion of actuality is almost miraculous—the varied textures of the heavy curtains, the creased map, and the brass chandelier are depicted with breathtaking skill and all are unified by the subtle handling of light—yet it is clear that this is not a straightforward, naturalistic scene. Most obviously, the painter is wearing a fanciful, old-fashioned costume, rather than everyday working clothes, and the picture is intended to glorify the art of painting, rather than to give a documentary record of a particular artist in his studio. The model underlines this point. She is represented as Clio, the muse of history; her trumpet will broadcast the painter's achievements and her book will record them for all time.

In fact the trumpet of fame was muted for many years as far as Vermeer was concerned. He seems to have lived a quiet provincial life in the Dutch town of Delft, rarely leaving it even for local journeys, and his name was virtually forgotten for about two centuries after his death. In part Vermeer's obscurity arose because his output was tiny. There are only about thirty-five surviving paintings by him; most of them are small and superficially similar to the work of other seventeenth-century Dutch artists, and they simply got swamped in the deluge of paintings by his contemporaries. He was a slow-working perfectionist and his output was probably further limited because he did not devote all his career to painting; his father worked as a picture-dealer and an innkeeper, and Vermeer probably inherited both businesses. He had a large family to support—he had fifteen children, eleven of whom were still alive at his death—and was often in financial trouble. When he died, aged only forty-three, his widow was in such desperate straits that she was reduced to selling two of his paintings to the baker to settle a debt. The most important figure in rediscovering Vermeer was the French writer Théophile Thoré, who published a series of articles on him in 1866.

The Art of Painting, c.1665–70, oil on canvas, Kunsthistorisches Museum, Vienna

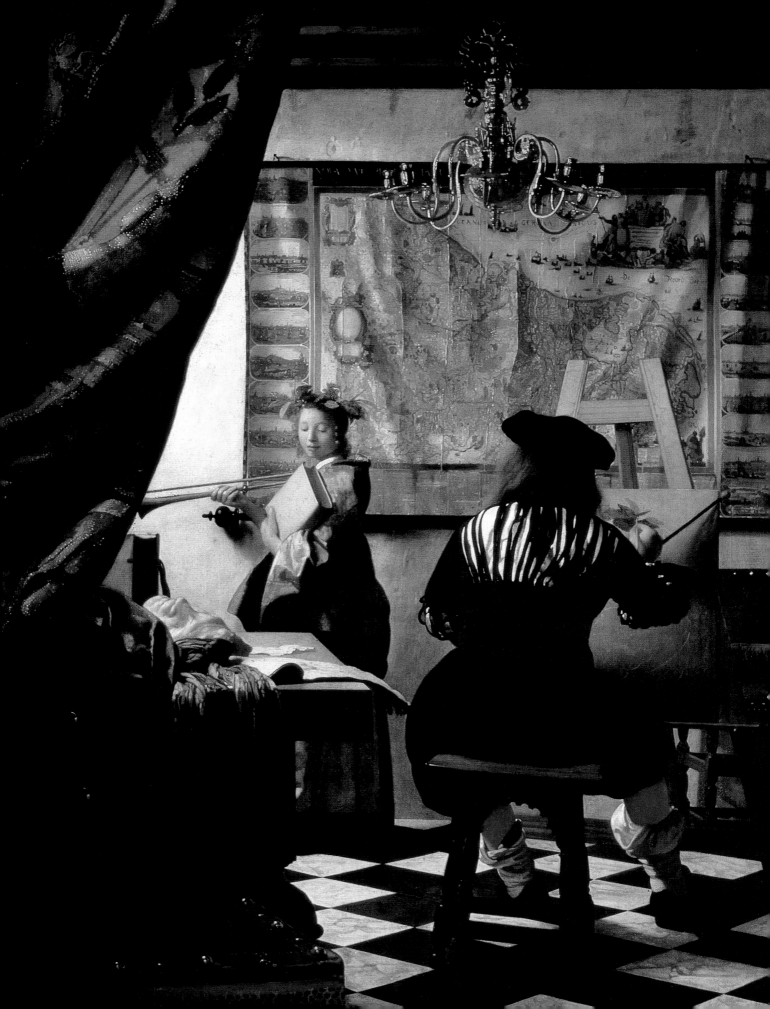

Style and technique

Vermeer's paintings have a flawless balance of forms and harmony of colors, but he combined this serenity with a sparkling vibrancy of brushwork. In reproductions, his paintings can look completely smooth, but in front of the originals one sees how subtly varied his brushwork is; sometimes he uses little raised points of paint to suggest the light playing over rough textures, and the surface he creates has been described as looking "like crushed pearls melted together." Typically his colors are cool, but his sensitivity enabled him to introduce brighter notes without upsetting the overall balance.

A heavy tapestry curtain has been pulled aside to reveal the painter's studio. In Vermeer's time, precious paintings were often protected by curtains, and seventeenth-century Dutch painters sometimes included painted curtains in their own pictures as a visual conceit. Here Vermeer uses blobs of thick white paint to suggest the play of light across the stitches of the tapestry.

A map of the Netherlands hangs on the studio wall and on it Vermeer has painted his signature. Printed maps such as this one, edged with detailed views of Dutch towns, often adorned the interiors of prosperous Dutch homes, and appear in several of Vermeer's paintings.

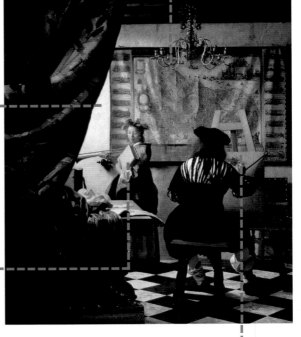

The painter's model is dressed as Clio, the muse of history. She wears a laurel wreath and holds a trumpet, signifying the honor and fame she will bring to the artist whom she inspires to paint. The soft-focus quality of her features is typical of the effects of a camera obscura, an optical device that art historians believe Vermeer sometimes used to assist him in creating his paintings.

The artist paints a detail of Clio's laurel wreath. He works directly from the model, with only a sketchy indication of the subject on the canvas. It is notable that no preliminary drawings by Vermeer survive.

Light and lenses

Many seventeenth-century Dutch artists were interested in optics, and Vermeer, like his contemporaries, seems to have been fascinated by the effects of light and lenses. Some scholars believe he used optical devices to help create his pictures.

Although there are a few pieces of surviving documentary evidence about Vermeer, they tell us next to nothing about his personality or his attitude to art. Our knowledge of his working methods depends largely on studying his paintings very carefully and seeing what deductions can reasonably be made. Most scholars who have made such studies agree that it is virtually certain that Vermeer sometimes used an optical device called a camera obscura. The camera obscura works on the same principle as a photographic camera, but instead of projecting an image onto light-sensitive film, it projects it onto a drawing or painting surface, so the artist can trace around the outlines and accurately record the object or scene in front of him. Features in the foreground of Vermeer's paintings sometimes look unexpectedly large, and brightly lit details sometimes look slightly out of focus—effects that could be related to the fairly primitive lenses that would have been used in camera obscuras at the time.

The use of such a shortcut does not detract from Vermeer's genius. The camera obscura would have been of little use if he had not had an extraordinary ability to arrange the people and objects he depicted into harmonious compositions. Many Dutch painters of everyday scenes liked to show domestic clutter, but Vermeer concentrated on a few broad shapes, such as the outline of a figure, the back of a chair, or a map on the wall. He arranged these elements into patterns of such strength and dignity that it can be a shock to stand in front of one of his paintings for the first time and see how small it is.

Below: A seventeenth-century illustration of an artist working inside a large camera obscura. Books about optics were popular among Dutch artists of Vermeer's time.

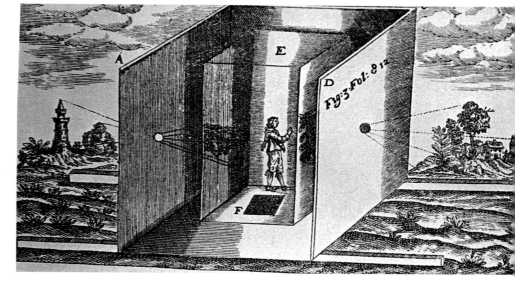

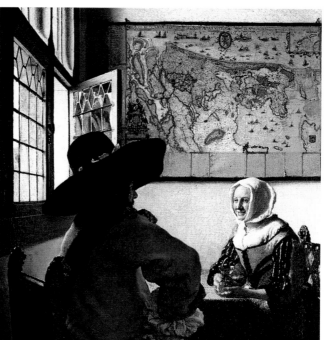

Left: Vermeer, Soldier with Laughing Girl, c.1658–60. The comparatively large size of the foreground figure has been interpreted as evidence that Vermeer used optical devices like the camera obscura.

WILLIAM HOGARTH

1697–1764

ppropriately, Hogarth shows himself with his pet pug, a breed rather like a bulldog, for he was one of the most pugnacious of artists, independent in his attitudes and always ready to stand up for his beliefs. He certainly looks like a tough, no-nonsense character, with his strong, rather coarse face—there is a prominent scar on his forehead—his obstinate mouth, and his steady gaze. However, he was a many-sided artist, as other features of the portrait suggest. The three books are volumes of Shakespeare, Milton, and Swift, indicating his interest in literature, which provided much of the inspiration for his work. In front of the books is a palette inscribed with the words "the line of beauty and grace" and a curving line, a reference to his individual ideas on aesthetics, which he wrote about in a treatise entitled *The Analysis of Beauty*, published in 1753.

Hogarth trained as an engraver and engravings played a prominent part in his career. He used them as a way of popularizing his work, for they could be printed in large editions and sold cheaply. In fact, his work proved so popular that pirated engravings appeared, and Hogarth complained about this so forcefully that Parliament passed the Engravers' Copyright Act in 1735, making unauthorized copies illegal. His greatest success came with a type of work he invented, in which he used a painted or engraved series of pictures to tell a moral story and satirize contemporary society. These moralizing works include *A Rake's Progress*, which in eight scenes shows the decline of a debauched young man from riches to death in a madhouse; the paintings are in the Soane Museum, London, and the engravings made from them were published in 1735.

Hogarth painted and engraved various other types of work, including portraits and religious pictures. He was easily the most important British artist of his day, not only because of the quality and originality of his work, but also because he showed his countrymen how they could develop a distinctive way of expressing themselves. At the beginning of his career, painting in Britain was dominated by foreigners, as it had been since Holbein's day in the early sixteenth century. By the end of Hogarth's career, British painting had a vigorous identity of its own.

The Painter and His Pug, 1745, oil on canvas, Tate Britain, London

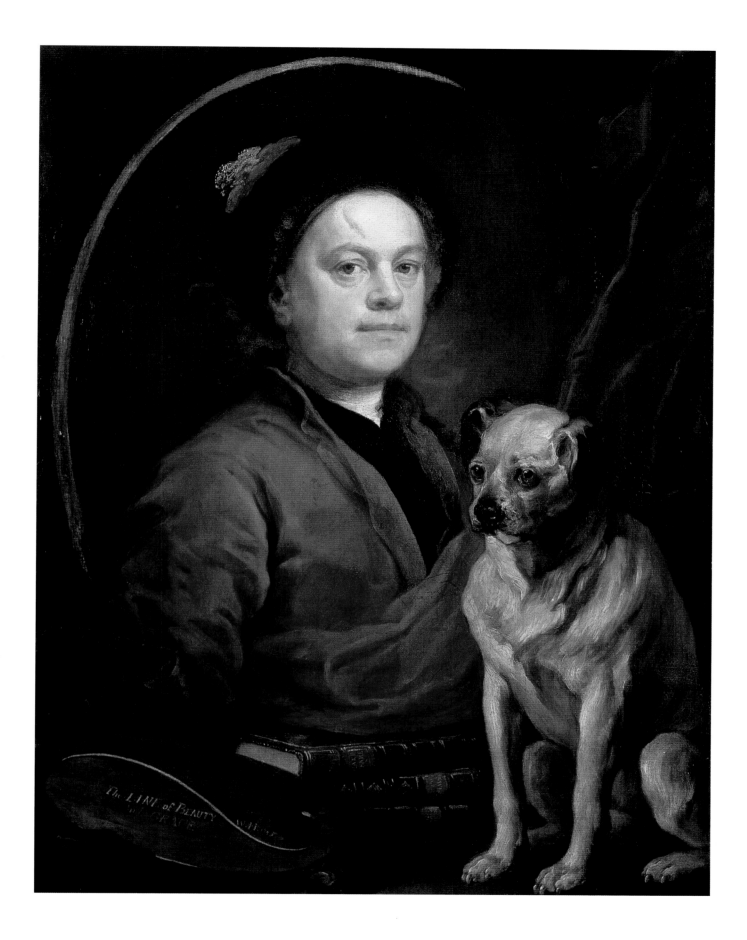

Style and technique

Hogarth's work is lively and inventive, full of details that show how keenly he observed his fellow men and women. Often his pictures were arranged like scenes from a play; their aim, he wrote, to "both entertain and improve the mind." They often appear comic, although usually there is a serious underlying moral, and Hogarth could be unsparingly brutal when exposing cruelty. As an engraver he learned to work with crisp precision. In painting he was mainly self-taught and developed a distinctive nimble touch; some of his informal pictures are extremely broad and free in handling.

Hogarth used free brushwork and warm flesh tones to create this image of a plain but resolute artist. His left ear is suggested with just a few marks, and touches of red paint at his left nostril, lips, and hairline tie in with the color of his smock and the top of his hat, helping unify the canvas.

The swags of drapery that enclose the composition, along with the palette, stacked books, and the device of placing a portrait inside a portrait, add an air of theater to the painting that is typical of Hogarth's art.

The palette bears the inscription "the line of beauty and grace," which is separated from Hogarth's initials and the painting's date with just such a sinuous, curving line. It was a theme that Hogarth discussed in his treatise The Analysis of Beauty, but was also, doubtless, a wry comment on his own ungraceful appearance.

With vigorous brushwork, Hogarth painted his pet pug Trump sitting in front of the oval portrait. Hogarth often included dogs in his paintings, usually as a humourous comment on the behavior of people depicted, and his inclusion of the muscular Trump invites reflection on his own appearance and nature.

London life

Hogarth lived all his life in London, and the teeming life of the capital fed his imagination with an abundance of subjects from all levels of society, ranging from the aristocracy and politicians to prisoners and the poor.

In Hogarth's day London was the largest city in Europe, with a population of more than half a million. The richest citizens lived in luxury, but many people endured lives of abject poverty. Hogarth gained early familiarity with the seamy side of life, for when he was a boy, his father, a schoolmaster, was imprisoned for debt in the notorious Fleet Prison. This experience seems to have left a deep mark on Hogarth, for much of his art is colored by the contrast between success and failure, and he painted several pictures set in prisons and other squalid places. Most of these are imaginary scenes, but in 1733 he visited a convicted murderer, Sarah Malcolm, in her cell two days before her execution, producing a painting and a bestselling engraving of her.

Hogarth was not simply an observer. He was a man with a highly developed social conscience, moved to pity and indignation by undeserved suffering, and he took part in several humanitarian schemes. In particular he was a governor of the famous Foundling Hospital, established in 1739 by his friend Captain Thomas Coram, who had been horrified by the sight of infants abandoned by their parents and "left to die on dung hills." Hogarth painted a wonderful portrait of Coram in 1740 and presented it to the hospital. He also persuaded some of the leading British artists of the day to present pictures of their own. Many people came to look at these paintings, which increased the fame of the hospital, thereby encouraging other benefactors. In this way Hogarth's scheme gave a focus to the distinctively British tradition in painting that he had been mainly responsible for creating.

Left: Hogarth's Portrait of Sarah Malcolm *(1733) was the basis of a bestselling engraving that cashed in on the public fascination with the 22-year-old murderer.*

JEAN-SIMÉON CHARDIN

1699–1779

This picture is one of a series of pastel portraits that Chardin created in old age, when he gave up oil paints because their fumes irritated his eyes. He was already over seventy when he first exhibited such pastels in 1771. Although he had only occasionally produced portraits before this and had never used pastel at all, he was immediately recognized as having matched the best specialist practitioners of the day. As he lived in a golden age for the pastel portrait, this was no mean achievement. It is easy to understand the admiration Chardin's contemporaries felt for portraits like this, for it is intimate in characterization yet has a magnificent sureness of design. He shows himself informally, with his head in a nightcap and a loosely knotted cloth around his neck. A green eyeshade suggests the trouble with his sight that made him give up oils.

Before this remarkable late transformation in his career, Chardin had devoted himself almost entirely to still-life paintings and quiet scenes of everyday middle-class life. He had a high reputation in these fields, but he was nevertheless regarded—even by his greatest admirers—as inferior to artists who painted more "elevated" subjects. At the time most artists and connoisseurs believed in a hierarchy of subjects; still life was placed at the bottom, because it was thought to be primarily a matter of skilled craftsmanship, with little or no intellectual content. At the top was "history painting," which included subjects from the Bible, mythology, and certain types of great literature; it was thought to be the highest branch of painting because it was more technically and intellectually challenging than any other.

These attitudes about art were promoted by the Academy of Painting and Sculpture in Paris, of which Chardin was a loyal member for half a century. From 1755 to 1774 he was the Academy's treasurer, a position to which he was well suited, as he had a reputation for honesty and integrity. He led a very uneventful life and never traveled more than a few miles from Paris. After his death he was quickly forgotten, but his reputation revived in the mid-nineteenth century and he is now one of the most admired artists of his age.

Self-Portrait, 1775, pastel on paper, Louvre, Paris

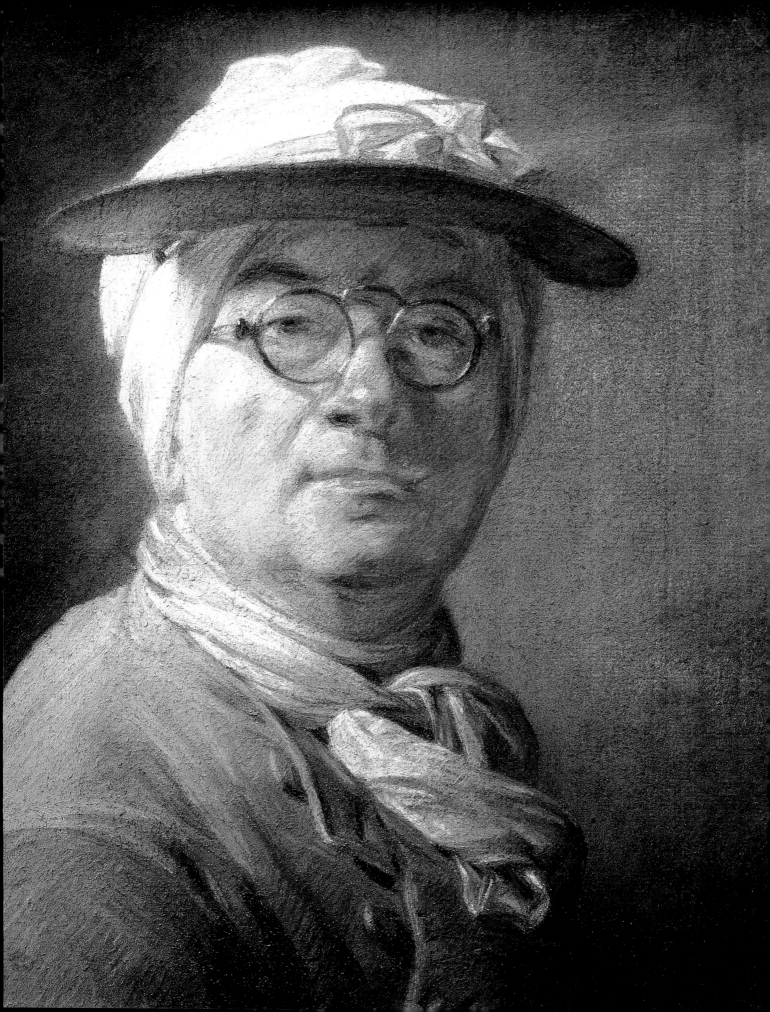

Style and technique

Chardin's subjects were generally modest, such as still lifes of kitchen utensils, fruit, and dead birds or rabbits, or genre scenes of maids at work and children at their lessons. However, his unerring sense of composition, his sureness of touch, and his avoidance of anything superficial or distracting gives his pictures a sense of timeless dignity. He was a slow, fastidious worker, and his oil paint is richly and subtly textured. In his late portraits he used firm, vigorous strokes of pastel, rather than blending tones smoothly as most of his contemporaries did.

The extraordinary headgear in which Chardin portrayed himself—a nightcap, knotted scarf, and eyeshade—make this one of the most memorable of all artists' self-portraits. In a celebrated description of the picture, the novelist Marcel Proust wrote that "The eccentricity of his negligent dress makes him resemble an elderly English tourist."

Unmodulated strokes of reddy brown and gray pastel are applied over more blended flesh tones to create the effect of aging, sagging skin.

Behind his glasses, Chardin's eyes appear to sag with their red rims and dull pupils. Yet critics have disagreed over the elderly artist's expression: is it one of resignation to old age and infirmity, or, with its raised chin, one of defiance?

The loosely tied scarf around Chardin's neck is another aspect of his eccentrically casual dress, but also shows the thought that he gave to the harmony of his picture. Its touches of earthy orange and greeny blue are repeated in the face, glasses, eyeshade, and headgear to unify the portrait.

French pastel portraits

The art of pastel had its heyday in eighteenth-century France, and masters like Maurice-Quentin de La Tour and Jean Baptiste Perronneau were famed throughout Europe for their skill.

Pastel lies on the borderline between drawing and painting; the artist uses it more like a drawing material than paint, but the picture that results resembles a painting much more than the usual idea of a drawing. Pastel consists of powdered pigment (coloring matter) mixed with a small amount of a sticky substance, usually gum arabic, and formed into a crayon-like stick. Whereas crayons are waxy, pastels are powdery. Strictly speaking they differ from chalks, which are prepared from natural stones and earths, but the terms are often used fairly loosely.

Pastels can create very rich and subtle effects, but they have the drawback that the surface they produce is extremely fragile, liable to be disturbed by the slightest touch. Consequently they are suitable only for fairly small works. Pastels were first used in the late fifteenth century, but did not become really popular until the eighteenth century, by which time a full range of colors was in use.

The first pastelist to achieve international success was the Venetian Rosalba Carriera (1675–1757). She visited Paris in 1720–21 and inspired Maurice-Quentin de La Tour (1704–88) to take up the technique. He became the most famous French pastelist of the time, portraying many of his leading contemporaries, and he is known for his lively characterization and the velvety richness of his coloring. His most distinguished contemporary was Jean-Baptiste Perronneau (c.1715–83), whose portraits are less vivacious than La Tour's but more psychologically penetrating. In the early nineteenth century pastel declined in popularity, but there was a major revival in the second half of the century. Several impressionists used it, above all Degas.

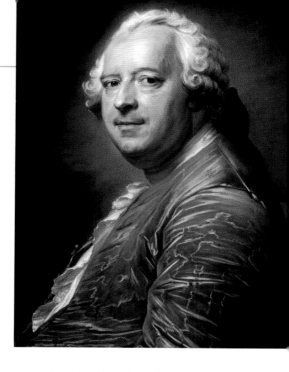

Above: Portrait of Monsieur Garnier d'Isle (c.1751) by Maurice Quentin de La Tour. The velvety finish and lively characterization in pictures such as this made La Tour the most celebrated pastelist in eighteenth-century France.

Below: The Air (1746) from a series of pastel pictures of the elements by Rosalba Carriera. Her delicate, decorative technique and lightness of touch popularized the use of pastels with patrons and artists alike.

JOSHUA REYNOLDS

1723–92

The dramatic lighting in this early self-portrait shows Reynolds's admiration for Rembrandt, but the striking pose with the hand shading the eyes is a novel feature of his own. Throughout his career Reynolds studied the work of his predecessors and took ideas from them, but he rarely imitated them directly, always finding a new slant. This painting is one of several self-portraits he produced over a period of almost half a century, from his late teens until a few years before his death. It is the only one in which he shows himself with painter's tools; in his later self-portraits he tended to stress the intellectual aspect of his profession, presenting himself as a thinker and a dignified gentleman. Here, however, aged about twenty-five, he still has an engaging sense of youthful freshness coupled with a slight awkwardness.

Reynolds was born in Plympton, a small town in Devon, southwest England, the son of a scholarly clergyman. He grew up in a bookish atmosphere and in later life his closest friends were mainly literary men—including the famous Doctor Samuel Johnson—rather than his fellow painters. He studied in London with Thomas Hudson, a leading portraitist of the time, and in 1743 set up his own practice. In 1749–52 he made a lengthy visit to Italy, staying mainly in Rome, where he studied the art of the past, particularly the great Renaissance masters.

After his return to London Reynolds quickly established himself as the leading portraitist of the day, a position he kept until the end of his career. His enormous success depended on hard work and skillful business management as well as on his talent and amiable personality, which put clients at ease. He kept careful accounts, most of which still survive, recording the people he painted and the prices he charged, so his career is documented in great detail. He sometimes had sittings with as many as six clients in a day—three was about average. By 1764 he was earning £6,000 a year—a vast amount at a time when the average working man in Britain was paid less than £1 a week. In addition to making him a fortune, Reynolds's success brought him numerous honors, including a knighthood, the presidency of the Royal Academy of Arts, an honorary doctorate from Oxford University, and finally a magnificent funeral in Saint Paul's Cathedral.

Self-Portrait, c.1748, oil on canvas, National Portrait Gallery, London

Style and technique

Probably no other portraitist has been as versatile as Reynolds. He painted men, women, and children with equal skill, and although his output was huge, he very rarely repeated himself; he responded to the individuality of each sitter and managed to find something interesting to say about almost all of them. Small wonder that his closest rival, Thomas Gainsborough (see pages 86–89), remarked in exasperated admiration: "Damn him! How various he is!" Reynolds liked to experiment technically and sometimes used methods that have proved unsound, causing his paint to crack badly or his colors to fade.

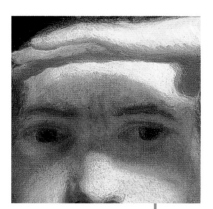

Reynolds shows himself in an inventive and memorable pose, his hand raised as if to protect his eyes from a bright light. Feathery brush strokes model the curve of the hand and strokes of red separate the shadowed palm from its brightly lit edge. A shadow is cast across the painter's eyes.

The artist shows himself in fashionable clothes, casually undone. Broad, free brush strokes convey the highlights of his white shirt, his pale blue silk waistcoat, and his brown jacket.

In his right hand Reynolds holds his brushes, a palette with a handle, and a mahlstick (see page 38). The tips and handles of the brushes are suggested with a few touches of reddish-brown paint and the mahlstick is rendered in a fluid stroke of black. The angle they form balances that of Reynold's bent elbow.

The lower part of the face is more thickly painted. The delicate shading and modeling around the softly rendered lips and tip of the nose are created with stippled marks, where Reynolds worked the wet paint on the canvas.

Ennobling English art

Reynolds is generally considered the most important figure in the history of British painting; he changed attitudes about his profession, winning it intellectual and social respect.

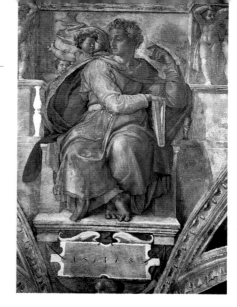

At the beginning of Reynolds's career, painters had little prestige in Britain. Portraiture dominated the country's art, but portraitists were usually regarded merely as skillful craftsmen, more or less on the level of dressmakers. There was almost no call for "history painting"—the depiction of imposing imaginative subjects based on history, mythology, or literature—which for centuries had been thought to occupy the highest realm of art. Reynolds, however, succeeded in winning a new dignity for portraiture by giving it some of the intellectual and poetic resonances of history painting. He often based the poses of his figures on ancient statues or Renaissance paintings, but he did so subtly and imaginatively, rather than merely by copying a formula. In one of his most famous paintings, *Mrs. Siddons as the Tragic Muse* (1784), the pose recalls that of Michelangelo's figure of Isaiah on the Sistine ceiling. A visual quotation from such a heroic source would usually be out of keeping in a female portrait, but its grandeur and rhetoric was entirely appropriate for Sarah Siddons, the greatest tragic actress of her age.

Reynolds's great prestige made him the obvious choice for president when the Royal Academy of Arts was founded in London in 1768 and he held the post until his death. The Academy aimed to raise the status of British artists, to give them a regular venue for exhibitions of their work, and to teach students. Between 1769 and 1790 Reynolds delivered a series of fifteen lectures to the students, in which he expounded his views on art. These *Discourses* form one of the most impressive bodies of writing ever made by a painter.

Above: A detail from Michelangelo's Sistine Chapel ceiling (1508–12) showing the Old Testament prophet Isaiah. Reynolds based the commanding pose of Sarah Siddons in his famous portrait (below) on this figure.

Right: Reynolds, Mrs. Siddons as the Tragic Muse, 1784. One of his most imposing and theatrical works, this picture shows the "grand manner" Reynolds brought to eighteenth-century English portraiture. Behind the celebrated actress stand two shadowy figures, Pity and Terror; they hold a dagger and a cup, the attributes of Melpomene, the muse of tragedy.

THOMAS GAINSBOROUGH

1727–88

here is no early documentation on this painting, but on the grounds of style and Gainsborough's apparent age, it is generally dated to about 1759. Although he was only in his early thirties at the time, Gainsborough already had several years of substantial achievement behind him, for he was highly precocious and painting seemed to come to him almost as easily as breathing. When he was about thirteen he left his home in Sudbury, a small town in the English county of Suffolk, to study art in London. He returned to Sudbury in 1748 and four years later he moved to Ipswich, the largest town in Suffolk. There he became the leading portraitist, but he was obviously cut out for more than provincial success and in 1759 he moved to Bath in Somerset, which at this time was a highly fashionable spa town, frequented by many rich visitors from London. This self-portrait was painted at about the time of Gainsborough's move, which lifted his career into a different social and financial league; in Ipswich his sitters had been mainly local merchants and squires and their families, but in Bath he painted lords and ladies. There is perhaps still a trace of provincial bluffness in the way he presents himself here, but also an easy grace that looks forward to the sophistication of his high-society portraits.

Gainsborough remained in Bath until 1774, when he settled in London. There he became the only serious rival to Joshua Reynolds (see pages 82–85). Their styles were very different—Gainsborough was less intellectual and more elegant—and in many ways they were opposites. Whereas Reynolds was orderliness personified, Gainsborough was easy-going and was often late in fulfilling his commissions; and whereas Reynolds kept company with some of the leading writers of the day, Gainsborough is said to have rarely read a book, his private passion being for music (he played several instruments well). Nevertheless, the two artists had great mutual respect, and the demand for portraits was so great at the time that neither took business away from the other. Reynolds won more worldly honors, but the royal family preferred Gainsborough's work. After Gainsborough's death, Reynolds paid generous tribute to him, devoting one of his lectures at the Royal Academy of Arts to analyzing his work.

Self-Portrait, c.1759, oil on canvas, National Portrait Gallery, London

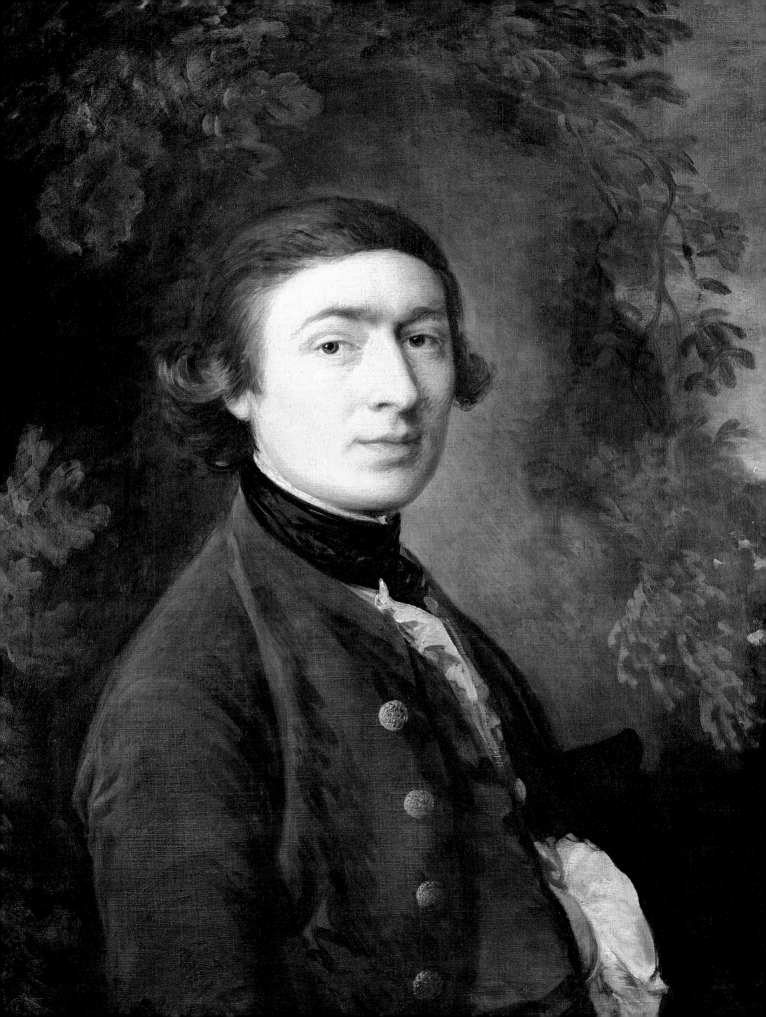

Style and technique

Most eighteenth-century British portraitists made extensive use of assistants, particularly for painting costumes, but Gainsborough liked to do everything himself. As his career progressed, he painted with increasing freedom and fluency, and the scintillating beauty of his brushwork became an important element in his pictures. In works that he produced for his own satisfaction, rather than on commission, he was even bolder in technique and often experimental; sometimes he mixed normally separate materials—such as oil paint and chalk—in the same picture.

Gainsborough used feathery brush strokes, working "wet on wet" to create the modeling of the face. The image that emerges is of an understated but handsome and fashionable young man. Gainsborough wrote about the difficulty of capturing a likeness in a portrait such as this: "A face confined to one view and not a muscle to move to say, 'Here I am,' falls very hard upon the poor painter who perhaps is not within a mile of the truth in painting the face only."

The foliage backdrop is painted with rapid, fluid strokes, here creating the impression of oak leaves tinged with fall color. The background was usually the last part of the painting Gainsborough completed, and as Joshua Reynolds remarked, the marks were often so free that they only assumed form when viewed from a distance.

Gainsborough's clothing—his brown coat and waistcoat, his white shirt and black scarf— are painted with only slightly more finish than the background. The patterned gold buttons nearest to the viewer flicker with highlights, while those on the far side are indicated with blobs of red paint, picking up on the color of the lips.

The area immediately around the figure is left plain, focusing attention on the face. Gainsborough favored a red-brown ground, or base color, for his canvases, and here it shows through vigorously applied washes of black, browns, and yellows.

Landscape and portraiture

Limited by the tastes of his patrons, Gainsborough earned his living mainly as a portraitist, but he was really a landscapist at heart; in some of his most memorable paintings he successfully combined both subjects.

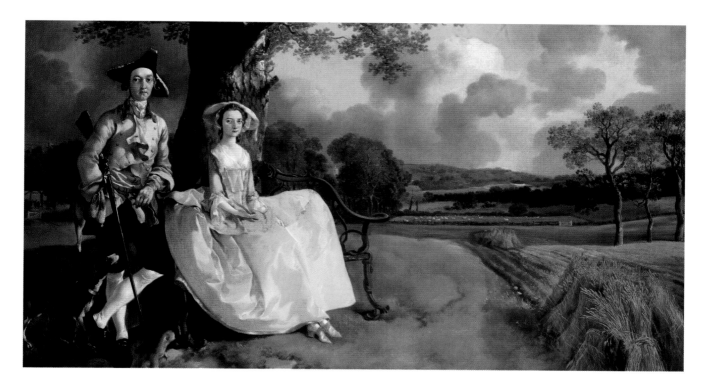

Above: In Mr. and Mrs. Andrews (c.1748– 49), Gainsborough devotes one side of the canvas to the newly married couple, and the other to the landscape of their estate.

Gainsborough grew up loving the countryside of his native Suffolk, and landscape was the subject that he preferred to paint. However, portraiture was the only means by which a British artist of his time could hope to earn a good living, so reluctantly he had to devote most of his time to it. In some of his early paintings he combined portraits and landscape in novel fashion by showing one or more figures in a setting that realistically represents a piece of the English countryside. The most famous example—and one of his loveliest works—is *Mr. and Mrs. Andrews*, which shows a handsome young

couple on their farm near Sudbury; it must have been painted soon after they married in 1748. The rather doll-like figures have great charm and the farmland is lovingly observed; the view is still recognizable today. In his later portraits Gainsborough sometimes used a landscape setting, but it tends to be generalized and something like a stage backdrop, rather than detailed and specific.

Gainsborough's pure landscape paintings are as admired as his portraits. His early landscapes are full of lively detail and are strongly influenced by seventeenth-century Dutch painting, which was much

collected in England; later his style, as in his portraits, became much looser and freer. He continued painting landscapes even after he had settled in London, basing them on his drawings or sometimes on materials such as twigs and pebbles, which he arranged in his studio as a stimulus to his imagination. Joshua Reynolds recorded that he used "broken stones, dried herbs, and pieces of looking glass, which he magnified and improved into rocks, trees, and water."

GEORGE STUBBS

1724–1806

Fittingly, the most famous of all equestrian painters here portrays himself on horseback. Obviously it is difficult for an artist to draw or paint himself while mounted on a horse, and Stubbs simply reused a composition from an equestrian portrait of a country gentleman he had painted a few years earlier, substituting his own face for that of the original sitter; he even used a similar background and retained the gesture of the left hand in the pocket. At the time he made this self-portrait, Stubbs was in his late fifties and well established as the leading horse painter in England, but he was not as financially secure as might be expected, partly because he had a passion for technical experiments in his art that took up his time but did not make him money. This painting is an example of a novel technique he pursued, using enamel (glasslike) paints on ceramic plaques specially made for him by Josiah Wedgwood, the famous pottery manufacturer. Stubbs hoped that pictures produced in this way would retain their freshness of color and resist cracking better than conventional oil paintings. He achieved impressive results, but the technique was difficult and never caught on with other artists.

Stubbs was involved with horses from an early age, as his father was a leather worker whose products included saddlery. Although he studied briefly with a minor painter, Hamlet Winstanley, Stubbs seems to have been mainly self-taught as an artist—in engraving as well as painting. In his early career he worked mainly as a portraitist in northern England, particularly Liverpool, where he was born, and York. Then in 1754–56 he lived in rural isolation in Lincolnshire, concentrating on dissecting horses in preparation for a treatise he was preparing on their anatomy. He settled in London in about 1758 and in 1766 he published his book, *The Anatomy of the Horse*, illustrated with his own superb illustrations. It was much praised and led to commissions for various kinds of pictures involving horses, including racing and hunting scenes. He also painted other animals, including dogs and several exotic species that were exhibited in England, notably a moose and a zebra. He kept his scientific curiosity and his artistic powers until the end of his long life in 1806.

Self-Portrait on a White Horse, 1782, enamel on creamware plaque, Lady Lever Art Gallery, Port Sunlight, U.K.

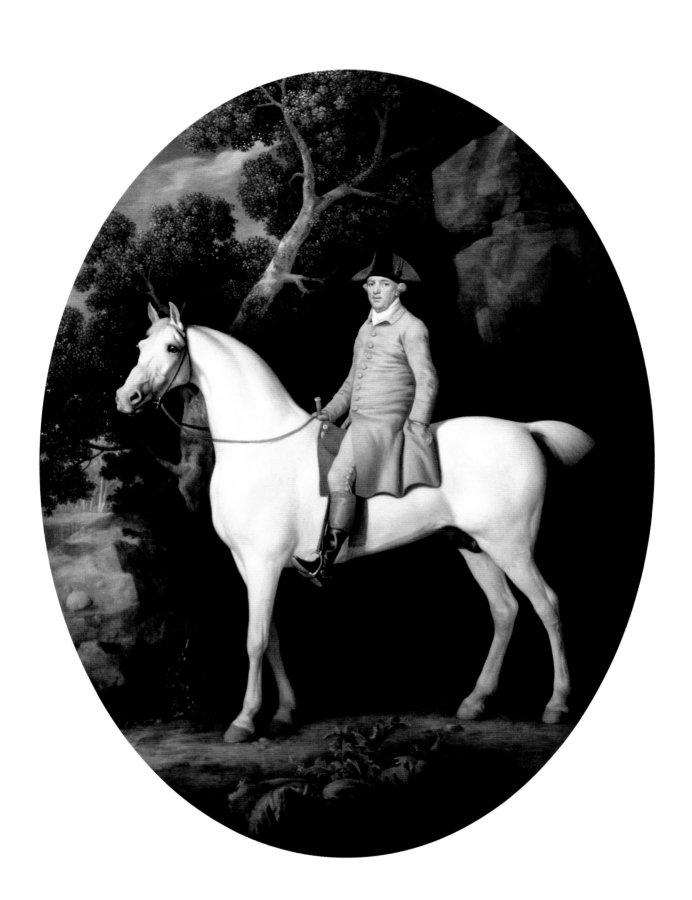

Style and technique

Stubbs has been described as second only to Leonardo da Vinci as the greatest painter-scientist in the history of art. His work combined scientific accuracy, based on dedicated research, with great artistic skill. He showed remarkable sensitivity to line and color, and he had an unsurpassed ability to convey the beauty and dignity of animals without sentimentalizing them. In addition, he was varied in his approach and could convey very different moods, from the idyllic peace of horses grazing in a meadow to the savagery of animals in combat.

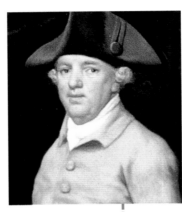

Stubbs is dressed in fashionable but modestly colored riding clothes. Despite the associations of status and wealth that accompany other equestrian portraits, this image is not showy, and Stubbs looks out of the picture with a serious, even dour, expression.

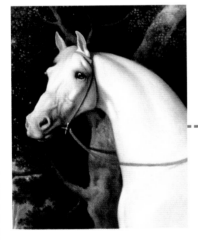

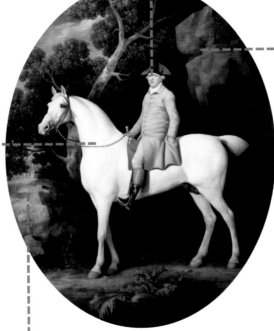

The deep shadows of the rocky cliff and foliage create a dark backdrop against which the white stallion and the artist stand out. Stubbs often set his portraits in specific landscape settings and it seems likely that the backdrop here is based on studies he made of Cresswell Crags, a rocky area in Nottinghamshire.

The stallion's alert head is carefully depicted, with just as much, if not more, detail than the artist's face. Stubbs shows the sinew and musculature of the cheek and nose, the alert ears and eyes, the flaring nostrils, and the slight "smile" created by the bit.

Clear color, subtly blended paint, and soft brushwork were made possible by the ceramic plaque on which the portrait was painted. It was a type of porcelain known as creamware that allowed far more subtle brushwork and colors than copper, the other support that Stubbs experimented with for his enamel paintings.

Equestrian portraits

The painted equestrian portrait originated during the Renaissance; at first, only great leaders were portrayed on horseback, but by Stubbs's day the range of sitters was much more varied.

Equestrian monuments were made in the ancient world and a famous example has survived intact since antiquity: the statue of Marcus Aurelius, emperor of Rome from A.D. 161 to 180, which is now in the Capitoline Museum in Rome. It helped to inspire the great equestrian statues of the Renaissance, the pioneering examples of which are Donatello's Gattamelata monument in Padua (1443–53) and Verrocchio's Colleoni monument in Venice (1481–92), both of them erected to honor distinguished soldiers. The first painted equestrian portrait to approach such monuments in size and grandeur is the Venetian artist Titian's painting of the Holy Roman emperor Charles V, made in 1548. It shows Charles in armor, lance in hand, celebrating his victory at the Battle of Mühlberg in 1547, and is regarded as the start of the modern tradition of equestrian portraits. Titian's most distinguished successors in the field included Rubens and van Dyck; in particular, van Dyck painted two huge pictures of the English king Charles I on horseback that are among the most glorious works of their kind in the whole of European art.

Van Dyck painted equestrian portraits of aristocrats as well as royalty, and a little later (1663) Rembrandt produced a full-size equestrian picture of an Amsterdam merchant. By the following century, Stubbs's time, it was fairly common for gentlemen to be depicted on horseback, but usually on a scale smaller than life. It is easy to appreciate the attraction of being shown on horseback, for someone who has control of a powerful animal automatically assumes an air of great authority. Moreover, a good horse was a status symbol, just as an expensive car is today.

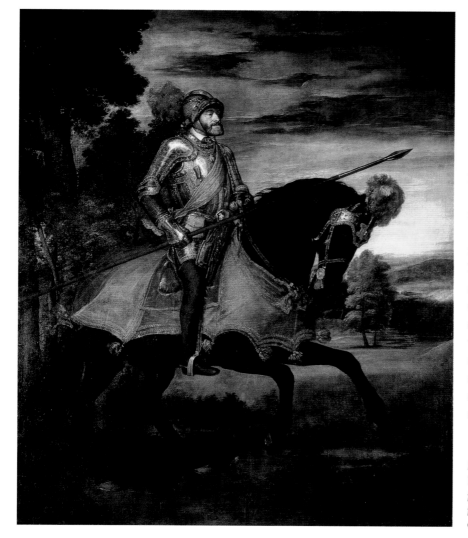

Left: Titian's Charles V after the Battle of Mühlberg *(1548) set the precedent for painted equestrian portraits. It presents a powerful image of the warrior king, clad in armor astride a prancing steed.*

BENJAMIN WEST

1738–1820

andsome, suave, and beautifully dressed, West looks rather like a glamorous movie star in this slick self-portrait, and his good looks and charm played a large part in launching his highly successful career. In his hand he holds a small easel or board on which can be seen two figures from his most famous painting, *The Death of General Wolfe*; it was painted in 1770, and this self-portrait must have been produced within a few years of that date, when West was in his mid-thirties. By this time he was already one of the most acclaimed painters in Britain and the first American artist to achieve recognition in Europe; no wonder he seems confident and content.

West was born near Philadelphia, the son of an innkeeper, and from childhood he showed a talent for drawing. He studied in Philadelphia and worked for a year in New York as a portraitist, then set out for Europe in 1760. After three years in Italy he went to England, intending to make only a short visit on his way back to America. However, he was such an immediate success that he settled there permanently. In 1768 he was honored by being made one of the founder members of the Royal Academy of Arts, and at the Academy's annual exhibition in 1771 he scored a triumph with *The Death of General Wolfe*, showing the heroic final moments of a famous British soldier who died while defeating the French in Canada in 1759. At the time it was the custom to depict the figures in such grand "history paintings" either nude or in vague "timeless" draperies, so that they were raised above the everyday world. However, West showed them in contemporary costume. He was not the first painter to do this, but he was the first artist in Britain to be highly acclaimed for such a work; the painting was so popular that West had to make several copies, and engravings of it earned him a fortune. When the first president of the Royal Academy, Sir Joshua Reynolds, died in 1792, West was chosen to succeed him. After his own death, West's reputation declined, but his place in the history of art is secure—he put American painting on the map.

Self-Portrait, c.1770–75, oil on canvas, Baltimore Museum of Art, Maryland

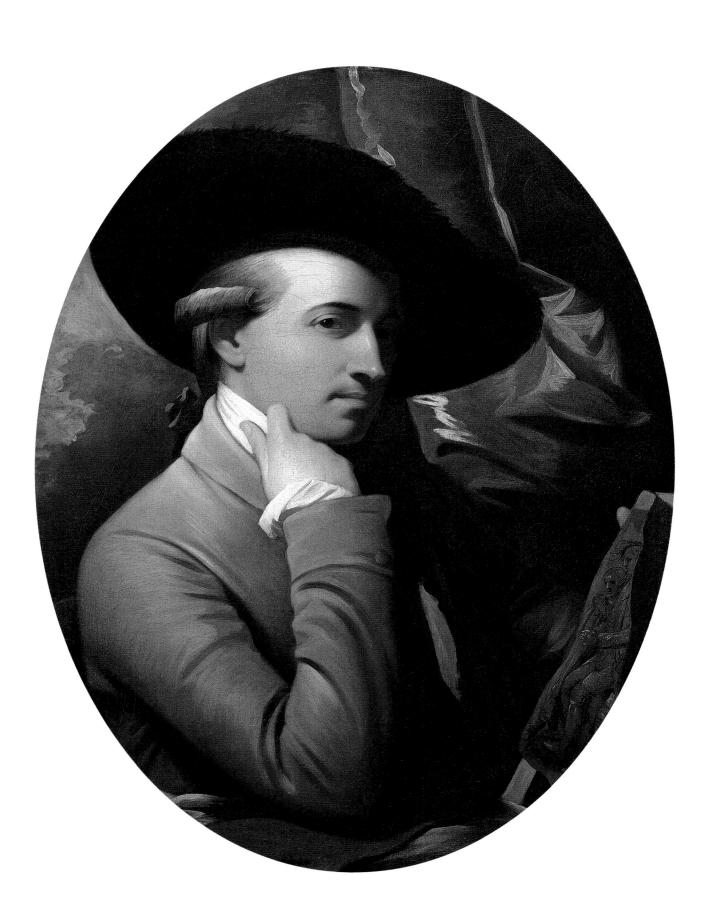

Style and technique

West devoted most of his career to history painting, but he was also a fairly prolific portraitist. Early in his career he was influenced by the stern neoclassical style that was beginning to become the major trend in European art, but later his work became much more flamboyant—in tune with the spirit of the romantic movement. He took on too much work and a good deal of his output is undistinguished, but his best pictures have dignity and dramatic flair, as well as vigorous handling of paint.

His hand resting nonchalantly on his collar, West looks out of the portrait with great assurance. The skin tones are smoothly painted and the features of his face carefully delineated, accentuated by deep shadows and set off by the wide brim of his fashionable, fur-trimmed hat.

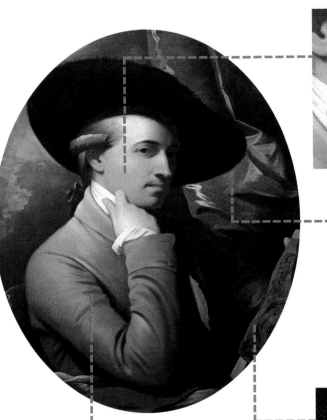

A drape of brown material with vigorously painted white highlights creates a flourish in the background, contrasting with the smooth finish of the face and hands.

The fragment of drawing that hangs off the end of the drawing board or book is a detail from West's famous painting The Death of General Wolfe—two figures from the right of the finished painting are visible here: an English grenadier and a servant.

West portrays himself in a blue-gray jacket, its cool color tying in with the muted colors of the rest of the painting—the dull gray-blue sky, the gray drawing, and the brown curtain. This limited color range is characteristic of the neoclassical style, which emphasizes precise line rather than bright color to create effect.

Father of American art

West was unstintingly generous in helping American artists who visited London; a whole generation of painters studied with him, lodged in his house, or benefited in other ways from his kindness.

From virtually the beginning of his residence in London, West acted as a magnet for his fellow Americans, and his home and studio formed a haven for many of them. The most famous American painter to follow him to England was John Singleton Copley, who settled in London in 1775 (see pages 98–101). Copley never actually studied with West, but West's praise for his work helped persuade Copley to give up his prosperous career in Boston and strive for higher artistic glory in Europe. The Americans who trained under West included some of their country's most illustrious painters of the late eighteenth and early nineteenth centuries, among them Washington Allston (1779–1843), Charles Willson Peale (1741–1827), and Gilbert Stuart (1755–1828). Allston was the leading American landscapist of his generation and a notable writer. He painted in a dramatic romantic style that later in his career became quieter and more dreamlike. Peale was the head of a dynasty of artists and his family played a major role in establishing Philadelphia as one of America's leading cultural centers. Stuart, who worked as West's assistant for several years, was an outstanding portraitist, famous for his images of George Washington, one of which still appears on the country's one dollar bill.

Two of West's pupils are better known for their achievements outside painting: Charles Robert Leslie and Samuel F. B. Morse. Leslie, who was born in England of American parents, was a moderately successful painter, mainly of literary subjects, but he is now remembered almost exclusively for his biography of his friend John Constable (1843). Morse gave up art for science and became famous as the inventor of the Morse code.

Right: One of some sixty portraits Gilbert Stuart made of George Washington. Stuart became the leading portraitist of his time in America.

Below: Washington Allston's Moonlit Landscape *(1819), the best-known of the dreamlike scenes of the natural world that typify his later work.*

JOHN SINGLETON COPLEY

1738–1815

opley was at the height of a remarkable career when he painted this sensitive, almost soulful image of himself. He had achieved brilliant success on both sides of the Atlantic, with very different types of picture, but fortune was soon to turn against him. Copley was the son of Irish immigrants to Boston. His father died when he was an infant and his mother remarried in 1748. Her second husband earned his living partly as an engraver, and when he died in 1751, the young Copley—fatherless for the second time at thirteen—inherited his tools and taught himself to be an artist. He developed his gifts with remarkable speed, and by his early twenties he was painting portraits of a quality never before seen in America. His clients included many prosperous Boston merchants—he married the daughter of one of them in 1768—and he earned a small fortune from his work. However, Copley longed to know how he would measure up against the best European artists. He hesitated for years until unrest against British rule persuaded him to leave his homeland; sensing that armed conflict was coming, he sailed for Europe in 1774, the year before the American Revolution broke out.

After a year in Italy, Copley moved to London, where he spent the rest of his life. Initially he was highly successful there—as a portraitist and even more so with "history paintings." The first major work of this type he produced, *Brook Watson and the Shark*, was the sensation of the annual Royal Academy exhibition in 1778. It was commissioned by a wealthy merchant who as a boy had lost a leg when he was attacked by a shark in Havana Harbor, and it was revolutionary in treating a subject merely because it was dramatic: previously, history paintings had always had serious, morally uplifting themes. Copley followed up this groundbreaking work with other successes, but he exhibited the paintings privately, charging an admission fee, and this alienated some of the other members of the Royal Academy, who objected to such rival attractions. By the 1790s his career was in decline, and he died leaving heavy debts; they were paid off by his son, John Singleton Copley the Younger, a distinguished lawyer and politician.

Self-Portrait, c.1780–85, oil on canvas, National Portrait Gallery, Washington, D.C.

Style and technique
The portraits Copley painted in America are sometimes rather stiff, but they have wonderful strength of characterization; John Adams, second president of the United States, summed up Copley's ability to bring people to life on canvas when he said, "You can scarcely help discoursing with them, asking questions and receiving answers." In England, Copley's portraits became more elegant but lost something in forthright vigor, and his finest achievements were in history painting. In this field he showed a flair for representing dramatic action that none of his English contemporaries matched.

Rapid, directional brush strokes of white and gray convey the swept hair of Copley's fashionable powdered wig; vigorously applied squiggles of white suggest its roll over his ear.

Copley shows himself looking out to the right of the picture, rather than directly out at the viewer. Combined with his high forehead, on which the main highlights fall, this adds to the contemplative air of the portrait.

Touches of unmixed paint applied with free, rapid brush strokes suggest Copley's vivid red jacket, white scarf, and the black velvet bow of his wig. He placed great importance on fashionable, expensive clothes—both his own and those of his sitters—and in his portraits often devoted much work to their sumptuous depiction.

Thick paint applied with vigorous brush strokes is used to model the fine features of Copley's face and to create an air of dash and spontaneity. The modeling of the nostrils, however, remains unresolved.

Colonial portraiture

Portraits were virtually the only type of picture for which there was any serious demand in colonial America; the market was supplied by both homegrown and imported artists.

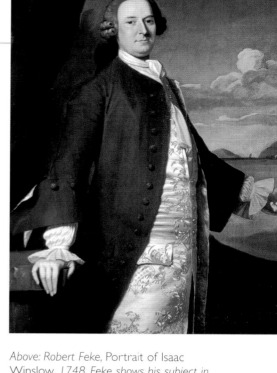

In Copley's day Boston was the country's most vigorous center for art. It was one of the largest and most prosperous cities in America and had the closest links culturally and otherwise with Europe. The merchants who had helped to make it so wealthy constituted the bulk of the market for portraits. New York was smaller at this time, but it was important as the headquarters of the British army, and when Copley visited the city in 1771 he was so besieged with commissions from officers that he said, "I hardly get time to eat my victuals."

Copley was fortunate that shortly before his career began the three leading portraitists who had preceded him all disappeared from the scene, leaving a gap in the market that he exploited. They were Robert Feke (c.1705–52?), John Greenwood (1727–92), and John Smibert (1688–1751). Feke's life is poorly documented, but he painted an impressive group portrait in Boston in 1741 and at that time he was probably the best painter in the country, showing dignity of composition and delicacy of brushwork. Later he worked in Philadelphia; nothing is known for

Above: Robert Feke, Portrait of Isaac Winslow, *1748. Feke shows his subject in fine clothing and proprietorial pose, standing in front of an expansive landscape.*

certain of him after 1751. Greenwood was born in Boston and was the leading portraitist there immediately before Copley, but he left the city in 1752 and never returned, eventually settling in England, where he became an art dealer. His style was less graceful than Feke's but more assertive. Smibert was born in Edinburgh and settled in Boston in 1730. He was the best of the small number of British painters who decided to try their fortune in the American colonies; his work is highly competent but generally uninspired.

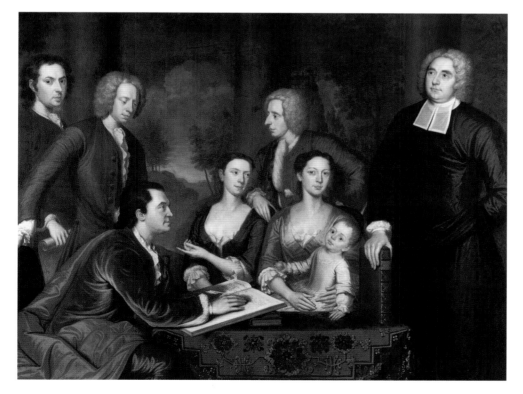

Left: John Smibert, George Berkley and His Entourage (The Bermuda Group), *c.1729. Smibert kept this large group portrait in his Boston studio, where it was seen by and influenced many colonial American artists.*

ANGELICA KAUFFMANN

1741–1807

This painting is one of several self-portraits by Angelica Kauffmann. Although they vary in certain respects, they tend to present her in a similarly modest and informal way, usually—as here—undemonstratively devoted to her art. Kauffmann's charm won her admirers throughout Europe, but she must also have possessed great strength of character to forge a brilliant international career in what was still very much a man's world. Looking back near the end of her life, she proudly stressed that she was a self-made woman: "All I possess has been attained by my work and industry."

Kauffmann was born in Chur, Switzerland, the daughter of an itinerant painter, Joseph Johann Kauffmann. She showed artistic talent from childhood, and by the age of about fourteen she was assisting her father in his work as he traveled around Switzerland, Austria, and northern Italy in search of commissions (her mother had died by this time). She was also a gifted musician, and for a time she found it difficult to decide whether she should devote herself to music or the visual arts. By her early twenties she was gaining a reputation as a portraitist. Her sitters included David Garrick, the most famous British actor of the time, whom she met in Naples in 1764, and she also impressed several other British visitors to Italy. This recognition encouraged her to visit England, and in 1766 she separated from her father for the first time and moved to London. She lived there for the next fifteen years and during this period she became an enormous success, professionally and socially.

Kauffmann's friends included some of the most distinguished men of the day and she could have had her pick of suitors, but in 1767 she married a man who soon turned out to be a confidence trickster, rather than the aristocrat he pretended to be. At considerable expense she managed to disentangle herself from him, but she remained legally married to him until his death in 1780. The following year she married Antonio Zucchi, an Italian painter living in London, and later that year they moved to the Continent, where she continued her successful career, mainly in Rome. When she died there, aged sixty-six, she was given a funeral fit for a queen.

Self-Portrait, 1784, oil on canvas, Neue Pinakothek, Munich

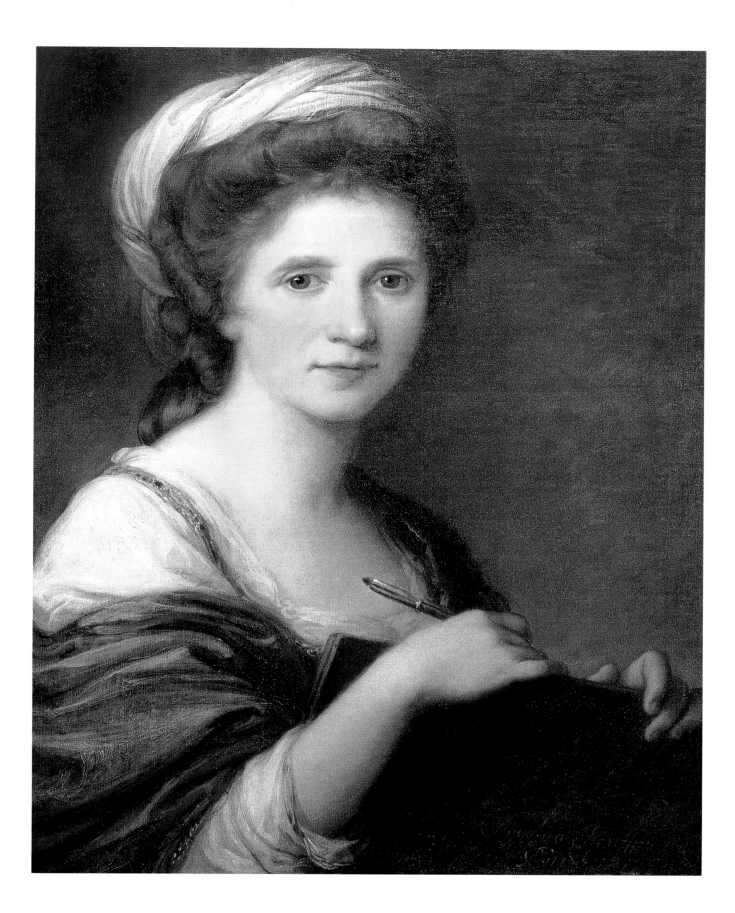

Style and technique

Kauffmann began her career at a time when the neoclassical style was coming to the fore. She was influenced by its purity and clarity of line, but whereas many neoclassical paintings are severe in tone, Kauffmann's are distinguished by lightness, grace, and delicate coloring. Initially she made her name as a portraitist, but she came to excel equally with figure compositions, including pictures on historical, literary, and allegorical subjects. Some of her best work was done in the form of decorative paintings specially commissioned for handsome neoclassical interiors in London.

Highlights of white paint enliven Kauffmann's gray-brown eyes. With her expressionless mouth, they convey an air of concentration, and we can almost picture her studying her reflection in the mirror.

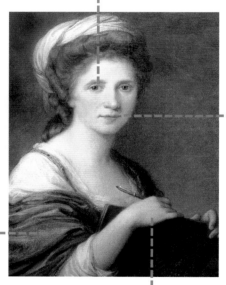

Soft, pinky flesh tones applied with almost imperceptible brush strokes convey Kauffmann's delicate complexion and the smooth skin of her neck. The subtle coloring, combined with Kauffmann's elegantly draped hands, add to the under-stated grace of the image.

Delicate brush strokes suggest the diaphanous fabric of the artist's gown and her golden brown shawl. Along with her turbanlike headgear, her clothes reflect the taste for Grecian-style clothes that became increasingly fashionable with the spread of the neoclassical style in eighteenth-century France.

Kauffmann depicts herself holding a pen and drawing book, on which her name and the date of the painting are subtly inscribed. These attributes not only relate to her profession as an artist, but also allude to the classical world; Clio, the muse of history, was traditionally shown with a tablet and stylus, or writing instrument.

An international artist

Kauffmann was the most famous woman artist of her age; her reputation owed much to her personal charm, but it also reflected the international appeal of her elegant neoclassical style.

Although she was Swiss by birth, Angelica Kauffmann was really a citizen of Europe. She spoke four languages (German, French, Italian, and English); she was patronized by royalty and aristocracy from Poland and Russia as well as the countries in which she lived; and she gained honors and respect wherever she went. In 1764, for example, she was made a member of the Academy of Saint Luke in Rome at the exceptionally early age of twenty-three, and four years later she was one of only two women to become founder members of the Royal Academy of Art in London. Her charm knew no national boundaries and the list of famous men who admired her is remarkable. Among them were the German writer Goethe, who thought that she had "extraordinary talent," Antonio Canova, the most celebrated sculptor of the age, who arranged her funeral, and Joshua Reynolds (see pages 82–85), one of her closest friends. Another British painter, Nathaniel Dance, is said to have been in love with her, and Henry Fuseli, a Swiss painter who settled in England, was also smitten.

Kauffmann's success as an artist was aided by the international popularity of neoclassicism. The style was born in Rome, which was a magnet for artists from all over Europe and even beyond—Kauffmann met the American painter Benjamin West (see pages 94–97) there. The basis of the style was the revival of the values of ancient Greek and Roman art, but it embraced pretty decorative charm as well as heroic grandeur. In her final years Kauffmann herself became one of Rome's cultural attractions, with fashionable tourists visiting her studio.

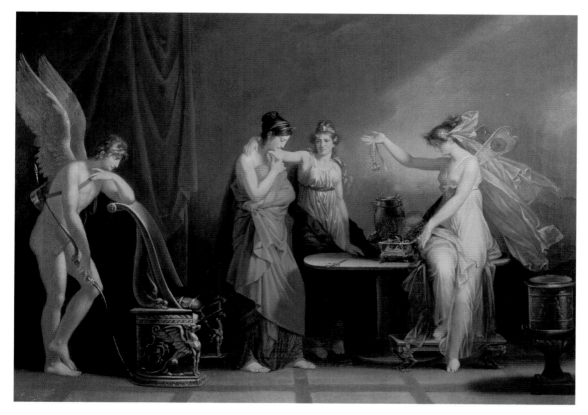

Left: Kauffmann, The Legend of Cupid and Psyche, c.1800. The decorative grace and charm of this scene and its classically inspired details are typical of Kauffmann's neoclassical style.

FRANCISCO DE GOYA

1746–1828

The most intriguing aspect of this self-portrait is easy to miss at first glance. In the brim of his hat Goya has placed a series of small candle holders to help him paint after daylight hours—we know from an account by his son that, unlike most painters, he often worked at night. It is such an unconventional little picture that Goya presumably painted it for his own satisfaction and amusement—it cannot be denied that the candles are rather comic. Partly because his face is obscured in shadow, it is difficult to gauge the artist's age, and scholars have differed widely in the dates they have assigned to the picture, ranging from 1775 to 1795. It is therefore an apt image by which to represent Goya, a nonconformist in many ways who is impossible to pigeonhole.

Goya had a very long and productive career. The first half was a story of gradual achievement and growing success, but it was only in the second half that the full force of his genius was released and he emerged not only as the greatest Spanish painter of his time but also as the most powerful and original figure in the visual arts anywhere in Europe. He was born in Fuendetodos, a village in the Aragon region of northeastern Spain, and he trained in nearby Saragossa and subsequently in Madrid, where he lived for most of his life, working for the royal family and other important patrons. The turning point in his life came in the winter of 1792–93 when he suffered a mysterious illness that paralyzed him for a while and left him permanently deaf.

The traumatic experience seems somehow to have unleashed creative energies, and Goya turned increasingly to subjects that examine the dark and sinister aspects of life. Some of his best work was purely imaginative, but he was also inspired by external events, notably the French occupation of Spain in 1808–13, which gave rise to a devastating series of prints entitled *The Disasters of War* (1810–14), in which he depicted atrocities committed by both sides. Goya left Spain in 1824 and spent his final years in Bordeaux in France. He worked until the end of his life, still exploring new ideas and techniques when he was in his eighties.

Self-Portrait in the Studio, c.1780–90, oil on canvas, Academia di San Fernando, Madrid

Style and technique
Goya was enormously prolific, versatile, and inventive. The bulk of his work consisted of portraits and it was on these that his contemporary reputation mainly rested, but he painted many other types of picture, including religious and historical images, and scenes of madness and terror. He was also a brilliant draftsman and one of the greatest of all printmakers. Technically he was extremely bold and free, sometimes manipulating paint with knives or his fingers. In his prints he used several methods; he was one of the first notable exponents of lithography, invented in 1798.

Metal candle holders line the rim of Goya's hat. Their purpose was explained by his son: "The final touches in order to secure the best effect in a painting would be added [by Goya] at night, under artificial light."

In this unusual self-portrait Goya shows himself "contre jour," or "against the daylight," with the result that his face and body are in shadow. Thickly applied white paint creates the impression of light shining in through the window behind his silhouetted body.

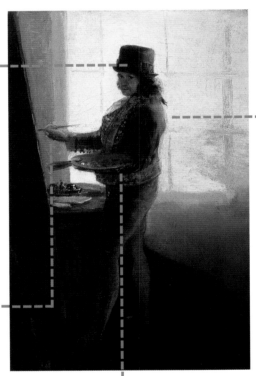

Goya portrays himself at work on a large canvas, his right hand poised to paint and his left hand holding a palette and brushes. It is the only self-portrait in which Goya shows himself at work in his studio.

Between the white of the window and the dark shadow of the easel and floor, highlights of color are concentrated on the artist: the vivid red trim of his jacket, the blobs of yellow and blue that indicate its buttons, the pigments on the palette, and the blue hatching that defines the curves of his stockinged legs.

Dark visions

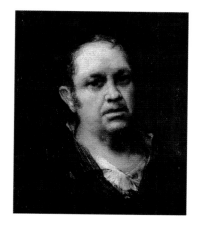

In his self-portraits Goya demonstrated the formidable strength of character that carried him through difficult times, but he also gave insights into his vulnerability and suffering.

There are more than a dozen surviving self-portraits by Goya, spanning virtually his whole career and showing his mastery of several techniques—in drawing and printmaking as well as painting. His earliest known self-portrait is a painting that evidently dates from the early 1770s—it has been suggested that Goya produced it to mark his marriage in 1773—and the last is a drawing made in 1824, when he was seventy-eight years old. An even later drawing, done near the end of his life, showing a feeble old man and inscribed "I am still learning," is sometimes considered a kind of spiritual if not literal self-portrait.

Goya's images of himself typically show a man with strong, rather coarse, and sometimes truculent features. They also convey an air of great vigor, and Goya did indeed have enormous energy and stamina: according to his son he would sometimes paint a portrait in one marathon ten-hour session. In one of his most famous portraits, however, he is far from vigorous. In 1820 he painted himself with the doctor who had nursed him through a serious illness the previous year; with his characteristic unsparing realism, Goya shows himself in the doctor's arms and evidently near death. In spite of the sense of suffering, there is no trace of self-pity in this remarkable work. The best-known of all Goya's self-portraits is the magnificent head-and-shoulders

picture in the Prado, Madrid, painted in about 1815. He was about seventy at the time, but seems younger because of his extraordinary vitality. It has often been observed that he looks rather like his contemporary Beethoven, another titanic genius who was isolated because of his deafness.

Below: In Goya's Self-Portrait with Doctor Arrieta (1820), the artist shows himself gravely ill in bed.

Above: In this Self-Portrait of c.1815 Goya presents a remarkably robust image of himself aged about seventy.

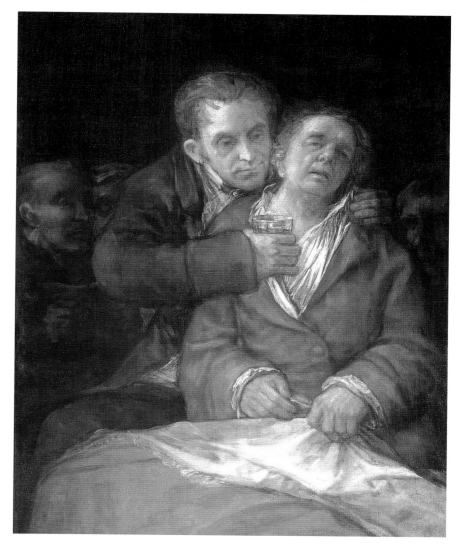

ELISABETH VIGÉE-LEBRUN

1755–1842

The sweet sentiment, easy grace, lively expressions, and delicate touch that made Elisabeth Vigée-Lebrun one of the most acclaimed portraitists of her day are all seen in this enchanting work. She had just turned thirty when she painted it, and was already highly successful in France. Three years later she began a period of travels that made her famous across Europe. Vigée-Lebrun was born in Paris, the daughter of a pastel portraitist, Louis Vigée, from whom she received her first lessons in art. He died when she was twelve, and within a few years she was earning her own living as a portraitist. Her reputation soon grew, and in 1778, aged twenty-three, she painted a portrait of Queen Marie Antoinette.

The queen was highly impressed by the young painter, personally as well as professionally, and Vigée-Lebrun painted about thirty portraits of her over the next decade. Her friendship with the queen helped to advance her career—as did her good looks and charm—but when the French Revolution broke out in 1789 Vigée-Lebrun's royal connections became dangerous to her and she decided to leave the country. By this time she had a husband and a daughter. In 1776 she had married an art dealer, Jean-Baptiste Lebrun, and their only child, Julie, was born in 1780. Her husband turned out to be a scoundrel who helped himself to her earnings to feed his gambling habits, so she left him behind when she escaped to Italy with Julie at the start of what was to be a thirteen-year exile from her country.

After four years in Italy, Vigée-Lebrun moved to Vienna, and then visited other cities in Central Europe before going on to Russia, where she lived from 1795 to 1801, mainly in Saint Petersburg. Everywhere she went she received important commissions and she was honored with memberships of several academies. In 1802 she returned to Paris, and after a period in England (1803–05) she settled permanently in France, thereafter making only short visits abroad. She was fifty by this time but still had many years ahead of her. In this period she painted only sporadically, but she revealed an impressive talent as a writer in her three volumes of memoirs, published in 1835–37, which give a vivid account of her life and times.

Self-Portrait with Her Daughter, 1786, oil on canvas, Louvre, Paris

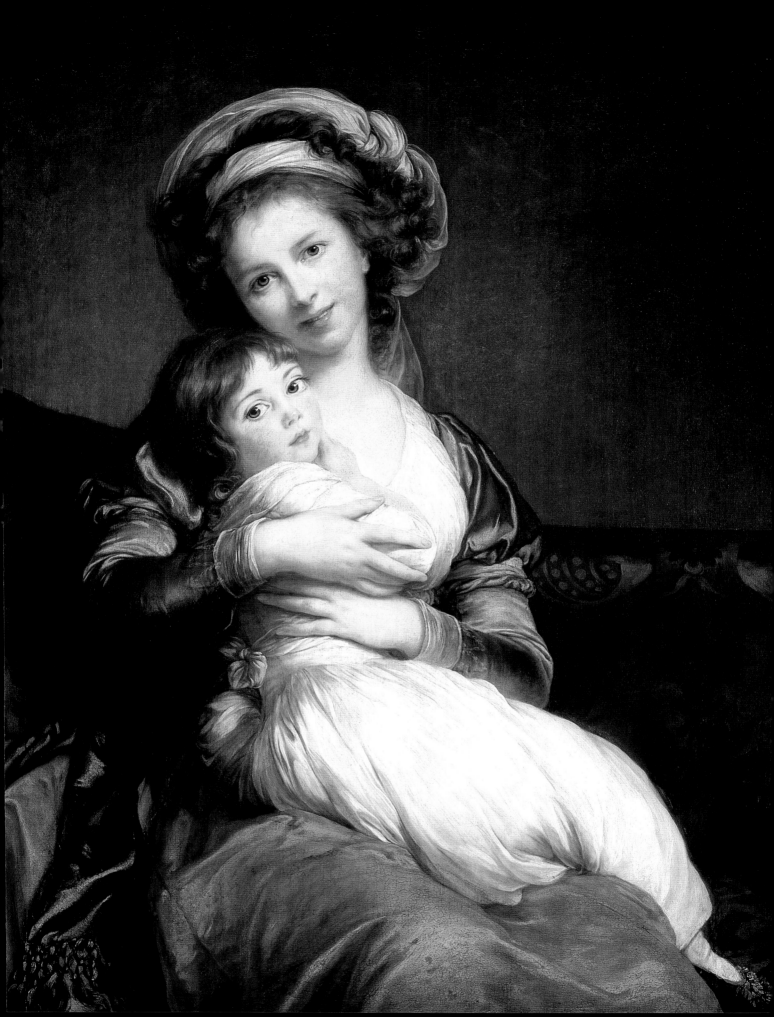

Style and technique
Most of Vigée-Lebrun's output consisted of portraits, but she also produced history paintings and—mainly for her own pleasure—landscapes. Like Angelica Kauffmann (see pages 102–105), whom she met in Rome, Vigée-Lebrun combined in her work the lightness of the rococo style popular in mid-eighteenth century France and the clarity of the neoclassical style that became dominant later in the century. She usually used minimal props in her portraits and set her figures against plain, unspecific backgrounds, although sometimes she used interior or landscape settings.

Vigée-Lebrun painted the pink cheeks, rosebud lips, blue eyes, and soft hair of her nine-year old daughter Julie with warmth and delicacy. Her daughter's pose conveys the affection between mother and child: Julie's hand rests on her mother's chest for comfort as she shyly turns her face to look out of the picture.

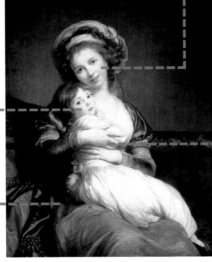

Vigée-Lebrun rests her cheek tenderly on her daughter's head and looks out of the painting with a warm and affectionate smile. The graceful beauty for which the artist was famed shines through in this self-portrait, which shows her smooth complexion, blue eyes, small nose, sweet smile, and mass of curling hair.

The fabric of Vigée-Lebrun's silver shawl and yellow skirt, the delicate folds of her daughter's dress, and the rich green brocade of the chaise longue are rendered with great finesse. Vigée-Lebrun was highly accomplished at painting the textures, sheens, and patterns of fabrics, and the fashionable, often elaborate dress of her royal and aristocratic sitters was an important element in her portraits.

Vigée-Lebrun shows her smooth and graceful hands at the center of the painting, gently embracing her daughter. Their central position emphasizes the bond between mother and daughter, a theme popular in Vigée-Lebrun's self-portraits and in other French art of the late eighteenth century.

Artists and their families

Artists have often shown their affection for members of their families by representing them in their paintings, either as subjects for portraits or as models for other types of picture.

Vigée-Lebrun's love for her daughter shines through their double portrait, and many other artists have depicted their close relatives with similar tenderness. Perhaps the two most famous examples are Rubens (see pages 50–53) and Rembrandt (see pages 66–69). Rubens was married twice and both wives appear memorably in his work: in straight-forward portraits and as the model for figures in religious and mythological paintings. One of his most remarkable pictures of his second wife shows her with a fur wrap barely covering her naked body. It is an extremely intimate work, and Rubens left it to his wife in his will; as it was the only picture he specifically bequeathed to

her, it must have had a special meaning for them. Rembrandt too depicted his wife and later his long-term mistress with deep affection. There are also pictures by him that probably show his mother and perhaps his father, and some of his most touching portraits are of his son, Titus.

An artist who rivals Rembrandt in the beauty of his depiction of his own children is the English painter Thomas Gainsborough (see pages 86–89). He had two daughters, whom he obviously adored. There are six known double portraits of them, from the age of about five or six, including enchanting pictures showing them chasing a butterfly and playing with a cat. Another doting father was the

Pre-Raphaelite painter John Everett Millais (1829–96). Two of his sons posed for *The Boyhood of Raleigh* (1870) and one of his grandchildren is shown in *Bubbles* (1886), one of the most famous images of childhood.

Below: The Fur *(c.1638), Rubens's unusual and intimate portrait of his second wife, Hélène, was partly inspired by a similarly erotic work by Titian entitled* Lady with a Fur.

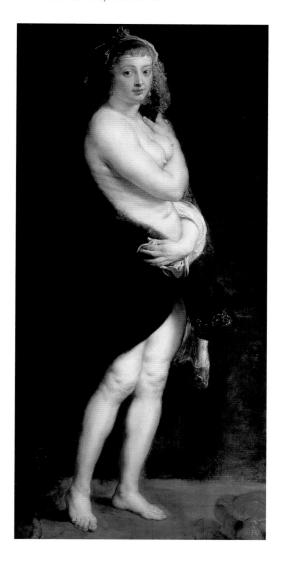

Left: In The Painter's Daughters Chasing a Butterfly *(c.1756) Gainsborough created a naturalistic and spontaneous portrait of his daughters. Margaret, his younger daughter, reaches forward to grab the butterfly, while her older sister, Mary, looks on with more reserve.*

JOSEPH MALLORD WILLIAM
TURNER

1775–1851

Although he rarely painted anything other than landscapes, Turner produced two self-portraits: a watercolor, done in about 1792 when he was still a teenager, and this oil, which judging from the style and his apparent age must have been painted when he was in his early twenties. He looks more attractive and dandified here than he does in representations of him by other artists, but the bright, intense eyes are conspicuous in those portraits too and must have been a striking feature of his appearance. They seem to look beyond the spectator and gaze into the future—a brilliant future for Turner. He had already achieved remarkable success by the time he painted this portrait, but far greater achievements lay ahead.

Turner was born in London, the son of a barber, and showed exceptional gifts from an early age, first exhibiting at the Royal Academy of Arts when he was only fifteen. In 1799 he was elected an associate of the Royal Academy at the youngest permissible age, twenty-four, and it is possible that he painted this portrait to mark the honor. In 1802, shortly before his twenty-seventh birthday, he became the second-youngest artist ever to be elected a full member of the Academy—the portraitist Thomas Lawrence (1769–1830) was the youngest, becoming an academician at age twenty-five. Turner was hardworking and a good businessman, and by this time he was already very prosperous. In spite of his wealth, however, he lived rather squalidly, being somewhat eccentric in his habits. His main extravagance was travel; he journeyed extensively around Britain in search of subjects and made numerous visits to the Continent, where the Alps and Venice became major sources of inspiration.

At the beginning of his career, Turner worked in a clear, precise style, but his outlook became increasingly subjective, as he tried to express the power, mystery, and beauty of nature rather than to give an accurate depiction of a particular place. Many of his contemporaries were baffled or repelled by his late work, in which almost all sense of solid form is lost in a radiant haze of color. However, Turner also had influential admirers and he remained a central figure in the British art world, in spite of leading an increasingly reclusive life. He is now revered as the most original landscape painter of the nineteenth century.

Self-Portrait, c.1798–1800, oil on canvas, Tate Britain, London

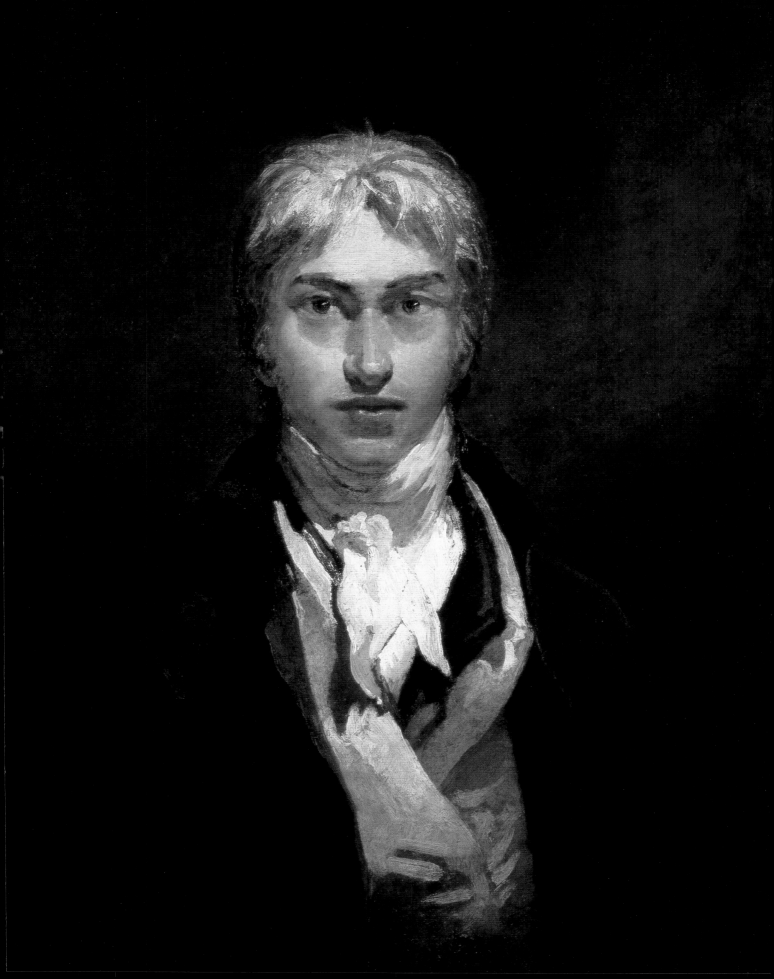

Style and technique
In both oils and watercolor Turner evolved a technique of extraordinary freedom and originality, and to some extent he blurred the normal distinction between the two types of painting. In his late oils the paint has sometimes been so subtly floated onto the canvas that it has almost the delicacy of watercolor, and in his watercolors he often painted with a rough vigor more traditionally associated with oils; a friend who saw him at work on a watercolor in 1818 wrote that "he tore, he scratched, he scrubbed at it in a kind of frenzy."

Turner looks out of the painting with an intense gaze, emphasized by his frontal pose. Touches of thickly applied pink paint pick out the eyelids and rims from the shadow, and tiny dots of white enliven his blue-gray eyes.

The modeling around the nose, lips, and eyes is blocked in with areas of heavy, unmodulated shadow—notably the gray-pink shading down the bridge of the nose, under the eyes, and under the mouth, and the red-black area around the nostrils. The blocky style of this self-portrait is unlike Turner's mature work, with its layers of diaphanous color, but is similar to the style he used in other studies and preparatory works early in his career.

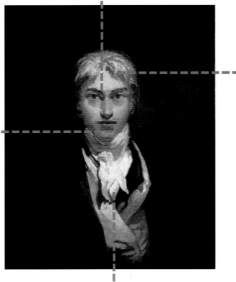

Vigorously applied strokes of cream and pale brown paint suggest the fall of Turner's thick, sandy hair.

Turner portrays himself as a well-dressed young gentleman. Thickly and freely applied paint suggests the knot of a white scarf and the open collars of a blue waistcoat and white jacket beneath a brown coat.

Toward impressionism?

The atmospheric and light-filled paintings of Turner's later years are often seen as precursors of impressionism, but it is hard to identify specific instances of influence.

Turner's late paintings are remarkable for their high-keyed color and their breadth of technique. One of his great contemporaries, the English landscape painter John Constable, wrote appreciatively that "he seems to paint with tinted steam, so evanescent and so airy," but some conservative critics ridiculed Turner's pictures, using such expressions as "yellow fever" and "soapsuds and whitewash" to refer to his love of very bright, light color. A generation later, such bright colors and lack of conventional finish were features that were associated with the impressionists, who were attacked by many critics in a similar vein. There is thus a certain kinship between Turner and the impressionists, although Turner was so successful from the outset of his career that he could ignore critical attacks, secure in his wealth and status, unlike the impressionists, several of whom suffered hardship. Another important difference is that Turner was often inspired by history and literature, whereas the impressionists took their subjects from contemporary life.

The impressionists were familiar with Turner's work to various degrees and several of them visited England. Claude Monet (see pages 154–57) first stayed there in 1870–71, when he took

Above: Monet's Houses of Parliament: Sunset *(1904), one of a series of paintings he made of this London landmark. Monet knew Turner's painting (below), but was more interested in atmospheric affects than pictorial drama.*

refuge from the Franco-Prussian War, and thirty years later he wrote that Constable and Turner "have certainly had an influence upon us." However, these words were addressed to an English correspondent, so Monet was perhaps politely playing up the English angle; in another context he was less enthusiastic about Turner. Indeed any resemblances between the works of the two men are superficial: there is no real similarity in color or brushwork. Rather than directly inspiring the impressionists, Turner's work probably offered an encouraging example after they had already embarked on their chosen path.

Left: In The Burning of the Houses of Lords and Commons *(1834) Turner shows the fire that destroyed London's old Houses of Parliament on October 16, 1834. As in much of his other work, Turner uses blazing colors and swirling brushwork to convey the drama and power of natural forces.*

EUGÈNE DELACROIX

1798–1863

T he painter's bearing in this self-portrait is almost military in its proud erectness, but the tousled hair and the rather melancholic eyes indicate an artistic temperament. This balance between strength and sensitivity is characteristic of Delacroix and his work. He was one of the supreme figures of the romantic movement, but the flamboyance and sensuality of his paintings were always underpinned by intellectual rigor.

Delacroix was born into a prosperous, cultured family and he grew up with a love of books and music—he was later a close friend of the composer Chopin—as well as art. He studied painting with respected teachers in Paris, but to a certain extent he was self-taught and a major part of his artistic education was gained by copying Old Master paintings in the Louvre. Rubens (see pages 50–53), with his great energy and warmth, was a particularly important influence on him. In 1822 Delacroix's career got off to a brilliant start when his first major painting, *The Barque of Dante*, was the most talked-about picture at the Paris Salon, the official state art exhibition. It shows a melodramatic scene described by the early Renaissance poet Dante in his epic poem *The Divine Comedy*. Literature remained an important source of inspiration for Delacroix, and he also took his subjects from mythology, history, contemporary events, and the people and places he saw on his travels; no other artist of the time had such a wide pictorial culture.

From the 1830s Delacroix devoted much of his time to large schemes of wall and ceiling painting in major public buildings in Paris, including the Louvre. He was the last European artist of the highest stature to work in the grandiose mural tradition that had been such an important strand in Western art since the early Renaissance. Unlike many of his predecessors, however, he painted in oil on canvas rather than fresco. Delacroix was showered with honors for his work, and his charm and intelligence made him a welcome figure in fashionable society. However, he remained essentially solitary in his way of life. He had few pupils, but he had an enormous influence on his contemporaries and successors in France, particularly through his vibrant use of color—which inspired the impressionists and postimpressionists—and his unfettered imagination.

Self-Portrait, c.1840, oil on canvas, Louvre, Paris

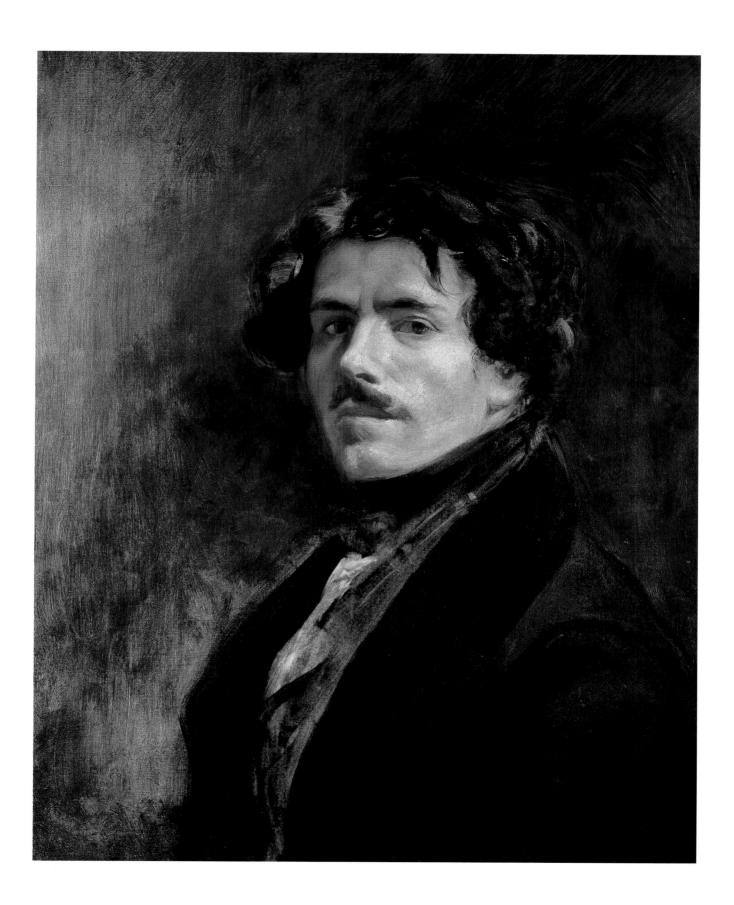

Style and technique
Delacroix was renowned for the speed at which he worked, and his output was enormous. However, although his paintings have a wonderful sense of life and spontaneity, he created them with great care and he thought deeply about all aspects of his art, including his vigorous use of color. Many of his paintings, particularly his murals, are huge, but he was also happy working on a small scale, and he could convey intimacy and tenderness as well as more expansive emotions. In addition to paintings and drawings, he produced some outstanding lithographs.

Delacroix's thick, curling hair is vigorously painted using the same browns as the background, but the brush marks are shorter and the paint thicker, and dabs of white and black paint create the effect of curls, one of which has fallen forward onto the painter's forehead.

Thicker paint and shorter directional strokes are used for the modeling of the face: the brushmarks are most pronounced around the chin and lower lip. Touches of red are used to create warm shadows on the upper lip, nostrils, eyelids, and under the curl of hair on Delacroix's forehead.

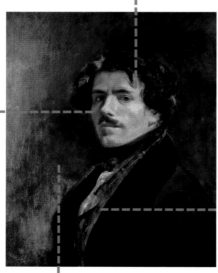

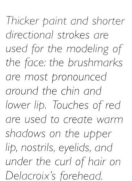

Delacroix's velvet-collared coat, his waistcoat, shirt, and scarf are rapidly sketched in, focusing attention on the more highly finished face of the dashing artist. The pale blue of his waistcoat serves as a foil to the warm tones used in the head and the background.

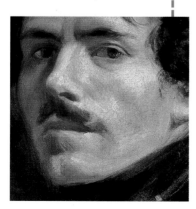

The plain background has been rapidly scrubbed in using thin brown paint; the brushmarks go in all directions and are clearly visible where the reddy brown ground, or base coat of paint, shows through.

The romantic artist

In the early nineteenth century romanticism was the dominant trend in the visual arts, music, and literature. Delacroix—with his passionate and colorful works—was its leading exponent in French painting.

Romanticism was not so much a style as an attitude, or set of attitudes, toward art and life. It placed great emphasis on sincerity and self-expression, and to some extent it was a reaction against the neoclassical style, which had prevailed throughout most of Europe in the late eighteenth century. Whereas neoclassical artists emphasized respect for the approved works of the past, romantic artists thought that rules were meant to be broken and that painters, writers, and composers should be spontaneous and original. Neoclassical artists often chose subjects that stressed duty and stoicism, but romantic artists favored wild, dramatic, exotic, or mysterious themes, often with a strong sense of the horrific or macabre. Delacroix's subjects in this vein included highly charged scenes from Shakespeare's *Hamlet* and from contemporary writers, bloody events from history, and images inspired by his visit to North Africa in 1832—lion hunting became one of his favorite subjects.

With his wonderful sense of color and movement and his uninhibited emotionalism, Delacroix at times created scenes of almost barbaric splendor, as in his *Death of Sardanapalus* (1827), inspired by a poetic drama by Lord Byron. However, even at its most intensely romantic, his art always remained disciplined. He had great respect for the art of the past, and like the Old Masters he drew constantly, often making scores of preparatory drawings for his major works. A contemporary, the poet and critic Charles Baudelaire, who was one of Delacroix's greatest admirers, brilliantly summed up his achievement when he wrote: "Delacroix was passionately in love with passion, but he coldly determined to express passion as clearly as possible."

Left: Delacroix's Death of Sardanapalus *(1827) shows the Assyrian king watching the destruction of his possessions before committing suicide in remorse for his evil life. Delacroix said that the painting should serve as a warning against leading a life of vice; however, his critics pointed out that Sardanapalus appears to be enjoying the spectacle of the carnage around him.*

JEAN-FRANÇOIS MILLET

1814–75

A powerful draftsman, Millet here uses broad, fluent strokes of chalk to conjure up a massively authoritative head. From out of the lionlike mane of hair gazes a pair of sad, solemn eyes, reflecting not only the very serious way in which Millet approached his art, but also the hard struggles he encountered in his life. In 1844, about a year before he made this portrait, his first wife died of tuberculosis, aged only twenty-three, her end no doubt hastened by their poverty. Although Millet later achieved recognition and even honors, he was rarely far from hardship (partly because he had a large family to support—he had nine children with his second wife) and his outlook was essentially pessimistic.

Millet was born in the village of Gruchy in northern France into a prosperous and cultured farming family (his father was an organist in the village church). He worked on the farm from an early age, but he also had a good education. At the age of nineteen he began studying art in the nearby town of Cherbourg, and from 1837 to 1839 he was a pupil at the École des Beaux-Arts in Paris, France's most prestigious art school. Over the next few years, as he struggled to earn a living, he experimented with various subjects. In 1848, however, he found his true direction when he painted *The Winnower* (see page 125), the first of the scenes of peasant life that became his speciality from this point onward. The following year he moved to Barbizon, a village on the outskirts of the forest of Fontainebleau, southeast of Paris, and this remained his home for the rest of his life. It was a popular place for painters, especially landscapists. Many of Millet's peasant scenes are in landscape settings, and in his later years he increasingly turned to pure landscapes.

Millet's most famous painting is *The Angelus* (1859), showing two peasants bowing their heads as a church in the distance tolls the Angelus bell signaling the hour for evening prayer. The picture became enormously popular in the form of engravings; indeed it was one of the most reproduced paintings of the nineteenth century. However, its sentimentality later caused a backlash against Millet; his reputation declined greatly in the early twentieth century and did not seriously revive until the 1970s, notably with a major exhibition devoted to him in Paris and London in 1975–76.

Self-Portrait, c.1845, pencil and black chalk on colored paper, Louvre, Paris

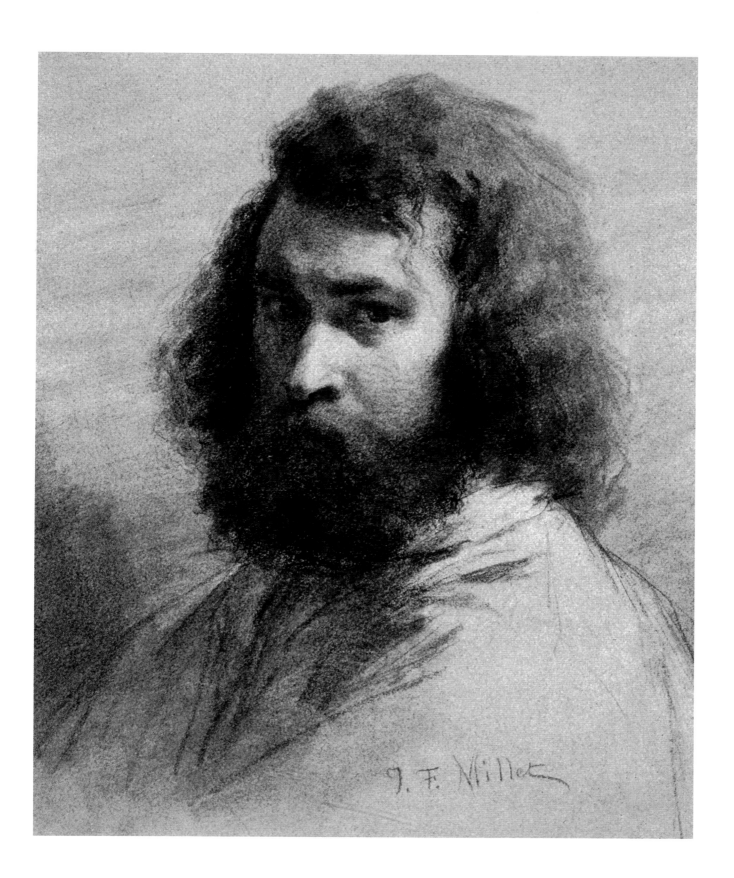

J. F. Millet

Style and technique

Although his peasant subjects were "lowly," Millet treated them in a grand and dignified way, consciously recalling the work of Old Masters such as Poussin (see pages 54–57); he said he wanted "to use the trivial to express the sublime." He was intimately familiar with rural life, but he worked mainly from imagination rather than direct observation in the countryside. His brushwork is rich and vigorous, and often he allowed the weave of the canvas to show through the paint, accentuating the variety of texture that is typical of his work.

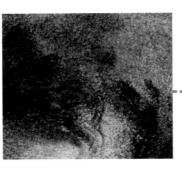

The soft, voluminous mass of Millet's hair and beard is suggested by layers of chalk, built up by carefully rubbing them into the paper and blending them together. The darkest tones are used around the hairline, to accentuate the face, and a few more distinct strokes suggest curls.

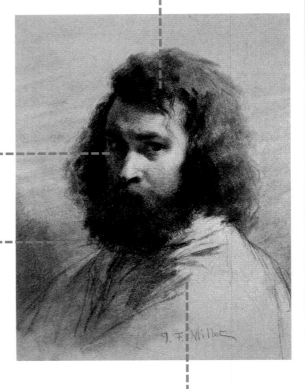

The eyes are in full shadow but, with the tiny highlight on the artist's left iris, appear to look intently out of the picture. With the lips almost lost in the shadow of the beard, Millet's expression is one of great seriousness.

Millet, like other artists, used colored paper for his crayon and pastel drawings; he favored blue-gray, buff, tan, and lilac papers because, with their midtones, they create a softer background for drawings than plain white paper.

A few quickly sketched lines suggest the mass of the painter's body, focusing attention on his face.

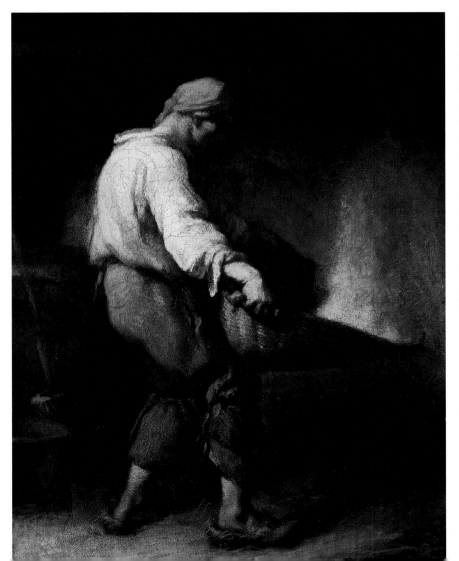

Art and politics

Painting and politics were often intimately linked in Millet's day, and his work was subject to contrasting interpretations from people who saw it from different ideological viewpoints.

Above: One of Honoré Daumier's caricatures attacking King Louis Philippe of France from the antigovernment journal La Caricature.

Below: Millet's The Winnower (1848) *presented the basic existence of the rural laborer with a fittingly rough and energetic handling of paint; one contemporary critic wrote that the picture had "everything it takes to horrify the bourgeois."*

Millet lived through an extremely complex period in French politics, with different forms of government replacing one another in sometimes bewildering sequence. After the final defeat of the emperor Napoleon Bonaparte in 1815, the monarchy was restored, but in 1848 King Louis Philippe was deposed in a revolution. A republican government took his place, and Louis Napoleon (nephew of Napoleon Bonaparte) became president; four years later he assumed the title of emperor.

In the year of the revolution, Millet's painting *The Winnower* was acclaimed at the Salon and it was bought by a member of the new republican government. From this point critics tended to interpret Millet's paintings in the light of their own social views. Conservatives regarded the peasantry as a potential source of civil unrest, so they saw Millet's pictures as coarse, subversive images; left-wing critics, on the other hand, thought that they expressed the dignity of working people in a new and progressive spirit. Millet himself was not overtly political, and saw his work in aesthetic and personal, rather than social, terms. In 1854 he wrote: "I must confess, at the risk of being taken for a socialist, that it is the treatment of the human condition which touches me most in art."

Other artists of the time, however, were in the political front line. The most notable example is probably Honoré Daumier (1810–79), the leading caricaturist of his time and also an outstanding painter and sculptor. In 1832–33 he spent six months in prison for satirizing King Louis Philippe as a monstrous giant extorting money from the people. The government banned political caricature in 1835, but Daumier was able to return to it after the 1848 revolution.

GUSTAVE COURBET

1819–77

This painting (reproduced in full on page 128) is perhaps the most grandiose and complex self-portrait ever created. The man who placed himself at the center of such an epic work obviously needed great pride and self-confidence, and Courbet was indeed one of the most forceful and independent characters in the history of art. He wrote an explanation of the painting, but his account is far from clear, and scholars have expended much ink in trying to fathom its mysteries. Courbet subtitled the picture "A real allegory summing up seven years of my artistic and moral life." On the right side of the picture are "friends, fellow workers, and art-lovers," among them the poet Baudelaire, reading a book. On the left is "the world of commonplace life: the masses, wretchedness, poverty, wealth, the exploited, the exploiters, those who live on death." Each individual figure is vividly depicted, but collectively they are obviously not meant to represent a situation in real life. An allegory is a work that uses symbolism to express generalizations or truths about the human condition. Courbet's term "real allegory" therefore seems like a contradiction, and he did not explain what meaning he was trying to convey. Nevertheless, there can be no doubt about the compelling power of the work or the sure magnificence with which it is painted.

Courbet was born at Ornans, a small French town in the Jura Mountains, not far from the Swiss border. He was the son of a farmer, and although he spent most of his life in Paris, he always retained an earthy feeling in his work. He first came to prominence in 1850 with a huge painting entitled *A Burial at Ornans*, which established him as the leader of realism, a movement that rejected the traditional elevated subjects from religion, history, and mythology in favor of pictures depicting unidealized scenes from contemporary life. *The Painter's Studio* was completed five years later for an exhibition of his own work that Courbet organized at the Paris Exposition Universelle (World Fair). He spent his final years as a political exile in Switzerland, but he had enormous influence on French painting. This influence was not only stylistic: in arranging an exhibition of his own work he helped break the stranglehold of the official art world in Paris, setting a precedent for subsequent rebels such as the impressionists.

The Painter's Studio (detail), 1854–55, oil on canvas, Musée d'Orsay, Paris

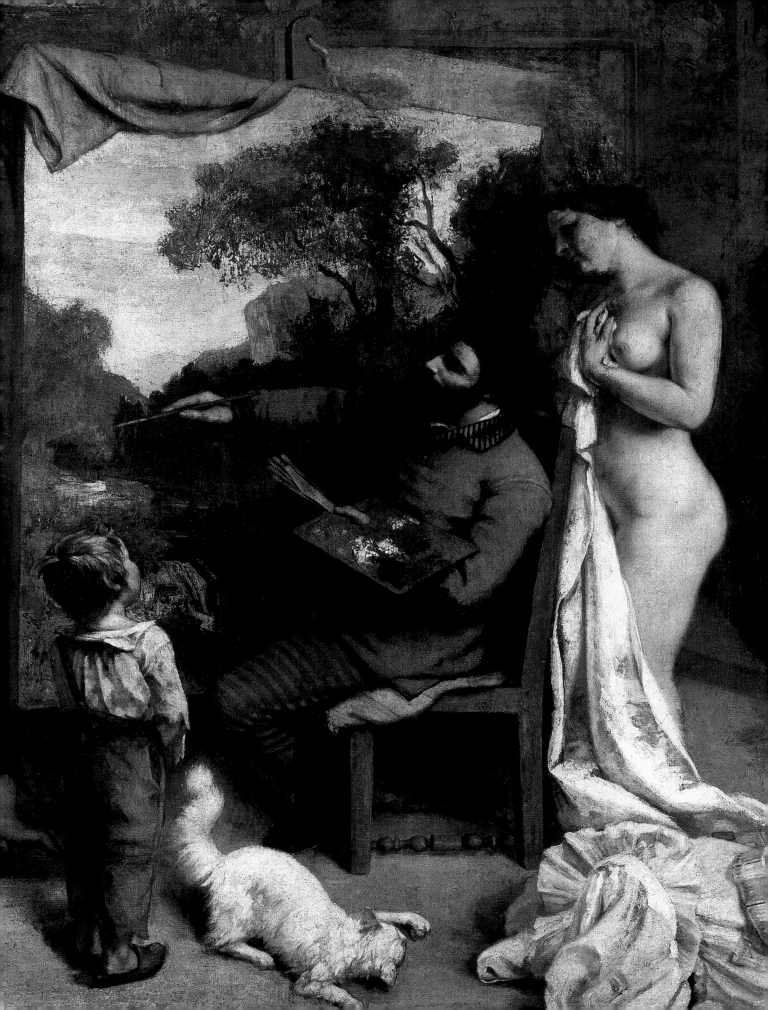

Style and technique

Courbet painted a wide range of subjects, including landscapes, nudes, portraits, and still lifes, as well as the large multifigure compositions for which he is most famous. Common to all his work is a powerful sense of weight and solidity, and he applied his paint with great richness, often with a knife, emphasizing its physical substance. His approach was resolutely naturalistic; when asked to paint angels in a picture for a church, he is said to have replied: "I have never seen angels. Show me an angel and I will paint one."

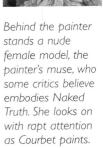

Behind the painter stands a nude female model, the painter's muse, who some critics believe embodies Naked Truth. She looks on with rapt attention as Courbet paints.

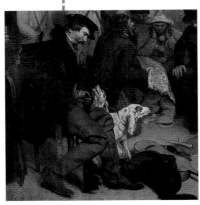

The man with dogs is thought to be a disguised portrait of the Emperor Napoleon III. Early critics referred to the figure as "the poacher," a term perhaps suggested by Courbet, who thought that Napoleon III had "bagged" the Republic for his own ends.

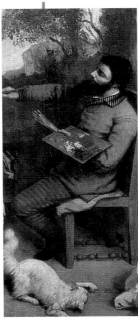

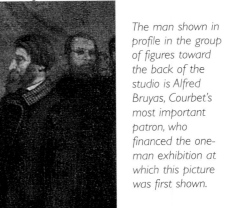

The man shown in profile in the group of figures toward the back of the studio is Alfred Bruyas, Courbet's most important patron, who financed the one-man exhibition at which this picture was first shown.

Courbet shows himself side-on to the canvas, not a pose that he would actually take for working, but one which—as he wrote—allowed him to show off his handsome "Assyrian profile."

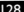

The artist's studio

Painters have often depicted themselves—or other artists—at work in their studios, but the best paintings are sometimes the least informative about their actual surroundings and working practices.

Diego Velázquez's *Las Meninas* (see pages 58–61), Jan Vermeer's *The Art of Painting* (see pages 70–73), and Courbet's *The Painter's Studio* are perhaps the three most famous images of artists at work ever created. Each in its own way conveys a wonderful sense of physical presence, but none of the three tells us much about the typical working conditions of an artist of the time. Velázquez shows himself in a large room in a palace in Madrid, and apart from a glimpse of the back of his canvas and the palette and brushes in his hand, there is no information about how he worked. Vermeer probably set *The Art of Painting* in a room in his own house, but it is so much an idealized scene that it is doubtful if it gives an accurate account of his procedures. Courbet said that his masterpiece represents his studio in a converted priory in Paris, but he painted the picture in Ornans and the interior he represents is rather vague. We know from a contemporary account that his studio was more cluttered than it appears here, and Courbet would not have painted in the position he shows himself, seated at an angle to the canvas; he chose this pose because it showed off his handsome profile.

The three pictures, however, give some idea of the very different environments in which artists have worked, reflecting their personal tastes as well as their status and means.

Some artists, such as Leonardo da Vinci and Poussin, liked solitude; others, such as Raphael and Rubens, thrived on working with a team of assistants. Some were extremely fastidious, Nicholas Hilliard for example (see pages 42–45), but others, notably Francis Bacon, have worked in virtual squalor.

Below: Painter in His Studio *(1663) by the Dutch artist Adriaen van Ostade. In this lifelike, if romantically cluttered, picture the painter is shown working intently amid a mess of brushes, rags, papers, and plaster casts.*

WILLIAM HOLMAN HUNT

1827–1910

Although he is only forty-eight in this self-portrait, William Holman Hunt has the look of an Old Testament patriarch, with his great flowing beard and earnest expression. He was indeed a man who took life and art—and religion—very seriously, and this outlook helped his paintings to appeal greatly to the Victorian public, as did the love of fastidious detail that is also evident here. By the time he painted this picture he was one of the wealthiest and most acclaimed artists in the country, and by the end of his long life he was the Grand Old Man of British art. Early in his career, however, he had been regarded as a rebel.

Hunt worked as an office clerk before gaining a place as a student at the Royal Academy Schools in London. There he met two other young students destined to make a great mark in the art world: John Everett Millais and Dante Gabriel Rossetti (see pages 134–37). Together in 1848 they formed the nucleus of a group—initially a kind of secret society—who called themselves the Pre-Raphaelite Brotherhood. They thought that British art had become stale and contrived and wanted to recapture the simplicity and sincerity of early Italian art from before the time of Raphael—hence the choice of name. Their work became highly controversial and they were subjected to some vehement attacks in the press, but John Ruskin, the most influential art critic of the day, publicly defended them in 1851 and thereafter their fortunes improved. By about 1853 the group was breaking up, but Hunt continued to express Pre-Raphaelite ideals in his work for the rest of his career: he believed that paintings should be morally edifying and based on a close study of nature.

Hunt painted various modern moral subjects, but he was chiefly a religious artist and he made three lengthy visits to the Holy Land so he could include accurate local detail in his pictures. His most famous painting, *The Light of the World* (of which he produced three versions between 1851 and 1904), was exhibited in America, Australia, and South Africa as well as Europe, and he made a fortune from the sale of engravings of such works. One version of *The Light of the World* hangs in Saint Paul's Cathedral, London, where Hunt was given a magnificent funeral.

Self-Portrait, 1875, oil on canvas, Uffizi, Florence

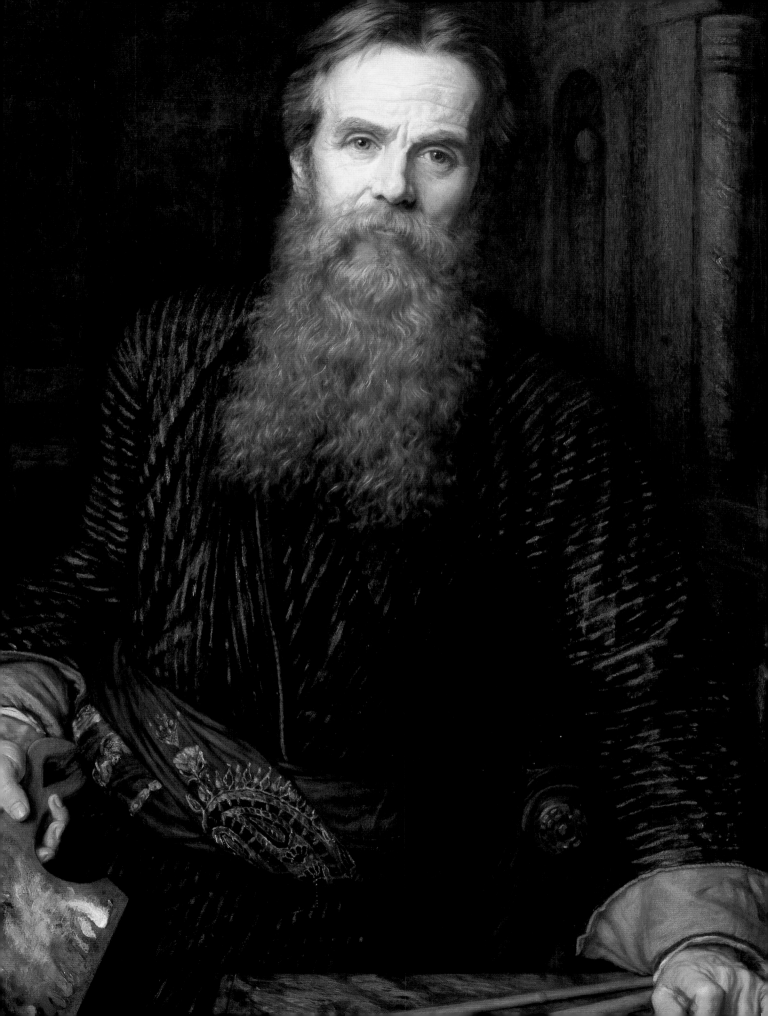

Style and technique

Like the other Pre-Raphaelites, Hunt painted with precise attention to detail, although in his later career his technique became somewhat broader—the brushes shown in this self-portrait are remarkably long, suggesting that at times he stood well back from the canvas on which he was working. His coloring tends to be strong—sometimes garish—partly because he spent so much time working in the bright light of the Near East. Usually he painted his landscape backgrounds outdoors in summer and fall, then added his figures in the studio in winter.

The meticulous detail and solidity of form seen in the rendering of the face are typical of Hunt's work. He often took years to achieve the finish he desired in his paintings. He wrote in 1863: "I am so weary of work ... I can't get anything finished. I work and work until I feel my brain as dry as a bit of cork, but completion slips away from me."

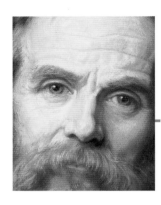

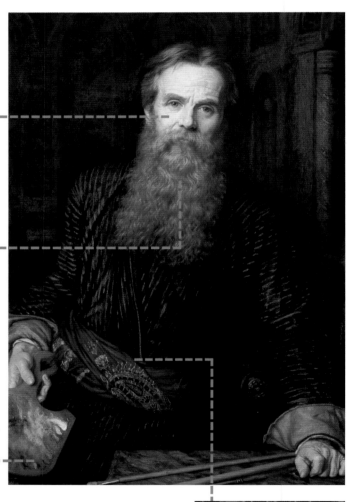

Light flickers over the curls of Hunt's striking red beard. The meticulous rendering and religious overtones of the beard— it lends Hunt the look of a biblical prophet— recall the German artist Dürer's self-portrait (see pages 18–21).

Hunt holds a paddle-shaped palette on which are mixed the colors he used for the self-portrait. He was extremely knowledgeable about painters' materials and techniques; he studied the works of the Old Masters and also contemporary experiments on the permanence of pigments. He avoided using bitumen as a brown (it was unstable and later cracked and discolored) and also used new chemically produced pigments, such as emerald green.

Hunt shows himself in exotic costume. He wears a finely striped silk robe fastened at the waist with a patterned sash. This clothing reflects the late nineteenth-century taste for exoticism, but more specifically Hunt's own fascination with the Holy Land. Many of his paintings include similarly patterned, lustrous fabrics.

Pre-Raphaelite ideals

The high moral principles and lovingly detailed craftsmanship of the Pre-Raphaelites bore fruit in some of the most distinctive paintings in nineteenth-century British art.

Above: Hunt's well-received The Shadow of Death *(1870–73) shows Christ stretching in a pose that prefigures his crucifixion.*

The art critic William Michael Rossetti, brother of Dante Gabriel Rossetti and like him one of the founders of the Pre-Raphaelite Brotherhood, outlined the group's aims as follows: "(1) To have genuine ideas to express; (2) to study Nature attentively, so as to know how to express them; (3) to sympathize with what is direct and serious and heartfelt in previous art, to the exclusion of what is conventional and self-parading and learned by rote; and (4) most indispensable of all, to produce thoroughly good pictures and statues."

Although these aims seem quite admirable, some Pre-Raphaelite pictures aroused strong hostility. Many critics thought they were harsh in style, and those on religious themes were sometimes attacked as irreverent or even blasphemous. The worst abuse was hurled at Millais's *Christ in the House of His Parents* (also known as *Christ in the Carpenter's Shop*). Millais tried to forget the soft idealization of traditional religious pictures and imagine for himself how the young Jesus might have looked in the workshop of his carpenter father. He went to great pains to make the details convincing, spending days in a real carpenter's shop, but when the picture was exhibited at the Royal Academy in 1850, the London *Times* referred to the "disgusting" way in which he had portrayed "the meanest details of a carpenter's shop" with "loathsome minuteness." Hunt later took Millais's ardor for accuracy even further, for

when he was painting *The Shadow of Death*, which shows Jesus as a young man, he sought out carpenter's shops in Bethlehem, where Jesus grew up. Unlike Millais's picture, however, *The Shadow of Death* (1870–73) was a great success from the beginning.

Left: John Everett Millais, Christ in the House of His Parents, *1850. The painting outraged critics with its detailed realism and depiction of the "holy family" as ordinary people.*

DANTE GABRIEL ROSSETTI

1828–82

This portrait drawing is inscribed "March 1847," so Rossetti, who was born in May 1828, was a couple of months away from his nineteenth birthday when he made it. He was a student at the Royal Academy of Art at the time, and a year later he and two fellow students—William Holman Hunt (see pages 130–33) and John Everett Millais—were the central figures in forming the Pre-Raphaelite Brotherhood. With his commanding personality, Rossetti was the driving force behind the Brotherhood. As this drawing shows, he was also blessed with extraordinary good looks, and his personal magnetism made him the center of attention in any gathering. In later life he grew stout, lost his beauty, and became reclusive, but he remained a major figure in the British art world.

Rossetti was born in London. His father was an Italian political refugee who became professor of Italian at King's College in London, and all four of his children had literary or scholarly talents. One of his daughters, Christina Rossetti, became a distinguished poet, and Dante Gabriel himself was for a time undecided whether to concentrate on poetry or painting. However, he thought that painting offered a better chance of a lucrative career, and his work did indeed bring him considerable wealth—he was a skillful businessman. His success came in spite of the fact that he rarely exhibited his paintings in public; he had been so hurt by the abuse that the Pre-Raphaelites suffered in their early days that he preferred to avoid exhibitions and sell his work privately. In addition to paintings in oil and watercolor, he also made book illustrations and designs for stained glass.

Although he was highly successful professionally, Rossetti had problems in his personal life. He was devastated by the death of his wife in 1862 and by about 1870 he was drinking heavily and taking anaesthetic drugs to try to ease insomnia. He also became eccentric in his habits, collecting a menagerie of unusual animals, including a wombat. In 1881 he had a stroke that left him partially paralyzed and he died the following year, prematurely aged. His work lived on, however, and was highly influential for about the next two decades. At the end of the twentieth century his paintings enjoyed renewed popularity as part of a general resurgence of interest in Victorian art.

Self-Portrait, 1847, pencil heightened with white on paper, National Portrait Gallery, London

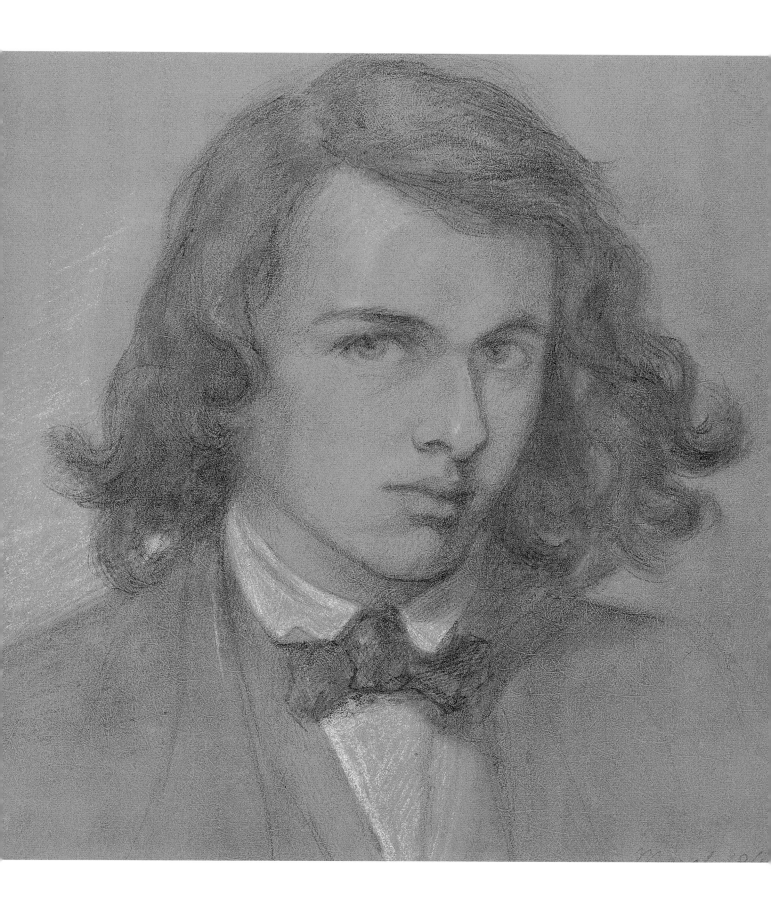

Style and technique

The independent-minded Rossetti had a disdain for academic training, and unlike his Pre-Raphaelite colleagues Hunt and Millais he was never concerned with achieving a minutely detailed finish in his paintings. With both oils and watercolors he followed his own instincts, sometimes using oils very thinly and, in contrast, employing watercolor in a rough, dry way, rather than in the traditional free-flowing manner. In spite of his disregard for normal working practices, he was the most prolific draftsman among the Pre-Raphaelites, producing drawings as independent works as well as preliminary studies for paintings.

White chalk is used to create the highlights in the drawing, as here on the temple, and for the shirt and background. Rossetti later used colored chalks for several of his pictures of women, exploiting the subtle effects of color and tone possible with the medium to add to the romanticism of his images.

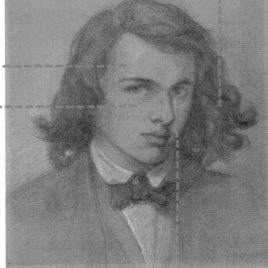

Rossetti's long, curling black hair hints at the Bohemian lifestyle for which he later became famous. His first biographer, F. G. Stephens, wrote that his dress and manner were "the outward visible signs of a mind which cared even less for appearances than the art student of those days was accustomed to care, which undoubtedly was little enough."

In this portrait Rossetti created a self-consciously romantic image of himself with dark flowing hair and smoldering gaze. Later portraits, like that painted by his friend William Holman Hunt in 1853, present less idealized views.

Rossetti used a very soft pencil to create the suffused shading and lines of this self-portrait. Although he had been studying drawing for some five years, parts of the picture—such as the rendering of the left eye—appear a little awkward.

Painter poet

A poet as well as a painter, Rossetti came to specialize in pictures of beautiful women charged with literary associations. They are often erotic or mystical in feeling, with dark, rich coloring, their subjects lost in reverie.

At the outset of his career, Rossetti, like the other Pre-Raphaelites, concentrated on religious subjects. In the 1850s, however, he turned mainly to watercolors on literary themes, including subjects from Arthurian romance. From about 1860 he returned to oils as his main medium and for the rest of his career devoted himself mainly to a distinctive type of picture he made his own, featuring a single figure of a voluptuous woman, usually shown half-length wearing rich robes and often with a suggestion of symbolic meaning. Sometimes there are allusions to the great Italian poet Dante, for whom Rossetti was named, and sometimes to ancient mythology or religion, but more often than not the symbolism is of a vague and personal kind.

Rossetti's favorite model was at first his wife Elizabeth Siddal. After her death in 1862 from an overdose of the drug laudanum, he commemorated her in a picture entitled *Beata Beatrix*. In this painting he expressed his love as a parallel to that of Dante for Beatrice, the lady who had inspired much of the great poet's work. As a further gesture of love, Rossetti had the only complete manuscript of his own poems buried with Elizabeth, but in 1869 friends persuaded him to have the poems exhumed and they were published the following year. Other women also featured prominently in Rossetti's work, the most notable being Janey Morris, wife of the designer William Morris (1834–96). Rossetti fell in love with her, causing the breakdown of the two men's friendship but inspiring some of his finest works. He immortalized Janey in what have become archetypal images of the smoldering-eyed femme fatale.

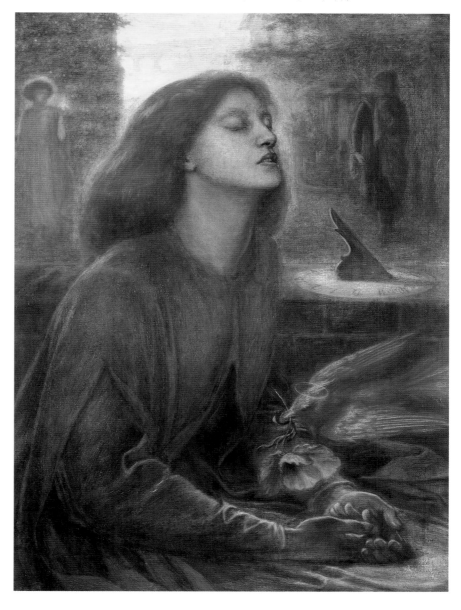

Below: Rossetti's Beata Beatrix *(1864–70), painted as a memorial to his wife Elizabeth Siddal. Its subject is the death of Beatrice from Dante's* Vita Nuova. *Beatrice sits in a deathlike trance while a bird, the messenger of death, drops a poppy into her hands.*

ÉDOUARD MANET

1832–83

This painting shows Manet impeccably dressed with an air of gentlemanly decorum about him, but it is brushed with extraordinary breadth and freedom. The contrast between emotional reserve and technical virtuosity suggests something of the tensions that characterized Manet's career. He came from a wealthy, conservative background and wanted to follow the traditional path to success, but his scenes of modern life shocked his contemporaries and made him a hero to progressive artists; he has been aptly dubbed a "reluctant revolutionary."

Manet was born in Paris, the son of a high-ranking civil servant who was sternly dutiful and disapproved of the boy's artistic inclinations—he wanted him to become a lawyer. As a compromise, Manet began training for a career in the navy before his father finally conceded that he was unsuited to this life and allowed him to begin studying painting in 1850. His teacher was Thomas Couture (1815–79), a respected painter of portraits and historical subjects. Manet stayed with him for six years, but he learned more from the Old Masters, whose work he studied in the Louvre, and on foreign travels; he especially loved the paintings of the Spanish artist Diego Velázquez (see pages 58–61). He first achieved prominence in 1863, when his *Déjeuner sur l'herbe* ("Luncheon on the Grass") was attacked for its "indecent" subject matter as well as its "sloppy" technique. Two years later his *Olympia* caused an even greater storm. Both pictures feature a naked woman, presented frankly and without idealization rather than like the remote goddesses traditional in art. By this time Manet's father had died, leaving him considerable wealth, so he had no need to earn a living with his work. He was deeply upset by the savage comments none the less.

Unlike most critics, the young painters who would soon be dubbed impressionists were greatly impressed with Manet's work and regarded him as an inspirational figure. Although he never showed his work in their exhibitions, he was friendly with them and took up their practice of painting outdoors. At the end of his career Manet belatedly achieved the official honors he desired. However, they came too late to be enjoyed, for his final years were marred by debilitating and painful illness. In spite of this, his artistic powers remained undimmed to the end.

Self-Portrait, c.1879, oil on canvas, Private Collection

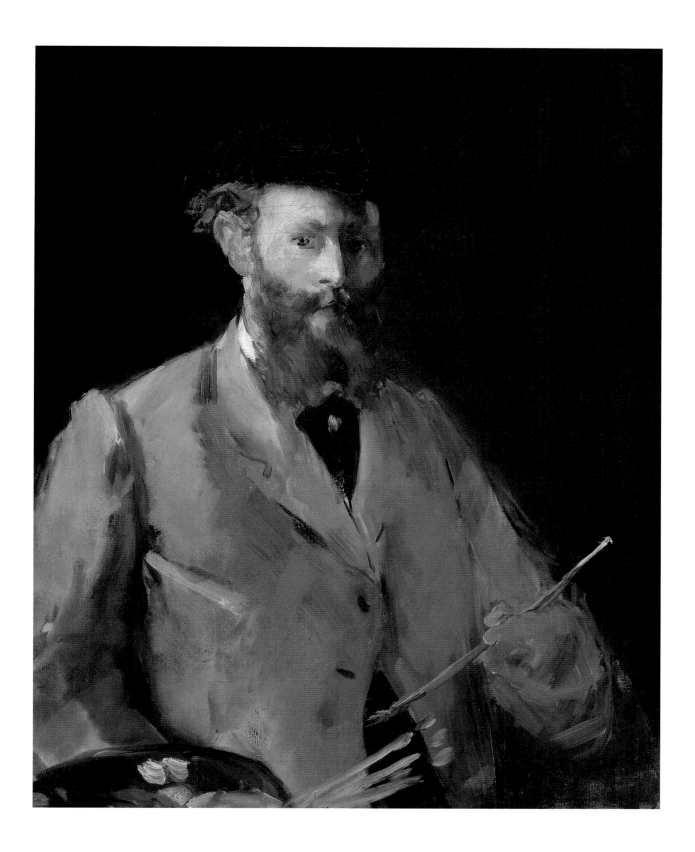

Style and technique

Although Manet is best known for scenes of contemporary life, his subject matter ranged widely—from traditional religious themes to still lifes, particularly of flowers. He was constantly making explorations in his art and rarely repeated himself. In matters of technique he was similarly versatile; most of his major works are in oil, but he was also a prolific draftsman, an accomplished printmaker, and a superb exponent of pastel. His freshness of approach and boldness of brushwork have won him a reputation as one of the most influential figures in nineteenth-century art.

Touches of red mixed into the creamier flesh tones provide the only notes of warm color in the portrait. As well as using red to enliven the face, Manet includes it on the tip of the brush and the raised hand that holds it.

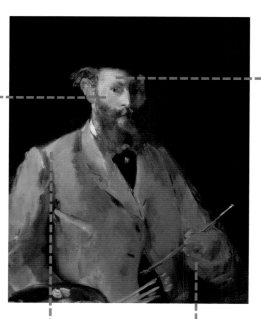

A creamy ground, or base color, shows through parts of the loosely painted jacket. Manet liked to work on pale grounds, because they facilitated the creation of dramatic tonal contrasts.

The impact of this self-portrait relies on Manet's bold handling of tone. Attention is focused on the brightly lit half of his face, which is set against a dark background. Manet's dramatic use of tone was inspired by the work of the seventeenth-century Spanish painter Velázquez (see pages 58–61), and he continued to use black, unlike many of the impressionists.

The form of Manet's hand is barely suggested. From the start of his career Manet aimed to attain a feeling of spontaneity in his paintings, though he often had to rework his canvases many times to achieve the effect. He admired artists who showed a freedom of handling, from Titian and Velázquez to Delacroix.

Portraits of modern life

Intelligent and charming as well as wealthy, Manet moved in distinguished circles and painted memorable portraits of several of his artistic and literary friends, among them the writer Émile Zola and the painter Berthe Morisot.

As Manet did not need to paint portraits for a living, he tended to portray only the people he knew or liked best, including friends and members of his family. The most famous of his literary friends was Émile Zola, one of the greatest novelists of the nineteenth century and also a tireless writer in many other fields. Zola was always prepared to champion a cause in which he believed, and he first wrote in praise of Manet in 1866, at a time when the artist was being routinely abused by most critics. Manet expressed his gratitude in one of the most dignified of all his portraits, painted in 1868. Other writer friends who sat for him included the poet Stéphane Mallarmé and the Anglo-Irish novelist and critic George Moore. Several other notable friends are shown in Manet's *Music in the Tuileries Gardens* (1862), including the poet and critic Charles Baudelaire and the composer Jacques Offenbach. His friendship with writers encouraged Manet to make book illustrations, among them a set for Mallarmé's translation of Edgar Allan Poe's poem *The Raven* (1875).

Manet's favorite model was the painter Berthe Morisot (see pages 158–61), who married his brother in 1874. Morisot was beautiful as well as highly talented and she is featured in some of Manet's loveliest works, including *The Balcony* (1868–69). She was one of the mainstays of the impressionist group and encouraged Manet to adopt their technique of painting in the open air and their lighter, more colorful palette.

Another woman artist memorably portrayed by Manet was Eva Gonzalès, who was his only formal pupil. She began studying with him in 1869 and he completed a handsome portrait of her the following year.

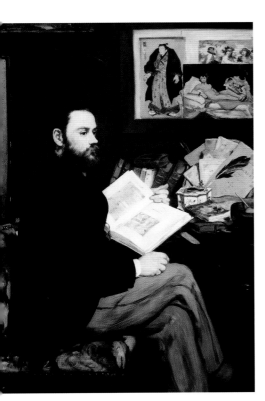

Left: Manet painted Portrait of Émile Zola *(1868) as a tribute to the young writer's support. He showed Zola at his desk, and included a reproduction of his controversial painting* Olympia *in the background.*

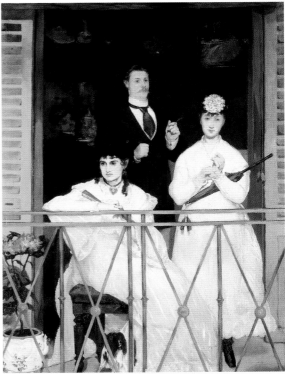

Right: Manet, The Balcony, *1868–69. This glimpse of fashionable Parisians features Berthe Morisot at left, the violinist Fanny Claus at right, and the painter and collector Antoine Guillemet.*

JAMES ABBOTT McNEILL
WHISTLER

1834–1903

The title of this painting, *Arrangement in Gray: Portrait of the Painter*, indicates that Whistler's main concern was the harmonious disposition of tone rather than the precise description of his appearance. The almost abstract use of color, shape, and texture in Whistler's work has won him a reputation as one of the most innovative painters of his time and a precursor of modern art. Many of his contemporaries recognized his remarkable powers, but others were baffled or outraged by his work.

Whistler was born in Lowell, Massachusetts, the son of an engineer. He spent several years of his childhood in Russia, where his father was helping to build the country's first railroad, and he had part of his education in England. Throughout his life he remained a cosmopolitan character, traveling a great deal. In 1851 he began studying at West Point Military Academy, but he had to leave in 1854 after failing a chemistry examination. He then became a naval cartographer, a job that involved learning the technique of etching. Shortly afterward, in 1855, he moved to Paris to pursue a career as an artist. In 1859 he settled in London, which was his home for most of the rest of his life.

Although his art was exquisitely subtle and refined, Whistler himself was a flamboyant character who enjoyed controversy, and his combative nature led him into a public conflict with the critic John Ruskin. In 1877 Whistler showed eight paintings at the opening exhibition of the Grosvenor Gallery in London. One of them was *Nocturne in Black and Gold: The Falling Rocket* (1875), which Ruskin thought was a mere daub. He attacked Whistler in print, accusing him of "wilful imposture" and "flinging a pot of paint in the public's face." Whistler sued for libel and the case came to trial in November 1878. He won the verdict, but the judge—sympathizing with Ruskin—awarded derisory damages of a mere farthing. The legal costs were crippling and the following year Whistler was declared bankrupt. He bore this burden with dignity, worked hard to reestablish his career, and in the 1880s began to enjoy public recognition and success. By the end of his life his art was still regarded with suspicion and distaste by some critics, but many admirers had no doubt that Whistler was one of the greatest artists of his age.

Arrangement in Gray: Portrait of the Painter, 1872, oil on canvas, Detroit Institute of Arts

Style and technique

Whistler's paintings consist mainly of portraits and landscapes. Early in his career he used fairly strong color, but it became much more subdued, sometimes involving extremely subtle variations of tone—even the juxtaposition of different varieties of white. He was a fastidious and self-critical worker and his flawless harmonies were hard won. He often abandoned or destroyed pictures that dissatisfied him. His brushwork was highly varied, his paint ranging from the thick and creamy to the thinly dripped. He was also an outstanding printmaker, excelling in particular at etching.

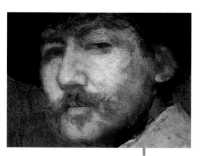

The face is built up with gestural strokes of thicker, creamlike paint, though the thinner underpainting is left uncovered at the shadow of the jaw, neck, and eyes. The subtle pink flesh tones and touches of red on the lips are the only passages of color in the arrangement.

In the early 1870s Whistler adopted a stylized mothlike motif with which to sign his work, feeling that it was less intrusive than a written signature. This change coincided with his first "harmony" and "arrangement" paintings, in which formal qualities such as tone and color became the main concern of his pictures.

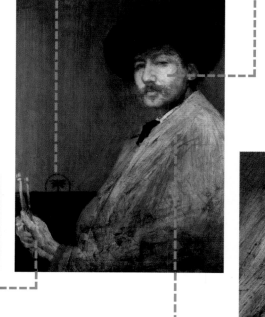

Whistler's right hand, which holds two rapidly sketched brushes, appears to be attached to his left arm. This rather unsuccessful detail was perhaps the reason Whistler did not want the self-portrait included in a retrospective of his work in London in 1892.

The grays and black on the clothing are applied very thinly. Inspired by English watercolorists, Whistler developed a technique based on thin layers of translucent paint, which he referred to as his "sauces."

Harmonies of color and tone

Like other advanced thinkers of his time, Whistler believed that painting should exist for its own sake, rather than to convey literary or moral ideas. Increasingly he used his pictures to explore the formal qualities of color and tone.

During the late nineteenth century numerous artists and writers on art discussed the idea that colors and forms could be used in painting as sounds are in music: for their own expressive sake rather than to represent something else. This line of reasoning eventually led to abstract art, which was born around 1910. Whistler was forceful and articulate in presenting his views, and he summed up his position on this subject as follows: "Art should be independent of all claptrap—should stand alone, and appeal to the artistic sense of eye or ear, without confounding this with emotions entirely foreign to it, as devotion, pity, love, patriotism, and the like. All these have no kind of concern with it, and that is why I insist on calling my works 'arrangements' and 'harmonies.'"

Among the pictures to which Whistler gave such musical titles are some of his most famous works, including *Arrangement in Gray and Black No. 1: Portrait of the Artist's Mother* (1871). Of this painting he wrote: "To me it is interesting as a picture of my mother; but what can or ought the public to care about the identity of the portrait?" In spite of this insistence on purely formal values, the picture is an excellent likeness and it is painted with obvious representational skill. Some of Whistler's paintings, however, particularly his landscapes, are more in the nature of "mood music," with literal representation reduced to subtle evocation. To these paintings he often gave a title that included the word "nocturne," a term he took from the piano pieces of the composer Chopin.

Left: Arrangement in Gray and Black No. 1: Portrait of the Artist's Mother, *one of Whistler's best-known works, painted in 1871. The picture combines a stark portrayal of his mother in mourning dress with an exploration of dark tonal values.*

EDGAR DEGAS

1834–1917

Degas is famous as one of the central figures of impressionism, but there is nothing in the least impressionist about this solid, serious work, in which he presents himself as an earnest young man at the outset of his career. In fact, even though he took part in seven of the eight impressionist exhibitions, Degas always stood somewhat apart from the other members of the group. He came from a higher social class than most of them and he had little interest in landscape, which was the archetypal impressionist subject. More than any of the others he was a figure painter, and however modern his art was in certain ways, it was based on traditional skills in draftsmanship. Ironically, it was in the 1890s, after the impressionists had broken up as a group, that Degas's work was closest to expressing their ideals. However, the soft, blurred forms of his pictures of this period were as much the result of declining eyesight as of conscious intention.

Degas was born in Paris, the son of an art-loving banker. He had a good education and a solid academic training in art, which he supplemented by studying Old Masters in the Louvre and in the great galleries of Italy—he had Italian relatives and made several visits to the country, the longest between 1856 and 1859. Up to 1874, the year of the first impressionist exhibition, he had no need to sell his work, because of his wealthy background. However, when his father died that year he left unexpected debts, which Degas paid off himself. From this point he had to market his work. Unlike the other impressionists, he never experienced any difficulty in selling his pictures; his superb draftsmanship meant that he could not be accused of sloppiness, as his colleagues were, and for many contemporaries he represented the acceptable face of modernity—portraying up-to-date subjects but with a skill worthy of the Old Masters. By 1880 he was firmly established as a major figure in the Paris art world, but by this time he was having serious trouble with his eyesight. After the turn of the century he could do little work, and by the end of his life he was virtually blind, but he was universally admired as one of the artistic giants of his time.

Self-Portrait, 1855, oil on canvas, Musée d'Orsay, Paris

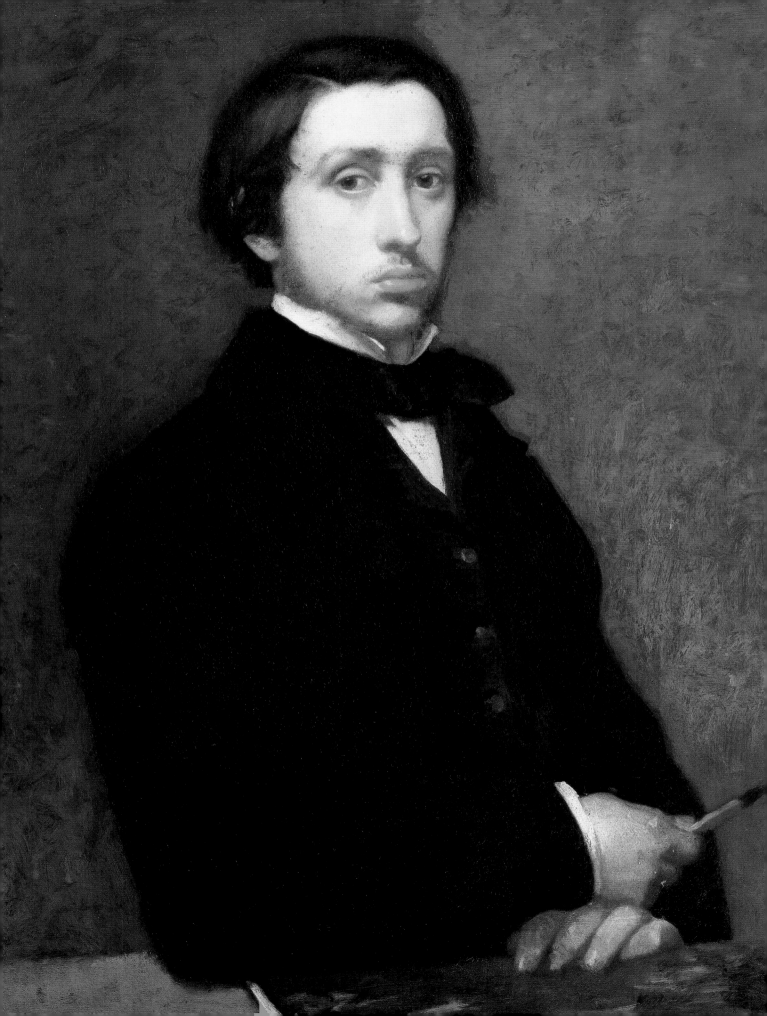

Style and technique

Early in his career Degas painted with firm dignity in the traditional method of oils on canvas, but in his maturity he experimented a good deal with other methods and his style became broader and bolder. In his later years pastel was his favorite painting technique; he sometimes mixed it with oils or manipulated it in unusual ways—even steaming the picture to make the colors more fluid. Degas also worked in various printmaking techniques, including etching, drypoint, aquatint, and lithography, and sculpture became of more and more importance as his eyesight declined.

Degas portrays himself impeccably dressed in a crisp white shirt and a black bow tie, vest, and jacket. The cracking over the jacket suggests that he used bitumen, a pigment that had long been popular with artists for its rich tones but which, because it never completely dries out, darkens over time and causes damage to the picture surface.

With his long face, deeply set eyes, full lips, and beginnings of a beard, the young Degas—he was only about twenty-one when he painted this self-portrait—looks out of the painting with an expression of aloofness tinged with anxiety and shyness.

Although Degas's style was always grounded on his natural facility for draftsmanship, the finish of his paintings—even in this, one of his earliest and most academic exercises—has softened contours rather than precisely delineated hard edges.

Degas holds a drawing implement in his right hand, in a pose based on a self-portrait by the French painter Jean-Auguste-Dominique Ingres (1780–1867). Degas admired Ingres and met him around the time he made this self-portrait; Ingres urged him, "Draw lines, young man, many lines, from memory or from nature."

The influence of photography

Photography had an important impact on nineteenth-century painting; some artists feared it as a ruthless and soulless competitor, but Degas keenly explored the new avenues it opened up.

When photography was first made public in 1839, the French painter Paul Delaroche remarked, "From today painting is dead." Like countless other people, he marveled at the amount of detail the camera could capture, and thought that his art could not compete with it in this respect. He was right up to a point, but photography of course did not kill painting, which offered realms of color and imagination the new art could not. Many painters, unlike Delaroche, recognized this from the start and happily embraced photography, using it to their advantage. Eugène Delacroix (see pages 118–21), for example, thought that photography could be used to make detailed studies of figures or objects that the painter could incorporate into his pictures—he made at least one photograph of a nude model himself—and he regretted that it had arrived fairly late in his career.

Several of the impressionists were interested in photography. Claude Monet (see pages 154–57) at one time owned four cameras, and Degas was intrigued by the subject throughout his career—in his later years he took many photographs himself. The informal, snapshot-like compositions of some of his paintings are often compared with photographs, but Degas in fact developed this type of composition before easily portable snapshot-type cameras became available in the 1880s. On the other hand, he certainly

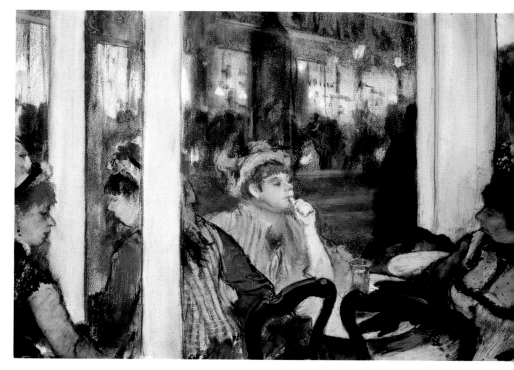

Above: The informal composition of Degas's Woman in a Cafe *(1877) reflects the impressionists' emphasis on spontaneity as much as the influence of snapshots.*

Right: A photograph taken by Degas in 1895 showing the painter Auguste Renoir (seated) and the poet Stéphane Mallarmé.

used photographs as an aid in painting portraits and he adopted some of the poses used by early portrait photographers. He also studied the photographs of horses in motion published in 1878 by the Anglo-American photographer Eadweard Muybridge (1830–1904) and found them useful for his paintings of the racetrack.

PAUL CÉZANNE

1839–1906

The cap Cézanne wears is a workman's *casquette*, and this together with his unruly hair and beard and the heavy outdoor coat gives him a rugged, even uncouth air. He was a big, strong man, and in his early years, when he had a hard struggle to make any headway in his career, he tended to hide his insecurities behind a gruff, abrasive, sometimes boorish manner. He is said to have once declined to shake hands with the elegant Manet because he claimed he had not washed for a week. In fact Cézanne came from a prosperous background, and in middle age he inherited substantial wealth that enabled him to devote himself to his work, oblivious to what anyone else thought of him. Recognition was a long time coming, but by the final years of his life he had become an inspirational figure to a whole generation of progressive artists.

Cézanne was born in Aix-en-Provence in southern France, the son of a hat manufacturer who became part owner of a bank. He began training for a legal career, until his father reluctantly allowed him to begin studying art in Paris in 1861. His early work was passionate but crude, and the paintings he submitted for exhibition at the annual state Salon were regularly turned down. In 1872 Cézanne moved out of Paris—where he could not afford to go on living—staying first at Pontoise, near his friend the landscapist Camille Pissarro (1830–1903), and then at Auvers-sur-Seine. He moved back to Paris in 1874. Although his interlude in the country was fairly brief, it was important for leading him to take up landscape seriously, under Pissarro's influence (see page 161). This choice of subject matter in turn encouraged him to abandon the predominantly dark colors of his youthful works and adopt a more impressionist outlook.

In 1886 Cézanne's father died and he inherited the family estate at Aix. Free of money worries for the first time in his life, he painted incessantly, pursuing his personal vision unremittingly. He remained virtually unknown until 1895, when an enterprising picture dealer, Ambroise Vollard, organized an exhibition of his work in Paris. This show made Cézanne into something of a cult figure, and a memorial exhibition devoted to him in 1907, the year after his death, established his reputation conclusively.

Self-Portrait with Cap, c.1873, oil on canvas, Hermitage, Saint Petersburg

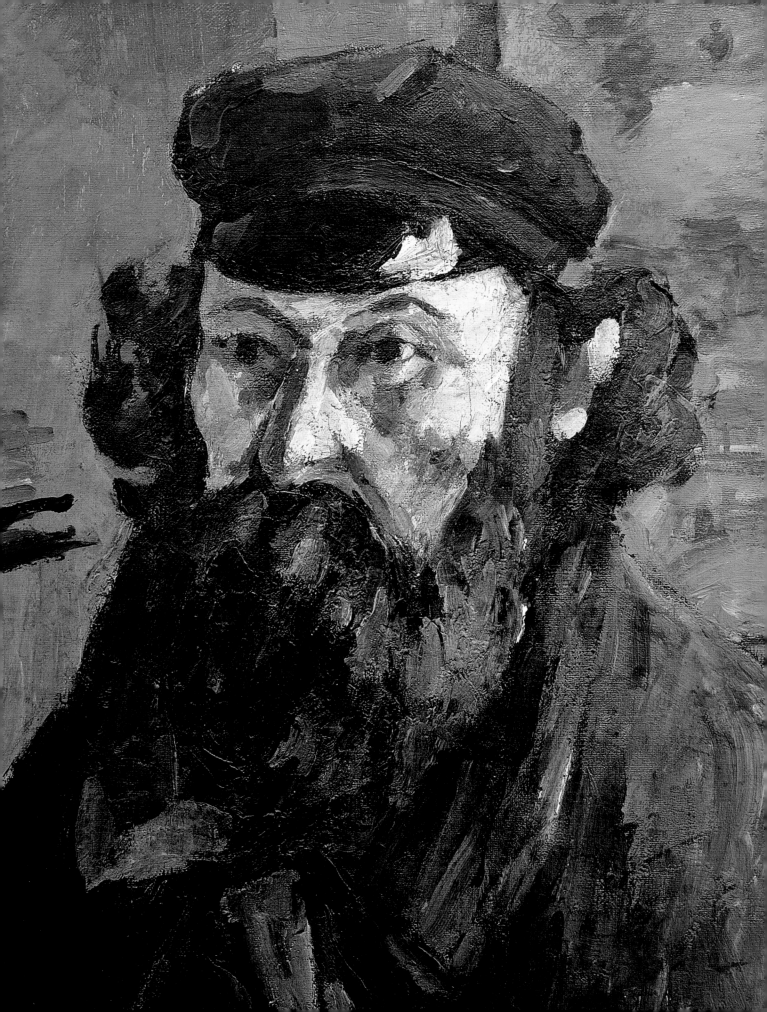

Style and technique

In his early years Cézanne painted imaginative subjects including violent and erotic scenes, but from his thirties he concentrated on aspects of the world around him, his main subjects being landscapes, still lifes, and portraits of people close to him. His wife was his favorite model and he also produced about forty self-portraits. He was a laboriously slow and self-critical worker, building up his pictures through a multitude of small touches. Often he worked on paintings over long periods, putting them aside for a while and then returning to them to make adjustments.

Black paint, modulated with greeny blue and white, describes the form of Cézanne's cap—the paint is applied so thickly that it stands out from the picture surface. The dark, slablike forms are typical of Cézanne's early style.

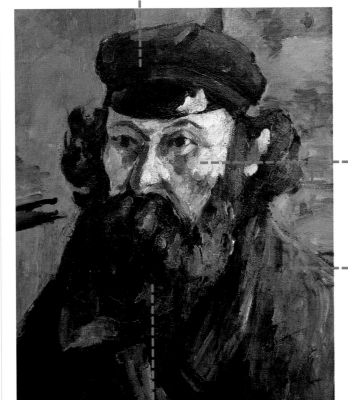

The features of the face are heavily delineated in black and modeled with vigorously applied dabs of paint. The creamy ochers and earthy reds and oranges are typical of Cézanne's palette.

This area of thinly applied pale blues and greens appears to represent a landscape— Cézanne showed himself in front of a more clearly defined landscape in another self-portrait painted the same year. The inclusion of this element reflects his growing interest in landscape, inspired by Pissarro.

Cézanne's beard and unkempt mane of raven black hair, which were such prominent features of his appearance during the 1870s, are here shown with particularly vigorous strokes and highlights of unmodulated red and yellow.

Impressionism and tradition

Although he showed paintings in two of the impressionist exhibitions, Cézanne differed fundamentally from his colleagues in the way he tried to represent the world.

Cézanne rarely theorized about art, but he eloquently summed up his aims in two famous remarks: that he wanted "to do Poussin again from Nature" and that he wanted "to make of impressionism something solid and enduring, like the art of the museums." In essence, he tried to combine the grandeur of the Old Masters with the freshness and color of the best painting of his own time. The task he set himself was formidable and he achieved his goal only with immense effort and self-discipline, transforming himself from the artistic hothead of his youth into a painter of unsurpassed patience. He began his career as a wild, impulsive romantic, but matured to create a style of noble dignity and almost unequalled subtlety.

Whereas his impressionist friends— particularly Monet—were interested in transient surface effects, Cézanne was concerned with solidity of construction. Monet's ideal was to finish a landscape painting in only one session of work so that it captured the feeling of a particular moment. Cézanne, however, returned to the same place again and again to create a highly considered image that usually gives no indication of the time of day or even what season is represented.

This way of working was also applied to his still lifes and portraits, which is why he usually painted only people—particularly his wife—who were available to model for him

almost indefinitely. The slowness at which he worked became legendary, and he is said to have abandoned a portrait of the dealer Ambroise Vollard after a hundred sittings with the remark that he was "not altogether displeased with the shirt front."

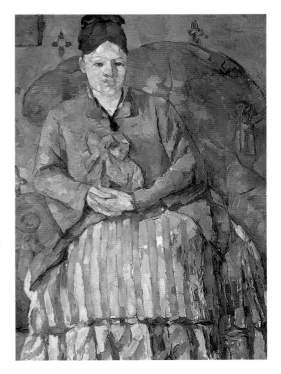

Right: In Madame Cézanne in a Red Armchair *(c.1877), Cézanne used small blocks of subtly varied color to create a serene but monumental portrait of his wife.*

Below: Cézanne, Mont Sainte-Victoire, *c.1906. This mountain became a central motif in Cézanne's work as he endeavored to create an enduring but fresh style of art.*

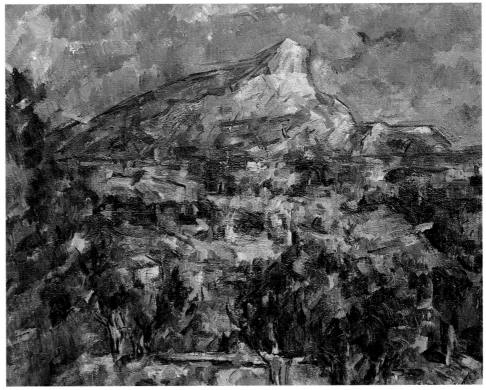

CLAUDE MONET

1840–1926

This is a rare example of a self-portrait by Monet. Vigorously executed and left unfinished, it was probably made while he was working on the Mediterranean coast early in 1884. At the time he was having financial problems—his dealer, Paul Durand-Ruel, was on the verge of bankruptcy—and this state of affairs could explain his rather troubled expression.

Monet was born in Paris, but he grew up in the port of Le Havre, at the mouth of the Seine River, where his father ran a successful business that supplied provisions for ships. He began his artistic career when he was still at school by making and selling caricatures. At the age of sixteen or seventeen he met the painter Eugène Boudin (1824–98), who inspired him to turn to landscape, more specifically to landscape painted outdoors, which was Boudin's speciality and at the time something of a novelty. In 1859 Monet moved to Paris to study art and in 1863 he met Pierre-Auguste Renoir (see pages 162–165) and Alfred Sisley, who were to form the nucleus of the impressionist group with him. During the Franco–Prussian War (1870–71) he took refuge in England, and after his return to France he settled at Argenteuil, on the Seine, a few miles outside Paris. Here he was often visited by his friends, during a period when the impressionist group was most closely united. The boats and bridges of Argenteuil appear in numerous works by Édouard Manet, Renoir, and Sisley, as well as occurring repeatedly in Monet's own pictures.

In 1876 Monet left Argenteuil and after various moves he settled at Giverny, about 40 miles from Paris, in 1883. Giverny was his home for the rest of his life, but he traveled a good deal in France and abroad in search of subjects. Early in his career he had often suffered great hardship, but in the late 1880s he began to prosper, and in the 1890s he spent a good deal of time enlarging and developing the splendid garden he created at Giverny. After the turn of the century it became his favorite subject, and eventually he concentrated almost exclusively on the water lilies there. In his final years he had trouble with his eyesight, but he continued painting with unflagging energy, and by the time of his death he was revered as the Grand Old Man of French painting.

Self-Portrait, c.1884, oil on canvas, Musée Marmottan, Paris

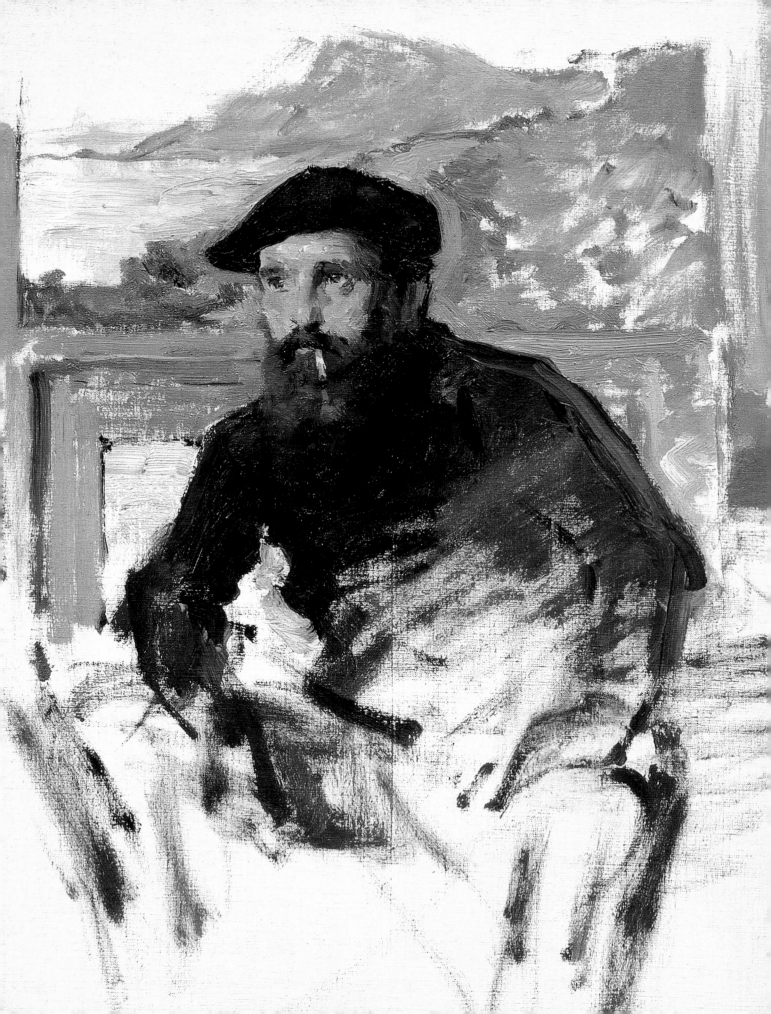

Style and technique

Although he occasionally painted portraits, still lifes, and figure compositions, the bulk of Monet's huge output was devoted to landscapes in the broadest sense—including townscapes, seascapes, and views of his garden. He was a fast worker, with a fluent and flexible technique. His loose brushwork and vibrant color at first seemed sloppy and garish to many people who were accustomed to carefully finished paintings, but critics and collectors were gradually won over and impressionism had an enormous influence on late nineteenth-century art.

Framed by a dark brown beard and black beret, Monet's face is rendered in warm flesh tones and barely modulated dabs of the pink and orange that are used in the landscape behind him. Monet's expression is similar to that in a portrait of him by Renoir (1875), though the treatment is less formal and the colors brighter.

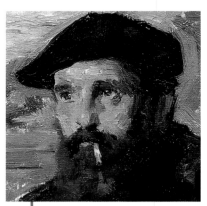

Much of this rapidly executed self-portrait is left unfinished. The legs, hands, and lower arms are quickly sketched using broad strokes of dry brown-black paint, leaving the cream ground of the canvas to show through.

Broad, rapid brush strokes are used to block in and delineate the picture with thickly applied paint. Combined with the use of black for the clothing, they create a flat effect, very different from the flickering brushwork associated with Monet's finished paintings.

The great impressionist

Monet is considered the archetypal impressionist painter. Throughout a long career he remained constant to his commitment to painting outdoors, in front of his subject, in order to capture the transient effects of light and nature.

Impressionism is named after one of Monet's paintings, *Impression: Sunrise* (1872), and this is appropriate, for no other artist matched him in his lifelong dedication to the movement's ideals. More than half a century after the first impressionist exhibition in 1874, he was still trying, in his old age, to capture on canvas what he called "the most fleeting effects" of nature. Central to his outlook was the idea that landscape painting must be done outside. He was by no means the first artist to paint directly from nature in this way, but no other painter had approached him in his thoroughness and consistency. At times this led to rather comic situations. In 1866–67, for example, he painted an exceptionally large picture called *Women in the Garden*. To enable him to work on all of it outdoors he had a trench dug in the garden and he raised or lowered the canvas with pulleys to the required height. On other occasions he painted in weather that would have driven most people indoors: During a visit to Norway in 1895 he said he worked with his beard "covered in icicles."

Monet came to realize that there was an inherent contradiction in his method of working, for the more sensitive he was to fleeting effects of light and atmosphere, the less time he had to capture such effects before they changed. Consequently he came to rely more on work in the studio, where he touched up his pictures to achieve the results he wanted. However, publicly he always liked to maintain his image as the outdoor painter par excellence.

Above: Monet, Impression: Sunrise, *1872. In 1874 this painting gave rise to the term "impressionism" when a hostile critic attacked it in a newspaper review.*

Left: Édouard Manet, Monet in His Floating Studio, *1874. Monet's studio boat enabled him to closely observe the play of light on water and afforded him fresh viewpoints.*

BERTHE MORISOT

1841-95

lthough she was renowned as a beauty, Berthe Morisot seems more interested in displaying her skills than her looks in this freely painted portrait. There is no doubt that she is a handsome, dignified woman, and her glance is arresting, but it is the sheer delight in painting that makes the most powerful impact—the freedom and freshness of brushwork and the delicacy of coloring create a visual feast. Morisot had art in her blood, for her great-grandfather was Jean-Honoré Fragonard (1732–1806), one of the outstanding French painters of the eighteenth century. Her father was a high-ranking civil servant and her impeccable upbringing included lessons in music and drawing. At the age of seventeen she began making copies in the Louvre, and three years later she began receiving informal instruction from Camille Corot (1796–1875), one of the most illustrious landscape painters of the day. In 1864, at her first attempt, she had two paintings accepted for exhibition at the annual Salon and they received encouraging reviews. She repeated her success over the next few years, but in spite of her steady progress in the official art world, she was attracted to modern ideas, especially after she met Édouard Manet (see pages 138-41) in 1868. In 1873 she submitted a painting to the Salon for the last time, and the next year she took part in the first impressionist exhibition; later that year she married Manet's brother Eugène.

Because of her wealthy background, Morisot had no need to sell her work, but she was dedicated to the impressionist cause and played a central role in the group's exhibitions and in the movement as a whole. She missed only one of the eight impressionist exhibitions, the fourth (1879), when she was sick following the birth of her only child the previous year; her daughter, Julie, later kept a diary that has been published in English as *Growing Up with the Impressionists* (1987). Morisot was admired by the other impressionists not only for her artistic skills but also for her personal qualities; she was beautiful, charming, and warmhearted. Her home became a meeting place for writers as well as painters, and her success—she won critical acceptance before most of the other impressionists—was an encouragement to her male colleagues. Although they now overshadow her to a certain extent, her reputation remains high.

Self-Portrait, 1885, oil on canvas, Musée Marmottan, Paris

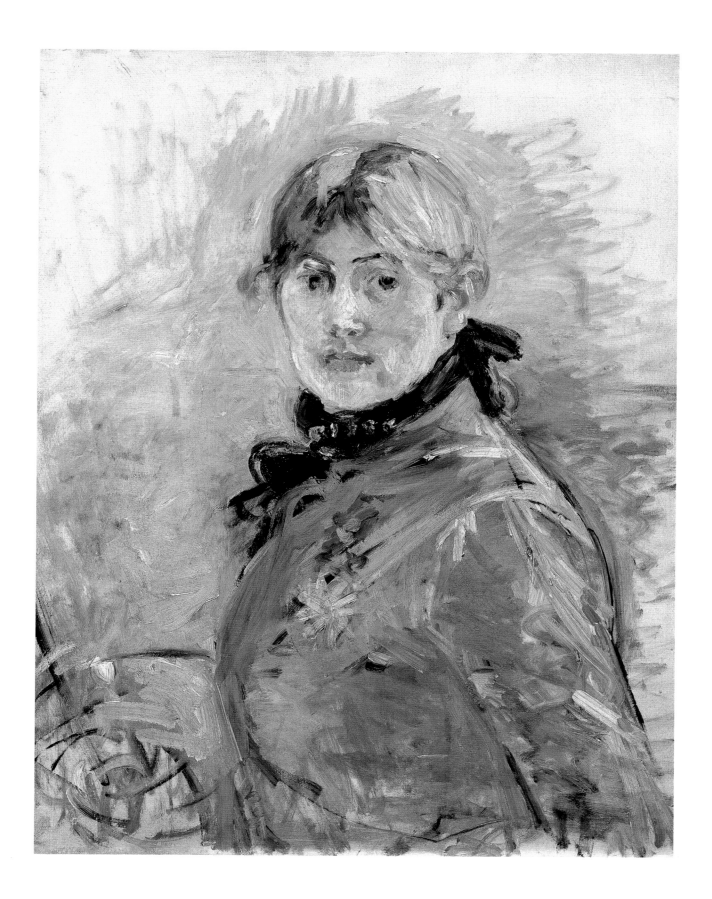

Style and technique

Morisot painted various types of picture, including landscapes and portraits, but she is best known for her scenes of domestic life. Although her subjects are often quiet and intimate, her technique was extremely lively, with bold strokes of the brush suggesting the inspiration of the moment rather than careful planning. In her final years, however, Morisot's brushwork became less dashing, following forms in a firm but supple way. She worked a good deal in watercolor and was just as impressive a technician in this medium as she was with oils.

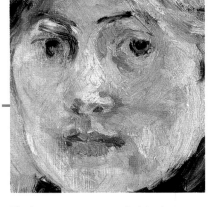

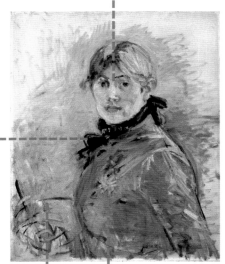

Morisot's dark scarf and the blue background behind it are sketched in with particularly nimble brush strokes.

Thick, creamy paint applied in short touches and directional strokes convey the fine features of Morisot's face. Fluid touches of red model her nose and lips, and curved strokes define her eye sockets. The right side of the face is the least finished, with little more than the brow, the line of the eyelid, and the dark iris suggested.

In this remarkably free area of painting, Morisot uses swift circular strokes of dark brown paint and touches of vivid red and white to suggest her palette and hand, with a straight stroke to represent a paintbrush.

Two flowers stand out on Morisot's dress among the strokes of earth colors, blues, grays, and greens. The paint is applied with speed and vigor, but the directional brushwork creates an impression of the solid form of Morisot's body.

Impressionist exhibitions

The eight impressionist exhibitions marked a watershed in nineteenth-century art; they undermined the authority of the Salon and promoted a new kind of fresh and informal art.

In 1874 a group of painters, most of whom had experienced difficulty getting their work accepted for the official Salon, banded together to arrange a collective exhibition of their work in Paris. This move was a bold step, for the Salon had immense power in the French art world; it received a great deal of publicity, drew huge crowds, and was virtually the only channel through which an artist could get noticed. Any artist who tried to operate outside it stood the risk of looking like a purveyor of defective goods. The artists who in 1874 decided to take this risk advertised themselves under the bland title of *Société anonyme des artistes, peintres, sculpteurs, graveurs, etc.* ("Limited company of artists, painters, sculptors, engravers, etc."). However, a journalist named Louis Leroy latched on to Monet's painting *Impression: Sunrise* (see page 157) and headed his sarcastic review "Exhibition of the Impressionists." Although the review was unpleasant, the painters in the group accepted the term as being appropriate to at least some of their aims in depicting contemporary life in a fresh and immediate way, and the name stuck.

Many of the other reviews were as damning as Leroy's and some people came to the exhibition purely to mock. However, there were also more positive responses, and the impressionists persisted, holding seven

Above: A caricature of the first impressionist exhibition reflecting the mockery the artists attracted. The caption reads "A revolution in painting! And what a terrifying beginning."

more exhibitions, in 1876, 1877, 1879, 1880, 1881, 1882, and 1886. Camille Pissarro (1830–1903), who was something of a father figure to other members of the group, was the only one to participate in all eight exhibitions. By the time of the final one, the impressionists as a whole were beginning to achieve critical praise and financial success.

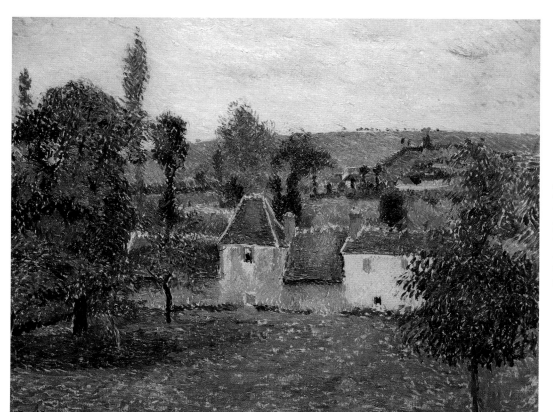

Left: Pissarro, Farm in Bazincourt, *1884. Landscapes and rural scenes were central subjects in Pissarro's work, and in the second half of the 1860s he began painting his pictures entirely outdoors, rather than in the studio. He was greatly respected by other impressionists as well as postimpressionist painters—such as Cézanne, Gauguin, and Seurat—and was in turn influenced by their ideas and techniques.*

PIERRE-AUGUSTE RENOIR

1841–1919

The thirty-five-year-old Renoir appears younger than his years in this painting. It has even been said that he looks like a youth with a false moustache and beard playing a part in amateur dramatics. He was rather shy, nervous, and frail-looking, all of which this portrait suggests, but he was also warmhearted and witty, and the joy he expressed in the beauties and pleasures of life has made him one of the best-loved artists of the nineteenth century.

Renoir was born in Limoges in central France, the son of a poor tailor and his dressmaker wife. The family moved to Paris when he was three, and ten years later he was apprenticed as a porcelain painter. When the firm closed in 1858 he found work painting fans and decorative blinds. By 1861 he had saved enough to pay for serious art tuition and became a student of Charles Gleyre (1808–74), a successful painter of portraits and anecdotal scenes. His fellow students included Claude Monet (see pages 154–57) and Alfred Sisley. He had paintings accepted for the Salon in 1864 and 1865, but in spite of this he found difficulty earning a living and often survived only through the generosity of friends. After the first impressionist exhibition in 1874 he concentrated for several years on portraits, and through them he at last began to achieve modest prosperity. In the 1880s his success grew, thanks partly to the efforts of the art dealer Paul Durand-Ruel, the impressionists' greatest champion.

By the time he turned fifty, Renoir was becoming internationally renowned, but his growing success was marred by illness, as he was attacked by arthritis with increasing severity. From 1903 he lived mainly on the Riviera coast, as the warm climate eased the pain caused by his affliction, which he bore with cheerful fortitude. From 1912 he was confined to a wheelchair, but he continued to paint, even though his arthritis was so bad that he sometimes had to have the brush pushed between his fingers by his nurse. Amazingly, he also took up sculpture, directing assistants who acted as his hands. In his final years he was a revered figure, and on his last visit to Paris, a few months before his death, he was invited to the Louvre to see one of his paintings that had recently been acquired by the state and placed on display there.

Self-Portrait, 1876, oil on canvas, Fogg Art Museum, Cambridge, Massachusetts

Style and technique

At the height of the impressionist movement Renoir's paintings often had a wonderful velvety softness of touch and a pearly beauty of coloring. In the early 1880s, however, he took stock of his career and decided he needed to introduce more rigor into his work. For a few years he experimented with what he called his "harsh manner," using firmer outlines and duller coloring, but in the later 1880s he relaxed into a softer and more supple style—grander and simpler than that of his early years but with the same warmth.

An area of deep blue-black suggests a shadowy background against which Renoir's pale face stands out. Thinner layers of blue and touches mixed with white are used for shadows on the face and clothing.

The eyes, eyebrows, hair, hat, and scarf are given added definition through the use of black. Although many impressionists banished black from their palettes, Renoir retained it, often combining it with pearly whites to great decorative effect.

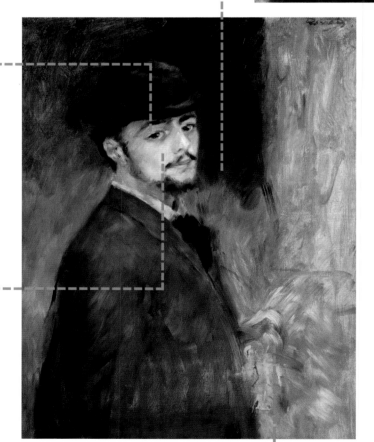

The flesh tones are applied more thickly than the paint elsewhere in the picture. Mixed with white, they convey a pale, smooth complexion through subtly blended brush strokes. Their handling, combined with the soft red lips and the dark eyes, recall the decorative charm of eighteenth-century rococo paintings, which Renoir admired.

Paint is applied thinly with light, feathery brushwork. Unlike other impressionists, Renoir used oil paint thinly, diluting it with a medium of oil and turpentine to create transparent and translucent layers that allowed the canvas to show through and enhance the luminosity of the color.

Images of women

One of the great worshipers of female beauty, Renoir created some of the loveliest images of women in nineteenth-century art, ranging from portraits and scenes of fashionably dressed young ladies to sensuous nudes.

Renoir's output was enormous—it has been estimated at six thousand pictures—and included a wide range of subjects: scenes of everyday life (particularly of people enjoying themselves), landscapes, portraits, still lifes (usually of flowers), and scenes from literature and mythology. However, more than anything else he enjoyed painting pretty young women—at work or at play, dressed in their finery or naked. He reveled in painting nudes, and in his later years he created a type of picture that became especially associated with him, showing voluptuous blond-haired beauties in the open air, with the light playing vibrantly on their glowing skin. These pictures are unashamedly sensuous, and Renoir said of such works: "When I have painted a buttock and feel like giving it a pat, I know it's finished."

Renoir used professional models as well as friends and members of his family to pose for him. His wife Aline appears many times in his art. When they met in 1880, Renoir was thirty-nine and Aline was a twenty-one-year-old seamstress with the kind of pretty plump features that appealed greatly to him. They married in 1890 and had three sons, one of whom became the famous film director Jean Renoir. Before he met Aline, Renoir's favorite model—and his lover—for several years was Lise Tréhot. They met in 1865, when Lise was only

sixteen, and they remained close until she married another man in 1872. In his later years, Renoir often painted his wife's young cousin Gabrielle, who joined the household in 1894, as a fifteen-year-old, when she came to help with the children.

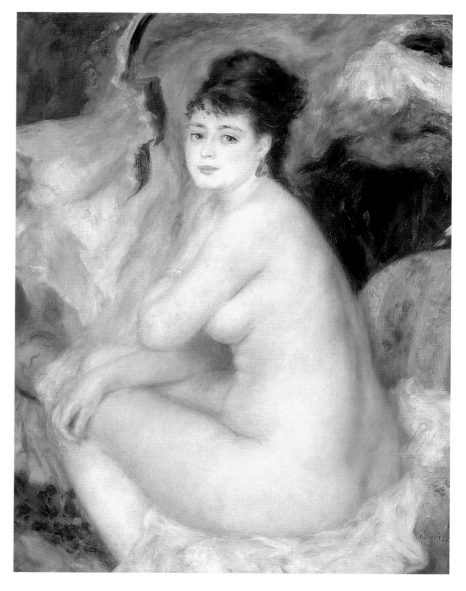

Below: Female Nude *(1876), one of Renoir's many sensual celebrations of female beauty. Pearly colors, subtle tones, and feathery brushwork convey the model's tender, translucent skin, her voluptuous curves, her blue eyes, and her soft silky hair.*

MARY CASSATT

1844–1926

This watercolor presents Cassatt in a shy, reticent way. However, the brushwork is vigorous and her art as a whole is far from timid. She spent almost all her career in France and she flourished in its highly competitive art world, winning the admiration of some of her greatest contemporaries. Comparing her with Berthe Morisot (see pages 158–61), the painter Paul Gauguin said, "Miss Cassatt has as much charm but more strength."

Cassatt was born in Allegheny (now part of Pittsburgh), into a cultured upper-middle-class family. Her father was a stockbroker and her mother was an intelligent and widely read woman who spoke French fluently. In 1860 Cassatt began studying at the Pennsylvania Academy of the Fine Arts in Philadelphia, and in 1866 she moved to Europe, where she remained for four years, continuing her studies in Paris and Rome. After spending about a year and a half in America, she returned to Europe, traveling widely before settling in Paris in 1874. In the same year she had a picture exhibited at the Salon, where it was admired by Edgar Degas (see pages 146–49). Three years later Degas met Cassatt and they became friends. At his invitation she took part in the fourth impressionist group exhibition in 1879, then in three more, including the final exhibition in 1886.

By this time Cassatt had made a considerable reputation, and her work sold so well that in 1894 she was able to buy an impressive country home, the Château de Beaufresne at Le Mesnil-Théribus, about 50 miles northwest of Paris. She lived there much of the time, but also maintained her home in Paris and usually spent the winter months in the warmth of the south of France. From 1891 her reputation was consolidated by a series of one-woman shows in Paris and New York, and in 1904 the French government made her a member of the Legion of Honor. She continued painting until about 1915, when she had to give up because of failing eyesight; after an unsuccessful operation for cataracts in 1921 she was virtually blind. In her later years she devoted much of her time to helping her wealthy American friends to build up their art collections; it is partly because of Cassatt's promotion of her colleagues' work that the impressionists are today so outstandingly well represented in American museums.

Self-Portrait, c.1880, watercolor on paper, National Portrait Gallery, Washington, D.C.

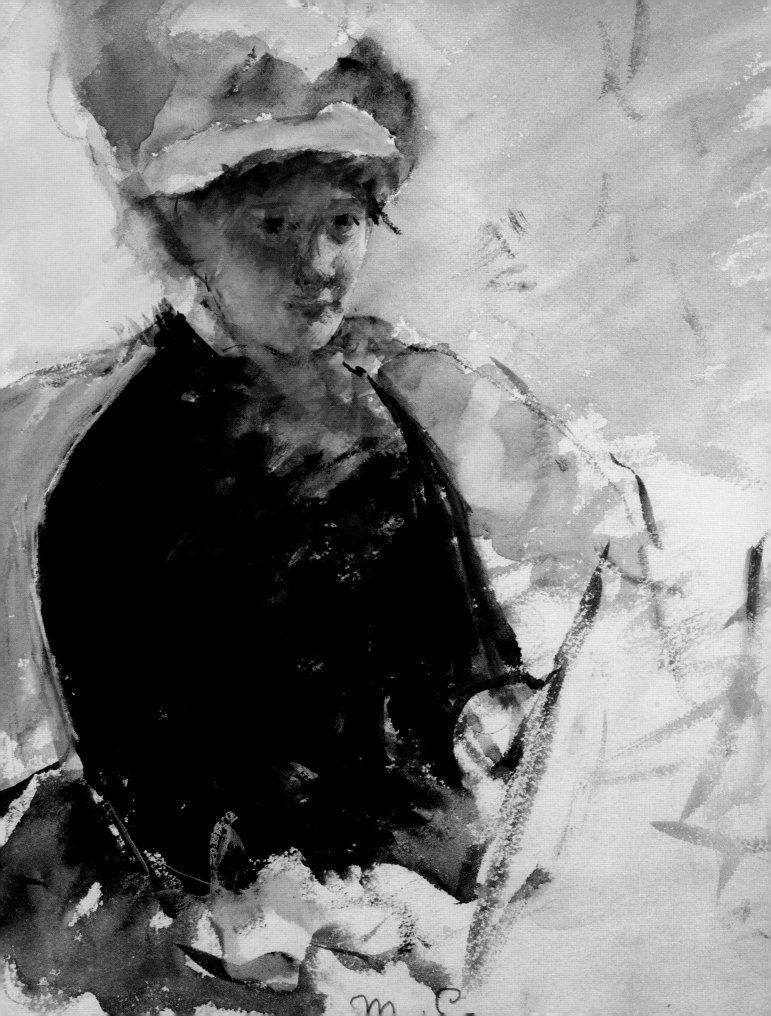

Style and technique

Cassatt began her career working in a solid, dark-toned, fairly traditional style, but by the late 1870s she had been converted to a softer, lighter, more impressionist approach. From about 1890 her style changed again, as she used firmer outlines and sometimes flat forms and unconventional viewpoints influenced by Japanese prints. Almost all her work is devoted to the human figure, and her favorite subject was the mother and child (although she never married). In addition to working in oil, watercolor, and pastel, she was an outstanding printmaker.

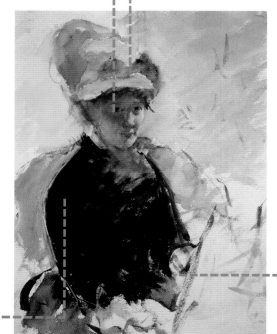

Shadow falls across most of Cassatt's face but her dark eyes look out with an intense gaze, and a warm expression animates her features. Fluid touches of brown, burnt sienna, rose, and white run into each other on the left side of her face, while the right half, which catches the light, is modeled with drier, more tightly worked strokes.

Pools of fluid ocher, umber, rose, and lilac watercolor create Cassatt's magnificent bonnet. Her friend Degas portrayed her in similarly fashionable clothes in several of his pictures of her, notably a portrait of c.1880–84.

The striking form of Cassatt's black dress is rapidly blocked in. Darker strokes of black suggest her arms and collar, while vigorously brushed lines of gray and white make her body stand out from the background.

Cassatt shows herself sketching or painting. Rapidly applied strokes of blue-black watercolor suggest the edge of a pad or drawing board to which she raises what appears to be her left hand—showing that the right-handed Cassatt did not correct the mirror image from which she made the portrait.

Americans in Paris

In the nineteenth century Paris was the artistic capital of Europe and it attracted painters and sculptors from all over the Western world, including numerous distinguished Americans.

Together with James McNeill Whistler (who was a decade older) and John Singer Sargent (who was a decade younger), Mary Cassatt was probably the best-known American artist of her period to make an impact in the Paris art world. Cassatt lived in Paris most of her life, and Whistler (see pages 142–45) and Sargent (see pages 186–89) each spent substantial periods there at the outset of their careers, when they were establishing their distinctive artistic voices. Other illustrious American painters of the time who had briefer stays in the city include Thomas Eakins and Winslow Homer. For many foreign visitors, the attractions of Paris included not only its artistic traditions and institutions, but also its reputation for hedonism. It was Europe's capital for sex as well as art and countless young men must have regarded a stay there as an opportunity to sow their wild oats at a safe distance from home. Things were different for Cassatt, though, as she was a model of middle-class feminine propriety; her subjects are mostly limited to those a respectable lady would encounter in her daily life, and it is notable that men occur in her work fairly rarely.

It was not only Paris that appealed to American artists. Barbizon, a village in the forest of Fontainebleau, was particularly popular with landscape painters, for example. One of the Americans attracted there was Theodore Robinson (1852–96), who studied in Paris in 1876–79 and later returned to live in France from 1884 to 1892. In 1887 he met Claude Monet and the following year he settled at Giverny, where he was the great man's friend and neighbor. Robinson's presence brought other Americans to Giverny, and the locals sometimes objected to their boisterous behavior.

Above: Theodore Robinson, The Bridge at Giverny, *1891. Influenced by the impressionists, Robinson painted outdoors, using free brushwork and fresh colors.*

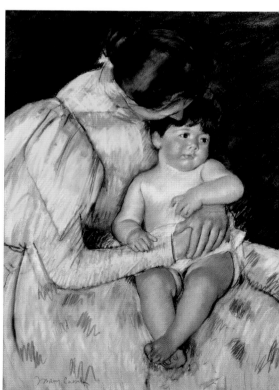

Right: Cassatt, Mother and Child, *1893. This intimate pastel is typical of Cassatt's works, many of which explore the tender bond between mother and infant.*

HENRI ROUSSEAU

1844–1910

The title, *Myself, Portrait-Landscape*, is Rousseau's own and has a quirkiness appropriate to the man and his work. He was one of the most engaging characters in the art of his time and the first naive painter really to make a mark in the history of art. Here he shows himself beside the Seine River, with the newly built Eiffel Tower in the background, in an image that combines formal strength with beguiling charm. Such freshness of vision has appealed greatly to modern taste, but Rousseau endured a good deal of mockery in his lifetime and it was not until after his death that his genius was widely appreciated.

Rousseau was born in Laval, northwestern France, the son of a tinsmith and hardware dealer. In 1863 he joined the army and served for five years. Later he claimed that during this time he had taken part in the French expedition to Mexico, but this story was a product of his lively imagination and as far as is known he never set foot outside France in his whole life. When he left the army he moved to Paris and in 1871 got a job with the municipal toll service, which collected taxes on various goods brought into the city. It is from this job that his nickname "Douanier" (customs officer) derives, although he never held such a senior title. He began to paint in his spare time, and soon his hobby became a passion. In 1884 he obtained permission to copy pictures in the Louvre, and in 1886 he began showing his work at the Salon des Indépendants, an exhibition venue set up in opposition to the official Salon; anyone who paid a fee could show their work. In 1893 he took early retirement so he could paint full time.

Initially Rousseau's paintings received some encouraging reactions in newspaper reviews, from critics who thought them odd but sincere. However, more usually he was a prime target for abuse and sarcasm. Neither this adverse criticism nor acute poverty put him off painting, and by the end of his life he had won the admiration of leading avant-garde artists—including Pablo Picasso—and critics. He was buried in a pauper's grave, but soon afterward his reputation began to rise steeply and he is now one of the best-loved painters of his time.

Myself, Portrait-Landscape, 1890, oil on canvas, National Gallery, Prague

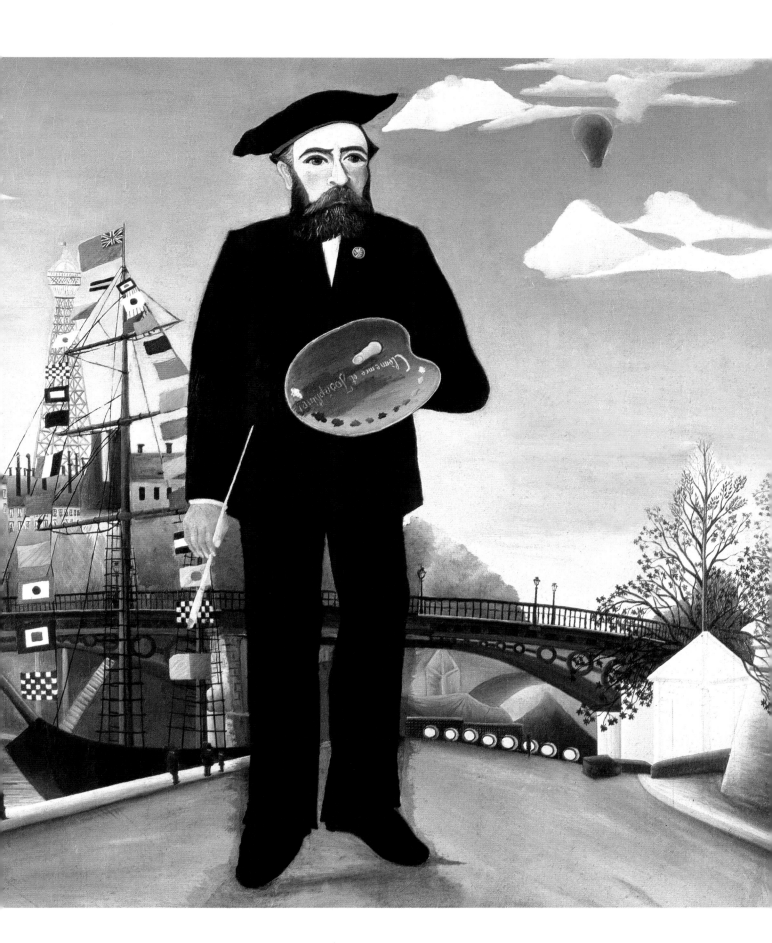

Style and technique

Rousseau painted various types of picture, including landscapes, portraits, flower pieces, everyday life scenes, and imaginative subjects. He is probably best known, however, for his jungle scenes. These works were said to be inspired by his nonexistent experiences in Mexico but in fact were based on visits to the zoo and botanical gardens in Paris and on illustrations in books. His work is often clumsy, but the clumsiness is charming and accompanied by a wonderful freshness of imagination—a freshness he somehow managed to maintain even when he was working on a large scale.

The features of Rousseau's face are sharply delineated and his body appears as a black silhouette looming in front of the cityscape. The minutely detailed style and flattening of pictorial form and space reflect both Rousseau's lack of formal training and the artistic concerns of his contemporaries such as Paul Gauguin (see pages 178–181).

The gray shape of a hot-air balloon rises in the sky to the right of the painter's face. It was inspired by a balloon that floated above Paris during the 1889 World Fair held in the city. It also has a mysterious, dreamlike quality.

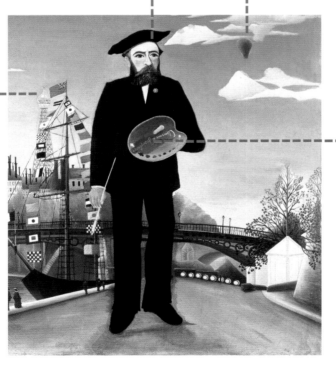

Rousseau shows himself holding a palette and brush. On the palette are neat dabs of paint and an inscription with the names of his wives, Clémence and Joséphine.

In the background is the Eiffel Tower, which had been completed in 1889 to mark the World Fair and the centenary of the French Revolution. Rousseau was one of the first painters to depict the landmark, which was unpopular at first. The tower is partly obscured by a ship's rigging adorned with colorful flags, which are partly taken from a book on signaling and partly imaginary.

The naive painter

Rousseau is the only naive painter to be widely acknowledged as one of the great masters, but many other naive artists have achieved recognition and honors.

Naive art is often easy to recognize, but it is hard to define precisely. It is a type of painting—or very rarely sculpture—in which an artist lacks conventional skills in naturalistic representation but compensates for this by freshness and spontaneity of vision. This kind of painting emerged in the nineteenth century but did not become a significant strand in art until the twentieth century. The first outstanding exponent was probably Edward Hicks (1780–1849), an American Quaker preacher. His work includes some farm scenes and landscapes, but he is best known for his many versions of *The Peaceable Kingdom*, which exemplify Quaker pacifism by showing people and animals living in harmony.

Rousseau's work began to become widely known soon after his death in 1910, but it was not until the 1920s and 1930s that naive art as a whole was put on the map. The man who was mainly responsible for this was

Above: Grandma Moses, Taking in the Laundry, *1951. This scene is typical of Moses's work, which draws on her memories of what she called "old timey" farm life.*

Wilhelm Uhde (1874–1947), a German art dealer and writer who settled in Paris in 1904. He wrote the first book on Rousseau (1911), organized an exhibition of his work in 1912, and after World War I discovered and encouraged other naive painters. Because Uhde was based in Paris, most of the naive artists he was involved with were French, but by about the middle of the century there were notable exponents in many other countries, including Grandma Moses (1860–1961) in America. She took up painting in her seventies and had her first exhibition in 1940 when she was eighty. The richest traditions of naive painting have been in the former Yugoslavia—mainly in the region that is now Croatia—and Haiti.

Left: Rousseau's Tiger in a Tropical Storm (Surprised!), *1891, the first of his jungle paintings. It is typical of Rousseau's work, combining freshness of design and color with meticulous detail.*

THOMAS EAKINS

1844–1916

This is a strong, severe face, with a feeling of sadness and even bitterness in the expression. It suggests the embattled nature of Eakins's life—he spent much of his career engaged in controversy or working in isolation, and eight years before he painted this picture he wrote, "My honors are misunderstanding, persecution, and neglect." It was only near the end of his life that he began to be recognized as a major figure in his country's art; since then his reputation has soared, and he is now regarded by many critics as the greatest of all American painters.

Eakins was born in Philadelphia and spent virtually all his life there. His only significant time away from the city was a period in Europe, from 1866 to 1870, when he rounded out his artistic education, mainly in Paris but also in Madrid, where he was particularly impressed by Velázquez's work (see pages 58–61). In 1876 he had his first notable experience of "misunderstanding, persecution, and neglect" when his picture *The Gross Clinic*, painted the previous year, was rejected for a major exhibition celebrating the centenary of the Declaration of Independence. It shows a famous Philadelphia surgeon carrying out an operation, and its powerfully realistic treatment of the subject was considered shocking. In the same year he began teaching at the Pennsylvania Academy of the Fine Arts, but in 1886 he was forced to resign after he allowed his women students to draw from a completely naked male model. Here again, his desire to search for truthfulness was at odds with official opinion.

Because he had a small private income and modest habits, Eakins was able to pursue his ideals without having to worry about selling his work. After the turn of the century he at last began to receive some critical acclaim, and the year after his death a memorial exhibition of his work was held at the Metropolitan Museum in New York and conclusively established his reputation. Among the people who saw it was the painter Robert Henri. He was an outstanding teacher and he urged his students to study Eakins's work, saying, "His quality was honesty. 'Integrity' is the word which seems best to fit him. Personally I consider him the greatest portrait painter America has produced."

Self-Portrait, 1902, oil on canvas on board, National Academy of Design, New York

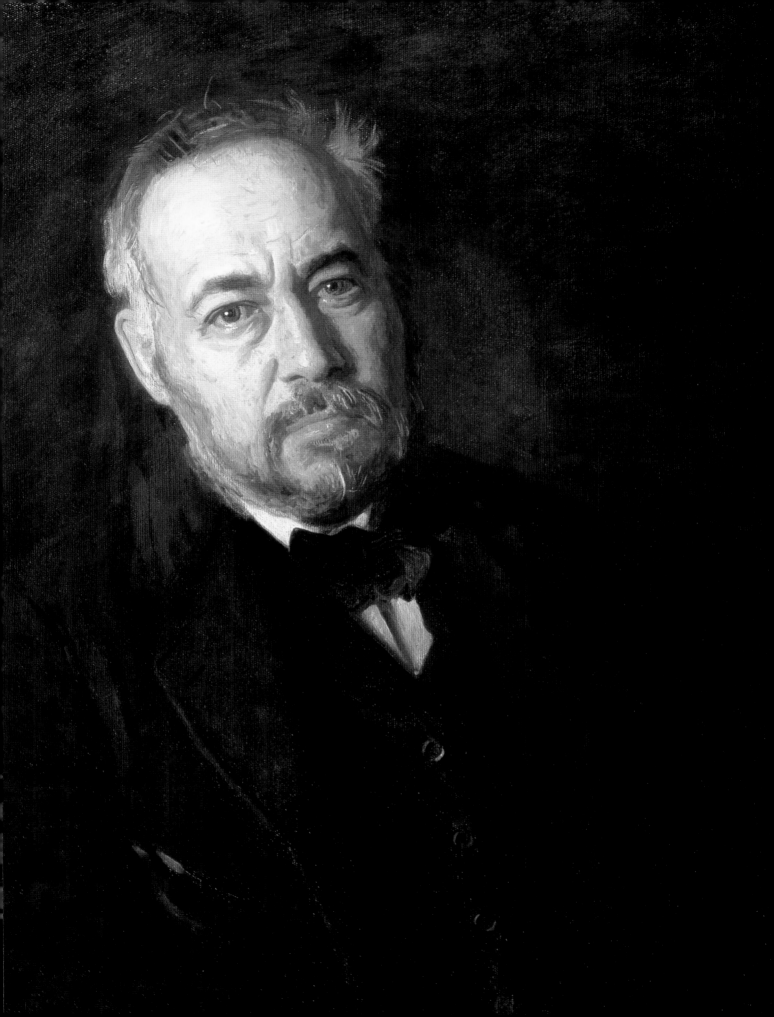

Style and technique

Almost all of Eakins's work involved the human figure and he had a great mastery of anatomy, based on serious scientific study. His searching realism penetrated beyond surface appearances, however, for his portraits have great depth of characterization; in this respect, as well as in his mastery of somber lighting effects, he is often compared with Rembrandt. For his major pictures he worked in oils, but he also used watercolors—generally for lighter subjects. In addition he made a few sculptures and he took photographs both as study aids and as independent works.

The painting is dominated by Eakins's serious expression. He looks out directly at the viewer, with an intense, almost stern stare, his brow slightly furrowed in concentration.

Strong directional light illuminates the left side of Eakins's face, spotlighting it against the dark tones of the rest of the painting. Eakins's style, based on tonal contrast, was influenced by the Old Masters, particularly the Spanish painter Velázquez.

The full form of Eakins's face is firmly modeled, using directional brush strokes, strong tones, and clearly delineated contours.

The aging artist, with his graying beard, formal clothes, and solid presence, exudes an air of authority. Eakins painted this portrait as a diploma work for admission into the National Academy of Design, a prestigious, honorary association of artists, of which he was elected a member in 1902.

Boating and bathing

In his outdoor scenes Eakins created some of the most original works in nineteenth-century American painting, combining his mastery of figure painting with vivid observation of nature.

Eakins is primarily famous for his somber portraits, but he also excelled in a completely different vein, creating memorable and highly inventive pictures of outdoor activities. These works reflected his own interests, for he loved outdoor exercise and took part in recreations such as hunting, rowing, sailing, and swimming. The most famous of his outdoor scenes is probably *Max Schmitt in a Single Scull*, painted in 1871, soon after Eakins had returned from Europe to Philadelphia. It shows a champion rower—a friend of Eakins's from boyhood—on the Schuylkill River. The oarsman in the middle distance behind him is Eakins himself—he often included himself in his pictures in this way. Although the painting has a feeling of great freshness and informality, preparatory drawings—including precise studies of boats in perspective—show how carefully Eakins planned it. At this stage in his career he often made such drawings, but he seems to have abandoned the practice in the late 1870s.

Another much-reproduced favorite among Eakins's outdoor scenes is *The Swimming Hole* (1883). Here too the artist has included himself, as a subsidiary figure on the right, swimming toward the main group preceded by his dog Harry. The five main figures are pupils of Eakins. Although one of the figures is caught in mid-dive, the painting is less

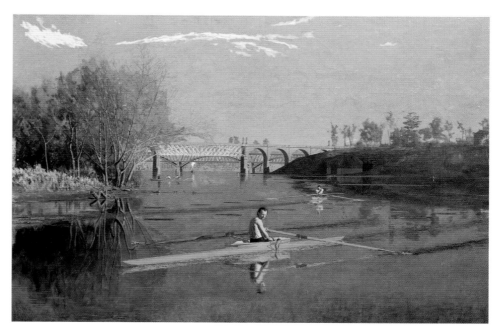

Above: Eakins, Max Schmitt in a Single Scull, *1871. Precise rendering of detail and crystal clear light characterize Eakins's meticulously planned river scene.*

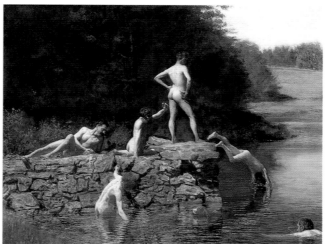

Left: Eakins, The Swimming Hole, *1883. In this painting Eakins treated a key theme in Western art, the active male nude, with a fresh realism.*

spontaneous-looking than *Max Schmitt in a Single Scull*. It is indeed a carefully composed exercise to show off Eakins's wonderful prowess in painting the nude rather than an attempt to capture the feeling of a specific moment. Here he used photographs and small preparatory wax models to help him achieve the varied poses he wanted.

177

PAUL GAUGUIN

1848–1903

Behind himself Gauguin has shown one of his best-known paintings, *The Yellow Christ* (1889), inspired by a roughly carved and brightly painted wooden crucifix he had seen in a church in Brittany. Although he was not a practicing Christian, Gauguin was touched by the humble faith of the peasants he encountered in this rugged region of northwestern France, which was very traditional—almost medieval—in its ways. Much of his career was the story of his efforts to escape what he called "the disease of civilization" in favor of the "great rustic and superstitious simplicity" he found in Brittany and later among the islanders of the South Pacific. This desire to feel in touch with earthy human emotions and his willingness to sacrifice everything for his art have helped make him one of the great cultural icons of modern times.

Gauguin's taste for places far away from the world of polite society had been with him from childhood, for although he was born in Paris, he grew up partly in Peru, his mother's ancestral country. In 1865, when he was seventeen, he joined the merchant navy, and in 1871 he had a complete change of direction, becoming a stockbroker with a bank. He was successful at his job, married in 1873, and settled into a life of respectable prosperity. However, he had begun painting as a hobby and it turned into a consuming passion. In 1883 he left his job so he could paint full time and in 1886 he abandoned his family—by this time he had five children. For the next four years he spent much of his time in Brittany, but he also visited Panama and Martinique, as well as Arles, where he briefly worked with Vincent van Gogh (see pages 182-85).

In 1891 Gauguin moved to Tahiti—a French colony—and after an interlude in France, in 1893-95, he returned permanently to the South Seas, living first in Tahiti again and then from 1901 in the Marquesas Islands, where he died. In his final years he often endured illness and poverty, but he painted indomitably. His reputation was firmly established in 1906, when a large exhibition of his work was held in Paris, and thereafter he became one of the most influential figures in progressive art.

Self-Portrait with Yellow Christ, 1889–90, oil on canvas, Private Collection

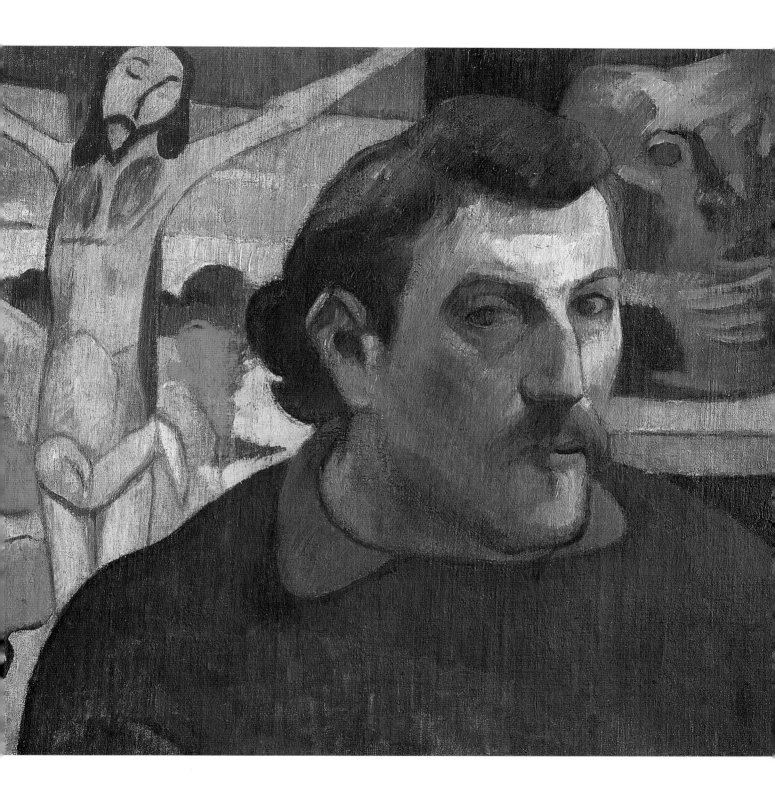

Style and technique

Gauguin's output was large and varied. In addition to paintings, he produced sculpture, prints, and pottery. He was largely self-taught and his work excels in rough vigor rather than surface polish, especially in his late paintings, when poverty often forced him to use pieces of coarse sacking in place of properly prepared canvas. He used colors and shapes for their expressive potential rather than to depict the world naturalistically, and his example was largely responsible for inspiring the fascination with "primitivism" that runs through so much of twentieth-century art.

A simplified detail of Gauguin's The Yellow Christ (1889) occupies a large portion of the background. It is reversed, indicating that Gauguin was working from a mirror. Its bright yellows and oranges complement the darker blues and greens of Gauguin's clothing, while its curves frame the artist's head.

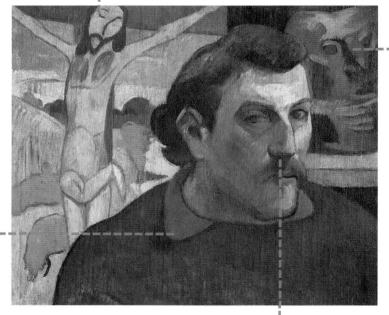

A primitive-looking ceramic tobacco pot made by Gauguin shares the background with The Yellow Christ. Gauguin modeled the vessel—now in the Musée d'Orsay, Paris—in the shape of his own head. Here he shows it in a three-quarters view that echoes his own pose.

Gauguin's collar and jersey are strongly outlined in black. The formal emphasis on simplified, bold outlines enclosing areas of flat color—popular with several of Gauguin's contemporaries—was inspired by medieval stained glass and enamels.

Gauguin's hooked nose and heavy, angular face are firmly modeled with clear contours and parallel, directional brush strokes. He looks pointedly out of the portrait, and the shadow that falls across the left side of his face adds a brooding quality to the image.

Postimpressionism

The impressionists revolutionized painting, but in concentrating on light and atmosphere they neglected factors that were supremely important to their successors, the postimpressionists.

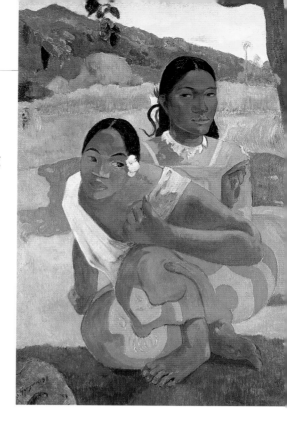

Together with Paul Cézanne and Vincent van Gogh, Gauguin is regarded as one of the central figures of postimpressionism. This imprecise but useful term—coined by the English art critic Roger Fry in 1910—describes various trends in painting that developed from impressionism or in opposition to it between about 1880 and 1905. After overcoming initial hostility, impressionism proved to be enormously influential, undermining the authority traditionally enjoyed by large, formal, highly finished paintings and promoting instead a kind of picture that expressed more directly the artist's individual response to the world. However, although progressive artists regarded this as a breakthrough, some of them thought that by focusing so much on surface appearances the impressionists had overlooked or diluted the emotional values of art. Gauguin, for example, wrote in 1889: "I greatly respect the work of Degas, yet I feel occasionally that he lacks something that carries him beyond himself—a heart that beats."

Gauguin's work was much concerned with the symbolic use of form and color, but Cézanne and van Gogh were very different in approach. Cézanne was interested above all in pictorial structure (see pages 150–53), whereas to van Gogh the expression of intense emotion was all-important (see pages 182–85). Another major postimpressionist, Georges Seurat (1859–91), took as his starting point the impressionists' use of vibrant color and tried to give it a scientific and rational basis by using small touches

Above: Gauguin, When Are You Getting Married?, *1892. The vibrant colors and simplified forms impart a decorative appeal and express an underlying tension.*

of pure color on the canvas rather than physically mixing them together. Collectively the work of Cézanne, Gauguin, van Gogh, and Seurat provided much of the impetus for the exciting developments that took place in art in the early twentieth century.

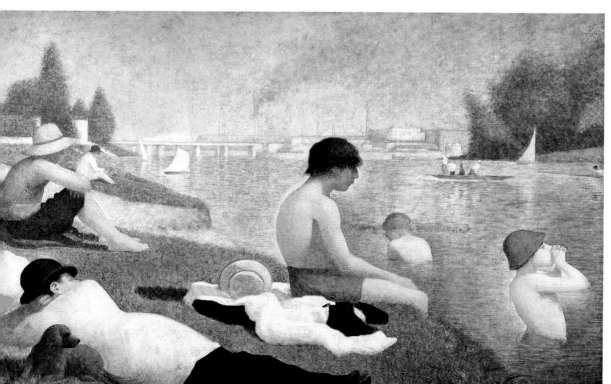

Left: Georges Seurat, Bathing at Asnières, *1883–84. In this, his first major painting, Seurat took a subject popular with the impressionists and employed their light palette, but he was much more systematic in his technique and use of color.*

VINCENT VAN GOGH

1853–90

This portrait commemorates one of the most famous incidents in the history of art, when, on Christmas Eve 1888, van Gogh mutilated his left ear in a fit of madness after a quarrel with his friend Paul Gauguin (see pages 178–81); it appears to be his right ear that is injured in the painting, because he did not correct the mirror image from which he worked. Contemporary accounts disagree as to whether he cut off his whole ear or only the lobe, but he certainly injured himself badly. The story encapsulates the extraordinary passion of van Gogh's life, a passion that has made him—in the public imagination—the archetypal example of the tormented, tragic genius.

Van Gogh was the son of a Dutch pastor and thought deeply about spiritual matters. It was only in the last ten years of his short life that he took up drawing and painting seriously, although an interest in art ran in his family. In 1869, aged sixteen, he got a job with a firm of picture dealers in which his uncle was a partner. He was posted to the firm's London branch and then to the Paris branch, but he was fired in 1876 because of his quarrelsome, unstable behavior. After a period when he worked variously as a teacher and lay preacher (he thought about training for the priesthood) and lived for a time in abject poverty and misery, in 1880 he decided to become an artist and worked at this new vocation as if it were a religious mission rather than a career.

Although he had a few lessons, van Gogh was essentially self-taught as an artist. He began with drawings, but took up oils in 1882. In 1886 he moved to Paris and then in 1888 to Arles in the south of France, where he hoped to found an artistic commune. It was there that he had his disastrous quarrel with Gauguin. After this episode he went voluntarily into an asylum for a year—epilepsy and schizophrenia are among the causes that have been suggested to explain his illness. In May 1890 he moved to Auvers-sur-Oise, near Paris, and two months later he died from a self-inflicted bullet wound. During his lifetime he was virtually unknown to the art world, but his reputation grew rapidly after his death and over the next two decades he became recognized as one of the founders of modern art.

Self-Portrait with Bandaged Ear, 1889, oil on canvas, Courtauld Gallery, London

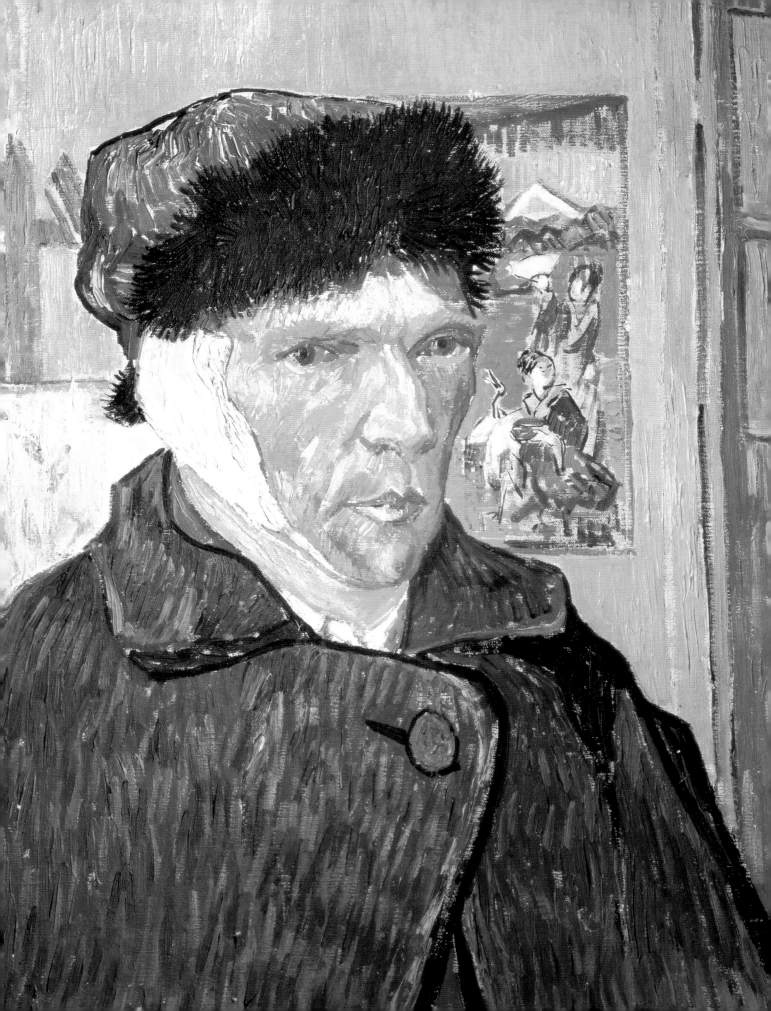

Style and technique

Although his career lasted only ten years, van Gogh's output was huge—roughly a thousand drawings and a thousand paintings by him are known. Obviously he was capable of working at great speed, but he thought carefully about his pictures rather than creating them in a kind of frenzy. His early work was predominantly somber, but in Paris and even more so in the south of France he celebrated the beauty of color and light. Most of his greatest works were produced in the last two or three years of his life—a creative outpouring rarely paralleled in the history of art.

Thick paint applied in short parallel strokes is used to render the bandage and blue hat with its black fur edging. Van Gogh's striking headgear recalls another self-portrait shown earlier in this book, that of the eighteenth-century painter Chardin (see pages 78–81). In Van Gogh's case, though, it has a terrible poignancy as a visual reminder of the self-mutilation and mental instability that presaged his death.

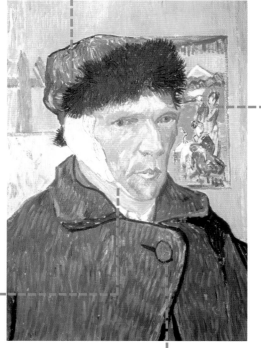

A brightly colored Japanese print with two ladies in front of Mount Fuji hangs on the back wall. Its inclusion indicates the influence Japanese prints had on van Gogh who, like many other avant-garde artists of his time, was struck by their flat decorative color, their expressive patterns, and their bold compositions.

The thick black outline and slablike appearance of van Gogh's heavy overcoat show the influence of Gauguin's style (see pages 178–81), though the paint is more highly modulated with the vigorous brushwork that characterizes van Gogh's style.

The face is modeled with a striking variety of colors applied with strong, directional brush strokes. Bright red and green define the features, while the basic skin tone is a brilliant yellow. A line of pale blue indicating the bandage delineates the chin.

Tortured genius

In his final years van Gogh regularly painted himself, and in his letters to his family he often provided fascinating information about the genesis of these compelling self-portraits.

Van Gogh produced one of the greatest series of self-portraits in the history of art. Probably only Rembrandt (see pages 66–69), a fellow Dutchman and an artistic hero to van Gogh, outshines him in this respect. Whereas Rembrandt's self-portraits are spread throughout his career, all of van Gogh's—there are about forty—belong to the final five years of his life. Unlike Rembrandt, he left a good deal of information about how and why he came to paint them, for he

was a voluminous correspondent, especially with his beloved brother Theo, with whom he often discussed art in great detail. On September 17, 1888, he wrote to Theo: "I have bought a mirror to work from myself in default of a model, because if I can manage to paint the coloring of my own head, which is not to be done without some difficulty, I shall likewise be able to paint the heads of other good souls, men and women."

Van Gogh had highly distinctive looks, but he painted himself in such a variety of moods that the features sometimes do not seem to belong to the same person. This variance is in line with something that he wrote

to one of his sisters: "I want to emphasize the fact that one and the same person may furnish motifs for very different portraits ... one seeks after a deeper resemblance than the photographer's." Sometimes he exaggerated or distorted his features for particular effects. Once he made his eyes "slightly slanting," giving him an Asian look like a "worshiper of the eternal Buddha"—a nod perhaps toward his admiration for Japanese art.

Below: In this self-portrait of 1888, van Gogh's exaggerated features give him an Asian look, and the heightened color imparts an otherwordly feel. Van Gogh dedicated the painting to Gauguin.

Below: In this self-portrait of 1889, van Gogh's pale, gaunt face with its intense stare is made more dramatic by the vigorous, swirling brushwork and the contrast between dark and light colors.

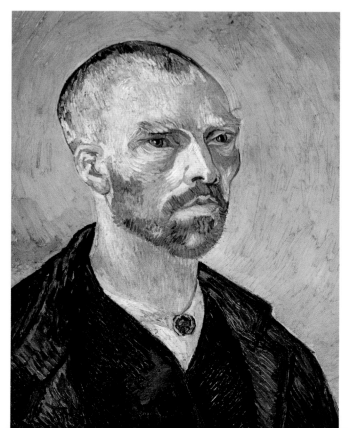

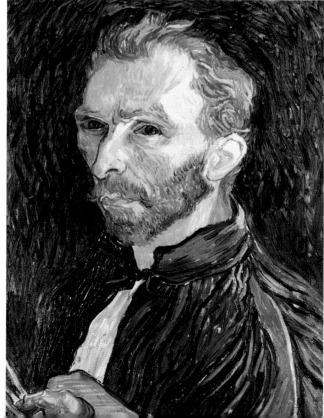

JOHN SINGER SARGENT

1856–1925

argent was far and away the most famous and successful portraitist in the world at the time he painted this picture. He depicted his sitters with such dazzling brilliance and glamor that there was an endless demand for his work on both sides of the Atlantic. However, Sargent came to hate the lucrative drudgery of commissioned portraiture, and in the year he painted this picture he decided to give it up to concentrate on the type of work he enjoyed—landscape watercolors and grandiose murals. In the remaining two decades of his life he kept his resolve, only occasionally producing a portrait, either to please a friend or out of a sense of duty.

As the self-portrait suggests, Sargent was every inch a gentleman—the American novelist Henry James, one of his many distinguished friends, described him as "cultivated to his fingertips." His life was cosmopolitan and sophisticated from the start. He was born in Florence to cultured American parents who were wealthy enough to spend their lives traveling around Europe. As a result of these travels Sargent's education was somewhat piecemeal, but he grew up speaking French, German, and Italian in addition to English. In 1874 he began studying art in Paris, which remained his base until 1884, when he moved to London. This city was his home for the rest of his life, but he traveled very widely and made many visits to America—he did not see his homeland until he was twenty-one, but he had strong patriotic feelings and turned down a knighthood because accepting it would have meant giving up his American citizenship.

After he virtually abandoned portraiture in 1907, Sargent devoted much of his time to landscapes and to murals for the Public Library and the Museum of Fine Arts in Boston. For the library he painted a series on the history of religion (1890-1916) and for the museum he painted scenes from classical mythology (1916-25). During World War I (1914-18) he worked as an official war artist for the British government and from 1918 to 1919 painted a huge canvas entitled *Gassed*, which is perhaps the greatest picture inspired by the war. After his death Sargent sank in critical esteem, being dismissed as slick and superficial, but since the 1970s his reputation has revived to something like its former heights.

Self-Portrait, 1907, oil on canvas, Uffizi, Florence

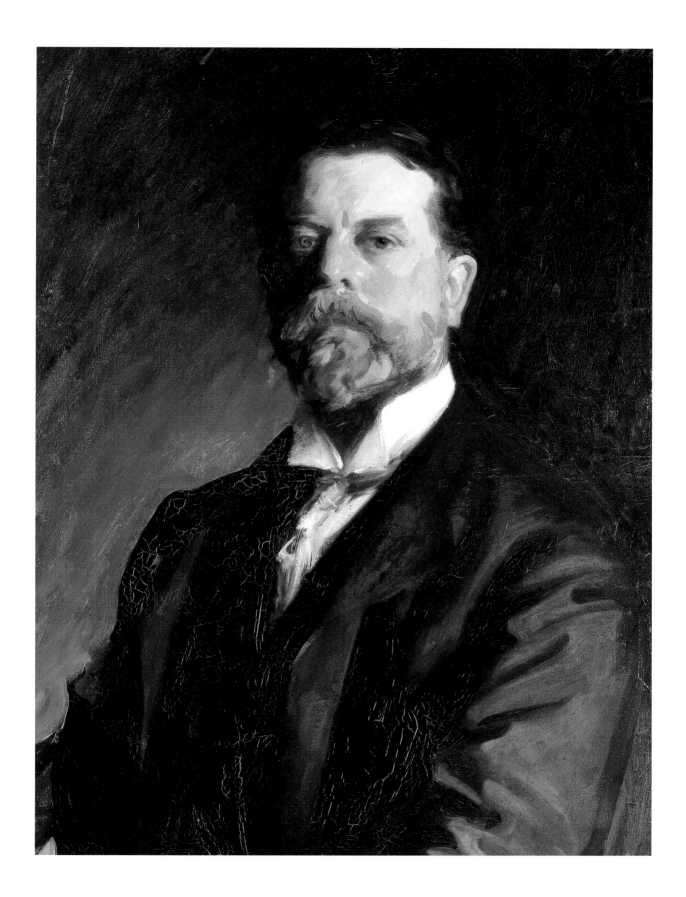

Style and technique

Sargent's portraits are marked by aristocratic elegance, poise, and assurance, coupled with brushwork of superb freedom and finesse. In addition to the grand formal portraits on which his reputation was mainly based, he painted many informal portraits of friends, some of them dashed off in only a few hours. The watercolor landscapes that he loved to paint have a similarly fluid and vigorous technique, with strong, glittering light effects. His mural paintings, on the other hand, are much more deliberate and somber in style, as befits their size and purpose.

Sargent looks out directly at the viewer with assurance, his head held high. This painting was commissioned by the Uffizi to hang in its gallery of self-portraits, which was a rare and great honor—the gallery also commissioned the self-portrait by the Pre-Raphaelite painter William Holman Hunt (see pages 130–133).

Broad, gestural brushwork is used to apply thick creamy highlights over warm pink fleshtones, and to convey the thick graying beard and moustache. Although the image is sober and understated, the handling has great facility and freedom.

Sargent portrays himself in immaculate formal dress: a crisp white shirt and tie, with black vest and jacket. His smart, dark clothing adds to the serious, authoritative air exuded by the self-portrait. The cracking visible in the darkest parts of the painting suggests that Sargent used bitumen, a very unstable pigment (see page 132).

Sargent portrays himself half-length, depicting only the upper portion of his body. He doesn't show his hands and there is nothing to indicate that he is a painter—no palette or brushes. As here, he usually favored plain or very spare settings in his portraits.

Society portraits

In his portraits Sargent memorably captured the glamor and opulence of his wealthy and privileged sitters; he was aptly described by the sculptor Auguste Rodin as "the van Dyck of our times."

The portraits for which Sargent is best known are very grand images of the rich and famous—people such as society hostesses, wealthy businessmen, and eminent politicians and soldiers. He was the last in a great line of portraitists in this vein stretching back to van Dyck in the seventeenth century (see pages 62–65). Such portraits continued to be painted after Sargent, but the social upheavals of World War I and the aesthetic revolutions of the early twentieth century meant that they never again held such a dominant place in the art world. Sargent greatly admired van Dyck and sometimes consciously echoed his work. Like van Dyck he was accused of shamelessly flattering his sitters, and many of them certainly look amazingly glamorous in his paintings. However, Sargent was by no means obsequious to his clients, and some of them were dissatisfied with their likenesses; one lady is said to have complained about the rendering of her nose, to which he replied, "Oh, a trifle like that you can alter yourself when you get home."

Some critics even claimed to detect a hint of deliberate caricature in certain Sargent portraits, as if he were seeking to undermine the pretensions of his clients. The painter himself denied any such aims and most of his sitters were delighted with the way he presented them. However, Sargent did come to hate having to make small talk with his clients, as he told his friend and fellow portraitist Jacques-Émile Blanche: "What a nuisance having to entertain the sitter and look happy when one feels wretched." By 1907, aged fifty-one, he had had enough and declared, "No more mugs!"

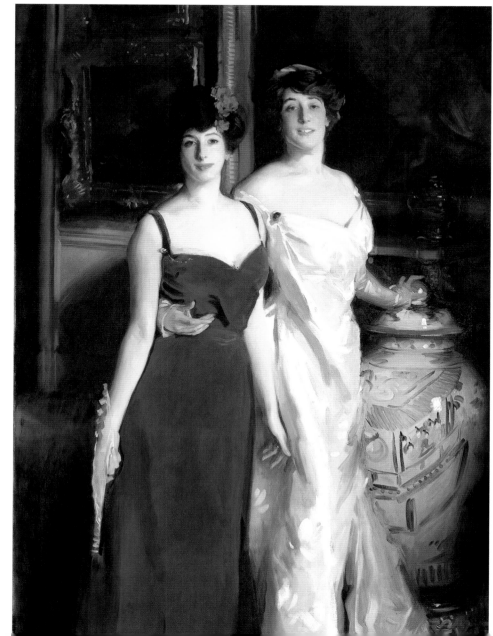

Below: Sargent, Ena and Betty, Daughters of Asher and Mrs. Wertheimer, *1901. One of Sargent's most brilliant portraits, it captures the wealth, beauty, and vitality of the sisters with deftness and panache.*

EDVARD MUNCH

1863–1944

Sitting by himself in a restaurant, his back turned to the other people in the room, Munch is absorbed in troubled introspection. He had an unstable life, and two years after he painted this self-portrait he suffered what he called a "complete mental collapse." Although he recovered from this breakdown and became more positive and outgoing in his work, he realized that the mental demons that had tormented him had also helped him to create his greatest paintings, in which he depicted anguished states of mind with an intensity never seen before in art.

Munch's career was shaped by a tragic childhood that gave him a bleak outlook on life. When he was four his mother died of tuberculosis, and when he was thirteen his eldest sister died of the same disease. His father, a doctor, was devastated by these deaths, becoming almost dementedly obsessed with religion and subject to outbursts of violence. A ray of light in the gloom came from Munch's kindly aunt, an amateur artist who encouraged him to draw. From 1881 to 1883 he studied art in Oslo and from 1885 to 1886 he painted the work that he regarded as "the breakthrough" in his art, *The Sick Child*. It is a hauntingly sad portrayal of a desperately ill young girl, poignantly recalling his own dead sister, and it set the tone for much of his subsequent work. It was attacked by almost all the critics who saw it, but Munch caused a much greater outcry in 1892, when an exhibition in Berlin was closed because the aching intensity of his work disturbed visitors so much. However, the publicity made him famous in Germany, so he based himself there until 1908.

This period from 1892 to 1908 was the creative heart of Munch's life, when he produced most of his greatest works, including *The Scream* (1893), his famous evocation of panic. In 1908 came his breakdown—the outcome of overwork and heavy drinking among other factors. After convalescing he returned to Norway and dedicated himself to recovery, working in a much more outgoing style. For the rest of his long life he was highly productive, his subjects including landscapes and commissioned portraits. By the time of his death his work had long ceased to be controversial and he was acknowledged as Norway's greatest artist.

Self-Portrait with Wine Bottle, 1906, oil on canvas, Munch Museum, Oslo

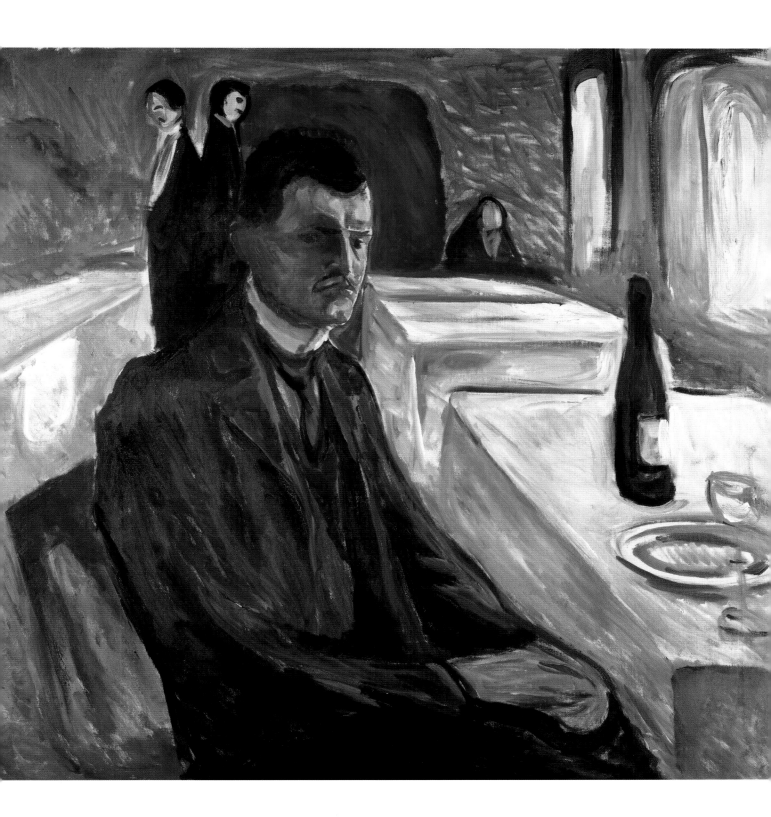

Style and technique

"I shall paint living people who breathe and feel and suffer and love," wrote Munch in 1889. For him, art was a matter of expressing powerful emotions, and certain themes—such as desire, despair, and jealousy—occur again and again in his work, depicted with extraordinary intensity in brushwork of immense vigor. In addition to being a painter of great stature, he was one of the supreme printmakers in the history of art, ranking with such giants as Dürer, Rembrandt, and Goya. He was equally masterful in etching, lithography, and woodcut.

Two waiters stand back to back, heads slightly bowed, increasing the sense of isolation in the painting. In 1905 Munch had written about his feeling that the soul was divided into two parts, the negative and the positive, which were good when combined but dangerous when separated. Some critics have interpreted the two waiters in this picture, who seem to spring from Munch's body, as a metaphor for the spiritual forces within the artist.

The dark, shrouded form of a lone, featureless diner emphasizes the sense of isolation conveyed by the painting. None of the figures communicates with its fellows or engages the viewer with eye contact.

Set against a blood-red background, Munch's thin face appears to frown with introspection. The angular lines of his brow, nose, and down-turned mouth, combined with his dark, shadowy, downward cast eyes, create an image of anxiety, tension, and unhappiness.

Contrasting colors—oranges and reds set against greens—and vigorous, almost frenzied brushwork express Munch's anguished state of mind.

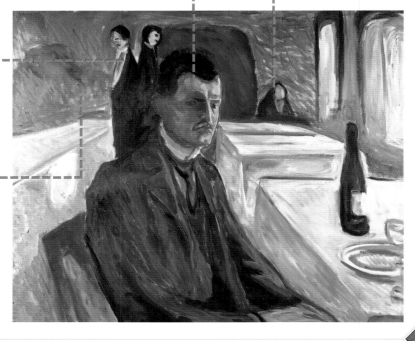

An anguished life

Few other artists have left such a memorable record of their journey through life as Munch did, as he developed from a troubled teenager to an old man awaiting death.

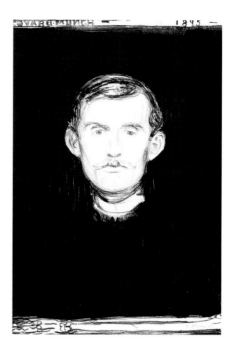

Munch's self-portraits cover the whole of his career, a period of more than sixty years. Most of them are in oils, but he also produced a few as prints, in particular a superb lithograph depicting him accompanied by a skeleton's arm. The first self-portraits date from the early 1880s, when he was still in his teens, showing him as a rather severe-looking youth, with a determined expression and observant gaze. The final ones were done shortly before his death in 1944, showing a man who is extremely frail but still a master of forceful brushwork and vibrant color. Munch was strikingly handsome, as numerous photographs attest, and women found him highly attractive, but in his self-portraits—even as a young man—he never seems interested in merely celebrating his good looks. He is much more concerned with examining his feelings.

In general the emotional temperature of Munch's work dropped after his recovery from his breakdown in 1908. However, in his later self-portraits he was often able to maintain the passion and profundity of his early years, and some of those from his last few years are among the most moving of all his paintings. They show him in various situations—wandering through his house at night, unable to sleep; convalescing after illness; or standing feebly by his bed. He never flinches from recording his physical decay, and he conveys a sense of desolate emptiness as he tremulously hovers on the edge of eternity. "It is no fun to grow old," he once said to a friend, "neither is it to die. We really have no great choice."

Right: Munch's Self-Portrait with Skeleton Arm *(1895) reflects on the transience of life and the continual presence of death.*

Below: Munch's anguished late Self-Portrait: The Sleepwalker *(1939) is painted with the emotional intensity of his early work.*

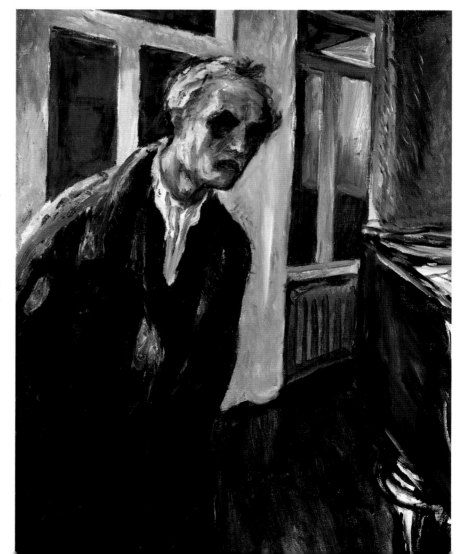

PIERRE BONNARD

This self-portrait is the last that Bonnard ever painted. He was in his late seventies at the time, with only another year or so to live. His bald head, the simple robelike costume, and the curious almond-shaped eyes give him the look of an Asian monk, and he peers out of the picture with an expression that can be interpreted as one of sagelike calm, as if he is preparing to say goodbye to the world in a mood of sad yet fond resignation. Such a sentiment would be appropriate, for he had led a life of quiet devotion to his work and had achieved steady worldly success; he had good reason to feel a sense of satisfaction and achievement in his old age. However, the blurred brushwork makes it difficult to be sure about his countenance; there is perhaps a feeling of bleakness, even desolation, suggesting Bonnard's grief at the death of his beloved wife—who was also his favorite model—five years earlier.

Bonnard was the son of an official at the French War Ministry, who insisted that he study law rather than art, which was his passion. However, he managed to combine the two, and by the early 1890s he was already having some success selling his work, so he was able to abandon the law and become a full-time artist. His early work was varied, for in addition to paintings he produced prints, posters, book illustrations, and designs for the stage. In 1896, for example, he worked on the original production of Alfred Jarry's satirical farce *Ubu Roi*, which is considered the pioneering work of the theater of the absurd—David Hockney later made designs for the same play (see page 249).

By 1912 Bonnard was a figure of sufficient stature in the art world to be offered the Legion of Honor, but with characteristic modesty he declined the award. In the same year he bought a house in the Seine Valley, although he was already spending an increasing amount of time in the south of France, where he loved the bright light. Eventually, in 1925, he bought another house at Le Cannet, near the Mediterranean resort of Cannes, and it was there that he spent most of the rest of his life, working with undiminished mastery to the very end.

Self-Portrait, 1945, oil on canvas, Private Collection

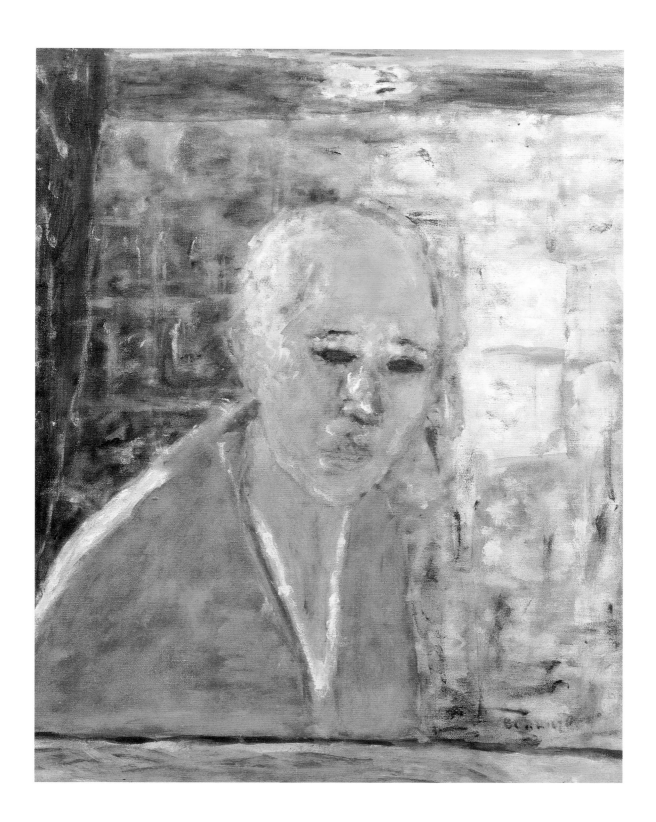

Style and technique

In his early career Bonnard was influenced by avant-garde ideas in art and his work shows the impact particularly of Gauguin's expressive use of color and pattern. However, from about the turn of the century he relaxed into a style that essentially continued the traditions of impressionism. He is regarded as the foremost upholder of this tradition in the twentieth century and also as one of the greatest colorists of his time. In addition to painting, he produced prints throughout his long life in a variety of techniques, including etching, lithography, and woodcut.

A loosely drawn grid of orange-brown lines suggests the tiled wall of a bathroom, and above Bonnard's head touches of yellow denote an electric light. The band along the bottom of the painting suggests that this is an image glimpsed in a bathroom mirror. Indeed, another of Bonnard's self-portraits of 1945 is clearly based on his reflection in a bathroom mirror—in it toiletries stand on the shelf under the mirror.

The dark, almond-shaped eyes make this a moving image of old age, their slightly downward gaze evincing an expression of sad reflection.

The touches of orange on Bonnard's forehead are typical of the high-key colors that characterize his style. However, the color range in this late portrait is narrower than in much of his work. There are few touches of the pinks, violet-blues, lilac, and yellow he used in his landscapes and interiors (see opposite).

Dark greens and browns, with flickers of orange and white, create a muted background behind the artist's frail form. Thickly applied yellow and white paint are used to make Bonnard's frame stand out from the background.

Intimate visions

Together with his close friend Édouard Vuillard, Bonnard created a distinctive type of painting called *intimisme*, in which he celebrated the comfort and warmth of untroubled domestic life.

Bonnard was a prolific artist and his output included various subjects, among them landscapes, portraits, still lifes—particularly of food and flowers—and townscapes. However, he is best known for his intimate scenes of everyday life set in his own home. In the 1890s the term *intimisme* was coined to describe such scenes, of which Bonnard and Édouard Vuillard (1868–1940) were the supreme exponents. They met while they were students and remained lifelong friends. Both of them were rather quiet and reserved in temperament and loved their home comforts. Bonnard was devoted to his wife; Vuillard never married, but he had a similarly stable domestic environment, living with his widowed mother until her death in

1928, when he was sixty. Another thing the two artists had in common was that they liked taking photographs and sometimes used them as an aid in their paintings.

Both Bonnard and Vuillard painted with a technique that can loosely be described as impressionist, but whereas the impressionists usually aimed at achieving naturalistic colors, the two *intimistes* often exaggerated or distorted theirs so as to enhance the sense of domestic warmth. Bonnard's color intensified as he grew older and his pictures tended to get bigger, with the result that in his later work he achieved a grandeur and richness that Vuillard never attempted. Bonnard's favorite model in his domestic scenes was his wife, Maria,

or Marthe, as she preferred to be called. They became a couple in 1893 but did not marry until 1925; she died in 1940. Bonnard's best-known pictures of Marthe show her in the bath—she was obsessed with personal cleanliness and spent an inordinate amount of time in the bathroom.

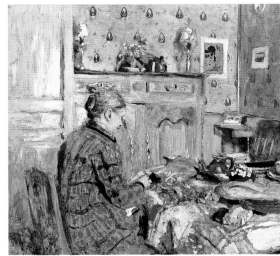

Above: Édouard Vuillard, Breakfast, *1899. This informal painting of the artist's mother is typical of Vuillard's work, with its free brushwork, warm colors, and cozy domestic subject matter.*

Left: Bonnard, Nude in a Bath, *1937. The intimate subject of the painter's wife Marthe taking a bath is the basis for an exploration of brilliant, shimmering color.*

PABLO PICASSO

1881–1973

Picasso was only twenty when he painted this striking self-portrait, but he looks appreciably older and also very careworn. At the time he was going through what is now called his Blue Period, when the subjects of his pictures were predominantly melancholy and depicted in cold blue tones. In line with this prevailing feeling he shows himself as if he is gaunt with suffering, like a martyred genius. Indeed, with his beard and his sunken cheeks, he looks rather like van Gogh (see pages 182–85). This may have been a conscious allusion (Picasso would certainly have known van Gogh's work at this time), part of the many-sided vision of the most prolific and versatile artist of the twentieth century.

Picasso was marked out to be an artist almost from birth. His father was a painter and drawing teacher, and the first word Picasso ever uttered is said to have been "piz," baby talk for "lapiz," the Spanish for "pencil." By the age of sixteen he already had his own studio in Barcelona. In 1900 he visited Paris for the first time, and he settled there in 1904. Over the next decade, up to the outbreak of the World War I, he was at the heart of the developments that revolutionized painting and sculpture in this period of unprecedented change in the arts. In particular he was the joint creator—with his friend Georges Braque—of cubism, which introduced a radically new way of representing the world. Instead of using a single fixed viewpoint, Picasso and Braque used many, so that a picture could show several different aspects of an object simultaneously.

During the war Picasso visited Rome, where he met his first wife, a ballet dancer. They married in 1918, by which time Picasso was wealthy and acclaimed. The marriage ended bitterly, as did several of his relationships with women, whom he once characterized as either "goddesses or doormats." He continued living in Paris up to and throughout World War II, but from 1946 he spent most of his time in the south of France, finally settling at Mougins, near Cannes. To the end of his life he remained amazingly productive, and when he died at the age of ninety-one he was universally recognized as one of the towering figures of twentieth-century culture.

Self-Portrait with Cloak, 1901, oil on canvas, Musée Picasso, Paris

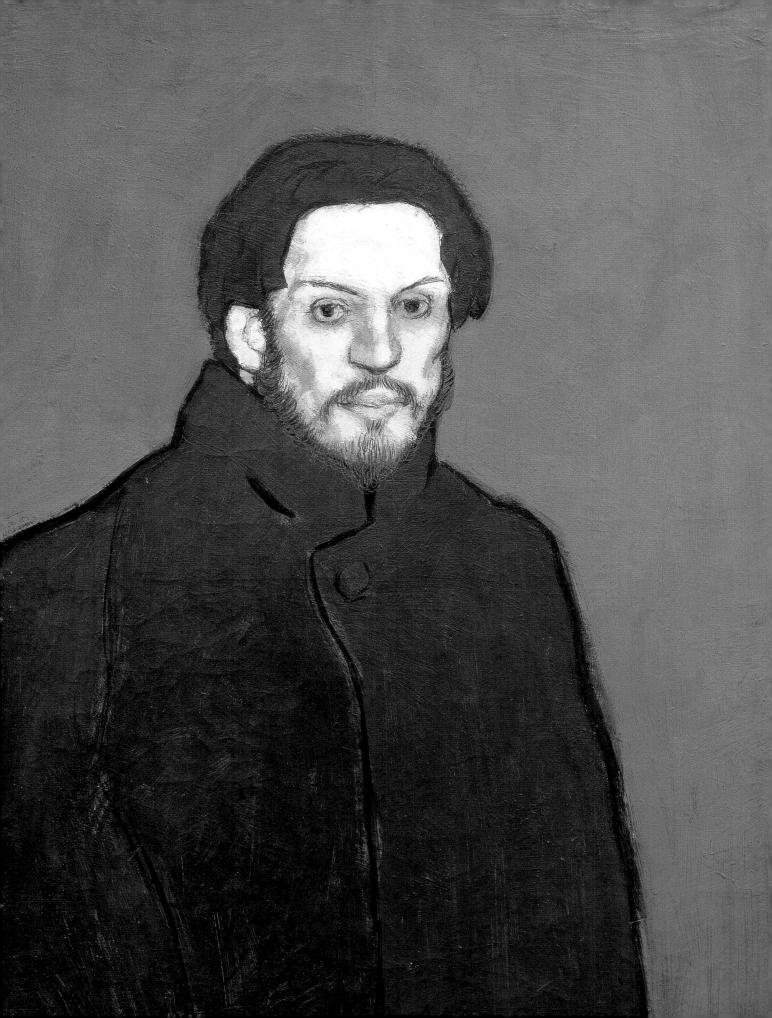

Style and technique
Picasso's career was enormously long—it began in the 1890s and ended in the 1970s—hugely productive and highly varied. He is primarily famous as a painter, but he was also a sculptor and printmaker, and he produced a large amount of work as a book illustrator, stage designer, and potter. Stylistically and technically he was always willing to experiment with new ideas, and emotionally he ranged from witty trifles to works that grapple with human tragedy and the momentous events of his time.

Despite its stylization, this self-portrait captures an essential likeness of Picasso—particularly his dark, intense, staring eyes. He exaggerated the gauntness of his face to accord with his notion of the poverty and hardships endured by artists.

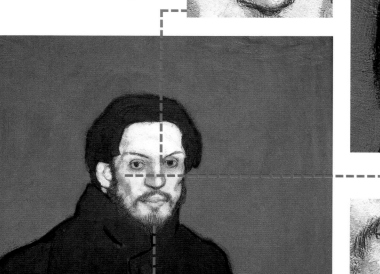

The painting is executed in a range of cool blues; the color is even used to model his deathly pale face and to render his hair. During the period 1901–04 Picasso based his palette on blue, a color with associations of melancholy and sadness, possibly partly in response to the suicide of Carlos Casagemas, a friend and fellow artist.

The cool pink lips and carefully delineated ginger hairs of the beard are the only parts of the painting that depart from the blue color scheme. The beard and gaunt look are reminiscent of van Gogh's self-portraits, which Picasso would have seen in Ambroise Vollard's gallery in Paris, though the painting lacks van Gogh's vigorous brushwork.

Heavy black lines delineate the simplified form of Picasso's cloak, enclosing slablike areas of largely unmodulated color. Picasso's style here has much in common with Paul Gauguin's (see pages 178–81)—though without his color range—and with that of avant-garde printmakers such as Henri de Toulouse-Lautrec (1864–1901).

Changing styles

Stretching over a period of more than three-quarters of a century, Picasso's self-portraits form an unequaled sequence of astonishing vigor, variety, and ingenuity.

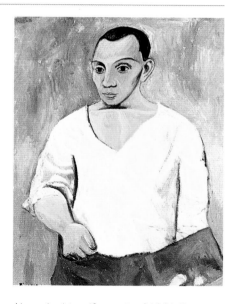

The earliest known self-portrait by Picasso is a drawing made in 1894, when he was only twelve or thirteen. At the other end of his life he was still producing drawings of himself in his final months, when he had turned ninety. In between these two extremes he created scores of other self-portraits in various techniques. No other great artist can match him for the sheer span of time he covered in his images of himself, and few can approach him in the richness and diversity of his treatment. Technically they range from substantial oil paintings, carefully planned and executed, to spur-of-the-moment sketches, done on a scrap of paper or even decorating a letter to a friend. In some of them he shows himself nude, in others in everyday clothes, and in still others specially dressed up, for example wearing a top hat. Some are deeply serious, but others are comic—in one drawing he depicts himself as a monkey. In addition to all the single self-portraits, there are numerous others in which he shows himself with other people, typically a female model or a group of friends. He also portrayed himself with his dog.

In general, Picasso's late work—after World War II—does not rank with his earlier production in quality or importance, although there was no decline in sheer quantity. In his final self-portrait drawings, however, he showed that at the very end of his life he could still produce work that was powerful and original. These drawings depict his head reduced almost to a skull, with eyes haunted by the ghastly imminence and finality of death.

Below: Picasso created this powerful self-portrait of 1906 using strong, angular black lines and summary color.

Above: In this self-portrait of 1906, Picasso represented himself with massive, simplified forms, his body looking heavy and sculptural.

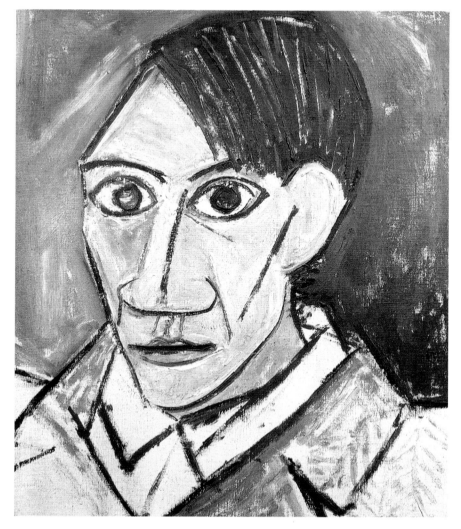

EDWARD HOPPER

1882–1967

The man in this self-portrait looks like a very solid and dependable character, and Edward Hopper did indeed lead a stable and regular life, quietly devoted to his art. His work is very solid, too, but it also has a strange haunting quality that makes him one of the most distinctive painters of his time. He spent almost all his career in New York—working in the same studio for more than fifty years—and created some of the most memorable images of urban life in the whole of twentieth century art.

Hopper was born in the small town of Nyack, on the west bank of the Hudson River, a few miles upstream from New York City. From 1899 to 1906 he studied illustration and painting, then made the first of three trips to Europe over the next four years, visiting many art galleries, particularly in Paris. After this period of travel he settled down to work in New York. He occasionally managed to sell a painting, but up to 1923 he earned his living almost entirely through commercial art such as book illustrations and magazine covers. In 1924, however, he had a successful exhibition of his watercolors and thereafter he was able to devote himself to painting. Over the next decade his reputation grew rapidly, leading to a major exhibition of his work at New York's Museum of Modern Art in 1933. This event firmly established him as one of the outstanding American artists of his time, and throughout the rest of his life he received a succession of prestigious awards, including various prizes and also honorary doctorates from several universities. His success did not go to his head or change his life in any way.

In 1964 another great exhibition of Hopper's work was held in New York, at the Whitney Museum of American Art. It was acclaimed by public and critics alike and was also shown in Chicago, Detroit, and Saint Louis. Hopper was still painting at the time, aged eighty-two, but he laid down his brushes the following year, two years before his death. His widow, who survived him by only a few months, bequeathed a huge amount of his work—including this self-portrait—to the Whitney Museum, which houses the world's greatest collection of twentieth-century American art.

Self-Portrait, c.1925–30, oil on canvas, Whitney Museum of American Art, New York

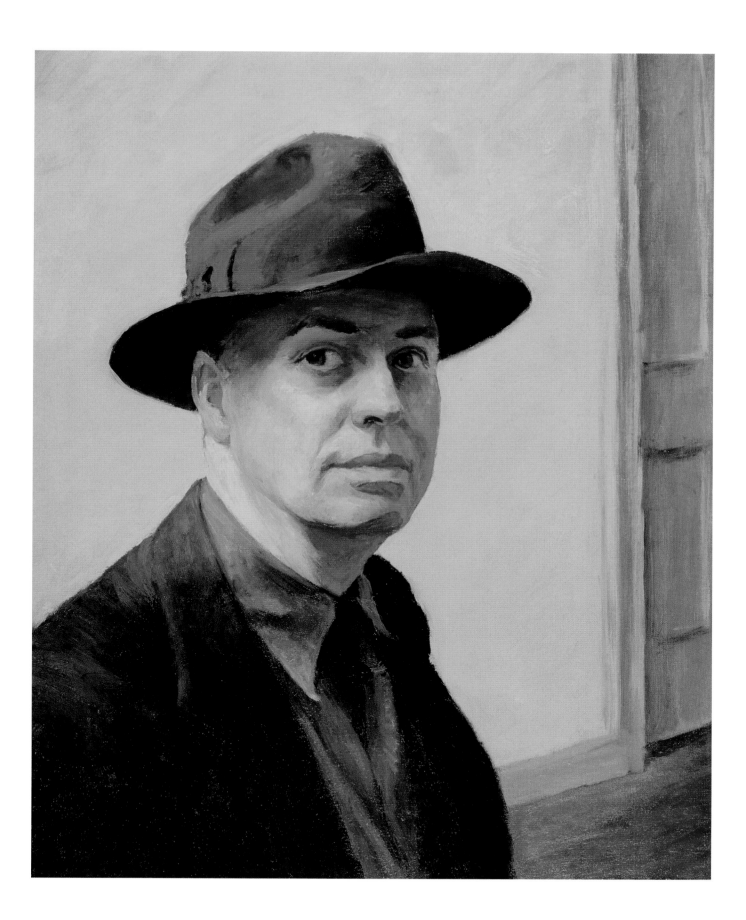

Style and technique

By the time he became a full-time artist in the mid-1920s, Hopper had already created his distinctive style and it changed little in the remaining four decades of his career. Stillness is a great characteristic of his art. Generally he shows one or two figures in a quiet interior setting, or an unremarkable building or patch of townscape with little or no human presence. His handling of paint is rather bland, and this somehow enhances the feeling of emotional reserve. In addition to painting, Hopper was arguably the greatest American etcher of the twentieth century.

The solid gaze of Hopper's eyes tells the viewer little about the artist's character—his feelings or ambitions. He was an immensely private man and this painting seems to exude the same self-contained anonymity that characterizes the generalized figures in his other paintings.

The paint is thickly applied with directional strokes. This self-portrait is a relatively early example of Hopper's oil painting technique. Later he used the paint much more thinly, diluted with turpentine, to create a flatter-looking finish.

Blocky tonal modeling, combined with the thick application of paint, conveys a solid impression of the artist's face. Hopper's style was based on tonal contrasts, reflecting his experience as a printmaker.

Hopper shows himself in a bare, white-walled room, its doorway and wooden floor visible to his right. Figures isolated in empty, soulless interiors were one of the key themes in his paintings.

Chronicling urban life

America's urban landscape and its inhabitants provided Hopper with a novel pictorial territory, which he explored in paintings that combine formal grandeur with a touching sense of melancholy.

Hopper was the leading figure of American scene painting. This term describes not a style, group, or movement, but a broad trend in the art of the 1920s and 1930s involving a patriotic celebration of American people and places, and a corresponding rejection of European influence. At this time Paris was still unchallenged as the world capital of contemporary art—New York did not take its place until after World War II—and it was still widely regarded as the font of artistic wisdom. However, many Americans, including Hopper, felt that their country should develop its own kind of art. In 1933 he wrote, "We are not French and never can

be." To attempt to imitate European styles, he went on, "is to deny our inheritance and to try to impose upon ourselves a character that can be nothing but a veneer upon the surface."

Although he lived in New York for most of his life, Hopper journeyed widely throughout America and he found inspiration for his pictures wherever he went. He traveled mainly by car, enjoying long motoring holidays, but railroads also figure prominently in his paintings. He was the first artist to realize what a fascinating pictorial world was offered by such distinctively American subjects as filling stations, motel

rooms, and drug stores. His most famous painting, *Nighthawks* (1942), is very much in this vein, showing an all-night diner in an otherwise deserted street. It exemplifies not only Hopper's wonderful strength and economy of design, but also the feeling of loneliness and isolation in the midst of the big city that is such a central feature of his work.

Below: Hopper, Nighthawks, *1942. The scene exudes an air of quiet and isolation; the figures, who occupy only a small part of the canvas, communicate neither among themselves nor with the outside world.*

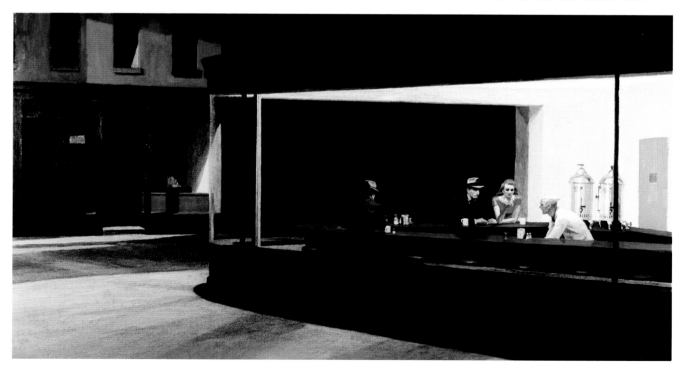

OSKAR KOKOSCHKA

1886–1980

The loose, flickering brushwork and the feeling of nervous sensitivity in this painting are typical of Kokoschka, whose portraits are among the most distinctive of the twentieth century. Initially many contemporaries found his work disturbing, but he became one of the most widely admired figures in modern art.

Kokoschka had an international career. He was born in Austria, but his father was Czech; he later took Czech and then British nationality himself, but he reverted to being an Austrian citizen a few years before his death. His early years were spent mainly in Vienna. He was beginning to make a name for himself there when his career was interrupted by World War I, during which he fought in the Austrian army and was badly wounded. Toward the end of the war, in 1917, he settled in Dresden, still recuperating from his wounds, and it was at this time that he painted this self-portrait. From 1919 to 1924 he taught in Dresden, then began a period of wide travel. He returned to Vienna in 1931, spent a good deal of time in Paris over the next few years, then moved to Prague in 1934. In 1938 he settled in London, which offered a comparatively safe refuge from the Nazis, of whom he had been an outspoken opponent.

By this time Kokoschka had a considerable reputation on the Continent, but he was little known in Britain and had difficulty making a living during the war years. After the war, however, his fortunes improved, and in his later years he was widely recognized as one of the outstanding artists of the twentieth century and received many honors. From 1953 he lived mainly in Switzerland. In addition to painting, he produced various other kinds of work, including prints and stage designs, and he was an accomplished writer, his literary output including plays, poetry, stories, essays, and an autobiography, published in German in 1971 and in English translation in 1974. He was also highly regarded as a teacher, running a summer school for artists in Salzburg from 1953 to 1963. Renowned for his energy and his personal magnetism, he remained vigorous into old age and died in Montreux, Switzerland, a month before his ninety-fourth birthday.

Self-Portrait, 1917, oil on canvas, Von der Heydt Museum, Wuppertal, Germany

Style and technique

In addition to the portraits for which he is most famous, Kokoschka painted various other kinds of picture, especially landscapes and townscapes and, later in life, allegorical and mythological works. The townscapes—often seen from a high viewpoint—were a reflection of his love of travel: during World War I he said that if he survived it he wanted to "go everywhere." His handling of paint was always vigorous and in his late work it became extremely loose and energetic, reminiscent of the brushwork of some of the American abstract expressionists.

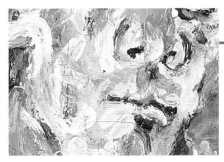

Kokoschka's face, which appears full and long in his many other self-portraits, here looks gaunt, the gestural brushwork conveying his sunken cheeks. In 1917 he was constantly sick and bedridden from his war wounds, and wrote to a friend: "I feel quite certain that my strength and youth are gone—not to mention my health."

Outlined in black, Kokoschka's sunken eyes appear mournful and pained, reflecting the physical and psychological injuries he suffered in World War I. He was also deeply depressed by the breakup of his love affair with Alma Mahler, widow of the composer Gustav Mahler.

Loosely interlinked strokes of red, ocher, and black paint convey the form of Kokoschka's right hand, which points to his chest. In 1915 he received a bayonet wound to his lung, and two years later, when he painted this self-portrait, the injury still caused him pain. He wrote: "My lung simply can't take the strain anymore; I get hellish chest pains."

Always free and gestural, Kokoschka's brush strokes here seem to wriggle, wormlike, with a life of their own. His paintings of 1917 are marked by their feverish brushwork and dark tonality; from 1918 he adopted less energetic brush strokes and a more high-key palette.

Expressionism

Throughout his immensely long career Kokoschka stayed true to his expressionist roots, creating works in which vigorous inner life counts for much more than surface appearance.

Kokoschka was one of the supreme representatives of expressionism. This term describes the use of exaggeration and distortion in art to achieve or emphasize emotional effect. The word can be loosely applied to art of any place or time, but usually it refers to modern European art. Vincent van Gogh (see pages 182–85) and Edvard Munch (see pages 190–93) in the late nineteenth century were the two great forerunners of expressionism in this sense, which was the dominant artistic movement in German-speaking countries from about 1905 until the Nazis came to power in 1933 and suppressed avant-garde art. Kokoschka was unusual in that his dedication to expressionism lasted throughout his career; whereas many of his contemporaries changed course, his outlook remained essentially constant and he was unaffected by other trends. He was also unusual among expressionists in that he was predominantly positive in attitude, instead of stressing—as others did—such emotions as anguish and fear.

Kokoschka first made his name as a portraitist, particularly with a series of pictures begun in 1909 that became known as "psychological portraits." To some contemporaries it seemed that in these works Kokoschka had managed to penetrate beyond surface appearances to lay bare the soul of the sitter. Many people found this unsettling, but Kokoschka's supporters regarded his work as poignant and compassionate. Among his sitters were leading figures from the worlds of art, music, science, and public affairs. He also made self-portraits throughout his career, the last of which shows him wittily confronting his own death.

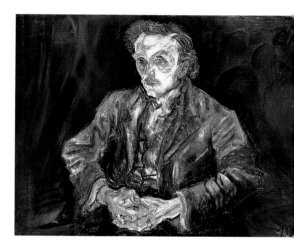

Above: Portrait of Adolf Loos (1909), one of Kokoschka's first "psychological portraits." Loos, an avant-garde architect, was one of Kokoschka's most influential supporters.

Right: Before the Masked Ball (1922) by Max Beckmann, one of the key figures of German expressionism. In allegorical works such as this, Beckmann attacked the vices of society.

MARC CHAGALL

1887–1985

Few other artists have created such a highly personal visual world as Chagall did. In this self-portrait, characteristically, he shows himself painting not in his studio but in a strange townscape in which the logic of everyday life is suspended. Such rich imagination, combined with warmth and humor, has made him one of the most popular of modern masters.

Chagall spent most of his very long life in France, but his work was dominated by memories of his early years in Russia, where he was poor but happy. He was born into a large, deeply religious Jewish family in Vitebsk (since the breakup of the Soviet Union in 1991 it has been part of the independent country of Belarus and its name is now spelled Vitsyebsk). From 1906 to 1909 he studied in Saint Petersburg, then in 1910 moved to Paris. In 1914 he went to Berlin for an exhibition of his work and decided to travel on eastward to see his homeland. The visit was badly timed, for World War I broke out that year, making travel across Europe virtually impossible and therefore trapping Chagall in Russia. He stayed there until 1922, when he moved to Berlin, and in 1923 he returned to Paris, where he remained until he fled because of the German invasion of France in 1940. As a Jew he was automatically at risk, and in 1941 he escaped via Spain to New York.

Chagall remained in America for seven years. He was successful there, building on the reputation he had enjoyed in Europe, but he never learned English or really felt settled in the country, and in 1948 he returned permanently to France, living first in Paris and then from 1949 near Nice on the Mediterranean coast. By this time he was in his sixties, but he still had more than thirty years of prolific activity in front of him. In addition to painting, he worked as a book illustrator and as a designer of stained glass and of sets and costumes for the theater and ballet. He received many honors and prestigious commissions and by the time of his death, at the age of ninety-seven, he was an almost legendary figure—the last link with the remarkable generation of painters and sculptors who had transformed art in the decade before World War I.

Self-Portrait: In the Twilight, 1938–1943, oil on canvas, Private Collection

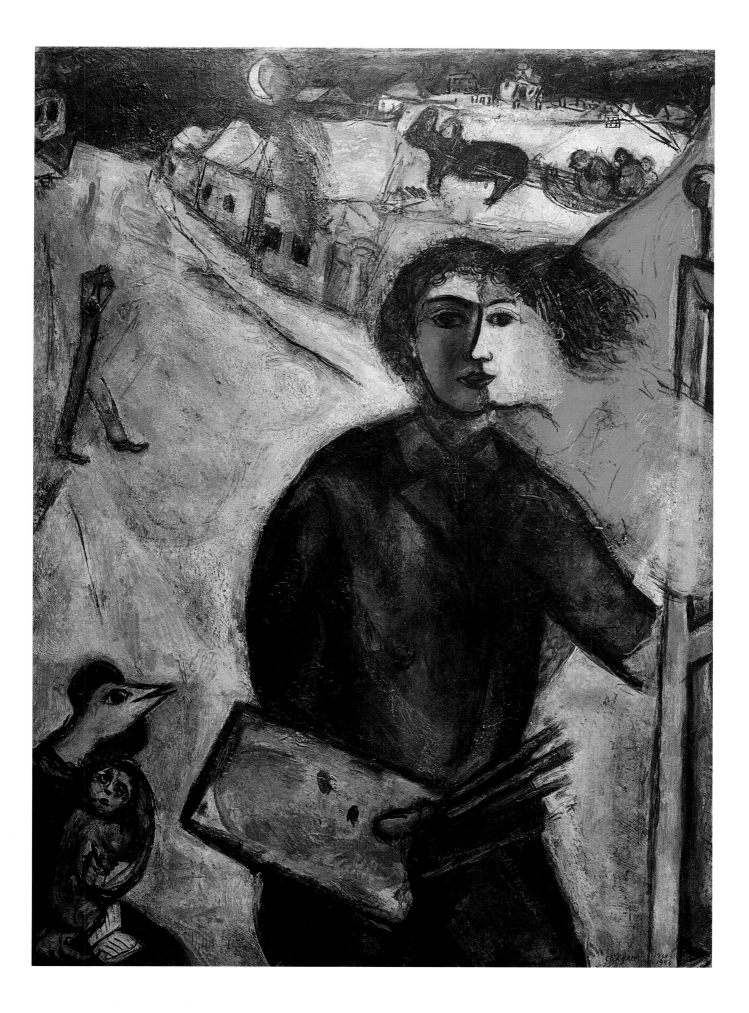

Style and techique
Chagall's style has links with several major artistic movements of the first half of the twentieth century. Some of his odd dislocations of form are influenced by cubism, for example, and his prismatic color effects recall orphism—a shortlived movement that sought to bring color and lyricism to cubism. More generally, the surrealists regarded him as a precursor because he shared their love of the irrational. However, in spite of these links, Chagall's work is highly personal. He established his distinctive voice early in his career, and although his style gradually became softer and sketchier, it did not alter in essentials.

The snow-covered buildings in the background recall Chagall's hometown of Vitebsk, but the flames gushing from one of them add a discordant note. This detail probably refers to the Nazi persecution of Jews and their burning of synagogues—a subject Chagall addressed in another painting of 1938.

Chagall shows the right side of his own face joining with a profile view of his wife, Bella. Their lips, noses, and eyes combine to create the image of one face. Bella appears angel-like, as if descending from the sky, the swath of pure red that accompanies her complementing the blue of Chagall's head.

In this rather unsettling detail, a roosterlike creature holds a baby. Animals often appear in Chagall's paintings as part of his highly personal imagery. In the late 1920s he also worked on a series of illustrations to the seventeenth-century French poet Jean de la Fontaine's Fables, in which animal characters are used to explore human morality.

Holding brushes and a rectangular palette and standing behind an easel, Chagall shows himself at work on a painting. It is one of several self-portraits in which he depicted himself at work.

Fantasy and life

By combining timeless themes and traditional symbolism with avant-garde artistic ideas and a spirit of imaginative freedom, Chagall created one of the most distinctive bodies of work in twentieth-century art.

In his autobiography, first published in 1931, Chagall wrote that however fanciful his paintings might appear, they were always grounded in reality—the world of his childhood in Russia. This is one of the fundamental ways in which he differed from the surrealists, who were a major artistic force in the 1930s, the time when Chagall acquired an international reputation. Whereas the surrealists aimed to explore the unconscious mind, Chagall liked to deal with such great perennial themes as birth, love, and death. However, he did so with such an unfettered spirit that his pictures are lifted into a world of wonder. Just as he mixed fantasy and reality, so he blended Jewish and Christian symbolism as part of his highly personal vision of the world.

Although Russia supplied the rich cultural background for Chagall's work, his stylistic vibrancy stemmed largely from Paris. When he first moved to the city in 1910 it was in the midst of a period of unprecedented experimentation in the arts, with movements like fauvism and cubism radically transforming painting. Chagall was too individualistic to subscribe wholeheartedly to the ideas of any one movement, but collectively they encouraged him to cast off inhibitions—to use bright colors in an unnaturalistic way, to separate a head from a body if he so desired, to show adjacent objects to different scales, or even to depict one figure inside

another. He wrote that "for me a picture is a surface covered with representations of things (objects, animals, human beings) in a certain order in which logic and illustration have no importance."

Below: Chagall, The Juggler, *1943. The painting's rich coloring, its highly individual imagery—which includes motifs from the circus and rural life—and its air of fantasy are typical of Chagall's work.*

GIORGIO DE CHIRICO

1888–1978

marble bust of the artist is seen in profile on the left of this strange self-portrait, while at right de Chirico himself looks out challengingly at the viewer. In front of the figures is a lemon and behind are curtains and strange architectural forms. Everything is very clearly and solidly painted, yet in spite of this there is a strong feeling of unreality about the picture. De Chirico made his name with this kind of deliberately enigmatic image, and his life and work continue to intrigue many people. He was a powerful personality and an influential figure, but his status among the major artists of the twentieth century is a matter of controversy.

De Chirico led a cosmopolitan life. His parents were Italian, but he was born and brought up in Greece—where his father was working as a railroad engineer—and his artistic training included a period in Munich. From 1909 to 1911 he lived in Italy and it was in this period that he began to paint hauntingly strange subjects. For the next four years he lived in Paris and was friendly with several leading figures in the world of avant-garde art, including Pablo Picasso (see pages 198–201) and Guillaume Apollinaire (1880–1918), a poet and art critic. It was Apollinaire who first applied the term "metaphysical" to de Chirico's pictures, and de Chirico himself later adopted the term "metaphysical painting" to describe his work. In 1915, during World War I, he was con-scripted into the Italian army, and in 1917 he suffered a nervous breakdown. While recuperating in a military hospital he met another painter, Carlo Carrà (1881–1966), who was converted to his views. The brief period they worked together, up to 1919, was the heyday of metaphysical painting.

After the war de Chirico lived for various periods in Italy, Paris, and America before eventually settling in Rome in 1944. He abandoned his metaphysical style and instead concentrated on paintings in which he expressed his admiration for the great masters of the past. In addition to painting he made sculpture and stage designs and wrote several books, including two volumes of autobiography. At his death, aged ninety, he was still a famous figure, but many critics thought that all his best work had been produced more than half a century earlier.

Self-Portrait with Statue and Lemon, 1922, oil on canvas, Toledo Museum of Art, Ohio

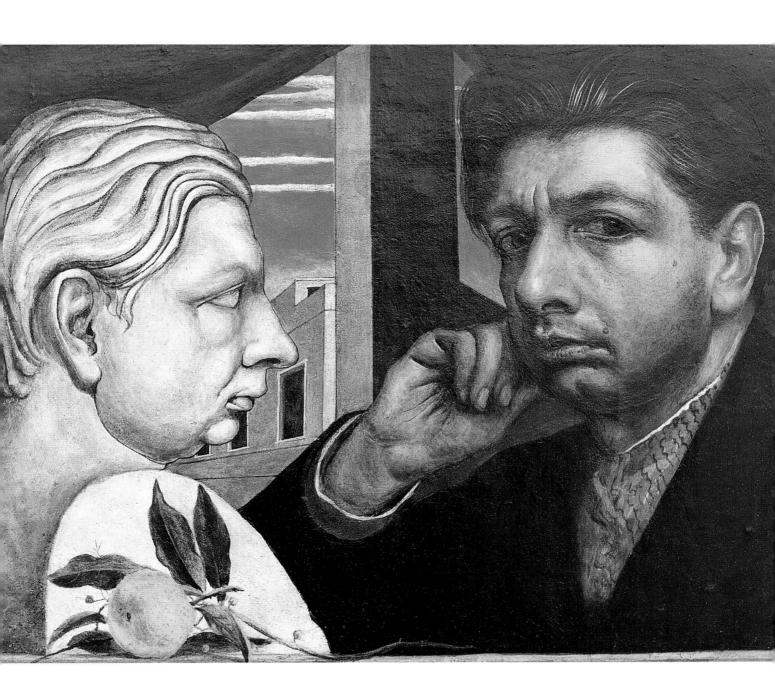

Style and technique

In his early work de Chirico tended to use rather thin, anonymously applied paint, but from the 1920s, having become absorbed in the study of the Old Masters, he began to experiment with different methods—he wrote a short handbook on the technique of painting, published in 1928. For a time he used tempera and pastels, but then began to use oils in a very rich, luxuriant manner, especially in the period from the mid-1940s to the mid-1960s. In his final years, however, he reverted to a straightforward technique recalling that of his early days.

The stark lines of a classical building can be seen in the background. Its sharp delineation and raking perspective are typical features of the classical arcades and piazzas that were a favorite motif in de Chirico's early work.

In a visual conceit, de Chirico shows a sculpted profile view of his head facing his painted image. He often included classical-looking busts and sculptures in his work.

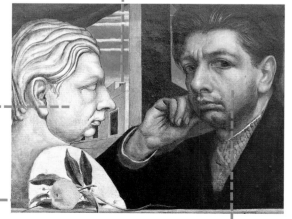

De Chirico renders his rather piggy features—his prominent nose, receding chin, and flabby jowls—in an evenly worked, anonymous technqiue. He looks out with an impassive gaze and slightly disgruntled expression, as he does in the many other self-portraits he made, including flamboyant full-length images in which he wears theatrical costume.

A freshly picked lemon rests on a stone ledge in the foreground of the painting. Its inclusion adds to the mysterious feel of the painting, with its juxtaposition of different elements, and possibly alludes to the baroque tradition of depicting fruit as a memento mori, or reminder of the briefness of life.

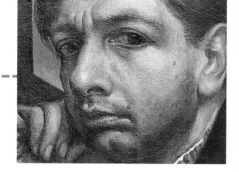

Metaphysical painting

In a brief but fertile period de Chirico and his followers created a series of enigmatic paintings that had a powerful and wide influence on artists during the 1920s and 1930s.

Above: Carlo Carrà, The Girl of the West, *1919. The mannequinlike figure, bare, urban setting, and general air of incongruity are typical of metaphysical painting.*

Below: De Chirico, The Soothsayer's Recompense, *1913. One of de Chirico's most popular works, the painting presents a bizarre combination of motifs in a pared-down style that exudes an air of stillness.*

Although de Chirico and his chief colleague Carlo Carrà wrote a good deal about metaphysical painting, which they jointly launched as a movement in 1917, they never clearly explained what they meant by the term "metaphysical." However, one definition of the word is "transcending physical matter," and what the artists imply is that their work expresses meanings that lie beyond the physical appearance of things. De Chirico's paintings of the time often depict open urban spaces—sometimes bounded by arcades—with an incongruous-looking object or objects placed in the almost bare setting. Often this object is a statue or mannequin. The various components of the painting are depicted more or less naturalistically, but together they make no rational sense, and the effect is to produce a feeling of brooding stillness, of mystery or hallucination. Carrà's paintings of the same time are similar in presentation, although generally less sinister in mood—sometimes there is even a touch of humor.

Apart from de Chirico and Carrà, only a handful of other Italian artists took up metaphysical painting and their involvement was short-lived. By the early 1920s the movement was over. However, in spite of its brief life, it made a powerful impact on European art. Its influence was spread partly by a journal called *Valori Plastici* (Plastic Values), which appeared from 1918 to 1921 in Italian and French editions. Several artists in Germany in the 1920s took up the idea of using featureless mannequins after seeing copies of the journal. More generally, metaphysical painting was a major source of inspiration for surrealism, which was the most widely spread artistic movement of the 1920s and 1930s.

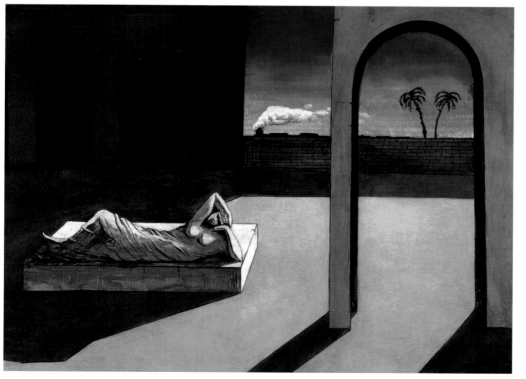

EGON SCHIELE

1890–1918

This is one of many self-portraits created by Egon Schiele and it is typical in showing him as anxious, even emotionally tortured. He had a decidedly odd, obsessive personality, which comes out in these narcissistic, exhibitionist pictures of himself, as well as in many other works. No other artist has so consistently presented himself in such an angst-ridden, self-pitying way, but far from being the persecuted outcast they suggest, he had what was in many ways an enviable existence: he was successful in his career at an early age and had a beautiful wife. However, his life was cut short in the appalling worldwide influenza pandemic that struck in 1918.

Schiele was born in Tulln, near Vienna, where his father Adolf was in charge of the busy railroad station. Adolf died insane in 1905, casting a pall over Schiele's adolescence and perhaps stimulating his interest in morbid subjects. He came to dislike his mother, whom he thought did not mourn his father enough, and he had a very close—possibly incestuous—relationship with his younger sister. From 1906 to 1909 he studied at the Academy of Fine Arts in Vienna. While he was still a student his work greatly impressed Gustav Klimt (1862–1918), the most famous Austrian painter of the day, and by the age of twenty Schiele was already launched on a promising career. Much of his work was highly explicit sexually, and in 1912 he spent nearly a month in prison for exhibiting erotic drawings in a place accessible to children.

In the winter of 1914 to 1915 Schiele had a substantial one-man show in Vienna, and this helped consolidate his growing reputation. He designed the poster for the exhibition, characteristically showing himself as a victim—Saint Sebastian pierced by arrows. Later in 1915 he married, four days before being called up for the Austrian army to fight in World War I. He had an easy time in the war—he was never in the firing line—and was able to continue exhibiting his work. By the end of the war he was becoming widely recognized as the most brilliant Austrian artist of his generation, but like millions of others he died in the influenza pandemic of 1918–19, aged only twenty-eight. His wife had died of the same cause three days earlier.

Self-Portrait with Chinese Lanterns, 1912, oil and gouache on panel, Private Collection

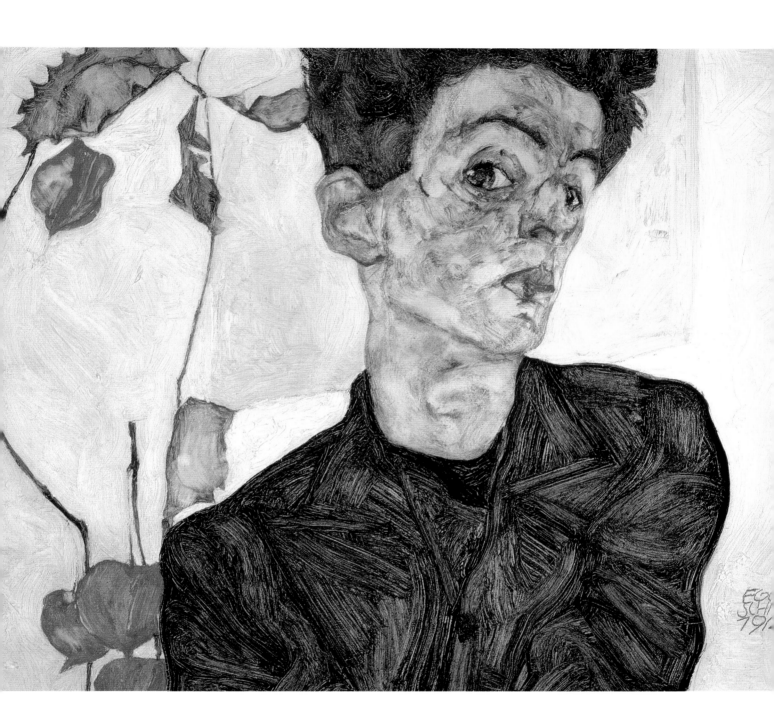

Style and technique

Schiele was one of the most powerful and original draftsmen of his time, and his work is characterized by a very distinctive, nervously energetic use of line. His output included landscapes, portraits, and allegorical subjects, but he is best known for his drawings of nude figures, who are often depicted as lonely and anguished, with emaciated, twisted bodies. Most of these figures are women or adolescent girls, but there are also numerous nude self-portraits. Usually the figures are presented against a plain, anonymous background that underlines their sense of isolation.

Schiele portrays himself as sallow and gaunt. Strokes of thinly applied green, gray, earthy brown, and red are brushed over a pale ground to produce the rather sickly skin tones.

The lines of Schiele's underdrawing are clearly visible in the jaw and ear. His style is based on his ability as a draftsman—on his economical use of outline to express contorted, often angst-ridden poses—and what seems to be a pursuit of ugliness or unease, as opposed to beauty.

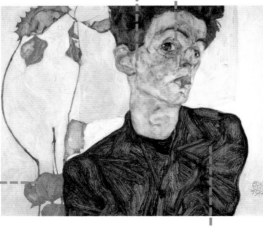

The brilliant orange seed casings and sinuous stems of the Chinese lantern impart a decorative appeal that makes this image one of Schiele's most compelling self-portraits. The inclusion of a plant motif reflects the influence of Jugendstil, the art nouveau style popular in turn-of-the century Vienna.

The black of Schiele's vigorously painted jacket and the white background concentrate attention on the painter's face. The limited palette of this portrait is repeated in its companion painting, Portrait of Wally, in which Schiele shows his lover in a similarly cropped pose.

The golden age of Vienna

Schiele's very brief career coincided with one of the most glorious periods in Vienna's cultural history, with his hero Gustav Klimt at the heart of events.

In Schiele's day Vienna was the fourth-largest city in Europe, with a population of about two million—only London, Paris, and Berlin were bigger. The empire of which it was the capital had been decaying politically for many years, but Vienna itself was a vibrant, cosmopolitan place that had a justified reputation as one of the greatest cultural centers in the world— its tradition in music was matchless. It was also the home of the founder of pyschoanalysis, Sigmund Freud (1856–1939). Between about 1860 and the end of the century the center of the city was transformed by the creation of an immense spacious boulevard called the Ringstrasse. This road was lined with magnificent buildings that provided work for an army of architects, builders, artists, and craftsmen. The city's golden age in culture lasted up to World War I (1914–18), which brought the Austro-Hungarian Empire to an end.

In painting, the key figure of this period was Gustav Klimt, whom Schiele idolized. Klimt began his career working in a traditional style, but he quickly became adventurous, creating works with richly decorative patterns and materials. By the 1890s he was regarded as a leader of the avant-garde. In 1897 he was elected the first president of the Vienna Sezession, an organization set up by a group of painters, sculptors, architects, and designers who regarded the official art world as too stuffy and who therefore broke away ("seceded") to hold their own more liberal and adventurous exhibitions. The Sezession was an immediate success, and the profits from its first exhibition in 1898 were used to erect a permanent exhibition hall. Schiele was the major participant in an exhibition there in 1918—his biggest triumph before his tragically early death.

Above: Schiele, The Hermits, 1912. In this somber double portrait, Schiele shows himself in front of his idol Gustav Klimt.

Below: Gustav Klimt, The Kiss, 1907. This famous painting is typical of Klimt's style, combining rich decoration and naturalism.

NORMAN ROCKWELL

1894–1978

The unpretentious charm, the amiable humor, and the loving attention to detail shown in this picture made Norman Rockwell a national institution for many years. His pictures reached a vast audience through their use as magazine illustrations and he helped to create an enduring image of middle-class America. For most of his career he was regarded as a brilliantly successful humorist rather than a serious artist, but late in life he turned to weightier subjects and began to receive attention from critics who had previously dismissed his work as sentimental.

Rockwell was born in New York and he studied there at various art colleges. By age eighteen he was working full time as an illustrator, notably for the magazine *Boys' Life*, of which he became art director. In 1916, still only twenty-two, he had the great breakthrough in his career when one of his pictures was used on the cover of the *Saturday Evening Post*. This was the biggest-selling weekly publication in America at the time, with about three million copies sold of every issue. Rockwell continued working for the *Post* until the 1960s (it stopped publication in 1969), producing hundreds of covers for it— about ten a year on average—as well as many illustrations for inside pages. He also worked for other popular publications, including *Ladies' Home Journal*, and produced book illustrations, notably for Mark Twain's *Tom Sawyer* and *Huckleberry Finn*.

In 1946 a collection of his work was published as *Norman Rockwell, Illustrator*, and several other books followed in similar vein. They had huge sales, even the expensive *Norman Rockwell, Artist and Illustrator* (1970), which is said to have sold almost sixty thousand copies in six weeks at a price of $60. In his later years he worked a good deal for *Look* magazine, for which he produced a series on racism—one of the clearest examples of his move into more serious subjects. From 1953 he lived in Stockbridge, Massachusetts, and in 1993, fifteen years after his death, a large museum dedicated to his work opened there. It was partly funded by the movie director Steven Spielberg, who feels an affinity with Rockwell's desire to appeal to a mass audience, not just a cultured elite.

Triple Self-Portrait, 1960, oil on canvas, Rockwell Family Trust

Style and technique

Although most of his large output is humorous, there was nothing spontaneous about the way Rockwell worked—he was very methodical. After developing his preliminary ideas in sketches, he gathered models, costumes, and props from which he made detailed drawings; from the 1930s he also used photographs to help him at this stage. The individual drawings were the basis for a full-scale detailed study of the whole composition, and only then did he go on to painting the finished work in oils.

Rockwell's craning neck and curious gaze are reflected in the mirror. In a clever visual conceit, he presents three main images of himself as well as four minor ones in the sheet of studies pinned to the top right of the drawing board.

Pinned to the top right corner of the drawing board are four self-portraits of famous artists—from top to bottom: Albrecht Dürer, Rembrandt, Picasso, and van Gogh—a gesture of Rockwell's respect, as well as a light-hearted suggestion of his own place in the history of art.

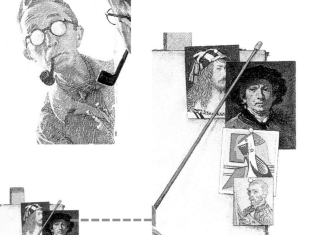

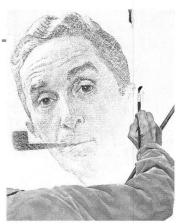

Rockwell's right hand rests on a mahlstick, or maulstick, as he paints the detail of his face, yet the image on the canvas looks more like a graphic work than a painting. It also shows a younger-looking Rockwell than the reflection in the mirror—his glasses are gone, his pipe no longer droops from his mouth, and his eyebrows are raised in a mirthful expression.

The only complete view of Rockwell in this triple self-portrait is a back view, in which he shows himself sitting astride a stool and leaning to study his reflection. In placing his back to the viewer, he recalls Jan Vermeer's famous work The Art of Painting (see pages 70–73).

America's artist

Rockwell is best known for the vast number of images he produced celebrating the American way of life, but in some of his later work he looked at less wholesome aspects of the country he loved.

Throughout his career Rockwell took an interest in modern developments in art and in particular was an admirer of Picasso (see pages 198–201). This is certainly not apparent from his own work, which was firmly rooted in tradition and for the most part popular and frankly sentimental in approach. He aimed to appeal to the ordinary American man or woman, rather than the art-lover, and he described the kind of subjects in which he specialized as "this best-possible-world, Santa-down-the-chimney, lovely-kids-adoring-their-kindly-grandpa sort of thing." However, his work amounted to more than just folksy entertainment, and during World War II he played an important role in boosting national morale. One of the most famous of all his covers for the *Saturday Evening Post* depicts Rosie the Riveter—based on a figure from Michelangelo's Sistine ceiling—a symbol of women's contribution to the war effort. In the same year that this cover appeared, 1943, an exhibition of his work helped to raise a huge sum for war bonds.

After the war Rockwell broadened his scope and also moved with the times to a certain extent, including such figures as astronauts among the American heroes he depicted. In the 1960s, a time of great civil conflict, he began to treat subjects that were far removed from the cozy world long associated with him. For a cover of

Look magazine in 1964, for example, he showed black children trying to enter a segregated school. Indeed, Rockwell's work, taken as a whole, provides a fascinating commentary on continuity and change in American values in the twentieth century.

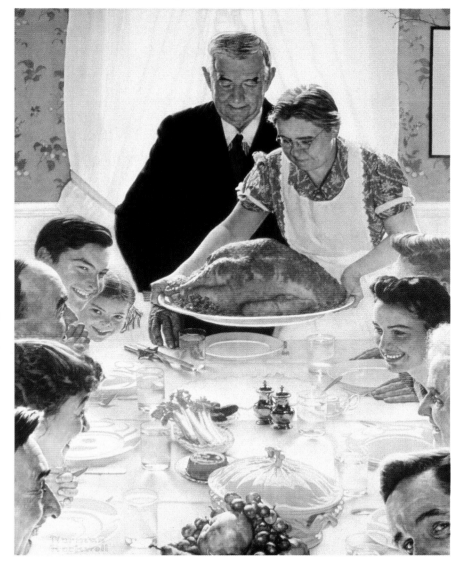

Below: Rockwell's Freedom from Want *(1943), one of four paintings he made to illustrate the Four Freedoms outlined by President Franklin D. Roosevelt in 1941 as a fundamental right of all peoples— freedom from fear, freedom from want, freedom of speech, and freedom of worship.*

RENÉ MAGRITTE

1898–1967

his picture looks almost like an ordinary domestic scene, presented with matter-of-fact realism, but Magritte has sprouted an extra pair of arms to help him dig in to his meal. Such witty combinations of the banal and the marvelous were Magritte's speciality and have won him a reputation as one of the most original and intriguing of modern artists.

Magritte was born in Lessines, a small town near Brussels. His family was prosperous, but his childhood was darkened by the suicide of his mother when he was thirteen. From 1916 to 1918 he studied art at the École des Beaux-Arts in Brussels. Over the next few years he experimented with various styles, including cubism, while supporting himself with jobs such as designing posters and working in a wallpaper factory. In 1925 he began painting in a surrealist style and quickly realized that he had found his true direction; by the following year he was already painting pictures that explore surrealist ideas in a distinctive way. From 1927 to 1930 he lived in Paris, which was the main center for surrealism, but like many other people he did not get along with André Breton, the French writer who was the dictatorial leader of the group. After a disagreement with Breton, Magritte returned to Brussels and thereafter rarely left the city. He disliked travel and led a life that—apart from his art—was one of unremarkable middle-class routine. Indeed, he was almost fanatically unvarying in his daily habits, walking his dog in the morning and playing chess at a favorite café in the afternoon. In this respect he was very different from many of the other leading surrealists, who loved publicity and scandal—Salvador Dalí being the extreme case (see pages 230–33).

Magritte showed his work in many surrealist exhibitions, but success was fairly slow in coming to him. It was not until after World War II that he began to be widely recognized as one of the outstandingly original artists of his day. In his final years his reputation was underlined with a number of major exhibitions surveying his life's work, including one at the Museum of Modern Art, New York, in 1965. By the time of his death two years later, he was not only an admired figure among connoisseurs, but also a favorite with the general public, and he continues to be the best loved of the surrealists.

The Wizard, 1951, oil on canvas, Private Collection

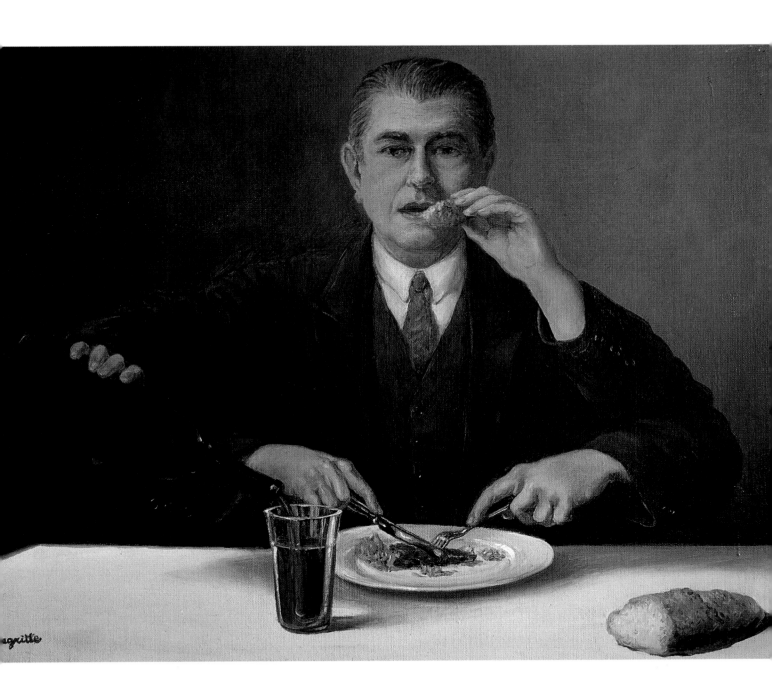

Style and technique
Early in his career Magritte tried out various styles and in the 1940s he went through a period when he experimented with comparatively bold colors and vigorous brushwork, but otherwise he painted in a deliberately self-effacing manner throughout his career. Imaginative vision was what mattered to him, rather than beauty of technique, and he found the actual process of painting boring— nevertheless he produced numerous near-exact copies of favorite compositions. In addition to paintings, he made wax sculptures late in life, some of which were cast in bronze after his death.

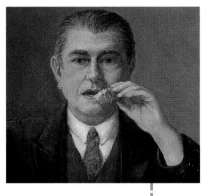

The self-portrait is rendered in a muted tonal palette of whites, grays, browns, and black. This use of low-key color, combined with careful brushwork, accorded with Magritte's intention of producing superficially understated, even banal, images—his technique has often been criticized as academic and unpainterly.

With his smart clothes and neatly groomed hair, Magritte looks more like a middle-aged businessman than an artist. He liked the idea of anonymity that such an appearance afforded, often wearing a bowler hat and dark coat, like the figures in so many of his paintings.

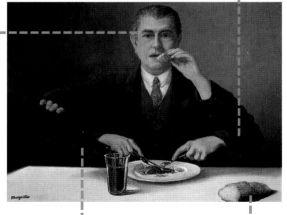

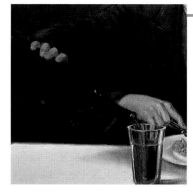

In his apparently realistic style, Magritte portrays himself with two right arms and two left arms. The anonymity of his technique was intended to make such bizarre distortions of nature all the more convincing.

As the carefully rendered bread shows, Magritte painted people and objects in a realistic style. Early in his career he experimented with several different styles but in 1925 announced that he intended "only to paint objects with their evident detail."

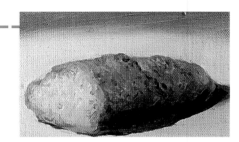

Visual trickery

Magritte's paintings are based on the commonplace world around him, but he subtly plays tricks with expectations to create teasingly enigmatic situations. His quietly captivating images remain immensely popular today.

The heyday of surrealism was the 1930s. Major exhibitions devoted to the movement were held in various European cities, in America, and in Japan, and its ideas were also spread through books and magazines, some of which were so beautifully produced they were works of art in themselves. The reputation of many of the leading surrealists have subsequently fluctuated, but ever since Magritte became established as a major figure his standing has remained high. It took him longer to win fame than some of his colleagues, but his work has proved more enduring in its appeal than theirs; whereas their aggressively attention-grabbing effects have worn thin, Magritte's deadpan humor still delights. In the catalog of the exhibition devoted to him at the Museum of Modern Art, New York, in 1965, the American art historian J. T. Soby well describes how Magritte's work creeps up on the spectator rather than seizing him or her by the throat: "In viewing Magritte's paintings ... everything seems proper. And then abruptly the rape of commonsense occurs, usually in broad daylight."

Magritte was a deeply thoughtful man who cleverly undermined our commonsense attitudes and feelings for what is ordinary and familiar. He loved visual puns, paradoxes, and trickery, playing on the ambiguity between real objects and painted representations of them—many of his works involve paintings within paintings. In several pictures he shows a clear sunlit sky that blends into a night scene below it. Other favorite themes include giant rocks that hover in the air and animals that transform into plants or into human figures.

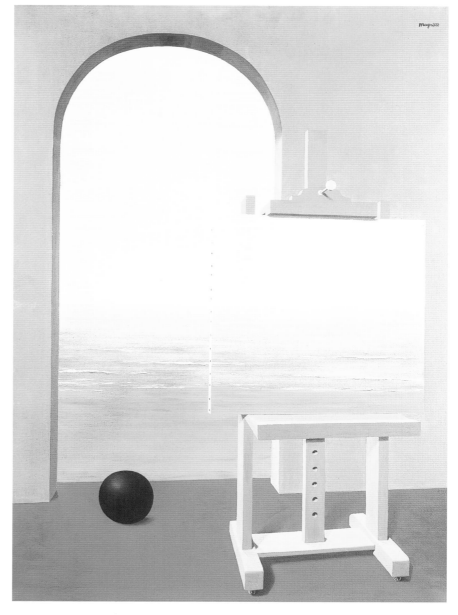

Below: Magritte, Human Condition II, *1935. This is one of many of Magritte's paintings that play with ideas of reality and illusion in art. Here an easel supports a painting that apparently blends into the beach scene that it portrays.*

SALVADOR DALÍ

1904–89

Although many famous artists have had massive egos, few can compete with Salvador Dalí in terms of self-love and self-promotion. He adored living in the public spotlight and his highly distinctive appearance, with his trademark moustache, made him instantly recognizable even to people who had no particular interest in art. In this self-portrait he presents himself crowned with laurel leaves, which were used in the ancient world to honor heroes, emperors, and even gods. Gazing reverently at him is his wife, Gala, who was the inspiration for much of his work.

Dalí's obsession with showing off went back to his early childhood. An elder brother, also named Salvador, died shortly before Dalí was born and he identified himself morbidly with his namesake, constantly craving attention. He showed artistic gifts from an early age, and by the time he was expelled from the Academy of Fine Arts in Madrid in 1926—for offensive comments to his teachers—he had already had a successful one-man show in Barcelona. After experimenting with different styles, he took up surrealism in 1929 and quickly became its most famous exponent. His celebrity was partly a result of his genius for publicity stunts; at a major surrealist exhibition in London in 1936, for example, he delivered a lecture dressed in a diver's suit and almost suffocated when the helmet became stuck. However, he also produced outstanding work during this period, including a number of pictures that rank among the most memorable images of the twentieth century. Most famous of all is *The Persistence of Memory* (1931), with watches melting as if made of wax. He said of such strange, hallucinatory pictures: "People love mystery, and that is why they love my paintings."

From 1940 to 1948 Dalí lived in America, then subsequently mainly in Spain—although he often visited New York and Paris. In old age he suffered illness and became a recluse, but he remained a newsworthy figure until the end of his life. Since his death he has continued to provoke discussion and controversy. Some critics regard him as a vulgar showman who was more interested in making money than in creating serious art, but there can be no doubt that his best paintings possess a haunting power and have become part of the mental furniture of people all over the world.

Self-Portrait with Gala, undated, photomontage, Fundación Gala-Dalí, Figueres, Spain

Style and technique

In his classic surrealist paintings of the 1930s Dalí used a highly polished technique to express his vivid imaginings, creating what he called "hand-painted dream photographs." In 1939 he was formally expelled from the surrealist movement, but he retained much of its attitudes in his later work. However, he tended to concern himself with subjects such as religion and sex rather than with dream imagery. In addition to his paintings, Dalí produced a large and varied output of other work, including sculpture, prints, and designs for furniture, fashion, jewelry, and the cinema.

Dalí's public image was defined by his distinctive upturned waxed moustache. He cultivated eccentricity, his life and art blending in his desire for self-promotion and publicity.

Dalí depicts himself wearing a laurel garland. In a typical act of self-promotion, he portrays himself as both mythic hero and painter—at the bottom left of the image his finger rests on the handle of a paintbrush.

Included in the collage are motifs familiar from Dalí's enormous output of paintings, including this melting clock, which comes from his famous painting The Persistence of Memory (shown opposite).

Gala's portrait is included as a painted profile view of her face looking up reverently at her husband. The zipper of Dalí's jacket separates her masklike face from her hair, which sprouts a forest of small trees. Dalí had married Gala in 1921 and she became an important subject in his work.

Surrealism

Dalí was a leading figure of surrealism, an influential avant-garde art movement that flourished between the world wars. Surrealist artists aimed to liberate the human spirit by revealing the creative powers of the unconscious mind.

Surrealism was concerned with expressing the bizarre and the irrational, particularly through using the unconscious mind—including dreams—as a source of inspiration. The founder of surrealism was the French writer André Breton (1896–1966), who believed that Western society had been corrupted by excessive rationalism and materialism and wanted to place a new importance on emotional and imaginative values. To him, surrealism was a way of life rather than an artistic movement—a method of understanding and expressing the inner self. He was interested in radical ideas in politics as well as in art, and for several years surrealism was strongly connected with the French Communist Party.

Breton officially launched surrealism with a manifesto published in 1924, in which he said the purpose of the movement was "to resolve the previously contradictory conditions of dream and reality into an absolute reality, a super-reality." Initially he conceived surrealism mainly in terms of literature, but he soon enlarged the concept to cover painting. He was very vigorous in promoting his ideas, and he often had strong disagreements with other surrealists, several of whom he expelled from the movement.

Many leading surrealists—including Breton and Dalí—took refuge in New York during World War II (1939–45) and they had a major impact on American art, particularly the abstract expressionists, who like them stressed intuition rather than calculation. By the end of the war surrealism had more or less broken up as an organized movement, but it has remained popular and influential.

Top: Dalí, The Persistence of Memory, *1931. Dalí termed such meticulously painted works, with their bizarre imagery, his "hand-painted dream photographs."*

Bottom: The Entire City (1935–36) *by Max Ernst (1891–1976), the leading German exponent of surrealism.*

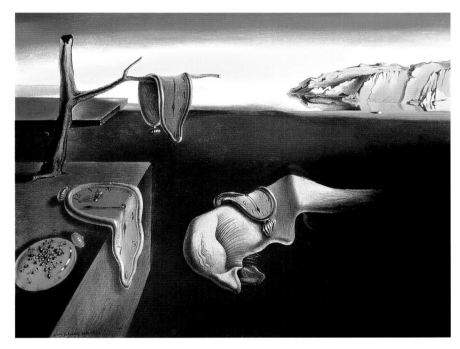

FRIDA KAHLO

1907–54

This is one of several self-portraits in which Kahlo depicted herself with a monkey or monkeys. In the mythology of her country, Mexico, the monkey is the patron of dance and a symbol of lust, but the animal also had a more personal meaning for Kahlo. She had a great love of animals and kept numerous pets—including deer, dogs, and parrots, as well as monkeys. They were companions in the solitude that was often forced on her because she was unable to lead a normal life, having suffered multiple injuries at the age of eighteen that left her a permanent semi-invalid.

The injuries were sustained on September 17, 1925, when the bus on which she was traveling from school collided with a tram. Several people were killed in the crash and Kahlo was so badly hurt that she was never really free from pain again; she was hospitalized many times throughout her life and underwent a total of about thirty operations. During her initial convalescence she took up painting and the passion she discovered for art helped to sustain her through the difficulties of her life. Her work attracted the attention of Diego Rivera (1886–1957), Mexico's most famous painter, whom she married in 1929. Physically they seemed like an extraordinary mismatch, for Rivera was an enormous, ponderous man—twice the size of the frail Kahlo (as well as twice her age); her parents described it as being like a marriage between an elephant and a dove. However, in addition to their artistic interests, they shared passionate political beliefs—both of them were communists. There were infidelities on both sides of the marriage and the couple divorced in 1939. However, the separation was brief; they remarried the following year and stayed together until Kahlo's death.

Kahlo showed her work successfully in New York in 1938 and in Paris in 1939, but nevertheless she was overshadowed during her lifetime by her husband, who was an extremely forceful personality as well as a major artist. Since her death, however, her reputation has grown enormously and she has become a feminist heroine—a woman who refused to allow prolonged physical suffering to break her spirit. A play about her, *La Casa Azul*—named after her blue-painted house in Mexico—opened in London in 2002, and a Hollywood movie of her life entitled *Frida* was released in 2003.

Self-Portrait with Monkey, 1943, oil on canvas, Private Collection

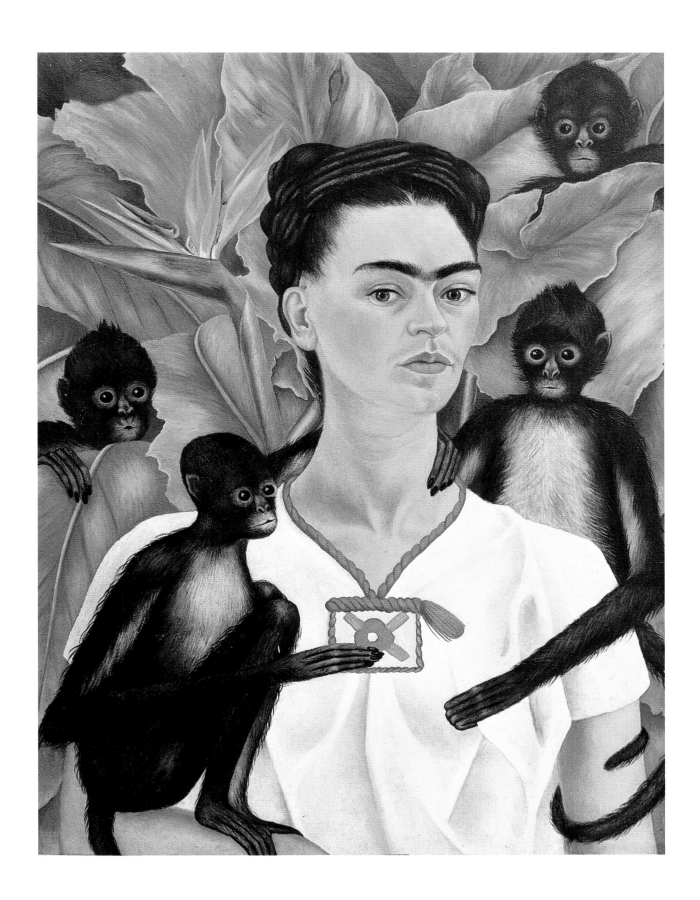

Style and technique

Kahlo was largely self-taught and her fiery and flamboyant style reflects her own personality very directly. She took some of her inspiration from the colorful traditions of Mexican folk art, and her sense of fantasy links her to surrealism, but her art is so distinctive that it transcends all influences. Her husband Diego Rivera described her work as "acid and tender, hard as steel, and delicate and fine as a butterfly's wing, loveable as a beautiful smile, and profound and cruel as the bitterness of life."

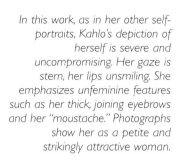

In this work, as in her other self-portraits, Kahlo's depiction of herself is severe and uncompromising. Her gaze is stern, her lips unsmiling. She emphasizes unfeminine features such as her thick, joining eyebrows and her "moustache." Photographs show her as a petite and strikingly attractive woman.

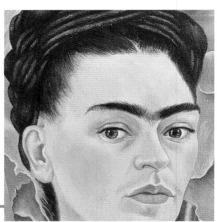

The striking form of a bird-of-paradise flower and the lush leaves of tropical plants form the backdrop to this self-portrait. Native to Central and South America, these plants were included to emphasize Kahlo's Mexican heritage.

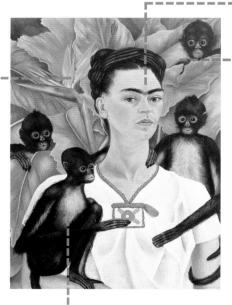

One of the monkeys has its arm around Kahlo's neck, adding an air of tender intimacy to the image. Its companion on the other side reaches down to her breast, referring to the animal's traditional association with lust.

Kahlo's style is meticulously detailed, smoothly finished, and brightly colored. Self-taught, she initially imitated European academic art, but from the late 1920s she cultivated a specifically Mexican style, drawing on her country's folk art.

Feminist heroine

In the self-portraits that make up the bulk of her work, Frida Kahlo produced a highly original and emotionally enthralling visual commentary on her remarkable life.

There are about two hundred known paintings by Frida Kahlo and well over half of these include an image of herself, either as the whole subject or as part of a larger composition. She said that "I paint myself because I am so often alone and because I am the subject I know best," and few other artists have left an output that is so intensely and overwhelmingly autobiographical. Some of these images of herself are fairly straightforward self-portraits, but in many others she charts the physical and mental pain that dominated her life after her horrific accident. These pictures formed a kind of exorcism that helped her to come to terms with her situation. Some of them are tender, but others are nightmarish visions of suffering. Often she explained the thinking behind her pictures—by inscriptions on the back or front of the canvas or by accounts in letters, but even without such clues, the emotional assault they make on the viewer is powerful and unsettling.

Kahlo shows herself in many different moods and situations—for example, in a hospital bed, with her animals, wearing the orthopedic corsets she had to use in her later years, with her heart lying bleeding at her feet, or with her head surmounting the body of a wounded deer. Some pictures express her belief in communism and numerous others document her difficult relationship with Diego Rivera. In most of her paintings her technique is firm and clear, but in her final works her handling of paint is much looser; this loss of precision probably reflects the large amounts of painkillers she was taking at the end of her life.

Left: Kahlo's The Two Fridas (1939), painted just after her divorce from Diego Rivera—the figure on the right holds an amulet of him as a child. This unusual and disturbing double self-portrait explores Kahlo's identity and heritage: at left she shows herself as European, and at right as Mexican. The two figures are linked by their joined hands and a vein connecting their hearts.

FRANCIS BACON

1909–92

T he features are smudged and twisted to create a face from a nightmare, yet the sheer vigor and breadth of the brushwork make this self-portrait visually exhilarating as well as disturbing. As in so many of his works, Bacon presents a figure in bleak isolation. He had an unremittingly desolate view of the human condition, regarding life as a "game without reason," and the raw power with which he conveyed this vision made him one of the most famous and controversial artists of his time.

Bacon was born in Dublin, the son of a racehorse trainer. He had little normal education because he suffered from severe asthma as a child, but he became a great reader. Although he inherited a love of gambling from his father, he otherwise did not get along with him, and left home at the age of sixteen. Over the next few years he drifted, living in Berlin and Paris before settling in London in 1929. He had no formal training in art, but he began earning a living as a designer of furniture and rugs, and also started exhibiting paintings. However, he worked intermittently and destroyed many of his pictures, and he did not make a major impact on the art world until 1945, when his *Three Studies for Figures at the Base of a Crucifixion* (1944) was exhibited in London and made him famous overnight because of its horrific imagery.

Bacon's paintings were extensively exhibited after this, leading to a major show of his work at the Tate Gallery, London, in 1962. Over the next two years the exhibition was seen in several European venues and at the Guggenhein Museum, New York, and this exposure firmly established Bacon as a leading figure in the international art world. Subsequently his reputation increased to such an extent that in his later years he was widely regarded as the world's greatest living painter, although some critics found his despairing vision of humanity hard to stomach. He became famous not only for his work, but also for his wild living. Nevertheless, in spite of his drinking, gambling, and promiscuous homosexuality, he remained passionately devoted to painting until the end of his life: in 1985 he said, "I hope I shall go on painting—in between drinking and gambling—until I drop dead, and I hope I shall drop dead working."

Self-Portrait, 1969, oil on canvas, Private Collection

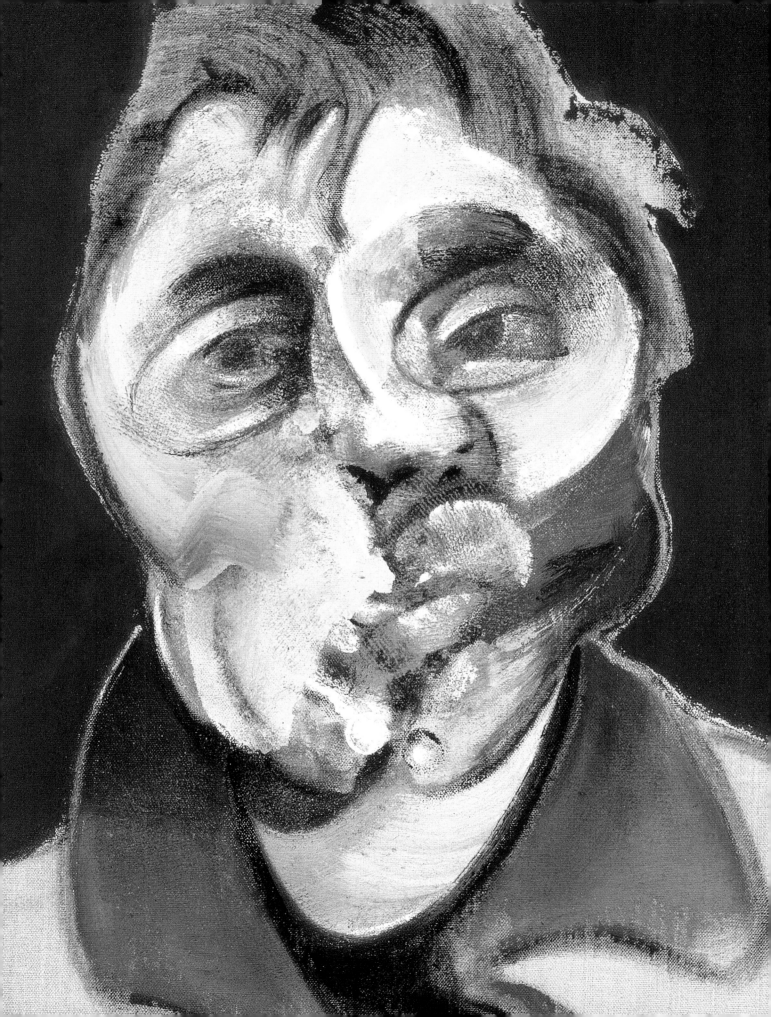

Style and technique

Bacon's paintings are modern in spirit, but the richness and masterly assurance of his brushwork have led him to be compared technically with some of the most revered Old Masters. Among such painters, Bacon had particular admiration for Diego Velázquez (see pages 58–61) and he said that he tried to paint "like Velázquez but with the texture of a hippopotamus skin." Self-taught, he was often unconventional in his working procedures: he sometimes painted with his fingers, mixed sand with his colors to achieve textured effects, or used different types of paint together, such as oil and pastel.

Dynamic curves and disks define Bacon's features, appearing to cut into the solid form of his face. These harsh distortions recall the tortured forms of expressionists such as Egon Schiele (see pages 218–21), as well as Picasso (see pages 198–201), whose work Bacon particularly admired.

The contorted sweep of the nose, sunken cheeks, harsh disks of the eyes, and deeply cleft chin present a disturbing yet recognizable image of Bacon. He said of his approach: "What I want is to distort the thing beyond the appearance, but in the distortion to bring it back to a recording of the appearance."

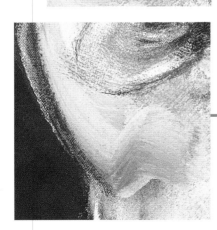

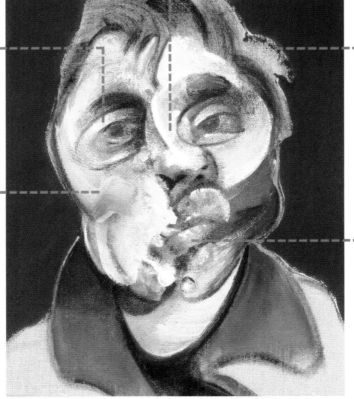

Raw, unprimed canvas shows through in the hair and overcoat. Touches of pale pink paint outline the painter's form against the plain black background.

Strokes of more fluid paint have been vigorously applied to pick out the highlights of the face, as here on the cheek. Bacon varied his application of materials; often he threw handfuls of paint at his larger canvases, exploiting the chance effects they created.

Vivid orange pastel is applied in thin, parallel strokes over several areas of the painting, as here in the mouth.

Disturbed reflections

In his portraits and figure paintings, Bacon created harrowing images that probe the horrors of the modern world while drawing on the inspiration of the past.

Above: Diego Velázquez's Innocent X *(1650), a masterpiece of portraiture that inspired many artists, including Bacon.*

Below: Bacon's The Screaming Pope *(1953), one of Bacon's disturbing variants on Velázquez's famous portrait.*

Almost all Bacon's work deals with the human face or figure. He found much of his inspiration in his own everyday world, painting numerous self-portraits and portraits of friends, for example. His first self-portrait was executed in 1956, and he commented on it with characteristic straight-forwardness: "I couldn't think what on earth to do next, so I thought 'Why not try and do myself?'"

His output also includes many pictures in which one or two figures (rarely more) are used as the basis for his explorations of the human predicament, although in some of his work the figures are so distorted that they are barely recognizable as human, seeming part animal or monster. Often the figures are alone, in despair or anguish, and sometimes they are accompanied by hunks of meat, as if to stress the carnality of his subjects: "We are all meat, we are potential carcasses," he said.

In addition to taking subjects from the world around him, Bacon often based his pictures on photographs or reproductions in books and magazines. Most notably, he was inspired by Velázquez's famous portrait of Pope Innocent X to produce a lengthy series of pictures of seated popes. However, whereas Velázquez's pope is a calm, commanding figure, those in Bacon's pictures are typically gripped by feelings of pain or terror; sometimes the face he gives them is based on a close-up of a screaming woman from Sergei Eisenstein's film *The Battleship Potemkin* (1925). Through such paintings Bacon showed that the tradition of figure painting could be sustained and enriched in a period when abstraction was becoming the dominant force in avant-garde art.

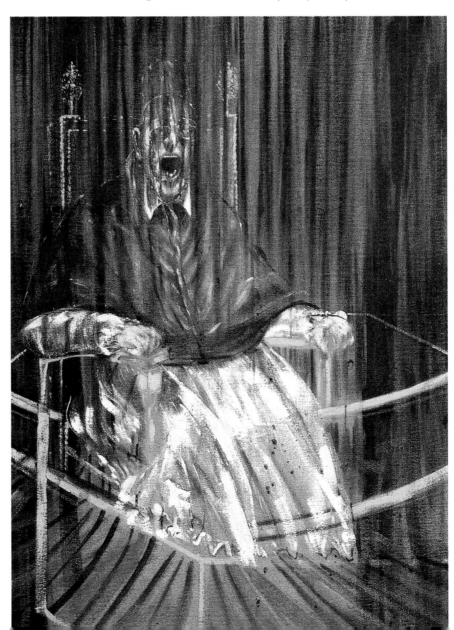

ANDY WARHOL

1928–87

nlike the other self-portraits in this book, which are unique objects, this picture of Warhol is one of several closely similar versions. It is a screen print, a type of image produced by squeezing ink through a fine mesh or screen—usually made of silk—onto paper or canvas below. The design is created by blocking out parts of the screen so that ink passes through only where required. A photographic image can be used in the design, as it is here, by treating the screen with light-sensitive chemicals and projecting a transparency onto it. Warhol and his assistants often produced numerous copies of a screen print, varying the colors from print to print. This self-portrait is one of a set of six he was commissioned to make for the American pavilion at Expo 67, the World Fair held in Montreal in 1967; he had burst on the art scene only five years earlier, yet already he was regarded as one of his country's leading artists.

Warhol was born in Pittsburgh, the son of immigrants from Slovakia. In 1949 he moved to New York, where he lived for the rest of his life. He quickly became extremely successful as a commercial artist—shoe advertisements were something of a speciality—winning awards and earning a huge amount of money, but he also wanted to make a name for himself as a "serious" artist. At first he had little success with the work he exhibited in galleries, but in 1962 he became famous with a one-man show of pictures representing Campbell's soup cans. He remained a celebrity for the rest of his life, treated more like a pop star than an artist. For a while he did indeed manage a pop group—the Velvet Underground—and he also devoted much of his time to making experimental movies. In 1965 he announced he had retired as an artist to concentrate on these other activities, but in fact he never gave up art and he continued earning vast sums of money from it; when he died, following a gall bladder operation, he left a fortune estimated at $100,000,000. Most of this money was used to create an arts charity called the Andy Warhol Foundation. His admirers regarded him as one of the most important artists of the twentieth century, but others saw him as merely a brilliant showman who was supremely skillful in riding the wave of fashion.

Self-Portrait, 1967, silkscreen ink on acrylic paint on canvas, Froehlich Foundation, Stuttgart

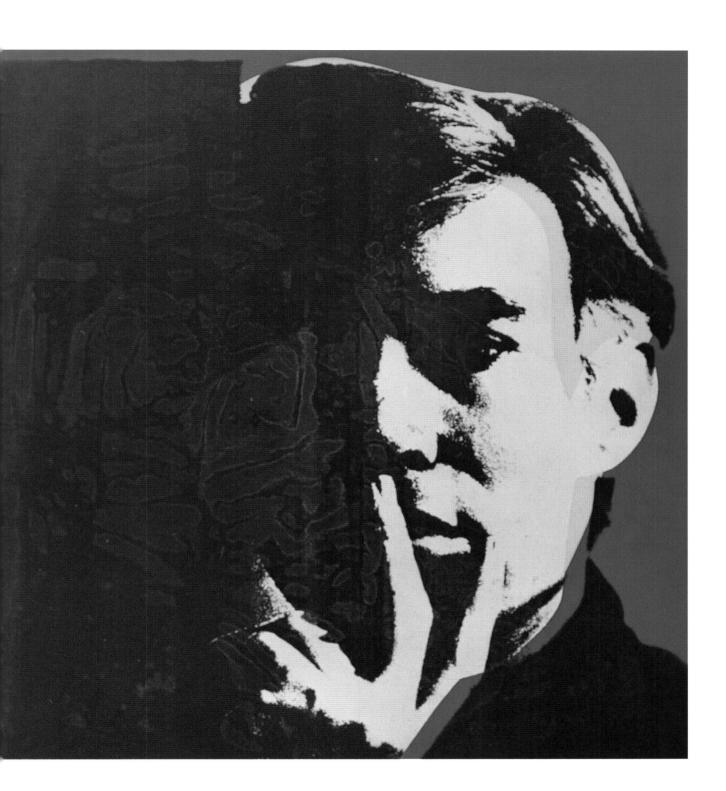

Style and technique

Most of the work for which Warhol is famous is in his favorite medium of screen printing. He did more than anyone else to establish this as a serious artistic technique. Previously it had been used mainly in advertising, a world Warhol knew intimately, and he used the strong, flat colors typical of the medium with a posterlike boldness. Warhol also worked in three dimensions, producing sculptures replicating supermarket cartons in a similar spirit to his pictures of cans of Campbell's soup. In all his activities, he delegated much of the work to assistants.

The dark ink in the left-hand section of the painting appears to have been thinned to create a marbled pattern. The printing ink was oil-based and the effect here could have been created by adding a diluent such as turpentine.

The different colored inks were applied in different printings, with a separate screen for each color. The alignment of the screens was often approximate; when one of Warhol's assistants suggested a method for more precise registration on one of his prints, he apparently shrugged off the advice, saying of the irregular appearance, "I kind of like it that way."

The blue-black ink that corresponds to the dark tonal areas of the original black-and-white photograph from which the screen print was made was the last color to be applied. It draws together the colored areas of the image.

Warhol made the blue background of the image by painting the canvas with acrylic, a water-based plastic paint that had only just come into use as a quick-drying alternative to oil paint.

High priest of pop

In his work and his lifestyle Warhol was obsessed by fame and glamor. He made himself the center of a large group of admirers and assistants, and produced slick, often shocking images celebrating the objects and icons of popular culture.

In 1962, at the time when Warhol shot to fame, pop art was becoming the most vibrant force in the art worlds of America and Britain—it flowered in other countries, too, but it was most prominent in the English-speaking world. As the name suggests, pop art was based on popular culture, taking its imagery from such fields as advertising, comic books, the movies, and television.

In both America and Britain this fascination with consumerism reflected a period of unprecedented affluence following the recovery from World War II. In America, pop art also marked a reaction against abstract expressionism, which had dominated the country's art in the 1950s.

Whereas the abstract expressionists took themselves very seriously and were often gloomy in mood, pop artists were typically jokey and brash. However, there was also a darker side to the movement, expressed for example in Warhol's pictures of the electric chair. And whereas the abstract expressionists placed great importance on the individual handling of paint, pop artists generally cultivated a slick, impersonal finish.

Warhol worked in a studio called "The Factory," where he attracted an entourage of unconventional characters—drop-outs, drug addicts, transvestites, and hustlers—some of whom appeared in his films. In 1968, however, he was shot and badly

Above left: Marilyn Monroe (c.1964), one of Warhol's best-known screen prints. Many of his works feature the stars of popular culture, icons such as Marilyn and Elvis.

Above right: Just What Is It That Makes Today's Homes So Different, So Appealing? (1956), a wry look at consumerism by British pop artist Richard Hamilton (1922–).

wounded by one of these hangers-on, and after his recovery he distanced himself from this dangerous subculture and instead started moving in high society. Much of his huge income in his later years came from portraits commissioned by the wealthy people with whom he mixed, but by this time he was probably more famous for being a celebrity than for what he actually produced.

DAVID HOCKNEY

1 9 3 7 –

nitially it looks as if this picture depicts a fairly deep space, with the artist seated at a table some way beyond the sleeping figure. However, as the title indicates, what we see behind the model is in fact a picture within a picture—*Self-Portrait with Blue Guitar*, which Hockney was working on at this time. On looking closer we can see that the foreground is painted in a more naturalistic style than the self-portrait image, which is flatter and more schematic in treatment. This sophisticated playing with different levels of reality exemplifies the wit and imagination that have helped make Hockney's work so popular. The painting is also typical of him in that it has a strong autobiographical element, for the model, Gregory Evans, was his lover at the time.

Hockney was born in Bradford, Yorkshire. He studied at the local art school and later at the Royal College of Art in London, where he was regarded as the most brilliant student of his generation; by the time he graduated in 1962 he had already won several awards and thereafter he quickly made an international reputation. In 1963 he had his first one-man exhibition in London—many others have followed in various countries—and in the same year he first visited Los Angeles, where he has subsequently spent much of his life. Many of his paintings express his vision of California as a land of affluence, leisure, and sunshine; in particular he has produced numerous works featuring swimming pools, which provide a suitable setting for the male nude—one of his favorite themes. He found that the flat, bold colors of acrylic paint helped to capture the effects of bright outdoor light, and he used it for most of his paintings between 1963 and 1972, when he returned to oils, which he had come to value for their slow-drying qualities.

Hockney has worked in various fields apart from painting, including printmaking, book illustration, photography, and stage design. His success and fame have depended not only on his versatility and flair, but also on his colorful personality and his ability to discuss his work—and other art—engagingly and unpretentiously. He has published several books in which he comments on his career and other artistic topics, most recently *Secret Knowledge: Rediscovering the Lost Techniques of the Old Masters* (2001).

Model with Unfinished Self-Portrait, 1977, oil on canvas, Private Collection

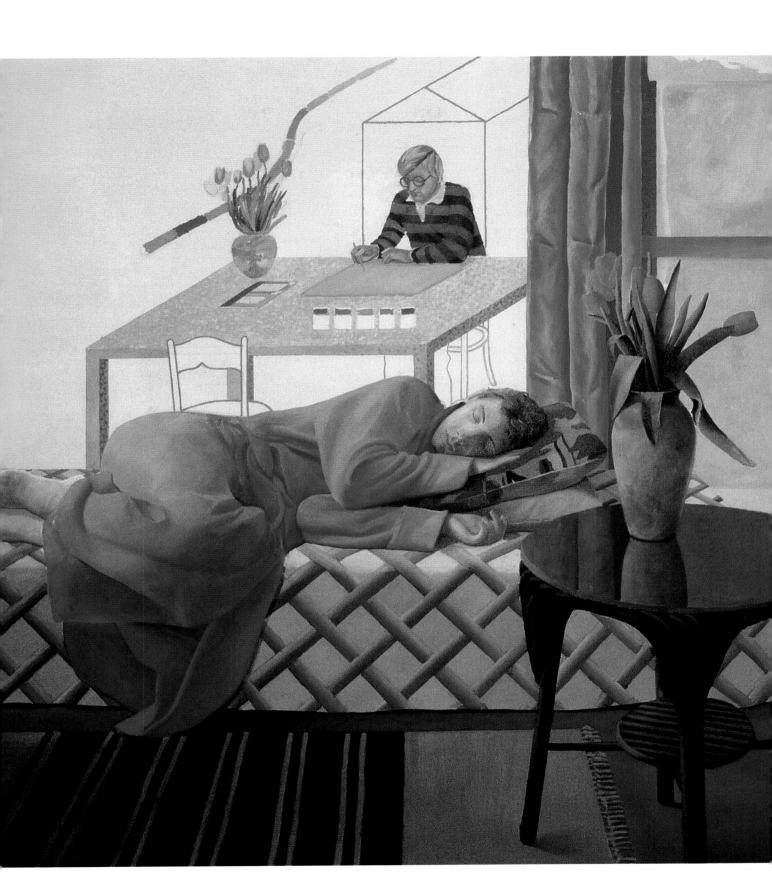

Style and technique

Initially Hockney painted in a solid, traditional style, but by the early 1960s his work had become lighter and jokier, coming close in spirit to pop art. By the later 1960s his style had regained a sense of firm construction, but he used strong, clear, bright forms that conjure up a sense of stylish living rather than the sobriety of his earliest works. In his later paintings his handling has become looser and his color lusher. In all his work he has demonstrated seemingly effortless fluency as a draftsman.

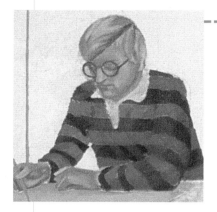

Hockney portrays himself with his distinctive blond hair and glasses, engrossed in making a drawing. Almost all the upper part of the picture, including the blue curtain, actually shows a work in progress: Self-Portrait with Blue Guitar, in which Hockney shows himself drawing the blue outline of a guitar.

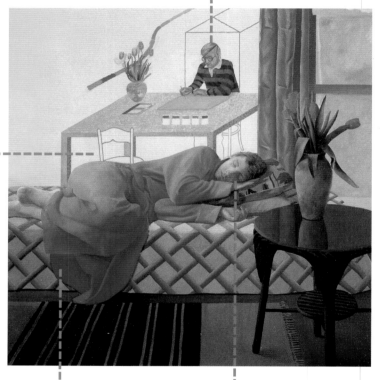

The red outline of a chair appears in front of a speckled table, painted in touches of pure color in a style rather like Georges Seurat's (see page 181). Set against the highly finished and fully modeled forms of the foreground, the formal treatment of these elements is one of the devices Hockney uses to play with levels of reality within the painting.

Intense blue dominates the painting. Blue forms—the dressing gown and curtain—frame the view of the artist, where the color is echoed in the dots of the table and the spangled form at top left. Bright reds and greens also run throughout the picture, from the tulips, rug, and patterned bed-spread, to the outlined furniture and Hockney's striped shirt.

The model is shown lost in sleep rather than engaged in posing for the artist, as might be expected from the painting's title. It is an intimate study of Hockney's lover Gregory Evans. Portraits are an important part of Hockney's work and are almost invariably uncommissioned paintings of his friends.

Stage designs

In the 1970s Hockney began making designs for opera sets and costumes. His work for the stage is innovative, bold, and stylized, and he quickly emerged as one of the outstanding artists working in the field.

Hockney's first stage designs were made for a production of Alfred Jarry's play *Ubu Roi* at the Royal Court Theatre, London, in 1966. They included costumes but were mainly small backdrops—a series of "stage pictures." In the spirit of the knockabout humor of the play, they are jaunty in feeling. Hockney did not receive another stage commission until 1974, when he was asked to design a production of Stravinsky's opera *The Rake's Progress*, to be performed the following year by Glyndebourne Festival Opera in Sussex. At first he had misgivings about taking the job, as he thought he might not know

enough about the technicalities involved, but he had loved opera since childhood and he eventually decided that a new challenge would be stimulating: "When you're working suddenly in another field, you are much less afraid of failure. You kind of half expect it, so therefore you take more risks, which makes it more exciting." Far from being a failure, Hockney's designs were acclaimed from the start; they are based on the engravings by William Hogarth (1735) that inspired the opera (see page 74), but recast in a vigorous modern idiom.

Following this success, Hockney was asked to design another opera for

Glyndebourne—Mozart's *The Magic Flute*, staged in 1978. His work on this production was also well received and thereafter designing for opera became an important strand in Hockney's prolific output. The musical master-pieces he has worked on include Wagner's *Tristan und Isolde* for the Los Angeles Music Center Opera in 1987 and Puccini's *Turandot* for the Lyric Opera of Chicago in 1992. His designs are stylized rather than naturalistic, with powerful use of bold forms and colors.

Below: Hockney's model for the set—a ship deck—of Act I of Tristan und Isolde *for the 1987 Los Angeles Music Center production.*

FURTHER READING

Portraiture and self-portraiture

Bell, Julian (intro). *Five Hundred Self-Portraits*. London: Phaidon Press, 2000.

Bonafoux, Pascal. *Portrait of the Artist: The Self-Portrait in Painting*. New York: Rizzoli International Publications, 1985.

Craven, Wayne. *Colonial American Portraiture*. New York: Cambridge University Press, 1986.

Drury, Elizabeth. *Self-Portraits of the World's Greatest Painters*. San Diego: Thunder Bay Press, 2001.

Gasser, Manuel. *Self-Portraits: From the Fifteenth Century to the Present Day*. New York: Appleton-Century, 1963.

Kinneir, Joan (ed.). *The Artist by Himself: Self-Portrait Drawings from Youth to Old Age*. New York: St. Martin's Press, 1980.

Schneider, Norbert. *The Art of the Portrait*. New York: Taschen, 1999.

Simon, Robin. *The Portrait in England and America*. London: Phaidon Press, 1987.

Whitford, Frank. *Expressionist Self-Portraits*. New York: Abbeville Press, 1987.

Woods-Marsden, Joanna. *Renaissance Self-Portraiture*. New Haven and London: Yale University Press, 1998.

Monographs on featured artists

Anguissola
Perlingieri, Ilya Sandra. *Sofonisba Anguissola: The First Great Woman Artist of the Renaissance*. New York: Rizzoli, 1992.

Bacon
Kundera, Milan (intro.). *Bacon: Portraits and Self-Portraits*. New York: Thames and Hudson, 1996.

Bonnard
Watkins, Nicholas. *Bonnard*. London: Phaidon Press, 1998.

Caravaggio
Wilson-Smith, Timothy. *Caravaggio*. London: Phaidon Press, 1998.

Cassatt
Pollock, Griselda. *Mary Cassatt: Painter of Modern Women*. London: Thames and Hudson, 1998.

Cézanne
Verdi, Richard. *Cézanne*. New York: Thames and Hudson, 1992.

Chagall
Haftmann, Werner. *Chagall*. New York: Harry N. Abrams, 1998.

Chardin
Rosenberg, Pierre, et al. *Chardin*. London: Royal Academy of Art/New York: Metropolitian Museum of Art, 2000.

Chirico, de
Faerna, Jose Maria. *De Chirico*. New York: Harry N. Abrams, 1995.

Copley
Flexner, James Thomas. *John Singleton Copley*. New York: Fordham University Press, 1993.

Courbet
Rubin, James. *Courbet*. London: Phaidon Press, 1997.

Dalí
Ades, Dawn. *Dalí*. New York: Thames and Hudson, 1995.

Degas
Roberts, Keith. *Degas*. London: Phaidon Press, 1992.

Delacroix
Jobert, Barthelemy. *Delacroix*. Princeton, NJ: Princeton University Press, 1998.

Dürer
Bailey, Martin. *Dürer*. London: Phaidon Press, 1995.

Eakins
Innes-Homer, William. *Thomas Eakins: His Life and Work*. New York: Abbeville Press, 1992.

Gainsborough
Vaughan, William. *Gainsborough*. New York: Thames and Hudson, 2002.

Gauguin
Bowness, Alan. *Gauguin*. London: Phaidon Press, 1994.

Goya
Ciofalo, John. *The Self-Portraits of Francisco Goya*. New York: Cambridge University Press, 2001.

Hilliard
Strong, Roy. *Nicholas Hilliard*. London: Michael Joseph, 1975.

Hockney
Livingstone, Marco. *David Hockney*. New York: Thames and Hudson, 1996.

Hogarth
Hallett, Mark. *Hogarth*. London: Phaidon Press, 2001.

Holbein
Langdon, Helen. *Holbein*. London: Phaidon Press, 1993.

Hunt
Wood, Christopher. *The Pre-Raphaelites*. New York: Viking Press, 1981.

Hopper
Goodrich, Lloyd. *Edward Hopper*. New York: Harry N. Abrams, 1993.

Kahlo
Herrera, Hayden. *Frida Kahlo: The Paintings*. New York: Harper Perrenial, 2002.

Kauffman
Manners, V. *Angelica Kauffman: Her Life and Works*. New York: Hacker Art Books, 1977.

Kokoschka
Faerna, Jose-Maria (ed.) *Kokoschka*. New York: Cameo/Harry N. Abrams, 1995.

Leonardo
Kemp, Martin. *Leonardo da Vinci: The Marvellous Works of Nature and Man*. Cambridge, Mass.: Harvard University Press, 1981

Magritte
Gablik, Suzi. *Magritte*. New York: Thames and Hudson, 1985.

Manet
Courthion, Pierre. *Manet*. New York: Harry N. Abrams, 1984.

Matisse
Watkins, Nicholas. *Matisse*. London: Phaidon Press, 1992.

Millet
Murphy, Alexandra. *Jean-François Millet: Drawn into the Light*. New Haven and London: Yale University Press, 1999.

Monet
Tucker, Paul Hayes. *Claude Monet: Life and Art*. New Haven and London: Yale University Press, 1995.

Morisot
Adler, Kathleen. *Berthe Morisot*. London: Phaidon Press, 1995.

Munch
Wood, Mara-Helen (ed.). *Edvard Munch: The Frieze of Life*. New Haven and London: Yale University Press, 1992.

Picasso
Hilton, Timothy. *Picasso*. London: Thames and Hudson, 1994.

Poussin
Blunt, Anthony. *Nicolas Poussin*. London: Pallas Athene, 1995.

Raphael
Oberhuber, Konrad. *Raphael: The Paintings*. New York: Prestel Publishing, 1999.

Rembrandt
White, Christopher. *Rembrandt by Himself*. London: National Gallery, 1999.

Renoir
Bailey, Colin. *Renoir Portraits: Impressions of an Age*. New Haven and London: Yale University Press, 1997.

Reynolds
Wendorf, Richard. *Sir Joshua Reynolds: The Painter in Society*. Cambridge, Mass.: Harvard University Press, 1996.

Rockwell
Marling, Karal Ann. *Norman Rockwell*. New York: Harry N. Abrams, 1997.

Rossetti
Rodgers, David. *Rossetti*. London: Phaidon, 1996.

Rousseau
Adriani, Gotz. *Henri Rousseau*. New York: Yale University Press, 2001.

Rubens
Belkin, Kristin Lohse. *Rubens*. London: Phaidon Press, 1998.

Sargent
Kilmurray, Elaine, and Richard Ormond. *John Singer Sargent*. Princeton, NJ: Princeton University Press, 1998.

Schiele
Dabrowski, Magdalena, and Rudolf Leopold. *Egon Schiele: The Leopold Collection, Vienna*. New York: The Museum of Modern Art, 1997.

Seurat
Herbert, Robert. *Seurat: Drawings and Paintings*. New Haven and London: Yale University Press, 2001.

Stubbs
Myrone, Martin. *George Stubbs*. New York: Harry N. Abrams, 2003.

Tintoretto
Nichols, Tom. *Tintoretto: Tradition and Identity*. London: Reaktion Books, 2002.

Titian
Hope, Charles. *Titian*. London: Jupiter Books, 1980.

Turner
Brown, David Blayney. *Turner in the Tate Collection*. New York: Harry N. Abrams, 2002.

Van Dyck
Brown, Christopher. *Van Dyck*. New York: Rizzoli, 1999.

Van Eyck
Harbinson, Craig. *Jan van Eyck: The Play of Realism*. Seattle: University of Washington, 1991.

Van Gogh
Keyes, George. *Van Gogh: Face to Face: The Portraits*. New York: Thames and Hudson, 2000.

Velázquez
Brown, Jonathan. *Velázquez: Painter and Courtier*. New Haven and London: Yale University Press, 1986.

Vermeer
Wheelock, Arthur. *Vermeer: The Complete Works*. New York: Harry N. Abrams, 1997.

Vigée-Lebrun
Sheriff, Mary. *The Exceptional Woman: Elisabeth Vigée-Lebrun and the Cultural Politics of Art*. Chicago: University of Chicago Press, 1997.

Warhol
Bastian, Heiner (ed.). *Andy Warhol: A Retrospective*. London: Tate Gallery Publishing, 2002.

West
Von Erffa, Helmut. *The Paintings of Benjamin West*. New Haven and London: Yale University Press, 1986.

Whistler
Dorment, Richard, and Margaret MacDonald. *Whistler*. New York: Harry N. Abrams, 1995.

Web sites
General
Art archive site with entries on artists, movements, and terms, providing biographies, extracts from published books, and images: http://artchive.com/ftp_site.htm
Artcyclopedia search engine for art subjects: http://www.artcyclopedia.com/
Olga's Gallery entries on artists including biographies, picture information, and images: http://www.abcgallery.com/
Web Gallery of Art virtual museum and searchable database of European painting and sculpture from 1150 to 1800: http://gallery.euroweb.hu/

Museums and galleries
Baltimore Museum of Art http://www.artbma.org/home.html
Borghese Gallery, Rome http://www.galleriaborghese.it/borghese/en/edefault.htm
Courtauld Institute of Art, London http://www.somerset-house.org.uk/attractions/courtauld/
Detroit Institute of Art http://www.dia.org/
Fogg Art Museum, Cambridge, MA http://www.artmuseums.harvard.edu/fogg/
Gemäldegalerie, Berlin http://www.smb.spk-berlin.de/gg/
Hermitage, Saint Petersburg http://www.hermitagemuseum.org/html_En/index.html
Kunsthistorisches Museum, Vienna http://www.khm.at/homeE/homeE.html
Lady Lever Art Gallery, Port Sunlight, U.K. http://www.portsunlight.org.uk/gallery/
Louvre, Paris http://www.louvre.fr/louvrea.htm
Munch Museum, Oslo http://www.museumsnett.no/munchmuseet/
Musée d'Orsay, Paris http://www.musee-orsay.fr:8081/ORSAY/orsaygb/HTML.NSF/By+Filename/mosimple+index?OpenDocument
Musée Marmottan, Paris http://www.marmottan.com/
National Academy of Design, New York http://www.nationalacademy.org/
National Gallery, London http://www.nationalgallery.org.uk/
National Gallery, Prague http://www.ngprague.cz/main.php?language=en
National Portrait Gallery, London http://www.npg.org.uk/live/index.asp
National Portrait Gallery, Washington D.C. http://www.npg.si.edu/
Prado, Madrid http://museoprado.mcu.es/prado/html/ihome.html
Tate Britain, London http://www.tate.org.uk/britain/default.htm
Uffizi, Florence http://www.uffizi.firenze.it/welcomeE.html
Victoria and Albert Museum, London http://www.vam.ac.uk/
Toledo Museum of Art, Ohio http://www.toledomuseum.org/home.html
Whitney Museum of American Art, New York http://www.whitney.org/

INDEX

PICTURE CREDITS